D0990147

FORT WORTH
PUBLIC LIBRARY
FORT WORTH
TEXAS 76102

# Courbet's Realism

# COURBET'S REALISM

## MICHAEL FRIED

THE UNIVERSITY OF CHICAGO PRESS

CHICAGO AND LONDON

Michael Fried is the J. R. Herbert Boone Professor of Humanities and director of the Humanities Center at the Johns Hopkins University.

Published with the assistance of the Getty Grant Program

The University of Chicago Press, Chicago 60637
The University of Chicago Press, Ltd., London
© 1990 by Michael Fried
All rights reserved. Published 1990
Printed in the United States of America
99  98  97  96  95  94  93  92  91  90     54321

Library of Congress Cataloging in Publication Data
Fried, Michael.
    Courbet's realism / Michael Fried.
        p.     cm.
    Bibliography: p.
    Includes index.
    ISBN 0-226-26214-6 (alk. paper)
    1. Courbet, Gustave, 1819–1877—Criticism and interpretation.
2. Realism in art—France.  I. Title.
ND553.C9F74   1990
759.4—dc20                                          89-35432
                                                         CIP

This book is printed on acid-free paper.

To Sydney J. Freedberg

and Jean Starobinski

[Courbet] est tout à la fois le plus curieux spécialiste et le plus abondant généralisateur. C'est la grande et féconde personnification du peintre dans ce qu'il a de plus multiplié et de plus individuel.
—Zacharie Astruc, "Récit douloureux," *Le Quart d'heure*, 20 July 1859

# Contents

# Illustrations

FIGURES

# Acknowledgments

THIS BOOK was written not so much chapter by chapter as painting by painting over a span of roughly ten years. For their help in thinking through the issues with which it engages I want especially to thank Neil Hertz, Ruth Leys, and Walter Benn Michaels. Other friends and colleagues have also been deeply supportive: Yve-Alain Bois, Stanley Cavell, Kermit Champa, Jonathan Crewe, Elizabeth Cropper, Charles Dempsey, Frances Ferguson, Stanley Fish, Stephen Greenblatt, Werner Hamacher, John Harbison, Peter Hughes, Herbert L. Kessler, Steven Z. Levine, Stephen Melville, W. J. T. Mitchell, Ronald Paulson, Peter Sacks, Joel Snyder, and Richard Wollheim. In the course of writing and rewriting chapter six, "Courbet's 'Femininity,'" I profited from the criticisms of Lynn Hunt, Sheila McTighe, Jacqueline Rose, and Eve Kosofsky Sedgwick; needless to say they have no responsibility for the end result. In the spring of 1987, at the invitation of Hubert Damisch and Louis Marin, I presented several seminars on Courbet at the Ecole des Hautes Etudes en Sciences Sociales; I'm grateful to them both, as well as to Claude Imbert and Jean-Claude Bonne who were equally part of those occasions, for the generosity of their welcome and the astuteness of their comments. My work on Courbet was also aided by a fellowship from the National Endowment for the Humanities. I spent the fellowship year mainly writing on Thomas Eakins and Stephen Crane, but it was also then that the overall shape of *Courbet's Realism* became plain to me.

Portions of this book have been published in somewhat different form. An earlier version of chapter 2 appeared in *Glyph* 4 (1978), © 1978 by the Johns Hopkins University Press. An earlier version of chapter 3 appeared in *Critical Inquiry* 8 (Summer 1982), © 1982 by The University of Chicago. An earlier version of chapter 4 appeared in *Critical Inquiry* 9 (June 1983), © 1983 by The University of Chicago. Chapter 5 includes material previously published in *MLN*, 99, no. 4 (September 1984), ©

1984 by the Johns Hopkins University Press; *Reconstructing Individualism: Autonomy, Individuality, and the Self in Western Thought,* ed. Thomas C. Heller, Morton Sosna, and David E. Wellbery (Stanford: Stanford University Press, 1986), © 1986 by the Board of Trustees of the Leland Stanford Junior University; *Art in America* 69, no. 7 (September 1981), © 1981 *Art in America;* and *Allegory and Representation,* Selected Papers from the English Institute, 1979–80, ed. Stephen J. Greenblatt (Baltimore: the Johns Hopkins University Press, 1981), © 1981 by the Johns Hopkins University Press. An earlier version of chapter 6 appeared in *Courbet Reconsidered,* ed. Sarah Faunce and Linda Nochlin (New Haven and London: Yale University Press, 1988), © 1988 by Michael Fried. I am grateful to Macie Hall for her help in gathering illustrations. And I want to thank André Jammes for making available prints of two rare photographs without which this book would be the poorer. The index is the work of Jane Marsh Dieckmann, and she, too, has my gratitude.

One further remark. In the pages that follow I refer often to the work of T. J. Clark, usually to take issue with it in one respect or another. Let me therefore state in so many words that I regard *Image of the People* as marking an epoch in Courbet studies, and that I consider it my good fortune to have had my friend Tim Clark to contend with.

# 1     Approaching Courbet

GUSTAVE COURBET was born in the village of Ornans, not far from Besançon, on 10 June 1819. His family, with extensive landholdings in the region, was well-to-do, and for a while it was hoped that Gustave would become a lawyer. But from an early age his sole interest was painting, and in the fall of 1839, after learning the rudiments of his art from provincial teachers, he left for Paris ostensibly to study law but in fact to become a painter. Throughout his life he remained loyal to his native Franche-Comté, returning often to Ornans for long visits and painting there some of his most important pictures.[1]

During most of the 1840s Courbet worked in obscurity. His friends included Max Buchon, poet, folklorist, and future translator of Hebel, with whom he had gone to school in Besançon and who was to become politically the most radical of all those close to him; Champfleury (Jules Husson), a novelist who was also to be his first critical champion; François Bonvin, a young painter; and Charles Baudelaire, not yet the poet of *Les Fleurs du mal* but already an art critic of genius and among the most flamboyant inhabitants of Bohemia.[2] Stylistically, Courbet apprenticed himself to the old masters, in particular to Rembrandt and the seventeenth-century Spaniards, and by the second half of the decade, to judge from self-portraits like the *Man with the Leather Belt* (1845–46?) and the *Cellist* (1847), both of which I discuss in chapter two, his mastery of painterly chiaroscuro to achieve effects of modeling and atmosphere was unequaled among his contemporaries.

The crucial turning in his art took place during the years 1848–50: in the aftermath of the Revolution of 1848, from which at first he had stood apart, Courbet produced a series of monumental, realistic canvases, notably *An After Dinner at Ornans* (1848–49), the *Stonebreakers* (1849), and *A Burial at Ornans* (1849–50), that mark his emergence both as a major painter and as a disruptive force in French cultural life. The disrup-

1

tiveness was partly a function of Courbet's public personality, which combined unbridled self-confidence ("I paint like *le Bon Dieu*," he once said),[3] disdain for officially constituted authority, and republican political sympathies. But the disruptiveness owed much as well to the affront offered by Courbet's Realism (the capital "R" apparently came into use around 1855) to prevailing canons of taste, most importantly to the classical tenet that art worth the name involved far more than the exact reproduction of natural appearances. The notorious *Burial at Ornans,* with its enormous dimensions, deadpan portraits of local notables, flouting of traditional compositional principles, and brutally physical application of paint, epitomizes that affront, which is largely why it created a scandal when it was exhibited in the long-delayed Salon of 1850–51.

Courbet's subsequent career is hard to summarize neatly. The full title of his enigmatic canvas, *The Painter's Studio, Real Allegory Determining a Phase of Seven Years in My Artistic Life* (1854–55), has been taken to imply that 1855 marks the end of his Realist period, while certain writers, T. J. Clark among them, believe that Courbet's art declined markedly after the mid-1850s, becoming relatively undistinguished well before his establishment of a workshop for producing mediocre landscapes to order shortly after his release from prison following the fall of the Commune. But too sharp a periodization within Courbet's oeuvre threatens to become merely arbitrary, just as too abrupt and dire a view of his decline fails to acknowledge the splendor of much of his work from the second half of the 1850s through the early 1870s (the superb and moving *Trout* pictures in Zurich and Paris date from 1872 and 1873). On the other hand, especially after the advent of Manet in the early 1860s, Courbet's painting ceased to be a source of innovation within the French avant-garde and partly for that reason was sometimes described by contemporary critics as having lost its edge. Nor can it be denied that, starting in the second half of the 1850s, his painting became less obviously "social" in its concerns as he turned increasingly toward hunting scenes, depictions of animals, erotically inflected representations of women, landscapes, seascapes, flower pieces, and finally, during and after his imprisonment in 1871–72, still lifes. It remains a question, though, exactly what to make of this shift of emphasis. And the question is rendered all the more difficult to answer by the recognition, basic to this study, that Courbet's paintings reward, and in that sense invite, acts of reading or interpretation (I shall use both terms interchangeably) that cut across the most incontrovertible-seeming distinctions of subject matter, so that for

example a picture of women sifting grain—the *Wheat Sifters* (1853–54)—will turn out to have significant affinities, indeed to participate in a single overriding project, both with a depiction of Courbet seated before his easel—the central group from the *Painter's Studio*—and with a hunting scene in the middle of a wood—the *Quarry* (1856–57). (In chapter five I discuss all three works at length.) Among the consequences of this strongly interpretive approach will be a radical revision not only of traditional notions of Courbet's relation to his subject matter but also of standard accounts of his development. In particular his breakthrough to major accomplishment in the Realist masterpieces of 1848–50 will emerge as involving less a rejection than a transformation of the representational mode of his early self-portraits, a body of work that will be shown to be far more interesting than has previously been thought.

Another consequence of insisting on the need to *read* Courbet's paintings, often against the grain of their ostensible content, will be a fundamental revision of the terms in which we are led to conceive of his Realism. I think it is fair to say that art history as a discipline has tended to view realist paintings of any period as if they were nothing more than accurate transcriptions of a reality outside themselves, or at any rate as if their "reality effect" (Roland Barthes's *effet de réel*) were simply a function of the painter's skill in representing more or less exactly what lay or loomed before his eyes.[4] Practically speaking, this has meant that commentaries on Courbet's art, as on that of other realist painters (Thomas Eakins, for example), have often focused on questions of subject matter, either narrowly or broadly construed. And it has also meant that discussion has tended to proceed on the unexamined assumption that a realist painting's representation of a given scene was to all intents and purposes determined by the "actual" scene itself, with the result that features of the representation that ought to have been perceived as curious or problematic, as calling for reflection and analysis, have either been made invisible (the usual outcome) or, if registered at all, have been attributed to reality rather than to art.[5] Indeed it's hard not to feel that realist paintings such as Courbet's or Eakins's have been looked at less intensively than other kinds of pictures, precisely because their imagined causal dependence on reality—a sort of ontological illusionism—has made close scrutiny of what they offer to be seen appear to be beside the point. Thus for example none of Courbet's many commentators has found it pertinent to remark on the frequency with which his paintings depict individual figures, often centrally placed, more or less from the rear (major works that

contain such figures include the *After Dinner,* the *Wheat Sifters,* and the *Source* [1868]). Nor, in all the copious literature on the *Burial at Ornans,* has there been a mention either of the open grave's oblique orientation relative to the picture plane or of the small collision that has just taken place between the young boy holding a candle and one of the coffin-bearers. Nor finally has it been suggested that there might be a connection between the river landscape on the artist's easel in the *Painter's Studio* and the waterfall-like imagery of the standing model's white sheet and discarded dress (not to mention the white cat playing at the artist's feet). Yet I shall argue that Courbet's propensity for depicting figures from the rear is nothing less than a key to the meaning of his art; that these and other equally unnoted features of the *Burial* are part of an extraordinarily complex and nuanced compositional structure that couldn't be more remote from traditional descriptions of how that painting works; and that no exegesis of the *Painter's Studio* can quite satisfy that doesn't ponder the meaning of the seated artist's metaphorical immersion in the outflowing waters of the picture he is portrayed completing.

As the last example suggests, an insistence on reading Courbet's paintings is by its nature an insistence on the primacy of metaphor or allegory in his art (these terms too will be used interchangeably, along with another term, analogy), a view that is at odds with previous art-historical accounts of his achievement and moreover would have astounded the foremost critical intelligence among his contemporaries, Charles Baudelaire. Nevertheless, between the approach taken in this study and Baudelaire's contrary sense of Courbet's enterprise there exists a relation worth noting if only to further prepare the ground for readings to come. Baudelaire and Courbet probably met for the first time in the late 1840s and for a while were friends, but by the middle of the 1850s Baudelaire had turned against Courbet's painting because realism as such seemed to him to leave no place for the exercise of the imagination, which he called the queen of faculties and regarded as crucial to art properly understood.[6] In Baudelaire's review of the Exposition Universelle of 1855, for example, both Ingres and Courbet are charged with waging war against the imagination: Ingres for the honor of tradition and Raphaelesque beauty, Courbet in the interests of "external, positive, immediate nature."[7] And in his "Salon of 1859," a text haunted by the modern invention of photography, Baudelaire posits a fundamental opposition between two classes of artists—the *imaginatifs,* who understand that all true art involves a feat of what might loosely be called projection and for whom

"comparison, metaphor, and allegory" are central, and the *réalistes* or *positivistes,* who believe on the contrary in representing reality as it is or rather as it would be if they themselves did not exist. "The universe without man," is how Baudelaire puts it.[8]

Now it is a basic claim of this study that Courbet's paintings are eminently imaginative in Baudelaire's sense of the term and that it's therefore ironic, to say the least, that Baudelaire not only failed to recognize that this was so but regarded Courbet as the arch exemplar of the realist/positivist/materialist esthetic he deplored. At the same time, that the critic who most strenuously championed the values of imagination and metaphor in painting also found Courbet's art devoid of both shows just how ideologically overdetermined the issue of realism was: the philosophical, political, and even moral connotations of realism made it all but inconceivable that a work of art, especially a painting, could be *both* realistic in effect and imaginative or metaphorical in its relation to its materials. (I am convinced that Courbet himself was largely unaware of the aspects of his work I focus on in the pages that follow.)

A similar historical irony hovers about Baudelaire's characterization of the realists or positivists as seeking to depict reality as it would be if they didn't exist, a formula that, applied to Courbet, I shall argue is almost exactly wrong. But just as Baudelaire's advocacy of the imagination turns out to be pertinent to Courbet's work in ways neither man could have suspected, so his introducing the topic of the realist painting's relation to its maker's existence engages with the issue I claim lies at the heart of Courbet's enterprise (more on that in a moment). In short I find in Baudelaire's attacks on realism in the name of the imagination terms of criticism that bear an altogether different relation to Courbet's art than Baudelaire intended, a relation that until recently was made invisible not only by the nature of Courbet's Realism but also by the unbreakable spell of a certain conception of realism as such. Even Baudelaire's contemptuous remark that with the invention of the daguerreotype all of society, "like a single Narcissus, rushed to contemplate its trivial image on the metal"[9] can remind us that during most of the 1840s Courbet's preferred genre was the self-portrait, though here too my reading of the self-portraits concludes that they are radically unlike photographs, and I also want to resist the notion that Courbet's project, even in the self-portraits, was essentially narcissistic. Other writings by Baudelaire not explicitly about painting can be read almost as glosses on specific pictures, as for example the famous passage in *Les Paradis artificiels* (1860) that describes the

"pantheistic" experience under hashish of identifying with one's surroundings, culminating in the sensation of *being smoked* by one's pipe (cf. my discussion of Courbet's *Man with the Pipe* in chapter two).[10] Finally, the brilliant essay, "On the Essence of Laughter" (1855), associates what it calls the absolute comic with effects of anthropomorphism,[11] and this also will turn out to have a bearing on Courbet's work. Once again, however, painter and critic would have been equally astonished at the connection.

THIS BRINGS me to the central issue of the present study: the relationship between painting and beholder in Courbet's art. The precise nature of that relationship will become clear as we proceed, but the basic terms in which I understand it were developed by me in a previous book, *Absorption and Theatricality: Painting and Beholder in the Age of Diderot*.[12] Before engaging with Courbet it will be necessary, first, to summarize the analysis given there of the opening phases of what I take to be a central antitheatrical tradition within French painting and art criticism, and second, to sketch the evolution of that tradition between roughly the middle of the eighteenth century and Courbet's arrival in Paris at the end of the 1830s. (In fact I go beyond 1840 to consider Millet's peasant pictures of the 1850s and 1860s as well as the photographer Disdéri's 1862 treatise on photography.) As *Absorption and Theatricality*'s subtitle suggests, the seminal figure for our understanding of the beginnings of the tradition is the *philosophe* Denis Diderot (1713–84), whose writings on drama and painting have at their core a demand for the achievement of a new and paradoxical relationship between the work of art and its audience.

Putting aside Diderot's early treatises on the theater, the *Entretiens sur le Fils naturel* (1757) and the *Discours de la poésie dramatique* (1758), which are analyzed at length in *Absorption and Theatricality* and in any case are consistent with his subsequent writings on painting, the fundamental question addressed by him in his *Salons* and related texts concerned the conditions that had to be fulfilled in order for the art of painting successfully to persuade its audience of the truthfulness of its representations. (The first of Diderot's nine *Salons* was written in 1759, the last in 1781; the longest and most impressive are those of 1765 and 1767.) He concluded that nothing was more abortive of that act of persuasion than when a painter's dramatis personae seemed by virtue of the character of their actions and expressions to evince even a partial con-

sciousness of being beheld, and that the immediate task of the painter was therefore to extinguish or forestall that consciousness by entirely engrossing or, as I chiefly say, *absorbing* his dramatis personae in their actions and states of mind. A personage so absorbed appeared unconscious or oblivious of everything but the object of his or her absorption, as if to all intents and purposes there were nothing and no one else in the world. The task of the painter might thus be described, and in Diderot's *Essais sur la peinture* (1766) actually was described, as one of establishing the aloneness of his figures relative to the beholder. A figure, group of figures, or painting that satisfied that description deserved to be called naïve, an epithet which for Diderot (as later for Baudelaire) amounted to the highest praise. However, if the painter failed in that endeavor his figures appeared mannered, false, and hypocritical; their actions and expressions were seen, not as natural signs of intention or emotion, but merely as grimaces—feignings or impostures addressed to the beholder; and the painting as a whole, far from projecting a convincing image of the world, became what Diderot deprecatingly called a theater, *un théâtre,* an artificial construction whose too obvious designs on its audience made it repugnant to persons of taste.

Diderot's use of the word *theater* in this connection reveals the depth of his revulsion against the conventions then prevailing in the arts of the stage, but it also suggests that if those conventions could be overcome it would mean simultaneously the death of theater as Diderot knew it and the birth of something else—call it true drama. (In Diderot's writings of the 1750s and 1760s theater and drama become antithetical concepts.) And in fact Diderot's conception of painting is profoundly dramatic, according to a definition of drama that insisted as never before on an absolute discontinuity between actors and beholders, representation and audience. Hence the importance in Diderot's writings of a dynamic ideal of compositional unity according to which the various elements in a painting were to be combined to form a perspicuously closed and self-sufficient structure which would so to speak seal off the world of the representation from that of the viewer. And hence the importance of a related ideal of unity of effect, chiefly involving the handling of light and dark, directed to the same end. All this might be summed up by saying that Diderot maintained that it was necessary for the painting as a whole actively to "forget" the beholder, to neutralize his presence, to establish positively insofar as that could be done that he had not been taken into account. "The canvas encloses all the space, and there is no one beyond

it," Diderot wrote in his *Pensées détachées sur la peinture* (1776–81).[13] In this sense his conception of painting rested ultimately on the metaphysical fiction that the beholder did not exist. Yet paradoxically he also believed that only that fiction was able to bring the beholder to a halt in front of the canvas and to hold him there in the perfect trance of involvement that Diderot and his contemporaries regarded as the experiential test of a completely successful painting.

One qualification must be made. Starting in 1763 we find in the *Salons* a second, alternative conception of painting which might be called pastoral as opposed to dramatic and which implies a seemingly opposite but at bottom equivalent relation to the beholder. In Diderot's accounts of certain pictures that were unsuited to dramatic rendering because of their subject matter, he took up the fiction that he himself was literally inside the painting, in one famous instance—an account of Claude-Joseph Vernet's contributions to the Salon of 1767—withholding until near the end of his commentary the information that the peopled landscapes he was enthusiastically describing were painted rather than real. This suggests that for Diderot the aim of such works was not to exclude the beholder, as the dramatic conception required, but on the contrary to draw the beholder into the representation—a feat that would equally have denied his presence before the canvas (and of course, again paradoxically, would equally have transfixed him precisely there). This alternative conception, which plays a secondary role in Diderot's criticism, will turn out to be pertinent to Courbet's paintings.

The intimate connection between Diderot's antitheatrical views and the painting of his time can best be brought out by looking briefly at representative works by two painters belonging to distinct artistic generations, Jean-Baptiste-Siméon Chardin (1699–1779) and Jean-Baptiste Greuze (1725–1805). In Chardin's *The Card Castle* (ca. 1737; fig. 1), a masterpiece of genre painting, the young man seated before a gaming table and arranging folded cards in a row can plainly be described as absorbed in what he is doing. The same may be said of the family members in Greuze's *Filial Piety* (1763; fig. 2), all of whom have been depicted reacting to an exchange between the paralyzed old man reclining in an armchair at the center of the composition and the standing male figure evidently ministering to him. But there are significant differences between the respective treatments of absorption in the two works. Whereas in the painting by Chardin the object of the young man's absorption is a trivial occupation (though one requiring concentration to

be brought off successfully), in the painting by Greuze the engrossed attention of the diverse personages gathered around the central pair is understood to be the outcome of a prior, emotionally charged sequence of events as the paralytic old man, deeply moved at being fed by his son-in-law, expresses his thanks in a feeble voice those furthest away must strain to hear. (Diderot's admiring commentary in his *Salon de 1763* spells

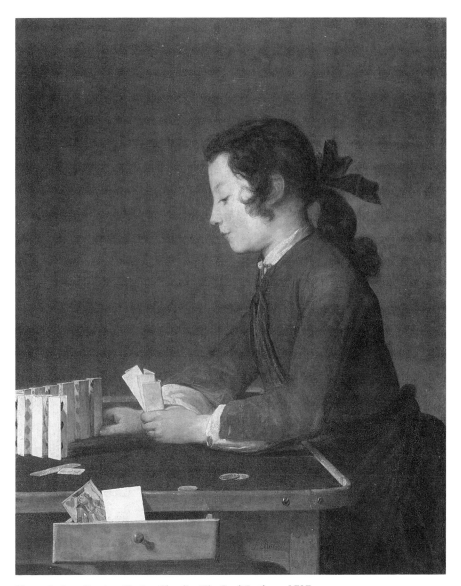

Figure 1. Jean-Baptiste-Siméon Chardin, *The Card Castle,* ca. 1737.

out the scenario.) A traditional characterization of that difference would stress that Greuze's art is sentimental whereas Chardin's is not. What must be emphasized, however, is that sentimentality in *Filial Piety* serves the interests of absorption and that at stake in the two paintings' thematizations of absorption is a more fundamental difference between their respective relations to the beholder. In my summary of Diderot's views I said that the persuasive representation of action and expression entailed evoking the perfect obliviousness of a figure or group of figures to everything but the objects of their absorption, including—or especially—the beholder standing before the picture. In Chardin's genre paintings of the late 1730s and 1740s that necessity remains mostly implicit: it is satisfied by seeming simply to ignore the beholder and by portraying ordinary absorptive states and activities as faithfully as could be imagined. (The trivialness of activities like building card castles, blowing bubbles, and

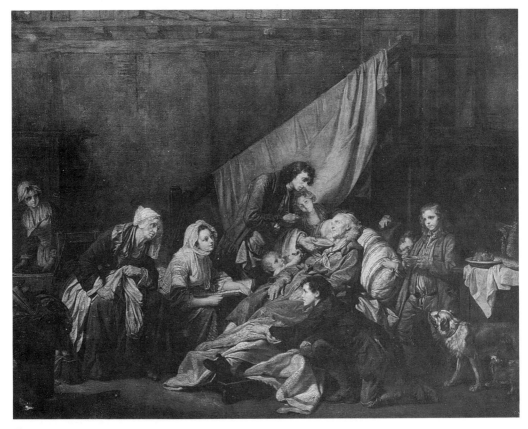

Figure 2. Jean-Baptiste Greuze, *Filial Piety,* 1763.

playing knucklebones epitomizes the ordinary as such). But by the time Greuze began to exhibit in Paris in the mid-1750s the presence of the beholder could no longer be dealt with in this fashion; it demanded to be counteracted and if possible negated in some more deliberate and pointed way; and the intensification (i.e., sentimentalization) of absorptive themes and effects as well as the resort to what are usually described as "literary" devices of plot, characterization, and composition that we find in a painting like *Filial Piety* are ultimately to be understood as means to that end.

(Actually Chardin's art is somewhat more complex than this suggests. For example, in my discussion of the *Card Castle* in *Absorption and Theatricality* I call attention to the contrast between the two playing cards in the half-open drawer in the foreground—one card, a face card, fronting the beholder, the other blankly turned away—and propose that it be seen as epitomizing the contrast between the surface of the painting, which of course faces the beholder, and the youth's absorption in his delicate activity, a state of mind that is essentially inward, concentrated, closed. More broadly, the composition of the *Card Castle* juxtaposes two axes meant to be understood as noncommunicating, axes I think of as those of absorption—parallel to the plane of the representation—and of beholding—perpendicular to the first. And although the radicalness of their separation isn't correlated with an intensification of absorptive effects, in the light of developments to come it appears that the basis of such an intensification—a heightened awareness of the beholder's point of view—is already in place. Or consider Flipart's engraving of a lost version of Chardin's *The Draughtsman* [1759; fig. 3] in which the manifest absorption of the draughtsman seated on the floor and depicted largely from the rear is contrasted with the overt theatricality of the naked male figure in the drawing on the studio wall in front of him. The effect of the image as a whole seems overwhelmingly absorptive, presumably because we see the draughtsman as "real" and the posturing figure as merely depicted. But the juxtaposition of absorbed and theatrical figures, even on different levels of "reality," in a single work suggests developments to come, as does the seemingly "blind" plaster cast of a woman's head immediately to the draughtsman's left.)

It is important to be clear about both the generality and the specificity of the issue of beholding as it comes to the fore in Diderot's criticism and Greuze's art. There is an obvious sense in which all paintings posit the existence before them of beholders, and we have only to think of works

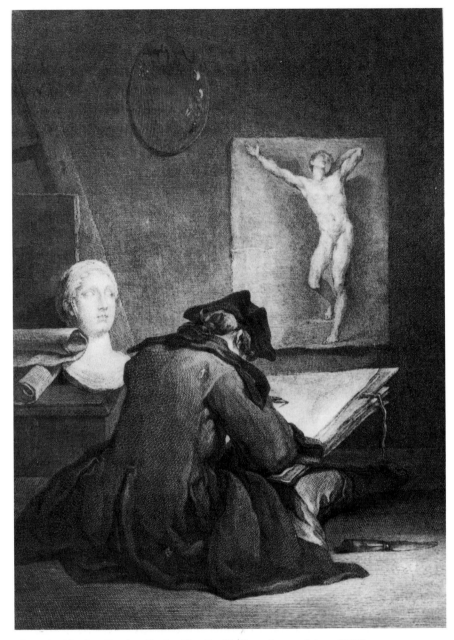

Figure 3. After Jean-Baptiste-Siméon Chardin, *The Draughtsman*, Salon of 1759, engraved by Flipart.

such as the *Sistine Madonna,* the Isenheim altarpiece, *Las Meninas,* the *Syndics,* and the *Déjeuner sur l'herbe* to realize that painters of different epochs and national schools have come to terms more or less emphatically with that basic truth in widely disparate ways.[14] My point, however,

FORT WORTH PUBLIC LIBRARY
01598   8824

is that starting around the mid-1750s in France (and only there) the in-escapableness of beholding, or say the primordial convention that paint-ings are made to be beheld, became deeply problematic for the enterprise of painting precisely to the extent that the latter took upon itself the task of striving to defeat what Diderot called theater, and that the irruption of that internal conflict or contradiction was something new in the his-tory of the art. Similarly, absorptive themes and motifs can be found in painting and sculpture going back to antiquity, seventeenth-century painting both in Italy and the North being especially rich in these. But around the 1750s in France—this is the gist of my comparison between Chardin and Greuze—the representation of absorption began to require special measures to be taken if it was to be persuasive, and not at all coincidentally it was also then that absorptive effects emerged in the crit-icism of Diderot and others as an explicit desideratum. In other words, absorption became a critical value just when it could no longer be taken for granted as a pictorial effect. And it could no longer be taken for granted as a pictorial effect because for the first time it was called upon to defeat theatricality.

Another expression of these developments was a new interest in the depiction of sleep, a state often characterized by contemporary critics as essentializing the obliviousness to surroundings I have associated with images of absorption. The enthusiastic response to Joseph-Marie Vien's *Sleeping Hermit* when it was exhibited in the Salon of 1753 is a case in point.[15] Still another related theme is that of blindness, as in Greuze's *Blind Man Deceived* (1755), a work that stands chronologically and dram-aturgically between Chardin's modest *Blind Man* (ca. 1737) and David's monumental *Belisarius Receiving Alms* (1781). (Images of sleep will later play a significant role in Courbet's art, as will effects of virtual blindness.)

A related point that should be stressed is the impossibility of determin-ing whether a given work has conclusively succeeded or for that matter conclusively failed in overcoming the condition I have been calling the-ater. Greuze's *Filial Piety,* for example, was described by Diderot in his *Salon de 1763* in terms that emphasize the collective absorption of its dramatis personae in the central event and in general suggest that for Diderot, as presumably for other viewers of his time, the painting suc-cessfully neutralized the beholder's presence—an accomplishment which, according to my argument, would account for its documented ability to hold contemporary audiences spellbound and even to move them to tears. On the other hand, we know that within just a few decades

Greuze's art wholly lost its power to persuade and move, and it is likely that viewers began to be unimpressed by *Filial Piety* largely because it came to seem theatrical in the pejorative sense of the term. I assume that most educated viewers today would agree with such a judgment, which may appear to run counter to everything I have said about Greuze until now. But my claim is not that *Filial Piety in fact* overcomes the danger of theatricality, only that it is how it is, however we may be inclined to describe how it is, because the painter who made it strove above all to represent figures deeply absorbed in what they were doing, thinking, and feeling—figures who by virtue of that absorption would appear oblivious to being beheld. May we then say that although this may have been the painter's intentions, *Filial Piety* itself turned out to be irremediably theatrical? It isn't hard to see why one might wish to say this. But, in the first place, to do so is implicitly to assert that an entire pictorial culture

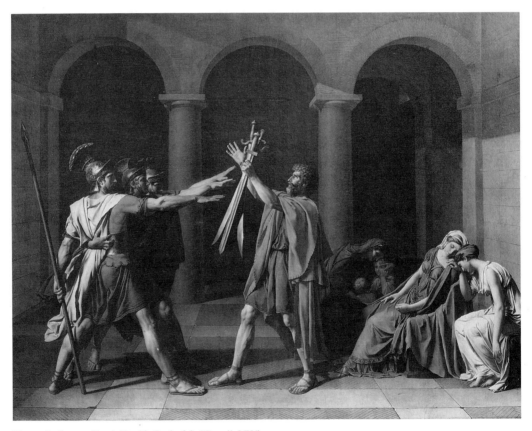

Figure 4.  Jacques-Louis David, *Oath of the Horatii*, 1785.

was fundamentally mistaken in judging it the opposite, as if our historical position allows us to distinguish sharply between another age's esthetic conceptions and the works it saw as realizing those conceptions (a dubious proposition). Second and more important, to insist on so unequivocal a view of *Filial Piety* is to fail to recognize the peculiar instability of historical determinations of what is and is not theatrical, an instability that becomes all the more apparent when we consider the work of the leading French painter of the late eighteenth and early nineteenth centuries, Jacques-Louis David (1748–1825).

In David's great history paintings of the 1780s, notably the *Oath of the Horatii* (1785; fig. 4), the *Death of Socrates* (1787), and the *Lictors Returning to Brutus the Bodies of His Sons* (1789; fig. 5), the dramatic conception theorized by Diderot and realized in genre terms by Greuze in the 1760s and 1770s has been given monumental expression in ways that

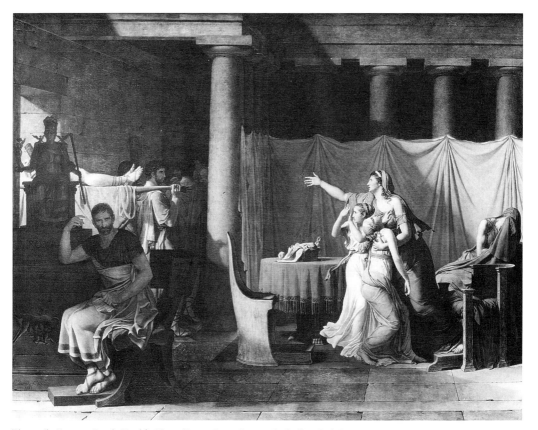

Figure 5.  Jacques-Louis David, *Lictors Returning to Brutus the Bodies of His Sons,* 1789.

contemporary audiences and younger artists in particular found paradig-
matic for ambitious painting.[16] (A prior work, the *Belisarius Receiving
Alms,* thematizes issues of beholding and being beheld, but the means by
which it does so place it somewhat apart from the three canvases just
cited.)[17] As early as the second half of the 1790s, however, a reaction
against certain aspects of the *Horatii,* the *Socrates,* and the *Brutus* took
place not only within David's studio, among the sect known as the *Bar-
bus,* but actually in his own painting—specifically in the *Intervention of
the Sabine Women* (1799; fig. 6). In part his dissatisfaction with the earlier
canvases stemmed from his new knowledge and appreciation of ancient
Greek art, which seemed to him vastly superior to the Roman models
that had influenced his sculptural treatment of the human figure in the
1780s. But he appears also to have become dissatisfied with the earlier
pictures on grounds directly pertinent to the issues we have been tracing.

We know from the testimony of Etienne-Jean Delécluze, who at that

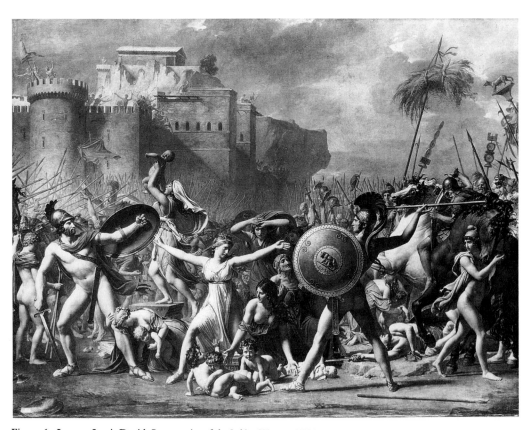

Figure 6.   Jacques-Louis David, *Intervention of the Sabine Women,* 1799.

time was David's student and who later became a leading art critic, that while working on the *Sabines* David characterized the composition of the *Horatii* as theatrical in a pejorative sense.[18] What he seems to have meant by this was that the unprecedented dramatic intensity—the trancelike absorption of the physically straining father and sons in the collective act of swearing their oath and of the grieving, swooning women in their anticipation of disaster, as well as the violent contrast between the male and female groups—that had made the *Horatii* so electrifying when it was first exhibited at the Salon of 1785 had come to strike him as excessive and exaggerated, which is to say as too deliberately aiming to impress. And in fact the *Sabines* marks a clear and deliberate withdrawal from the values and effects of pictorial drama as they had been brought to a new pitch of lucidity and expressiveness in David's paintings of the 1780s. In particular David seems to have found it necessary to eschew the compositional strategy basic to the earlier pictures, the evocation of a single, highly specific moment of tension or crisis (a strategy that reaches its zenith and perhaps its breaking point in the *Brutus*), in favor of a less actively temporal mode of representation that might be said to depict a moment of sorts but one that has been dilated, expanded, almost to the point of no longer serving to advance the action and within which the actors themselves have been made to relax, to suspend their efforts, in a general détente. This dedramatization of the action is most apparent in the sleek-limbed figure of Romulus poised to throw his spear, but it is also at work in the crowding of the pictorial field with innumerable personages at different distances from the viewer, and it is all but made explicit in a small *livret* issued to accompany the public exhibition of the *Sabines* in 1799. There David provided a speech of more than 170 words for Hersilia, Romulus's wife, whom the painting depicts intervening between her husband and Tatius, chief of the Sabines, to prevent further bloodshed. The effect of painting and text together might be compared to the arresting of action brought about by an aria in an opera.[19]

All this suggests that in the course of no more than a decade the concept of the theatrical had changed its meaning profoundly so that it now comprised, not just the obviously mannered and artificial conventions that Diderot had deplored both in painting and on the stage, but also the radically different and reformist—the Diderotian—representational strategies embodied in David's history paintings of the 1780s. David's new concern with the proper limits of expression and, in part, his preference for Greek over Roman art must also be seen in this connection. In

1807 he gave Delécluze a drawing of two heads that he had made roughly thirty years before; one head had been copied accurately from the antique while the other, based on the first, had been enlivened in various ways. "I gave it," David remarked, "what the moderns call expression and what today I call grimace."[20] Significantly, the suspension of dramatic action in the *Sabines* goes hand in hand with an unmistakable toning down of expression among the principal figures.

David's withdrawal from dramatic values and effects, and in a sense from action and expression as such, is carried still further in his next and last ambitious history painting, the *Leonidas at Thermopylae* (begun ca. 1800 but not finished until 1814; fig. 7), in which the principal action, that of Leonidas himself, is explicitly atemporal and antidramatic—a purely inward act of meditation, consecration, prayer. Delécluze's witness is again invaluable. In the early stages of his work on the *Leonidas* David asked his students to sketch their conceptions of the subject and Delécluze complied; David's response is worth quoting at length:

> You have chosen . . . another instant from the one I propose to render. Your Leonidas gives the signal to take up arms and march to combat, and all your Spartans respond to his appeal. As for me, I want my scene to be more grave, more reflective, more religious. I want to paint a general and his soldiers preparing for combat like true Lacedaemonians, knowing well that they will not escape; some absolutely calm, others garlanding flowers *for the banquet they will hold in Hades*. I do not want passionate movement or expression except for the figures who accompany the man inscribing on the rock: *Traveler, go tell the Spartans that their children have died for her.* . . . You must understand now, my friend, the direction I will be aiming for in the execution of my canvas. I want to try to put aside those movements, those expressions of the theater, which the moderns have called the *painting of expression*. In imitation of those artists of antiquity, who never failed to choose the instant before or after the great crisis of a subject, I will make Leonidas and his soldiers calm and contemplating immortality before the battle. . . . But I shall have a hard time getting those ideas accepted in our time. We love *coups de théâtre*, and when one does not paint the violent passions, when one does not push expression in painting to the point of *grimace*, one risks being neither understood nor appreciated.[21]

David's repudiation, in terms derived from Diderot, of the taste for pictorial drama that his own paintings of the 1780s had done much to promote could hardly be more emphatic.[22]

The significance of David's history paintings for our understanding of the vicissitudes of Diderot's dramatic conception of painting is therefore great. The *Horatii, Socrates,* and *Brutus,* I have claimed, were quickly and

widely accepted as exemplary masterpieces largely on the strength of the unequaled perspicuousness with which they were seen as representing figures wholly absorbed in a moment of tension or crisis in the unfolding of a heroic, tragic action. Within less than a decade, however, David moved in the *Sabines* to a far less urgently dramatic mise-en-scène, one to which the notion of absorption can scarcely be applied. And by the time he came to plan and paint the *Leonidas* he seems to have found himself compelled, throughout most of his teeming composition, to forgo all but the most superficial representation of action and expression, and to concentrate instead on depicting, in the figure of the Spartan general, a strictly inward action whose avowed content couldn't have been less momentary or more final. Indeed the inwardness of that action was described by David in terms so etherealizing as to call into question the very synchronization of inner meanings and outward signs on which the persuasive representation of action and expression implicitly depended.[23] It's

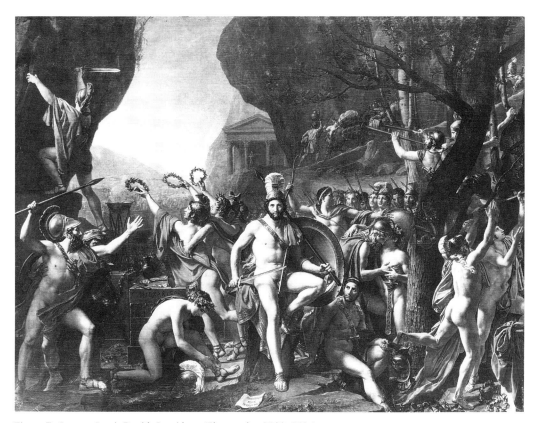

Figure 7. Jacques-Louis David, *Leonidas at Thermopylae*, 1800–1814.

hard not to see in these developments a drastic loss of conviction in action and expression as vehicles of absorption and therefore as resources for ambitious painting.[24]

At first glance, Napoleonic painting—typically, monumental pictures made to commemorate Napoleon's triumphs and more broadly to serve his propagandistic purposes—may seem to controvert this claim. For example, David's student Antoine-Jean (later Baron) Gros's most famous canvases, the *Plague-House at Jaffa* (1804; fig. 8) and the *Battle of Eylau* (1808; fig. 9), scarcely appear to eschew the depiction of action and expression.[25] Nor is there external evidence of the sort we have for David that Gros shared his teacher's preoccupation with the theatrical as a basic pictorial or ontological category. Nevertheless, the increasingly desperate struggle against the theatrical that we have followed in David's history paintings provides a necessary context for understanding Gros's achievement.

Specifically, I suggest that the *Jaffa* and the *Eylau* reveal an unqualified

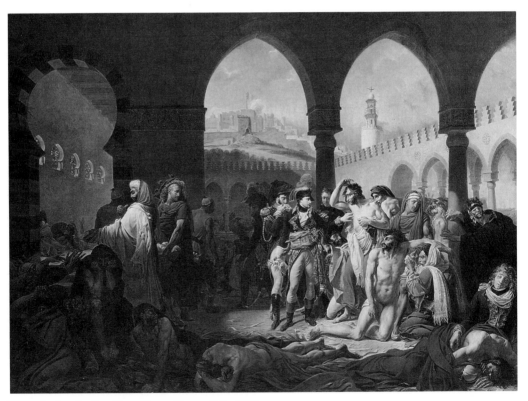

Figure 8. Antoine-Jean Gros, *Plague-House at Jaffa*, 1804.

acceptance of action and expression as *already* wholly theatrical—an acceptance of the theatrical not merely as pervasive but as normative, a universal ground of action and expression rather than an exceptional, and in principle avoidable, modality of these. Simply put, in Gros's Napoleonic pictures, as in Napoleonic painting generally, action and expression are intended to be beheld by viewers both inside and outside the representation. Questions about the relation of inner meaning to outward manifestation are thus rendered moot (the concept of absorption seems no longer to have any purchase), or at any rate they are continually displaced in ways that make them impossible to resolve (although one might think to say of Napoleon in the *Jaffa* that he appears absorbed not in touching the sick man's plague sore but rather in being seen to do so, the painting's full political effectiveness depended on his not appearing to perform it merely for that reason). And what this process of displacement makes possible is a new and affecting naturalness of action and expression (as in Napoleon's gesture or those of the two figures on either side of him),

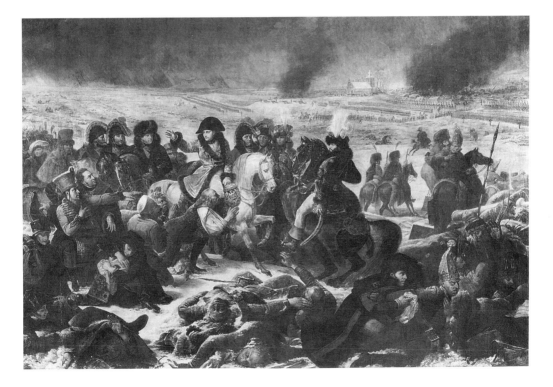

Figure 9. Antoine-Jean Gros, *Battle of Eylau,* 1808.

though in fact Napoleonic painting often juxtaposes effects of natural-ness and exaggeration (the colossal plague-victims in the foreground of the *Jaffa* exemplify the latter), as if to minimize the difference between them.[26] In all these respects Gros's art was admirably suited to its political mission, but what I want to stress is that throughout this period politics as such must be understood as bearing *directly* on pictorial problems and issues, insofar as a distinction between the two can be sustained. It is as though the rise of Napoleon and the need for propagandistic painting not only mobilized a generation of painters (led by the older David, who from the first lent his talents to the Empire) but also placed in abeyance the entire Diderotian project, thereby staving off for more than a decade a representational crisis, the worst of which was yet to come.*

The depth of that crisis is nowhere more evident than in the art of Théodore Géricault (1791–1824), the greatest painter of the Restoration

---

*From the perspective of the later work of Michel Foucault, the ubiquitous gaze at play in Napoleonic painting is ultimately that of the Emperor himself, or rather of the Imperial regime of systematic surveillance. "The importance, in historical mythology, of the Napoleonic character probably derives from the fact that it is at the point of junction of the monarchical, ritual exercise of sovereignty and the hierarchical, permanent exercise of indefinite discipline," Foucault remarks.

He is the individual who looms over everything with a single gaze which no detail, however min-ute, can escape. "You may consider that no part of the Empire is without surveillance, no crime, no offence, no contravention that remains unpublished, and that the eye of the genius who can en-lighten all embraces the whole of this vast machine, without, however, the slightest detail escaping his attention" [a quotation from Treilhard's *Motifs du code d'instruction criminelle* (1808)]. At the moment of its full blossoming, the disciplinary society still assumes with the Emperor the old aspect of the power of spectacle. As a monarch who is at one and the same time a usurper of the ancient throne and the organizer of a new state, he combined into a single symbolic, ultimate figure the whole of the long process by which the pomp of sovereignty, the necessarily spectacular manifesta-tions of power, were extinguished one by one in the daily exercise of surveillance, in a panopticism in which the vigilance of intersecting gazes was soon to render useless both the eagle and the sun (*Discipline and Punish: The Birth of the Prison,* trans. Alan Sheridan [New York: Pantheon, 1977], p. 217).

A description by Guizot of Adolphe-Eugène-Gabriel Roehn's *Bivouac of His Majesty the Emperor on the Battlefield of Wagram* (1810) could serve as a switchpoint between Foucault's problematic and mine. "His Majesty the Emperor," Guizot writes,

asleep in a chair, near a fire, arms crossed, head lowered, one leg resting on a table, illuminated by the reflection of the flames, is surrounded by all the officers of his staff, who stand there, eyes fixed attentively upon their general who, even asleep, occupies all their faculties, all their thoughts; to the left, His Excellency the Prince of Neuchâtel, seated at another table, promptly dispatches orders . . . Agamemnon awake when all are asleep; Racine made of that some beautiful verses; it's the image of the cares that accompany power: here, the Emperor sleeps and all are awake; it's the image of power

and one of the master figures of European Romanticism.[27] Reaching maturity during the last years of the Napoleonic regime, Géricault from the first was drawn to values of action and expression such as had inspired David's history paintings of the 1780s. But unlike David then or later, Géricault appears to have sensed in the theatrical a metaphysical threat not only to his art but also to his humanity (this was his romanticism). And he seems to have spent most of his short, tormented life in an impassioned effort, in and out of painting, to repulse that threat by main force, through physical acts that aspired to *go beyond* the theatrical by virtue of the sheer excessiveness of their commitment, if not to their own meanings exactly (the possibility of that commitment having been called into question), at any rate to their own exalted or excruciated physicality. So for example Géricault—a passionate horseman whose death was partly caused by a succession of riding accidents—found in the depiction of

itself ([François-Pierre-Guillaume] Guizot, "De l'Etat des beaux-arts en France et du Salon de 1810," *Etudes sur les beaux-arts en général* [Paris: Didier et Cie., 1858], p. 79).

S. M. l'Empereur, endormi sur une chaise, près du feu, les bras croisés, la tête baissée, une jambe étendue sur une table, éclairé par le reflet de la flamme, est entouré de tous les officiers de son état-major, debout, les yeux fixés attentivement sur leur général qui, même dans son sommeil, occupe toutes leurs facultés, toutes leurs pensées; sur la gauche, S. E. le prince de Neuchâtel, assis devant une autre table, expédie promptement des ordres . . . Agamemnon veille quand tout dort: Racine a tiré de là de fort beaux vers; c'est l'image des soucis qui accompagnent la puissance: ici, l'Empereur dort et tout veille; c'est l'image de la puisance elle-même.

Ostensibly the scene is one of the collective concentration of Napoleon's officers on the sleeping figure of their Emperor; but as Guizot recognizes, and as the figure of the Prince of Neuchâtel dispatching Napoleon's instructions makes clear, the power of the Emperor is forever awake, which is to say that the gazes converging on his person may be imagined as emanating from there in the first place.

It might also be noted that whereas the full title of the *Battle of Eylau* includes the statement that the Emperor visiting the battlefield the day after that particularly murderous encounter "is struck with horror at the sight of that spectacle," in the painting he is shown looking heavenward while others, presumably including the viewer, gaze at him, a displacement of emphasis—from one spectacle to another—that epitomizes the subjection of the realm of the visible to the Imperial will. The full title of the painting reads:

Champ de bataille d'Eylau. Le lendemain de la bataille d'Eylau. L'Empereur visitant le champ de bataille, est pénétré d'horreur à la vue de ce spectacle. S. M. fait donner des secours aux Russes blessés. Touché de l'humanité de ce grand monarque, un jeune chasseur Lithuanien lui en témoigne sa reconnaissance avec l'accent de l'enthousiasme. Dans le lointain on voit les troupes françaises qui bivouaquent sur le champ de bataille, au moment où S. M. va en passer la revue (quoted by Robert Herbert, "Baron Gros's Napoleon and Voltaire's Henri IV," in *The Artist and the Writer in France: Essays in Honour of Jean Seznec,* ed. Frances Haskell, Anthony Levi, and Robert Shackleton [Oxford: Clarendon, 1974], p. 65, n. 53).

I say more about the relation of Foucault's work to mine in chapter seven.

horses in movement, often in conjunction with human riders and/or attendants, a means of representing actions and expressions that at once relate intimately to human impulses and desires, far surpass human capabilities, and owing to their nonhuman nature—their animality—escape being perceived as theatrical, as grimace. An early work of this sort is his first Salon entry, the bravura *Charging Chasseur* (1812; fig. 10), which carries further than any previous equestrian painting I know not merely the idea of a merging of horse and man in a single rearing contrapposto "figure" but in particular the suggestion that the massive haunches of the former are the seat of power, including sexual power, for horse and man alike. More broadly, the representation of animals, whether active or in repose, provided Géricault with something like a natural refuge from the theatrical, as if for him the relation of animals to their bodies and to the world precluded the theatricalizing of that relation no matter what. This is to say more than that animals take on an unprecedented expressive burden in Géricault's art, though that is certainly true. It's also to maintain that, in his tragic pictorial universe, animality becomes an ideal of humanness that ultimately lies beyond human reach. (The unattainability and consequent bestializing of that ideal is variously imaged in his oeuvre, most movingly in the *Cattle Market* [1817].)

Another index of Géricault's commitment to dramatic values and effects is the fundamental role played in his art, indeed his life, by extreme opposites and contrasts of every kind. As Stanley Cavell has remarked in a related context, opposition and contrast are the natural medium of drama,[28] and in many of Géricault's paintings, drawings, and lithographs the resort to these attains an extraordinary level not only of intensity but also of condensation, compression, even abstraction. In the Michelangelesque wash drawing, *Executioner Strangling a Prisoner* (ca. 1815; fig. 11), the straining, grotesquely muscled figures can't be identified with any literary or historical subject but instead seem personifications of titanic effort countered by heroic suffering, or say of the principle of opposition, of dramatic conflict, itself. The effect is compounded by contrasts of light and dark that simultaneously evoke the sculptural solidity of the antagonists' bodies and impart a lurid atmosphere to the bare scene as a whole. And there is a sense too in which the character of the drawing in this and similar images—its tendency to geometricize and abbreviate the forms it encloses—conveys an impression of an equally fierce struggle between contour and matter, a struggle that around this time issued also in at least one small but magnificent carved sculpture.[29]

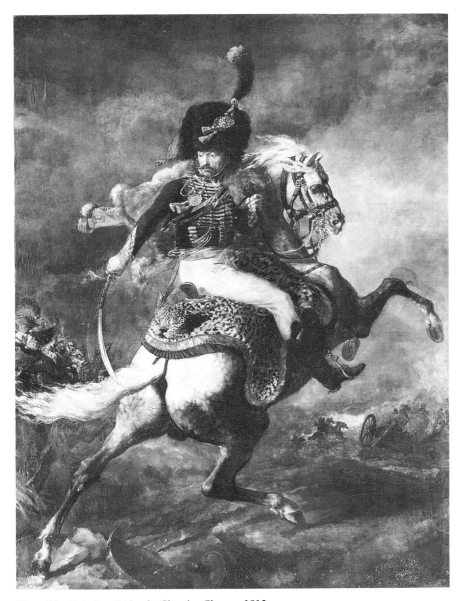

Figure 10. Théodore Géricault, *Charging Chasseur*, 1812.

Géricault's problem, one might say, was not only how to keep such insensate dramatic energies within the realm of the pictorial but more precisely how to make paintings of recognizably major ambition on the basis of a predilection for pictorial drama that found its ideal, because most self-absorbed, expression in "subjectless" scenes of hyperbolic opposition. No wonder, then, that Géricault in his career completed just one large-scale multifigure composition (the *Raft of the Medusa*) and that

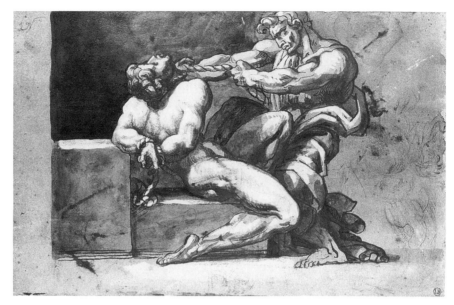

Figure 11. Théodore Géricault, *Executioner Strangling a Prisoner,* pencil, pen, and wash, ca. 1815.

Figure 12. Théodore Géricault, *Study of Severed Limbs,* ca. 1818–19.

some of his most memorable, seemingly unprecedented canvases are ones in which opposition and contrast structure virtually every aspect of the image. For example, in the Montpellier *Study of Severed Limbs* (1818–19; fig. 12), one of a number of studies of severed heads and limbs painted in connection with the project of the *Raft*, death-dealing violence of the sort depicted in *Executioner Strangling a Prisoner* is manifest only through its effects (but is far more horrific for that); the dramatic chiaroscuro of the earlier work is made the vehicle of a pathos-charged realism; and the juxtaposition of an arm cut through at the shoulder and two legs severed around the knee invokes by inadvertent synecdoche the fatal dénouements of countless history paintings and of the narratives on which they are based (cf. the *Horatii* and the *Brutus*). This last impression is all the more powerful in that the *Study of Severed Limbs* suggests sexual difference—the contrast of male and female—without in any way stating it, though in other works of the same moment, notably the Stockholm *Study of Two Severed Heads* (ca. 1819; fig. 13), both a male-female oppo-

Figure 13.  Théodore Géricault, *Study of Two Severed Heads,* ca. 1819.

sition and the intimation of an erotic scenario, hence of sexual violence, come piercingly to the fore. (For several years Géricault had secretly been conducting a love affair with the young wife of his father's brother, who in August 1818 bore him a son. The particular emotional cast of the severed heads and limbs doubtless expresses the artist's state of mind as their relationship reached its crisis.)[30]

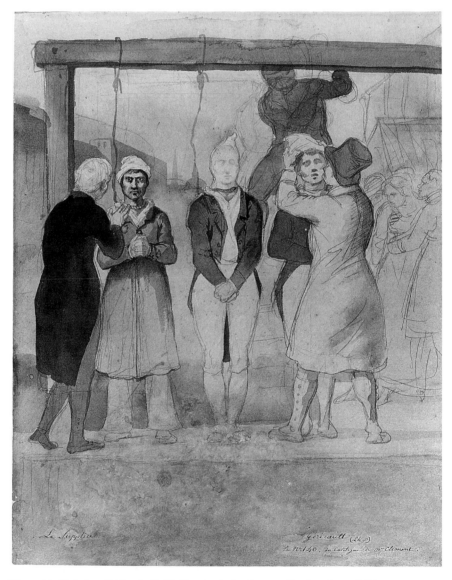

Figure 14. Théodore Géricault, *Public Hanging in London,* pencil and wash, ca. 1820.

In other paintings and drawings too a realism that has no equal in its age and has often been viewed as simply breaking with current artistic conventions turns out to be grounded in issues of absorption and beholding. For example, in a large wash drawing, *Public Hanging in London* (ca. 1820; fig. 14), made during his visit to London in 1820–21, the prisoner standing with clasped hands at the left, whose face and in particular whose staring eyes are the focal point of the image, appears so terrified at the prospect of execution as to be capable of seeing nothing, or at least of registering nothing that he "sees"—a state of virtual blindness (or blankness) that the hooded visage of the man at his left may be taken as literalizing. The chief precedent for a figure facing the viewer but apparently so immersed in painful thoughts as to be unaware of being beheld was David's Brutus, who is jarred from his brooding only by the entry of the lictors bearing the headless bodies of his sons; although Géricault in this drawing surely wasn't alluding to David, I suggest that a familiarity with what might be called the Brutus-motif may be reflected in Géricault's treatment of his theme and just possibly in his choice of subject in the first place. Similarly, Géricault's masterly portraits of the insane have justly been admired for combining scientific detachment with sympathetic identification in equal measure. (I have reproduced the most searing of these, the *Monomanie de l'envie* [ca. 1822; fig. 15].) But what I want to stress is that persons afflicted with the illness then known as monomania were described by a leading medical authority (whose patient Géricault may have been) not only as wholly absorbed in various obsessive delusions but also as seeking to flee their fellows, either to escape being seen by them or "to entrench themselves all the more securely in their own manner of looking."[31] The lability this alternative captures goes to the heart of Géricault's vision.

Appropriately, however, it is Géricault's one major attempt to achieve public success, the colossal *Raft of the Medusa* (1819; fig. 16), that most profoundly exemplifies his antagonism to the theatrical.[32] The subject of the painting was taken from an actual event, the shipwreck of the frigate "Medusa" off Cap Blanc in West Africa and the atrocious sufferings of 150 officers and passengers on a makeshift raft that was supposed to be towed by lifeboats but was shamefully abandoned to its fate. And the specific phase of that subject that Géricault after much deliberation chose to depict took place when, after two weeks on the open sea, the last survivors, now just fifteen men, spotted a ship (an English brig named the "Argus"!) on the horizon and mounted a desperate collective effort to

attract its attention. In fact the "Argus" failed to spot the frantically signaling men and sailed out of sight; but later the same day, having changed direction, it bore down on the raft and rescued its occupants. The scene finally selected thus implies an exceedingly drawn-out moment—at that distance the miniscule brig would appear to be moving with tantalizing slowness—and yet, unlike the dilated moment of the

Figure 15. Théodore Géricault, *Portrait of a Woman Suffering from Obsessive Envy (Monomanie de l'envie,)* ca. 1822.

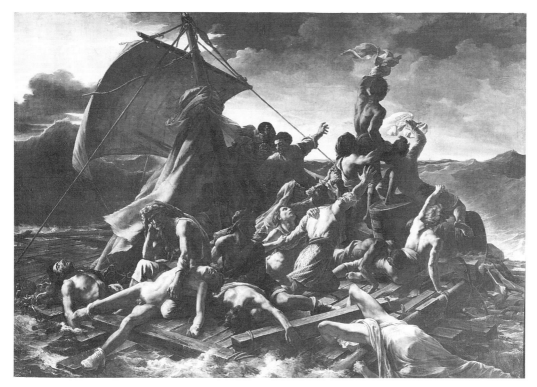

Figure 16. Théodore Géricault, *Raft of the Medusa*, 1819.

*Sabines*, one that could hardly be more wracking, physically and psychologically. Moreover, the absorption of the straining, waving figures in their efforts to be seen is underscored not only by the horror of their situation and the presumed feebleness of their physical condition (actually they look much too strong for what they have been through) but also by the fact that they have been depicted largely from the rear, which further emphasizes their ostensible obliviousness to our presence. Indeed one way of describing the action represented in the *Raft* might be to say that the figures on the raft are *striving to be beheld* by a potential source of vision located at the farthest limit of illusionistic space, a source that, if it could be activated, would rescue them at last *from being beheld by us:* as if our presence before the painting were the ultimate cause of their plight, or, less luridly, as if the primordial convention that paintings are made to be beheld threatens to make theatrical even their sufferings.

Here again my claim isn't that by these means Géricault unequivocally defeated theater. On the contrary, it may be that the unworkableness or impossibility of such a "solution," the sheer hyperbole of the conceit on which it depends, is acknowledged in the painting not only by the choice of a moment when rescue is far from certain (the "Argus" sails on past)

but also by the tragic figure group of an old man supporting across his knees the corpse of a young man, for both of whom in different ways, as by then for the artist himself, the possibility of rescue no longer exists.

The lengths to which Géricault was forced to go in his struggle against theatricality are emblematic of the broader situation of French painting in the 1820s and 1830s. On the one hand, Stendhal in his art criticism of the mid-1820s excoriated David's *Sabines,* which he took to be the model for the contemporary practice of the David school, for its emphasis on pose and self-display at the expense of action and expression, and called for a renovation of painting that would put an end to the frozen gestures and mannered posturing summed up in the phrase "the imitation of [the famous actor] Talma"—a catchword that shows how pervasive a certain theatricality seemed to him to have become.[33] (Remember that David had associated the aspects of the *Sabines* that Stendhal most deplored with an avoidance of what he himself had come to see as the theatricality of the *Horatii*.) On the other hand, Géricault's attempt to resurrect the values and effects of pictorial drama resulted, with one conspicuous but highly controversial exception, in works of no more than minor "official" ambition, which quite apart from other considerations meant that they were powerless to establish a new paradigm for painting generally. In fact Stendhal never mentions Géricault and may have been unaware of his achievement. What matters most, however, isn't the lack of contemporary response to Géricault's fragmented, idiosyncratic, and largely private art—within a short time after his death his reputation was considerable—but rather the inability, by the later 1820s and 1830s, of any new dramatic painting to establish itself more or less incontrovertibly as antitheatrical in the sense Diderot had earlier defined. This was because by then the dramatic as such had come more and more to be perceived as *inescapably* theatrical, which is to say that the basic strategies and conventions that once had secured the fiction of the beholder's nonexistence were now increasingly seen merely as attesting to his controlling presence.[34]

A brief consideration of the work of three very different artists belonging to successive generations—Paul Delaroche (1797–1856), Honoré Daumier (1808–1879), and Jean-François Millet (1814–1875)—and then of the writings of an influential photographer born the same year as Courbet—André-Adolphe-Eugène Disdéri (1819–1889)—will complete the historical preliminaries.

Of the first three, Delaroche seems to us today by far the least distin-

guished.[35] But his work is significant in that it epitomizes a major tendency in French painting during the decades before the advent of Courbet: the enthusiastic embracing of the most explicit forms of theatricality by a younger generation of history painters for whom the Diderotian project of neutralizing the presence of the beholder was a closed book. This is evident in all the history paintings Delaroche exhibited in Salons between 1824 and 1837 (the last to which he submitted), but it is nowhere more palpable than in two of his most famous canvases, the *Children of Edward IV in the Tower* (1830; fig. 17) and *Jane Grey* (1833; fig. 18), in both of which a concern for historical accuracy in the treatment of costumes and accessories has been combined with what contemporary audiences understood to be a manifestly stage-oriented mise-en-scène

Figure 17.   Paul Delaroche, *Children of Edward IV in the Tower,* 1830.

that in the case of the *Children of Edward* actually inspired a melodrama by Casimir Delavigne.[36] Other characteristic features of these pictures include a choice of moment that by the standards of Davidian painting too grossly solicits the viewer's imagination (in Stephen Bann's phrase, Delaroche became "the poet of impending catastrophe");[37] an emphasis on a smooth-textured, even-focus, indeed waxworklike descriptive realism at the expense of stylistic or other features that might in any way detract from the overall effect of dramatic verisimilitude; and a demonumentalizing of size and scale that completes a certain domestication of the genre. Perhaps not surprisingly, both canvases enjoyed great popular success, but what I find particularly interesting is that numerous writers including Gustave Planche, one of the foremost critics of the period, cas-

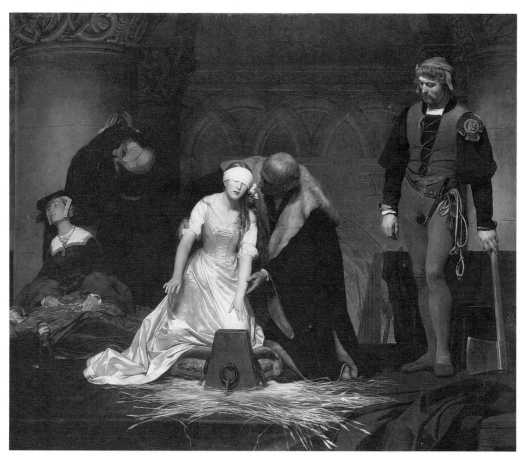

Figure 18. Paul Delaroche, *Jane Grey*, 1833.

tigated them precisely for their theatrical or melodramatic qualities, and moreover connected their success with the inability of the Salon-going public to appreciate more refined and demanding modes of painting (Planche was chiefly thinking of Delacroix). In fact it was in the course of the 1830s that a liking for the theatrical became identified by a gradually emerging avant-garde as the hallmark of a general debasement of artistic taste, an identification that persisted throughout the rest of the century. Or to put this slightly differently, starting in the early 1830s what I have called Delaroche's embrace of theatricality became equated with an attempt to achieve success by appealing directly to an audience that knew nothing of the true nature of art, as though the beholder that the anti-theatrical tradition had always sought to neutralize now assumed concrete form in the collectivity of the Salon-going public.[38] (By the 1840s that public was regularly characterized as bourgeois.)[39] At the same time, the outstanding alternatives to manifestly theatrical painting of the Delaroche type—the work of Ingres and Delacroix respectively—can't be said, and to the best of my knowledge weren't said, to be potently anti-theatrical in the Diderotian sense of the term. It is as though by different but perhaps complementary means both Ingres and Delacroix managed to sidestep the issue of theatricality, or at any rate to shift the burden of their art away from dramaturgical considerations.[40] And yet, as we shall see, that they were able to do this didn't signify that the issue was no longer one to engage painters of high ambition.

A second artist, younger than Delaroche, also may be said to have embraced the theatricalization of action and expression, but to have done so in a way—in a medium—that implied a fundamental critique of theatricality and thereby for a brief span of time gave new life, a kind of posthumous existence, to the David-Géricault tradition. The artist was Daumier and the medium of his recuperation *but not detheatricalization* of visual drama was caricature, as practiced in the political lithographs he drew chiefly for Charles Philipon's journal *La Caricature* in the years just before the imposition of government censorship of images in August 1835.[41] In fact I suggest that it was primarily the structural or internal relation between caricature and the mode of exaggeration the eighteenth and nineteenth centuries called grimace that made caricature in Daumier's hands an effective if also "officially" a minor vehicle for representational energies otherwise irrevocably compromised by the developments I have been tracing.

This is most apparent in lithographs like *Enfoncé Lafayette! . . .*

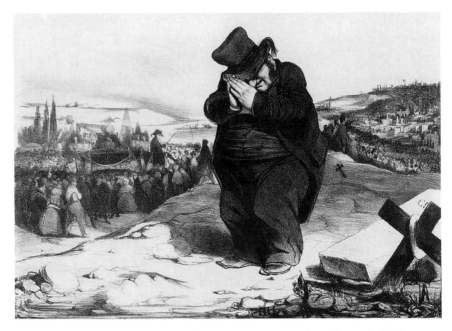

Figure 19. Honoré Daumier, *Enfoncé Lafayette! . . . Atrappe, mon vieux!* lithograph, 1834.

Figure 20. Honoré Daumier, *Vous avez la parole, expliquez-vous, vous êtes libre,* lithograph, 1835.

*Atrappe, mon vieux!* (May 1834; fig. 19), with its colossal, insincerely grieving Louis-Philippe; *Vous avez la parole, expliquez-vous, vous êtes libre* (14 May 1835; fig. 20), with its Davidian mise-en-scène, straining figures, and moralized contrast between judiciary and accused; and the great *Rue Transnonain* (April 1834; fig. 21), with its dramatically foreshortened corpse that amounts to nothing less than a reworking (and de-idealization) of the dead youth in the foreground of Géricault's *Raft*. But Daumier's most arresting images in this regard may be those in which his political militancy comes close to being subverted by the inherent drama of his medium. In *M. Pot de Naz* (2 May 1833; fig. 22), for example, the silhouetting of the royalist deputy Podenas's open greatcoat, especially of its outturned, rounded collar, against the blank white ground of the page is extremely imposing; his body in its vest and trousers conveys an impression of solidity and power, and there is nothing mean or comic—there is at most an impersonal irony—about the classical dignity with which he bears in the crook of his right arm a role of documents labeled "improvisations"; even his head, unhandsome as it is and stamped with

Figure 21.  Honoré Daumier, *Rue Transnonain*, lithograph, 1834.

Figure 22. Honoré Daumier, *M. Pot de Naz,* lithograph, 1833.

a physiognomy that under other circumstances might seem ludicrous, commands respect by the sculptural force of its rendering. The result, in this case as in others, is an image at once extravagant and gripping: thus contour-drawing, figure-ground opposition, black-white contrast, and sculptural modeling (all vehicles of drama in Géricault) contribute to an

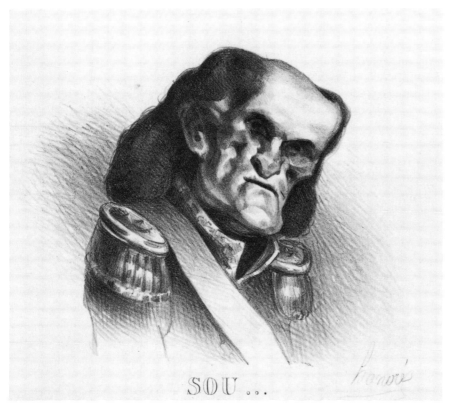

Figure 23. Honoré Daumier, *Sou . . .* , lithograph, 1832, detail of head.

effect of grimace that seems less the property of any gesture or expression than of the image as a whole, but that effect in no way undercuts, if anything it enhances, a dramatic sense of personhood at odds with the intended political meaning (mockery of Podenas) and very likely not a response to the specific person of the deputy at all.

An even more extreme version of this phenomenon is found in some of the caricatures of deputies and other politicos Daumier drew after a series of small terra-cotta busts that he had sculpted (apparently at Philipon's suggestion) to serve as models for his lithographs.[42] For instance, in the riveting *Sou . . .* [Soult] (28 June 1832; fig. 23), a brilliantly and as it were exaggeratedly sculptural depiction of a lost terra-cotta *portrait-charge*[43] produces an effect of pathos and even of a senile dignity that has little to do with either psychology or politics as these are usually understood. Not that politics is irrelevant to an image like the *Sou . . . .* With the banning of political caricature by the so-called September Laws of

1835 Daumier and his colleagues were forced to turn to an essentially typological, hence politically largely anodyne, mode of satire, and the undeniable fact that Daumier's caricatures of the second half of the 1830s and early 1840s represent a falling off in artistic level from his earlier work suggests that *La Caricature*'s overtly oppositional program formed part of the dramatic substratum of his art even in those lithographs of the first half of the 1830s in which politics as such seems most in abeyance.[44] In any case, the example of Daumier in the precensorship years shows how it was then just possible for an *imagier* of genius, whose gifts and temperament inclined him toward effects of visual drama, not to overcome the theatrical but to turn it artistically to account.

A third artist, Jean-François Millet, found the theatricality of his teacher Delaroche's painting repugnant,[45] and in fact I see his mature

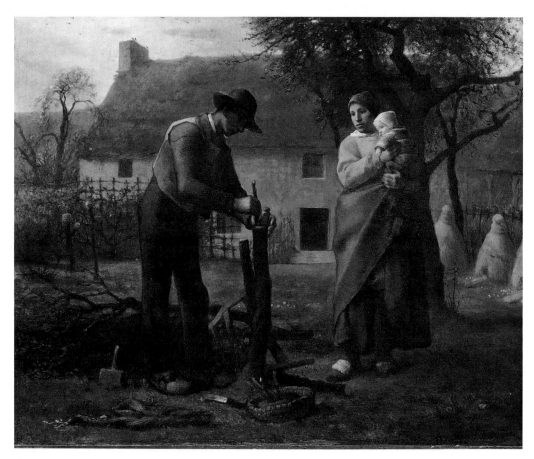

Figure 24. Jean-François Millet, *Man Grafting a Tree*, 1855.

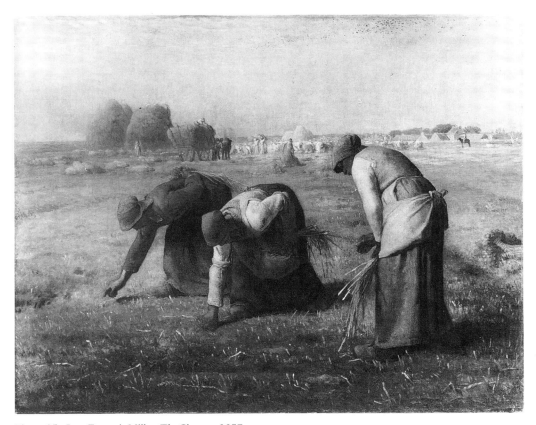

Figure 25. Jean-François Millet, *The Gleaners,* 1857.

production—the scenes of peasant life of the 1850s and after—as a sustained attempt to defeat the theatrical by exploiting a thematics of absorption in work and work-related states as an alternative to the representation of dramatic action and expression. For example, *Man Grafting a Tree* (1855; fig. 24), one of his finest canvases, depicts with characteristic single-mindedness the impassive-seeming concentration of a peasant farmer performing a graft and of his wife and child looking on; a similar thematics of absorption, this time in a mechanically repetitive task, governs the composition of works such as *The Gleaners* (1857; fig. 25) and the large pastel *Men Digging* (1866) as well as of the more modest *Woman Sewing by Her Sleeping Child* (1854–56; fig. 26) and *Woman Carding Wool* (1863); while in the notorious *Man with a Hoe* (1860–62) and the less well-known but equally impressive *Vineyard Worker* (1869–70; fig. 27) figures brutalized by physical labor stare vacantly into space as if registering nothing but their utter exhaustion. Significantly, contemporary commentators praised Millet's art not only for its avoidance of

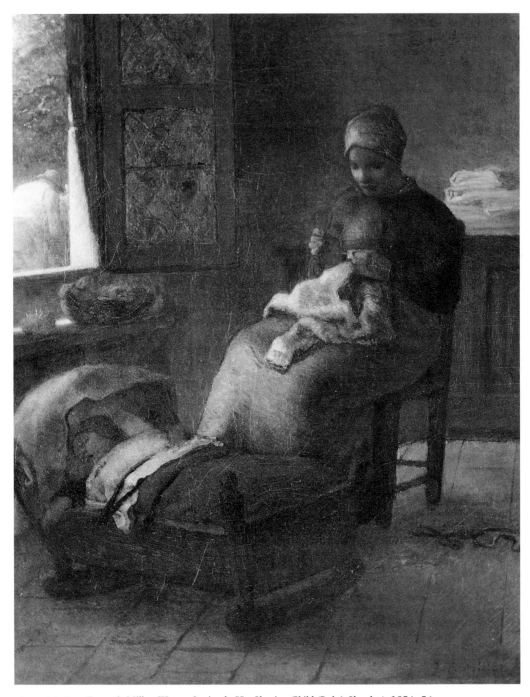

Figure 26. Jean-François Millet, *Woman Sewing by Her Sleeping Child (Baby's Slumber)*, 1854–56.

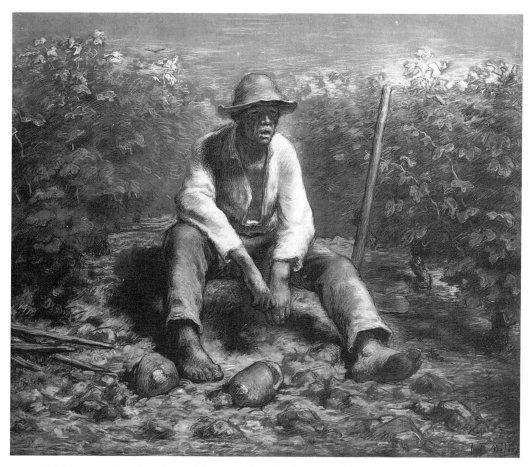

Figure 27. Jean-François Millet, *Vineyard Worker*, pastel and black crayon, 1869–70.

drama and exaggeration but also for its depiction of personages whose lack of intellectual development—almost of consciousness—ruled out all treatment of the passions. "[Millet] avoids all dramatic effect because it would be false," the critic Ernest Chesneau wrote in 1859. "And if his women are unhappy, it's we who draw that conclusion; they themselves are unaware of it."[46] And in an important article published shortly after Millet's death, Chesneau observed approvingly that in his oeuvre nothing poses—not men, nor animals, nor trees, nor blades of grass—and went on to attribute the veracity of Millet's art to his practice of working strictly from memory instead of from the model.[47] This was true, Chesneau maintained, not only of Millet's scenes of peasants at work but also of his images of repose. "If he knows he is observed," he wrote of the old man in the *Vineyard Worker*, "do you think he will retain this sagging of his whole body, this characteristic curve of his inner ankles, this gaping

mouth, this dull and vacant look? Not at all. Apart from his clothes, which you will have him keep wearing, he will give his limbs, his muscles, and his countenance their Sunday-best look"[48]—a passage that recalls Diderot in content and rhetoric.

From another perspective, however, Millet's avoidance of drama was far from absolute, especially as regards considerations of mise-en-scène. Thus he typically placed his personages in the foreground (though not the immediate foreground) of a strongly receding and often vast spatial arena; simplified the drawing of contours and indeed echoed famous images by Michelangelo and others in an effort to monumentalize his figures' humble, supposedly unself-conscious actions; muted or grayed his backgrounds in contrast to the fuller chiaroscuro of his figures to make the latter stand out impressively against the former; and in general did all he could to stage effectively—in that sense, to dramatize—his ostensibly antidramatic subjects. Moreover, the accounts he gave of his intentions express a Diderotian emphasis on pictorial unity conceived in terms of internal dramatic necessity.[49] Again, my point isn't that Millet's art, despite its concern with absorption, at bottom *is* theatrical. But I suggest, first, that his art emerges as divided against itself with respect to the crucial issue of visual drama, and second, that it's for this reason that a number of contemporary critics, including some like Théophile Gautier who had previously been admirers, came to attack Millet's work for what they saw as its especially galling brand of self-importance. "His three gleaners have gigantic pretensions; they pose like the three Fates of pauperism," Paul de Saint-Victor wrote in 1857 of *The Gleaners*. "[T]hey too visibly betray the pretension of descending from the Sibyls of Michelangelo and of wearing their rags more proudly than Poussin's harvesters their draperies. I don't like seeing Ruth and Naomi stride across Boaz's fields as if across the stage of a theater."[50] Baudelaire too deplored Millet's overt pursuit of style and noted with something like disgust the manner in which his peasants always seemed to be calling attention to the moral significance of their condition.[51]

In short, both Millet's art and the critical writings it provoked demonstrate beyond a doubt the currency of the issue of theatricality in the 1850s and after. But those writings also show that Millet's attempt to hypostatize absorption within a pictorial format which in decisive respects remained that of visual drama could have at most an equivocal—a partial, unstable, and highly controversial—success. Indeed his pictures of peasant life constitute *the* test case for what I have been calling the

dramatic conception of painting during the period of Courbet's maturity. Further than those pictures in the direction of absorption and antidrama while remaining within the framework of the dramatic conception it was impossible to go. Yet the critical response alone suggests that it wasn't nearly far enough, or rather that, so long as that framework remained intact, the most extreme efforts to undo its effects ran a high risk of appearing not only theatrical but egregiously so.[52]

Finally Disdéri. Arguably the most important event to take place in France in the late 1830s was the invention of the daguerreotype (the process was made public in 1839), a means of mechanically representing aspects of the world with an almost microscopic exactness that contemporary viewers found awe-inspiring.[53] It was probably inevitable, then, that writers of a somewhat later period should have equated photography and Courbet's Realism, but what interests me here is that the issue of theatricality turns out not only to have been relevant to photographic practice but to have been given a particular inflection by the powerfully veristic character of the photographic medium. Thus Courbet's exact contemporary, A.-A.-E. Disdéri, inventor of the *carte de visite* photograph, claims in his *L'Art de la photographie* (1862) that any attempt to compete with painting by constructing multifigure compositions even of comparatively simple genre subjects is doomed from the start because the absolute verism of the photographic image is bound to detect the least failure of one or more sitters to become completely absorbed in their roles. (Disdéri speaks of the photograph revealing "the conflict or indecision of [the sitter's] thoughts," which I take to mean the conflict between an act of imaginative projection into a fictive situation and a consciousness of oneself as actually posing before the camera.)[54] But what if the photographer were to try to overcome the problem by employing leading actors and actresses from the theater, men and women who specialized in sustaining effects of dramatic illusion? Disdéri insists that it wouldn't work: the photograph in its "inexorable fidelity" would register the inevitable component of conventionality in the actors' expressions and gestures and so would result in "portraits in action" of actors striving to create an impression of a fictive reality rather than persuasive images of that reality.[55] As Disdéri also puts it, the perfection of the photographic instrument means that it "shows us the actor where we believed we put the man, the theatrical action where we attempted to place the natural action."[56] In sum for Disdéri photographic verism exacerbates the issue of theatricality with respect to an entire class of subject matter

which the photographer is therefore called upon to eschew. And while this in itself might not seem to bear directly on the problems of painting, it demonstrates beyond a doubt the persistence within the new technology of the problematic Diderot first theorized roughly a century before. (Note by the way that it does so in terms that imply a fundamental distinction between that technology and even the most realistic painting— Courbet's, for example. I say more about the relation of Courbet's painting to photography in chapter seven.)

My BASIC claim in *Courbet's Realism* is that Courbet's art belongs to the antitheatrical tradition I have just outlined but that the strategies by which his paintings seek to overcome the theatrical involve a radical break with the values and effects of the dramatic as such. Or perhaps one should say that his art shares with that tradition both an antagonism to the theatrical and a commitment to the representation of something like significant human action while repudiating the tradition's basis in conflict, opposition, closure (but not its basis in absorption, which Courbet's work continually thematizes). In any case, I understand Courbet's difference from his French predecessors, as well as his connectedness with them, in terms of such a structurally ambivalent relation to their enterprise.

The plan of the remainder of this book is as follows: chapter two analyzes Courbet's self-portraits of the 1840s; chapters three and four consider the Realist or "breakthrough" pictures of 1848–50, with special emphasis on the *After Dinner at Ornans,* the *Stonebreakers,* and the *Burial at Ornans;* chapter five concentrates on three major canvases of the 1850s, the *Wheat Sifters,* the *Painter's Studio,* and the *Quarry,* all of which (not just the *Studio*) I interpret as allegories of Courbet's Realism; chapter six investigates the implications of Courbet's antitheatrical enterprise for the representation of women, focusing in particular on paintings of the 1850s and 1860s and considering also various landscapes and other works that either have been or can be related to a "feminine" thematics; finally, chapter seven concludes this study by reflecting on a range of topics that are crucial to my account of Courbet's art. This is to say that the structure of *Courbet's Realism* is at once roughly chronological and loosely generic, though (as I earlier implied) I continually call attention

to affinities between ostensibly disparate works or works widely separated in time, affinities that either come close to dissolving even the most fundamental-seeming generic distinctions or suggest that Courbet is best understood as having pursued a single overarching aim throughout his career, or both. And it is to acknowledge that I don't attempt to deal with all of Courbet's well-known paintings (for example, I discuss *The Meeting* [1854] only very briefly and say next to nothing about his relations with his patron Alfred Bruyas), though I hope that my selectiveness in this regard is more than offset both by a concern with portions of Courbet's oeuvre that until now have been neglected, notably the early self-portraits, and by the intensiveness of my engagement with works which, like the *Burial at Ornans* and the *Painter's Studio,* have always been considered central to his achievement.

A few more remarks about the general nature of my work may help forestall misunderstanding:

I

I don't think of my approach in this book (or in *Absorption and Theatricality*) as in any sense "formalist," an epithet that has tended mechanically to be affixed to my work ever since the 1960s when I wrote about recent abstract painting and sculpture in terms of particular issues that, having come to the fore in the abstract painting and sculpture of the immediate past, were inevitably issues of abstraction. Basically, I understand formalism in art history or art criticism to imply an approach in which: 1) considerations of subject matter are systematically subordinated to considerations of "form," and 2) the latter are understood as invariable or transhistorical in their significance (the second of these points is often left implicit). Now in contrast to such an approach my concern with issues of absorption and theatricality involves taking subject matter seriously, or rather it involves effacing the distinction between subject matter and "form." (Does Brutus's expression in David's painting belong to the one or the other? What of the collective effort of the shipwrecked men in Géricault's masterpiece to be beheld by the distant "Argus"? Or what of Daumier's handling of extreme contrasts of light and dark in his lithographs of the mid-1830s?) Similarly, my insistence that it makes no sense to try to determine whether a given painting conclusively (i.e., once and for all) does or does not succeed in defeating the theatrical expresses a strictly nonformalist attitude toward the question.[57]

Or consider another example, this one from the art of Courbet. In the

chapters that follow I repeatedly suggest that central, foreground figures depicted from the rear are in various respects surrogates for the painter (or, as I shall chiefly say, the painter-beholder) and moreover that they evoke the possibility of quasi-corporeal merger between the painter-beholder and themselves. This too calls into question the distinction between subject matter and "form" (to which category does the figures' orientation belong?), while the actual conduct of my argument will make it clear that my claim is that *in Courbet's oeuvre but not necessarily elsewhere* figures depicted from the rear are best understood as having this particular significance. To expand somewhat on the second point, a foreground figure depicted from the rear *might* mean literally anything (the credo of a nonformalist); my account of what such figures mean in Courbet's pictures is entirely a historical one, though of course I am aware that the specific terms of my analyses, as well as the frequent characterization of my procedures as reading or interpreting the works under discussion, mark a break with traditional histories of nineteenth-century French painting. But I concede nothing to those histories in the way of historicalness as such.

I I

In *Absorption and Theatricality* my claims about the emergence of a problematic of beholding in mid- and later eighteenth-century French painting were grounded in a simultaneous and mutually clarifying analysis of numerous writings by Diderot and other art critics and of a representative selection of paintings by leading artists of the period. Throughout the present chapter too I appeal to the criticism of Delécluze, Guizot, Stendhal, Planche, Chesneau, and others to support my accounts of the work of various painters. But in the chapters to come I make only occasional reference to art criticism, not because I believe the relation between criticism and practice changed abruptly in the 1840s or 1850s, but because no contemporary critic appears to have recognized in any sustained way the aspects of Courbet's art that are central to my argument. The blankness of the criticism in this regard isn't the result of mere insensitivity. In the first place, as I have noted, the topic of realism was ideologically overdetermined to an extent that effectively restrained commentary within narrow bounds, so that for example the relation of Courbet's paintings to their audience was most often described as one of confrontation or aggression, a formula I suggest stands in need of modification. And in the second, the claims I advance about Courbet's art are so ex-

treme—what I see as taking place in his paintings is pictorially and on-tologically so remarkable—that it seems altogether unlikely that any nineteenth-century critic, indeed that Courbet himself, could have understood the meaning of his enterprise in the terms developed in this book. (It's above all in this sense that I speak of Courbet as unconscious of that meaning.)

On the other hand, I have suggested that Baudelaire's writings on painting, while mistaken about Courbet, nevertheless develop terms of criticism that bear intimately on his work, and throughout the pages that follow I make use of Baudelaire both to illuminate Courbet's art and to indicate wider ramifications of my readings. Similarly, the critical reac-tion to Millet's peasant pictures as well as Disdéri's discussion of the es-thetics of the group photograph in *L'Art de photographie* prove beyond a doubt that a concern with theatricality was current throughout the years of Courbet's maturity. Moreover, in the course of this study I touch on writings by certain other contemporary figures, notably the philosopher Félix Ravaisson and the novelist Gustave Flaubert, that seem to me to relate closely to what I have to say. So my claim that Courbet's paintings engage with the issue of theatricality in ways no one, including their maker, was then able to recognize (or at least articulate) is not a denial of the pertinence of a larger critical and intellectual context, but rather an acknowledgment that seemingly the most directly relevant portion of that context, contemporary responses to Courbet's art, won't be of more than incidental help in what follows.[58]

## III

Starting with my discussion in chapter two of the self-portraits of the 1840s, I repeatedly suggest that Courbet's paintings are powerfully ex-pressive of having been made by an embodied being engaged in a partic-ular activity: the production of those very paintings. As a general empha-sis this is in line with the philosophical tendency known as existential phenomenology, and in fact a long-standing familiarity with phenome-nological thinking (in particular with the work of Maurice Merleau-Ponty) helped shape the approach of this study.[59] At the same time, it would be misleading to characterize that approach simply as phenome-nological in the sense of finding in Courbet's relation to his embodied-ness the ultimate meaning of his painting. (This alone is a difference be-tween the present study and Merleau-Ponty's famous essay, "Cézanne's Doubt.")[60] Rather, as I have already said, my readings will be grounded

in a consideration of the relationship between painting and beholder in Courbet's art; but what distinguishes that relationship from its antecedents in the art of Greuze or David or even Géricault is that beholding in Courbet so profoundly implicates the body, goes by way of the body, that all discussion of the issue of theatricality as it pertains to his work will necessarily be concerned with questions of embodiedness and corporeality, including, so to speak, the corporeality of painting. (It will prove impossible to separate the issue of beholding from questions of the physical making of his pictures.) I take this aspect of Courbet's oeuvre to be characteristic of a vital strain in mid- and late nineteenth-century cultural production in Europe and America, the poetry of his exact contemporary, Walt Whitman, being very nearly analogous to his paintings.[61]

Another point that should be emphasized (and another difference between my approach in this book and Merleau-Ponty's in "Cézanne's Doubt") is that the body in question must be understood not only as "primordially" given but also, equally important, as the object and fulcrum—in Foucauldian language, the target and relay—of historical forces, which is to say it must be understood as culturally coded, even culturally produced, in the most intimate recesses of its "primordialness."[62] In the modern period this is nowhere more evident than in matters of sexuality, and it isn't surprising that the cultural configuration of bodily valences comes most to the fore in chapter six, "Courbet's 'Femininity.'" I should add that in that chapter and in a few other places psychoanalytic concepts are mobilized to assist in the reading of Courbet's pictures. As in the case of phenomenology, however, psychoanalysis is in effect subordinated to the problematic of the painting-beholder relationship, not because the last is intrinsically more fundamental than either of the first two but because the aim of this study is to sustain a discourse of painting rather than of embodiedness as such or the internal dynamics of the psyche.

## IV

Finally, I want to say something about the relation of this study to my previous work. *Courbet's Realism* chronologically extends the argument of *Absorption and Theatricality* well beyond the middle of the nineteenth century, not only through its intensive treatment of Courbet and its brief remarks about Millet and Disdéri, but also through its comments in chapters six and seven on the art of Edouard Manet, who I see as having liquidated the Diderotian tradition—in the process instigating modern-

ist painting—by his pictures' acknowledgment of the inescapableness of beholding.

In addition, the interpretation of Courbet developed in this book can be read in conjunction with my account of the work of the American realist painter Thomas Eakins in *Realism, Writing, Disfiguration: On Thomas Eakins and Stephen Crane*. As regards matters of style Courbet and Eakins are not unalike, and it was only after having come to an understanding of Courbet's Realist masterpieces that I began to discover analogous structures—roughly, of surrogacy for the painter—in Eakins's *The Gross Clinic* (1875) and *William Rush Carving His Allegorical Figure of the Schuylkill River* (1877). To this extent my accounts of Courbet and Eakins are mutually confirming, suggesting between them that a primary feature of nineteenth-century realist painting was a metaphorical or allegorical, as well as insistently corporeal, thematics of self-representation. Equally important, however, the two arch realists emerge in my accounts as pursuing fundamentally different enterprises—I find no equivalent in Courbet's art to the tension in Eakins's between "graphic" and "pictorial" seeing, just as there is no equivalent in Eakins to Courbet's antitheatricality—which of course supports my claim to be practicing a mode of interpretation that everywhere seeks historical specificity, not formalist universality. (In keeping with that aim, *Realism, Writing, Disfiguration* stresses Eakins's training in a particular corporeal discipline, that of writing and drawing conceived as aspects of a single representational system, in Philadelphia high schools around the middle of the nineteenth century.)[63]

As for the relation of this book to my writings on abstract painting and sculpture of the 1960s and early 1970s (in particular to the essay "Art and Objecthood"), there is an important sense in which, like *Absorption and Theatricality*, it investigates the roots of what I characterized in 1966–67 as a new, decisive split within contemporary artistic practice.[64] What must be emphasized, however, is that the aim of my readings of French eighteenth- and nineteenth-century painting has not been to make value judgments that turn on the issue of theatricality, though it does provide food for thought if, as I argue, painters of the stature of David, Géricault, Millet, and Courbet all sought to defeat the theatrical in their art. But there is perhaps a deeper respect in which my approach to nineteenth-century realism has been conditioned by my early and continuing involvement with abstract painting and sculpture: not because, as formalist doctrine would suggest, I have been enabled by that involve-

ment to see past the realistic appearance of Courbet's paintings to some (nonexistent) abstract core, but rather because, being at home in abstraction, it's realist painting like Courbet's or Eakins's that has particularly seemed to me to require explanation. In any case, *Courbet's Realism* attempts to provide just that.

# 2    The Early Self-Portraits

In the course of the 1840s, when Courbet was in his twenties, he painted and drew a considerable number of portraits of himself—in fact it is no exaggeration to say that throughout that decade Courbet himself was his favorite subject and the self-portrait his preferred genre.[1] Other painters have of course been notably obsessed with their own images: Rembrandt and Van Gogh come at once to mind. But there is no parallel in the history of painting to the role played by Courbet's self-portraits in the evolution of his art, and it is one index among many of the inadequacy of traditional accounts of his achievement that that role has gone, if not quite unrecognized, at any rate uninvestigated. As will emerge, coming to terms with the extraordinary representational project of Courbet's self-portraits will provide the basis for a new understanding of his monumental Realist pictures of 1848–51 and, more broadly, will begin the work of reconstruing Courbet's Realism from before its advent, so to speak.

In this chapter I discuss about a dozen of his self-portraits of the 1840s. I make no effort to treat them in chronological order, a procedure that would run into insuperable problems of dating, but move freely from one painting or drawing to another according to the demands of my argument. No doubt similar conclusions could be reached by analyzing the same paintings and drawings in a different order, or by treating others that I don't discuss, but that is my justification for proceeding as I do. In any case, the significance of the self-portraits becomes manifest only when a number of them are juxtaposed, their common features noted, and the import of those features painstakingly worked out.

I want to begin by looking at a painting not given much attention in surveys of Courbet's art: the self-portrait known as *The Sculptor* (1844; fig. 28).[2] In it Courbet has depicted a young man, unmistakably himself,

Figure 28.  Gustave Courbet, *The Sculptor*, 1844.

dressed in a costume traditionally described as medieval (an ochre jerkin over a white shirt, red tights with narrow yellow stripes and jagged bottoms, slipperlike shoes) and seated on the bank of a small brook. More precisely, he appears to be sitting on a large object, probably a boulder, over which a peacock-blue cloak has been spread. Two trees spring from the top of the bank to his left (our right), and further back, in the middle distance, a wall of rock crowned by other trees rises and obliquely recedes. In the upper left corner of the canvas we glimpse bright blue sky.

The young man's head is beardless. It lolls back and to the side—its connection with the rest of his body seems tenuous at best—while the eyes roll upward. His expression is one of engrossment in reverie, a condition that in this instance we may suppose to be a response to his surroundings or at least to be in harmony with them. Indeed the existence of a special relationship between the young man and his setting is strongly implied by perhaps the oddest feature of this very odd painting. The brook, such as it is, issues from a circular orifice near the young man's left knee, and just above that orifice can be discerned the image of a woman's head and left shoulder (fig. 29). Evidently we are meant to see that

Figure 29. Gustave Courbet, *The Sculptor,* detail of woman's head and shoulder.

image, whose orientation implies that the woman is lying on her back with her head nearer to us than the rest of her body, as having been carved in deep relief by the young man into the living rock of the bank. There is thus the suggestion of a double link, the nature of which remains to be specified, between the image of the woman and the brook on the one hand and between both of these and the young man, the sculptor, on the other.

Like his expression, the young man's attitude is clearly intended to convey a sense of ease and reverie in the midst of nature. But various aspects of his pose compromise that effect. To begin with, he is shown leaning backward and to his right while turning his upper body to the left, a posture that, especially in conjunction with the lolling of his head, appears anything but relaxed or natural. In fact his torso is turned almost sideways, with the physically improbable and visually unpersuasive result that his left shoulder and the left half of his chest are lost to view. Even more peculiarly, his right arm, depicted in foreshortening, is supported at about the height of his head by a thin branch beneath his wrist. The branch, little more than a twig, scarcely seems equal to the task: our first impression is that the sitter's right hand, drooping this side of the branch and holding a small mallet, is suspended in mid-air; even after we have seen this isn't the case, it's hard not to feel that his arm lacks adequate support. The young man's left hand, holding a chisel and resting on his left thigh, presents no problem. But the position of his legs is another matter. The left leg is bent sharply at the knee, planting the left foot as far back as it can go, and the right leg is stretched out almost straight, the tip of the shoe just touching the water in the immediate foreground. The effect is somewhat like a curtsey, which is to say that it is at odds both with the naturalness of the setting and with the ostensible absorption of the young man in his reverie.

Those few scholars who have dealt specifically with the *Sculptor* have tended to characterize it as immature and Romantic, two terms more or less synonymous in the literature on Courbet, and to treat it as a foil for his later work. The notion of Romanticism seems to me unhelpful in this context, while the picture's alleged immaturity is beside the point. Admittedly the *Sculptor* bears the stamp of Courbet's youth and inexperience. But those features whose awkwardness and unnaturalness are most obtrusive turn out under further investigation to be early instances of characteristics that turn up repeatedly in his art and the importance of which for our understanding of his enterprise will be fundamental. Noth-

ing is more typical of Courbet's oeuvre than the repetition or reuse, throughout all phases of his career and often with only slight variation, of a number of highly specific and, to put it bluntly, extremely peculiar motifs, bodily positions, facial expressions, compositional structures, and the like. In the paintings of his maturity (the late 1840s and after) these tend to be both integrated with one another and subsumed within a strongly realistic mode of representation to a degree that makes them far less conspicuous (and therefore far less disturbing) than in an early work like the *Sculptor*. But they are everywhere to be understood as vehicles of an undertaking that in crucial respects remained constant throughout the artist's career.

In this connection it is revealing to compare the *Sculptor* with one of the most famous of the self-portraits, *The Wounded Man* (ca. 1844–54; pl. 1).[3] In obvious respects the contrast between the two paintings could not be stronger. For example, the later canvas eschews the fussy detail, bright local color, elaborate costume, and confusions of pose that divide and puzzle our attention in the earlier picture. Instead we are given a single unitary image: the upper half of the body of a wounded man, Courbet himself, reclining on his back in a wooded setting, his head propped against the base of a tree and his left hand grasping a fold of the dark brown cloak that covers much of his torso and presumably his lower body as well. In keeping with the internal scale of the image, the later painting is considerably larger than the earlier one; its execution is broad and confident: all in all it exemplifies the radical simplification of means and effects that took place in Courbet's art in the late 1840s and early 1850s. But these and other differences should not be allowed to obscure certain similarities between the two works.

To begin with, there is the figure's situation in the two paintings. Each depicts its sitter in a natural setting with trees and a patch of sky behind him, and in each he is shown inclined back into the space of the painting along a diagonal that runs from the lower right toward the upper left. The lower portion of his body is thus thrust significantly nearer to us than his head. In fact in both it almost seems we are obliged to look up at the sitter's head and face from below, an impression that is particularly vivid in the case of the *Wounded Man*.

There is also an affinity between the respective states of mind and body of the sitters in the two canvases. The wounded man's eyes are closed (though it seems just possible that he is looking out from beneath his lids), and he appears on the verge of losing consciousness if he hasn't

already done so (*vide* the wound in his breast and the sword behind him to his right). At the same time we feel that the whole crepuscular scene expresses his condition, or to put this another way, that his consciousness although on the verge of extinction nevertheless flows out toward his surroundings. In short, although we may not know exactly how to read his expression, we seem to be dealing with a state of mind which, like intense reverie, involves both an extinguishing and a dilation of ordinary waking awareness.

Then too a prominent role is played in both pictures by one of the sitter's hands. In the *Sculptor* it is the young man's right hand, all but suspended in mid-air, that mainly strikes us, while in the *Wounded Man* we are shown only the protagonist's left hand grasping a fold of his cloak. Especially in the latter painting the hand is a focus of interest both because of its place in the composition—it is the sole bright accent in the lower half of the canvas—and because of the vigorous yet melting plasticity with which it has been rendered. (I shall have a lot more to say about the role of hands in Courbet's self-portraits in the pages to come.)

But the chief similarity between the two works that I want to stress at this stage of my argument concerns the assertion in each of the apparent nearness, the seeming physical proximity, of the painted image to the surface of the painting and, beyond that surface, to the beholder. In the *Sculptor* the extension of the young man's right leg brings the toe of his shoe almost to the bottom of the canvas, which of course represents the boundary of the scene lying closest to the viewer. In fact it may be that the awkwardness and unnaturalness of the position of the young man's legs are mostly to be understood in this light—that it was above all in order to assert the nearness of the painted image to the picture-surface that Courbet was compelled to depict the young man as if the latter were seeking to span with his body the distance between the foreground proper, where his trunk and head are located, and the immediate foreground, as defined by the water in the brook that flows toward us in the lower right corner of the canvas. A plainer and far more powerful assertion of the apparent proximity of the image takes place in the *Wounded Man*. To begin with, the entire scene is pitched much nearer the beholder than in the *Sculptor*. What's more, the situation of the wounded man—lying on his back with his head against the base of a tree—together with the truncation of his body at about the waist by the bottom framing-edge leave no doubt that a significant portion of his body extends toward the beholder beyond the limits of the canvas; it is even possible, given the

implied distances, that the lower half of his body is to be imagined lying "this" side of the surface of the painting. The *Wounded Man* thereby calls into question what might be termed the ontological impermeability of the picture surface, by which I mean its standing as an imaginary boundary between the world of the painting and that of the beholder. Or perhaps it mainly calls into question the impermeability of the bottom framing-edge, the capacity of that edge to contain the representation, to bring it to a stop, to establish it at a fixed distance from both picture surface and beholder.

There is in this regard a further point of resemblance between the *Wounded Man* and the *Sculptor:* the way in which in the earlier painting the water in the immediate foreground functions as a natural metaphor of continuity, of the spilling-over of the contents of the painting into the world of the beholder, and therefore of the incapacity or the refusal of the painting to confine its representation (to confine *itself*) within hard-and-fast limits. If this seems fanciful, let me simply say that images of flowing water are deployed to much the same effect throughout Courbet's art (see for example my discussion of the *Painter's Studio* and the *Source* in chapter five and of his *Source of the Loue* pictures in chapter six), and that in general the bottom edges of his paintings have a problematic status unlike anything to be found in the work of any painter before or since.

Three other early self-portraits throw light on Courbet's preoccupation with nearness. In the precocious and delicate *Small Portrait of Courbet* (1842; fig. 30), the earliest of all the paintings we shall examine in this chapter, Courbet has portrayed a young man of almost female beauty dressed mostly in black and seated upright at a table with a spaniel in his lap. Although the young man's body is angled back into space, his head is seen from the front, and, as in very few of the self-portraits, he looks straight ahead as if to meet the viewer's gaze. At the same time, his expression of quiet absorption in his own mirror-image (it will become necessary to qualify this slightly), as well as the fact that his eyes although plainly open are in dark shadow, go a long way toward divesting the viewer's relation to the young man of a sense of confrontation. Another important factor here is the placement in the immediate foreground, resting lightly on a table which we almost feel we share with the young man, of the latter's right hand and forearm. As in the *Sculptor* and the *Wounded Man,* the hand is shown with its back toward us and is modeled finely in light and dark. (It is further set off both by the dazzling cuff of his shirt

Figure 30. Gustave Courbet, *Small Portrait of Courbet*, 1842.

and by the broader aquamarine cuff of the jacket, a *tour de force* of restrained colorism.) Also as in those paintings, only more conspicuously, the hand is a focus of the composition in its own right, competing for our attention with the exquisitely rendered head and face, though by virtue of its position at the bottom of the painting it also asserts the intimate proximity to the picture surface of the image of man and dog as a composite whole.

Another early work, *The Desperate Man* (1843?; fig. 31), presents the young Courbet—eyes wide and staring, nostrils flared, mouth slightly open, one hand gripping his head while the other pulls violently at his hair—looming, almost lunging, directly toward the beholder. (Once again, however, the all but palpable interposition of a mirror holds to a minimum any sense that it is *we* who are confronted by him.) The *Desperate Man* has been characterized as "an attempt to capture 'realistically' as it were, an effect of momentary expression in much the same manner as did the young Rembrandt in his series of etched self-portraits of 1630,"[4] and as regards Courbet's use of sources the comparison is germane. I suggest, however, that we find in the *Desperate Man* an attempt not so much to capture an expressive effect—the longer we study the painting the less plausible this seems—as to portray in action, in a sense to dramatize, the impulse toward extreme physical proximity that we have seen at work in the other pictures by Courbet we have examined. Such a notion helps explain the otherwise arbitrary lighting, which calls attention to features—the desperate man's nose and left elbow—that thrust forward toward the picture surface, as well as the billowing of his loosely tied blue-gray scarf across most of the bottom framing-edge, which has the effect of softening that edge, of making it billow slightly too, in short of preparing it to be transgressed. It is as though Courbet's object in this eccentric canvas were by an act of almost physical aggression to cancel or undo all distance not merely between image and picture surface but also, more importantly, between sitter and beholder, to close the gulf between them, to make them one.

An even more eccentric self-portrait of roughly the same moment, the so-called *Man Mad with Fear* (1843?; fig. 32), depicts the young Courbet in medieval costume in the act of leaping from the edge of a cliff; he seems to be springing directly toward the beholder, and the image as a whole perhaps suggests that he has been driven to his insane deed by contemplating the abyss before him. The *Man Mad with Fear* relates

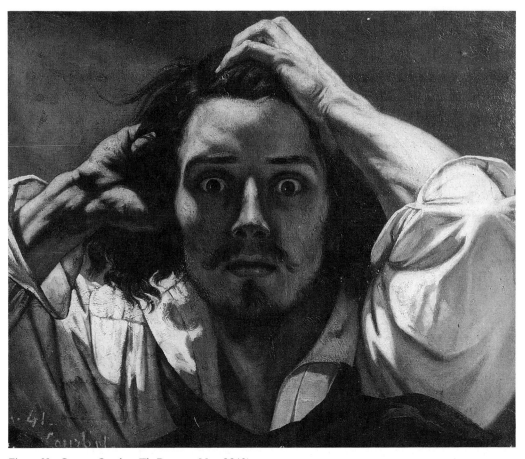

Figure 31. Gustave Courbet, *The Desperate Man,* 1843?

closely to the *Desperate Man* and, even more emphatically than the latter, may be read as thematizing what I take to be the painter's sense of a vertiginous gulf between sitter and beholder—and ultimately, I shall claim, between painting and beholder.

A few pages back, while comparing the *Sculptor* and the *Wounded Man,* I suggested that an affinity exists between the sitter's condition in the two works, an affinity I went on to describe in terms of a simultaneous extinguishing and dilation of ordinary waking consciousness. This raises several questions: What larger significance, if any, should we attribute to the states of mind depicted in those paintings? More broadly, how are we to interpret the peculiar expressive tonality of Courbet's self-portraits as a group? And what implications follow for our understanding of his enterprise not only in the self-portraits but throughout his oeuvre?

In the first place, it should be clear that the self-portraits we have looked at so far cannot plausibly be construed as explorations either of comparatively stable aspects of the artist's nature or of more or less transient moods and emotions. Even the *Desperate Man*, which at first glance can strike one as a study of extreme emotion, turns out to have something else in view; while the *Sculptor,* the *Wounded Man,* and the *Small Portrait of Courbet* are all manifestly uncommunicative on the level of "character"

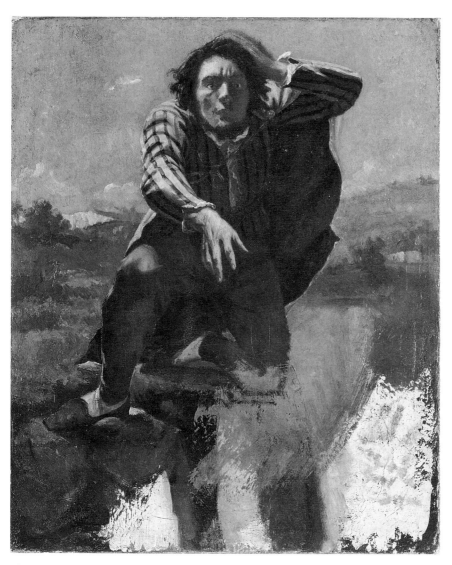

Figure 32.  Gustave Courbet, *Man Mad with Fear,* 1843?

or "personality."[5] (The contrast in this regard with Rembrandt and Van Gogh is acute.) Now it has often been held by commentators on Courbet's art that he was at bottom a painter of inanimate matter—in René Huyghe's words, of "*things,* in all their powerful materiality."[6] And the impassivity of the self-portraits, their virtual blankness as regards the sorts of interest most closely associated with the genre (culminating in the air of somnolence that pervades the *Wounded Man* and is more than hinted at in the *Sculptor*), may seem to indicate that Courbet saw in himself as subject merely another material entity, albeit an intimately familiar one whose features he candidly admired and could scrutinize at his leisure and depict as often as he wished. The truth, however, is more complex.

I suggest that the peculiar inexpressiveness of Courbet's self-portraits is most accurately understood as the product of an attempt to evoke within the painting his intense absorption in his own live bodily being— his bodily liveness, as twentieth-century phenomenologists would say.[7] Not that Courbet himself would have characterized his undertaking in equivalent terms (the language of existential phenomenology was of course unavailable to him). Rather, from his beginnings as a painter, as in the *Small Portrait of Courbet,* he seems to have been driven to express in and through the medium of the self-portrait a sense or intuition or conviction of his own embodiedness that he could not have expounded in words, not only because for Courbet verbal speech lagged far behind pictorial expression but also because, here as elsewhere in his art, a certain unconsciousness of what he was about appears to have been an enabling condition of his most radical inventions.

Some of the most telling evidence in support of this reading of the self-portraits concerns the depiction in them of the sitter's *hands.* The use of the motif of hands for specific ends is one of the recurring features of Courbet's art to which I alluded earlier in this chapter, and it says a great deal about the importance of the self-portraits for any broader comprehension of his work that the key to the meaning of that motif lies there. Simply put, the treatment of hands in the self-portraits tends to be of two kinds: either a single hand is presented in a state of apparent passivity or relaxation and at some distance from the rest of the sitter's body, as if in that way the existence of the hand as a source of internal feeling could be brought into focus (made a target of the sitter's absorption); or one or both hands are shown in a state of relative tension or activity—grasping, pulling, clasping, pressing, etc.—as if in an attempt to evoke, again from within, the sensation of effort itself. Early instances of the first are found

in the *Small Portrait of Courbet,* in which the distancing of the hand from the rest of the body is accentuated by the horizontal table-edge that makes a separate zone of the bottom portion of the canvas, and the *Sculptor,* in which the apparent suspension in mid-air of the sitter's right hand produces a similar effect. The second approach is adumbrated in the *Desperate Man* and is developed in a somewhat later self-portrait, the *Cellist* (fig. 40), about which I shall have more to say, but it is above all in the powerful and enigmatic *Man with the Leather Belt* (pl. 2), a painting I shall discuss later in some detail, that hands that are tense and active but divorced from any practical activity are foregrounded as a motif. In the *Wounded Man,* a picture that has in it something of both approaches, the sitter's left hand takes the place of his body, which, except for the head and upper torso, is hidden from view. More precisely, it is the sitter's body *as object* whose contours the painter has obscured under a shapeless dark brown cloak; and it is his body *as actually lived,* as possessed from within, that has been given expression in the masculine yet delicate hand that emerges from beneath the cloak to grasp firmly but not tightly a fold of the heavy, indeterminate stuff of which the cloak is made. The ambiguity or doubleness of that gesture, which may be read as directed simultaneously outward toward the world and inward toward its own lived physicality, is characteristic of Courbet's art. So for that matter is the double nature of the cloak itself, which would seem to belong unequivocally to the world of objects but whose darkness, lack of definite contours, and obscuring of the body it covers suggest that it functions as a visual metaphor for the wounded man's (nonvisual) experience of his embodiedness, an experience that, whatever its content, is not of the body as an object.[8]

Or consider the delicately nuanced charcoal drawing known as the *Country Siesta* (early 1840s; fig. 33), which depicts Courbet and a young woman who has been called Justine asleep against a tree. The angle at which the male figure's head leans back against the base of the trunk, the orientation of his body, and the implied extension of his legs toward the surface of the sheet, all correspond closely to equivalent features of the *Wounded Man,* and in fact recent X-rays have revealed that the latter was originally conceived as a painted version of the *Country Siesta* and that several years after the painting was begun, perhaps in the late 1840s, perhaps around 1851, Courbet decided to eliminate the figure of Justine.[9] In the drawing Courbet has again portrayed one of his hands—the right hand, resting palm up on his thigh—in a manner that attracts our

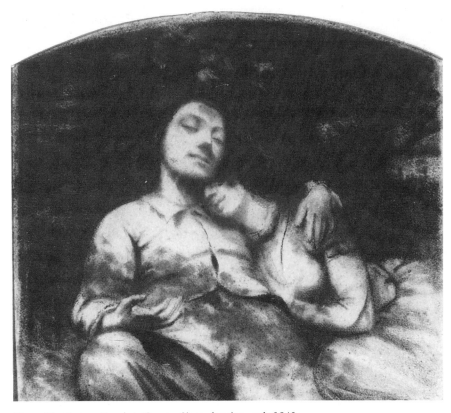

Figure 33. Gustave Courbet, *Country Siesta,* drawing, early 1840s.

attention. On first view the hand's openness and slight awkwardness are felt to evince the sitter's perfect unconsciousness. But something about those qualities—an intimation of poise, even of tension, in its disposition—soon makes us aware of the hand as a potential locus of sensation and hence as a sign of the male sitter's possession from within of his own body.

A second feature of the *Country Siesta* that deserves emphasis in this connection is its representation of *sleep,* another motif that runs throughout Courbet's oeuvre, as Huyghe was the first to note.[10] Except for a few early drawings, one of which will be analyzed shortly, there is no other work in which Courbet portrayed himself as unambiguously asleep. But we have seen that he was inclined to depict himself as engrossed in reverie or as semiconscious, conditions that have much in common with sleep; and I now suggest that we may regard that inclination as aiming to present the body's liveness in its simplest, most elemental form—as a "primordial presence" that itself has the character of somnolence and that far from being extinguished in sleep is there in effect given free rein. There is

also a sense in which in the state of sleep a "primordial" relation to the world is allowed to reassert itself by virtue, first, of lying down—abandoning the upright posture that establishes human beings in perceptual opposition to the object world—and second, of surrendering all control of bodily functions as if to a power or rhythm outside oneself.[11] The role of the woman in the *Country Siesta* is significant in this regard. On the one hand, she is part of the world outside the sleeping Courbet; on the other, she seems literally to meld into his body to an extent that foreshadows her eventual disappearance from the *Wounded Man*.

Still another aspect of the *Country Siesta* that leads me to see in it an image of embodiedness is the male sitter's pose and orientation, or rather the way in which these allow the artist to depict the sitter's body in foreshortening. It may seem that Courbet thus calls attention to the body's physical bulk, and in a sense this is true. But I suggest that it is truer to the drawing's metaphorics of corporeality to say that we are thus invited to become aware that the sitter's view of his own body, should he awaken and open his eyes, would itself be foreshortened—more precisely, that he occupies toward his body a fixed and unchanging point of view, whereas his relation to all other objects is a function of his ability to approach or withdraw from them, to survey them from different sides, in short to adopt toward them a multiplicity of perspectives according to interest and desire, limited only by contingent circumstances. The experience of that fixed point of view, which entails the impossibility of surveying one's body as a whole, belongs to the body as actually lived and provides a sort of immediate foreground relative to which the perception of objects in perspective is to be understood as taking place.[12]

We are now in a position to appreciate the significance of a basic feature of Courbet's self-portraits: the consistency with which they seek to avoid or at least minimize all sense of confrontation between sitter and beholder. The sitter is typically portrayed either reclining with his head leaning against a tree, as in the *Country Siesta* and the *Wounded Man*, or seated with his body at an angle to the beholder and his head tilted back or to the side or both, as in the *Sculptor*, the *Cellist*, the *Man with the Leather Belt*, and a picture that hasn't yet been mentioned but fits perfectly into our discussion, *Courbet with a Black Dog* (1844; fig. 34). Sometimes, notably in the *Country Siesta*, the *Wounded Man*, and *Courbet with a Black Dog*, the beholder feels himself to be looking up at the image from below. Even the few paintings in which the sitter seems at first to

directly engage the beholder, such as the *Small Portrait of Courbet* and the *Desperate Man,* turn out to call that initial impression into question. But Courbet's self-portraits do more than simply modify the relationship of mutual facing between sitter and beholder that is one of the staples of the genre. Instead they attempt by various means to establish or at least imply another, altogether different relationship between sitter and beholder, one in which the two are *made congruent* with one another as never before or since in Western painting. And since the *first* beholder, not just chronologically but ontologically, was Courbet himself, I am led to see in that relationship of congruence a further manifestation of what I have been claiming was his desire or compulsion to evoke in and through the medium of the self-portrait his intense if less than fully conscious absorp-

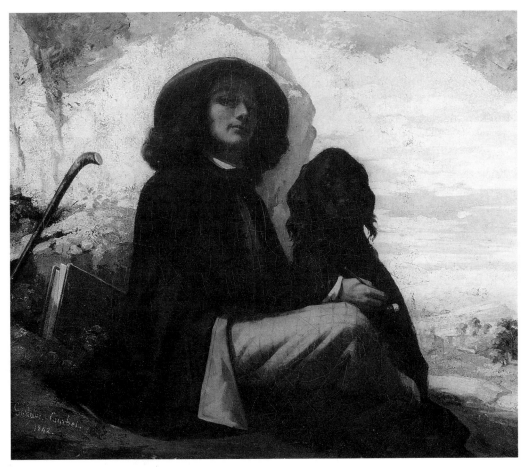

Figure 34.  Gustave Courbet, *Courbet with a Black Dog,* 1844.

tion in his own bodily being. A brief survey of a few works we have not yet considered will help make my meaning clear.

In the *Lovers in the Country* (1844; fig. 35), Courbet has portrayed himself and his mistress Virginie Binet clasping hands in a forest landscape at dusk. Both the poses of the figures and the composition as a whole are unconventional and have been seen as verging on the absurd. Clearly, however, the most salient features of the *Lovers in the Country* are variants of those we have been tracing in other works. For example, Courbet appears to have been at pains to assert the proximity of the lovers to the picture surface and, implicitly, to the beholder; the male sitter's left hand clasping the woman's right one is a further instance of the use of hands to convey a sense of bodily liveness; while the lovers' expressions connote rapture and/or absorption (he seems enraptured, she pensive), states which involve the suspension of ordinary waking consciousness. In addition, that the male sitter has been depicted in profile with his head tilted toward the picture plane exemplifies the avoidance of face-to-face confontation that I have just attributed to the self-portraits as a group. In fact the last observation doesn't go far enough. Only the male sitter's head is in profile; the rest of his upper body has been portrayed largely from behind, a distinctly odd compositional stroke which, because our attention goes first to the lovers' faces, is easily overlooked. Yet nothing in the *Lovers in the Country,* certainly not the lovers' expressions, is more significant than the extent to which the figure of Courbet turns toward that of Virginie. Put succinctly, I see in this an attempt by the painter to align his image as impassioned lover with his actual bodily orientation before his easel by representing himself in the painting as nearly as possible *from the rear.*

This interpretation finds support in two other works of roughly the same moment, *The Great Oak* (ca. 1844?; fig. 36), in which a reclining Courbet has his back mostly turned to the viewer, and the oil sketch also known as *Lovers in the Country* (ca. 1844; fig. 37), in which Courbet and a woman companion have been portrayed literally from the rear. But the most compelling document in this regard is not a painting nor even a finished drawing but a page from a small sketchbook that Courbet used in the early 1840s (fig. 38).[13] The page has on it four separate and distinct images, each with a different internal scale. Starting at the lower middle of the page and moving counter-clockwise, these are:

1. A scene of five figures (three men and two women), evidently village bourgeois, all but one of whom are standing before an open plot of

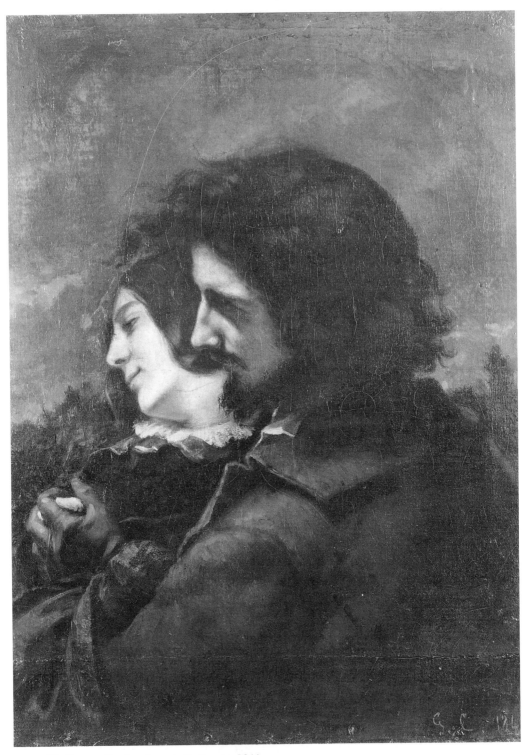

Figure 35. Gustave Courbet, *Lovers in the Country*, 1844.

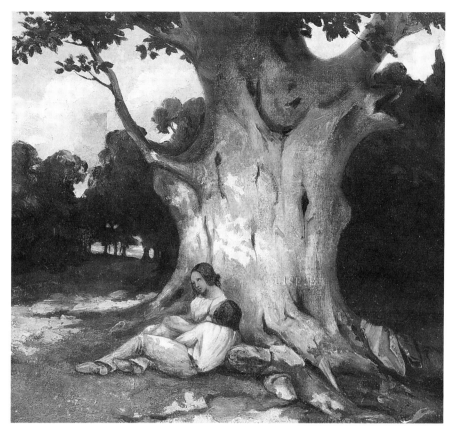

Figure 36. Gustave Courbet, *The Great Oak,* ca. 1844?

Figure 37. Gustave Courbet, *Lovers in the Country,*
oil sketch, ca. 1844.

ground with a tree behind them in the middle distance and more trees, buildings (among them the belfry of Ornans), and hills in the far distance. The long shadows cast by the standing figures suggest that the hour is near dusk; possibly the group is watching a sunset. The lone seated figure, a young man, is somewhat apart from the others and rests his head on his hand as if in thought.

2. A depiction of Courbet sleeping, his head pillowed on a knapsack. We are shown only his head and shoulders, turned partly to the side; his hat rests lightly on the other side of his head, pushed there when he lay down; and he has a pipe in his mouth. The bulk of his body is to be understood as advancing at an angle toward the surface of the sheet. It isn't clear whether the setting is meant to be indoors or outdoors: what might be folds in a curtain behind and to the left of the sleeping sitter seem to become trunks of trees toward the right, but neither reading is sure. (Can he too be reclining against the base of a tree?) This image is the most heavily shaded and altogether the most elaborated of the four. A comparison with the *Country Siesta* suggests that it was a source, perhaps *the* source, for Coubert's portrayal of himself in that drawing.

3. A woman's head, eyes turned upward as if in reverie, drawn rather

Figure 38. Gustave Courbet, *Sketchbook Page,* early 1840s.

faintly in almost pure outline with shading just outside her profile. In feeling though not in pose, as well as in its relation to the portrait of Courbet, this image anticipates that of the woman carved into the bank of the brook in the *Sculptor*. More immediately, though, it seems to be an early version of the figure of Justine asleep with her head on Courbet's shoulder in the *Country Siesta*.

4. A close-up study of what must be presumed to be the artist's left hand, held palm up, forefinger extended, the other fingers loosely bent. This image too has its sequel in the *Country Siesta*—the crucial motif of the male sitter's right hand resting palm up on his thigh.

We are thus given separate images of the sleeping Courbet and of his hand, as though the distancing of the hand that we have observed in several self-portraits is here manifest as an actual disjunction. But what makes the last image truly remarkable is that the hand has been delineated from Courbet's point of view, by which I mean from the point of view *of his body:* I am thinking not only of its scale (largest among the four images) and position on the page (at the bottom left, i.e., in the appropriate sector of the page considered as an image of his perceptual field) but also of the hand's orientation relative to the artist (pointing away from him, into the world of the representation). In all these respects Courbet's drawing of his hand expresses as directly or, to use a Baudelairean term, as naively as could be imagined his conviction of being one with his body, of inhabiting it from within. And because it does, the page as a whole is uniquely revealing of the extent to which Courbet's project of self-portrayal was inherently at odds with the traditions and conventions of the self-portrait and in a sense with those of representational painting altogether. It suggests that his attempt to give pictorial expression to his absorption in his own embodiedness tended "naturally" to issue in images that can only be characterized as disunified, multiscalar, technically disparate, and bizarrely orientated; and that his task as a painter who aimed to compete successfully with the great artists of the past and to impose himself triumphantly on his contemporaries was therefore to transform the raw material of such images (or say of his imagination) into ostensibly integrated, illusionistically coherent, and, if often unusual, at least not glaringly eccentric representations. The working up into the *Country Siesta* of at least three of the four drawings on the sheet we have just examined (and perhaps all four images if, as seems possible, the *Country Siesta* is meant to evoke the hour of dusk), followed by the further evolution of the *Country Siesta* into the *Wounded Man,* gives a fair idea of the operations by which that task was carried out.

Further light on those operations is thrown by Courbet's most ambitious painting of the period, the *Man with the Leather Belt* (1845–46?; pl. 2). Alluding broadly to Venetian, Spanish, and Dutch prototypes (and perhaps to Michelangelo's *David*), the artist has portrayed himself approximately life-size, seated alongside a table whose near edge runs parallel to the bottom of the canvas. The sitter's upper body is turned away from the table, and, as so often in the self-portraits, is at an angle to the picture plane. His head too is turned in the direction of his body, though his gaze appears to be directed back (and down) toward the beholder. Once again, however, we don't feel that we meet that gaze; it seems to slide past us to our left, as if the sitter were exclusively concerned with his own thoughts and feelings. His right elbow rests naturally enough on a leather-bound portfolio, but his right hand, its back and top plus the back of his wrist modeled powerfully under bright illumination, twists back into the space of the painting to graze but not quite to support his right cheek and jaw. The effect of both illumination and gesture, as well as of the slightly too large size of the hand and its placement just above the center of the canvas, is to make the hand extremely conspicuous—the primary focus, the protagonist, of the composition. In the lower right corner of the canvas, the sitter's left hand, also brightly lit, grips his broad leather belt, the accessory that gives the painting its name. In this it resembles the left hand in the *Wounded Man,* only here the impression of physical effort is far more intense. On the table to the sitter's right (our left) stands a small cast of a sculpture, the original of which has been idenitifed as an *écorché* then thought to be by Michelangelo. A piece of white chalk in a holder lies on the portfolio. Finally, a length of cloth covers one corner of the portfolio before falling past the table edge at the lower left.

It hardly needs stressing that connections may be drawn between the *Man with the Leather Belt* and the self-portraits already considered. For example, the image of the sitter has deliberately been pitched near the surface of the picture—so near, in fact, that we tend to assume without thinking about it that the sitter's lower body thrusts beyond the plane of the picture surface into our world. This impression of extreme physical proximity is given further point by the way in which the leather-bound portfolio (at once a metaphor and a metonymy for the sitter) juts beyond the edge of the tabletop on which it rests; while the length of cloth that falls past the table edge is another of those elements that serve to call into question the impermeability of the bottom limits of the painting. (This

is also the effect of what I see as a general overloading of the bottom portion of the canvas, as if most of the weight of the representation had come to settle there.) The abstracted, quasi-somnolent mood indicated by the sitter's facial expression, as well as the devaluation of vision implied not only by the sitter's averted gaze but also by the deep shadowing of his eyes, support the type of interpretation, phenomenological rather than psychological or autobiograhical, that I have attributed to the self-portraits as a group.

But by far the most unsettling feature of the *Man with the Leather Belt* is the prominence given to the sitter's hands, whose actions become intelligible only when they are viewed in terms of a desire to make manifest within the painting an intense conviction of the painter's own embodiedness. Thus the sitter's left hand gripping his belt with a far greater expenditure of effort than the action warrants may be seen as striving to experience not merely the texture, thickness, and resistance of the leather belt but also, by virtue of that excess of effort, *its own* activity, its "being," as a grasping, feeling, physically substantial living entity.[14] As for the sitter's right hand, its largeness recalls that of the image of the left hand on the page from the early sketchbook (fig. 38); its state of tension, devoid of any obvious rationale (I shall suggest a rationale shortly), evokes its possession from within even more effectively than does the action of the hand gripping the belt; and its orientation within the painting, conspicuously, almost painfully turned away from the beholder, exactly matches what we know must have been the orientation of Courbet's right hand, indeed his entire body, as he sat working on the canvas. (All the evidence we have—photographs, eyewitness accounts, paintings and drawings by Courbet of himself at his easel[15]—indicates that he habitually painted sitting down. And as we shall see, a seated position is also indicated by the poses given to figures not directly shown in the act of painting but which may be read as surrogates for the painter.)

Finally, the cast of Michelangelo's *écorché* may be taken to summarize the painting's main concerns as they have emerged so far. Its pose, which has something in common with the sitter's, suggests the notion of effort in and through which the body is brought forcibly up against its inherent limits and so is made aware of the latter at the level of feeling. That the cast depicts a man who has been flayed is consistent with the primacy of internal sensation over visual perception. And the placing of the *écorché* with its back to the beholder reinforces my argument that the sitter has been portrayed, although not literally from the rear, in a pose that in

decisive respects is grounded in the painter's orientation before his picture.

I said at the outset that I didn't intend to examine all of Courbet's self-portraits of the 1840s. But no account of his work in that genre would be adequate without some discussion of the famous and masterly *Man with the Pipe* (1849?; fig. 39). On first viewing one is struck by its simplicity as compared with the *Man with the Leather Belt*. Nevertheless, most of the features that have emerged as significant in the other self-portraits are also present in the *Man with the Pipe*. The sitter's expression has always been perceived as one of reverie and self-absorption ("He dreams of himself as he smokes the pipe," wrote Courbet's contemporary, Théophile Silvestre).[16] Although his eyes are partly open, the whites are lost in shadow, a characteristic touch, which, as in other pictures we have considered, devalues the gaze. The overall impression conveyed is of a state of somnolence that has nothing to do with fatigue and everything to do with the evocation of a "primordial" or *somatic* order of activity— the automatic processes by which the body sustains itself, by which it lives (automatism in Courbet will be a primary concern of chapter five). Another crucial and familiar feature of the painting is its vigorous assertion of the nearness of the sitter to both picture surface and beholder. In this the *Man with the Pipe* is fully as extreme as the *Desperate Man* and immeasurably more persuasive in its extremity than the earlier work. But what I want to emphasize is the sitter's pose and orientation. At first glance the sitter seems to face us directly, though as usual his head is slightly tilted back and to the side. Gradually, however, we become aware that his upper body is turned at a sharp angle to the plane of the painting, that his left shoulder is higher than his right one and pushes forward to the immediate vicinity of the picture surface, and that his left arm, of which we see very little, appears drawn across his body as if in a kind of contrapposto. These asymmetries are underscored by the leftward thrust of his pipe and the direct illumination of only the left tip of his collar. And they are driven home by the fact that whereas we glimpse over the sitter's right shoulder a distant horizon at dusk, there looms dimly behind his left shoulder what seems to be the trunk of a tree, against which, as against the back of a chair, he is perhaps to be understood as leaning. (The darkening over time of initially dark pigment has made this hard to see.) Furthermore, the painter has come close to straining verisimilitude in order to show us a portion of the sitter's jacket that lies above and behind the seam of the left shoulder, which is to say that once again he

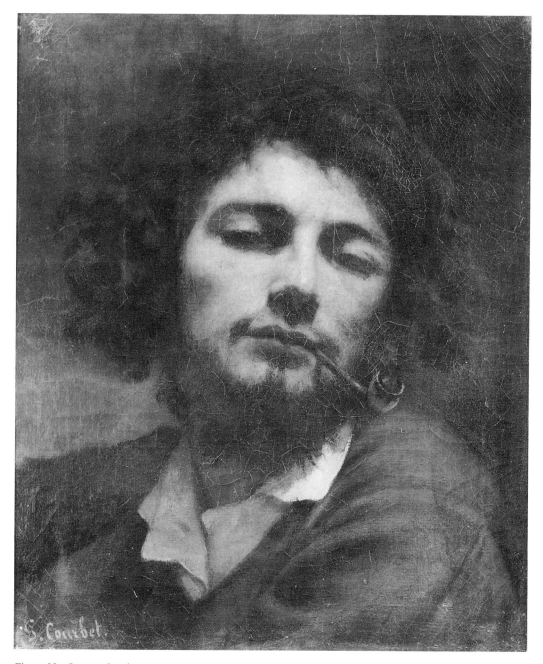

Figure 39. Gustave Courbet, *Man with the Pipe*, 1849?

seems to have been driven, against the conventions of the genre, to build into his composition at least a hint of his own bodily orientation.

One last feature of the picture deserves mention: the pipe itself. We have seen that Courbet drew himself with a pipe in his mouth on the

page from the early sketchbook; a pipe also turns up in *Courbet with a Black Dog;* others are smoked in works we have not considered;[17] and on one notable occasion he is said to have painted the image of a pipe as a symbolic self-portrait.[18] There is no need to digress on the iconography of the pipe in his art. My point is simply that whatever else may be said about its significance, the pipe in the *Man with the Pipe* functions as a virtual extension of the sitter's embodiedness, the slowly burning tobacco giving visual, indeed multisensory, expression to his somatic life.

Until now I have presented Courbet's self-portraits of the 1840s in phenomenological terms: as the work of a painter who, far from desiring simply to reproduce his outward appearance, to analyze his character or personality, or to record the external signs of various transient inner states, found himself compelled to seek to express by all the means at his disposal his conviction of his own embodiedness. The devaluation of the sitter's gaze, in fact the frequency with which Courbet portrayed himself with eyes closed or all but closed, are, I have suggested, expressions of that emphasis on the body as experienced from within rather than as observed from without. One might say that the self-portraits convey the impression that Courbet painted them, if not literally with his eyes shut, at any rate while relying on the sense of sight merely to guide his brush across the surface of the canvas and not at all, or only very little, to determine the subject to be represented. And this means that the pictures we have been considering, with their determination to match rather than reflect Courbet's bodily orientation, have less of the character of mirror images than any self-portraits ever made (this even applies to those pictures, like the *Small Portrait of Courbet* [fig. 30] and the *Desperate Man,* [fig. 31], in which we sense the interposition of a mirror as if between the sitter and us). I have also called attention to the assertion throughout the self-portraits of the nearness of the sitter to the surface of the painting and implicitly to the beholder, and that too I understand, up to a point, in terms of Courbet's drive to reconstitute in paint his conviction of his own live bodily being, as if the elimination of apparent distance between himself and his painted image allowed that conviction to be infused directly from the one into the other.

Having said all this, however, I now want to go beyond a strictly phenomenological reading of the self-portraits by placing their concern with embodiedness in the framework of certain highly specific and historically conditioned *pictorial* demands. In the first chapter of this book I sketched

a beholder-centered account of the evolution of a central tradition within French painting from the middle of the eighteenth century through the 1830s and 1840s and beyond. At the core of that tradition, mobilizing and directing it, was the imperative that the painter find a way to negate or neutralize the primordial convention that paintings are made to be beheld—that he manage in one way or another to establish the fiction, the metaillusion, that the beholder does not exist, that there is no one standing before the picture. From Greuze through Géricault this was chiefly to be accomplished in and through the medium of pictorial drama, by representing figures so deeply absorbed in a single, comprehensive, emotion-charged situation, and so strongly bound together by a whole array of compositional devices, that they would strike one as immured in the world of the painting and therefore as oblivious to the very possibility of being beheld from a vantage point outside that world. (The painting would be sealed in front as by an invisible wall.) And I have described the crisis that overtook that central antitheatrical tradition after Géricault's death by saying that the dramatic as such came more and more to be perceived as inescapably theatrical, a development that on the one hand set the stage for the emergence of the overtly theatrical painting of Delaroche and his imitators and on the other eventually led to Millet's attempt to replace drama by (a return to) absorption—an attempt which, as we have seen, met with a mixed response. It's in this context that Courbet's self-portraits must be understood. For not only were his efforts at self-representation guided less by the data of vision than by other ranges of feeling and sensation, but also in an important sense Courbet, in seeking to portray his own embodiedness—to revoke not only all distance but also, so far as might be possible, all *difference* between himself and the representation of himself—was in effect striving to annul, if not his own identity as beholder, at any rate something fundamental to that identity: his presence outside, in front of, the painting before him.

Let me be as clear as possible about what I am claiming. I don't say that Courbet's earliest self-portraits were essentially antitheatrical in impulse. It seems far more likely that his precocious attraction to and handling of the genre were motivated by desires and compulsions deeply rooted in his psyche and only minimally shaped by a specific pictorial context. But those desires and compulsions were evidently in full accord with his growing sense of vocation as a young French painter of titanic ambition, which suggests on the one hand that they unavoidably engaged the problematic of painting and beholding outlined in chapter one

and on the other that it may have been the peculiar strength of those desires and compulsions in Courbet's case that underlay the radicalness of his innovations.

Nor do I mean to suggest that because the self-portrait inevitably—generically—put the painter in the picture it was in any sense inherently antitheatrical. My claim is rather that, far more than the conventions of any other genre, those of the self-portrait brought various issues associated with Courbet's own spectatorhood into special focus, thereby enabling him to come almost physically to grips with them and, within broad limits, to shape them to his needs. In particular, by calling for the depiction of a figure that would at once double and, at least approximately, face its maker, the conventions in question provoked in Courbet both as painter and as beholder—that is, *as painter–beholder*—a heightened intuition (I don't quite want to say awareness) of his physical separateness from and opposite orientation to the painting before him. And it was by subtly but profoundly subverting those conventions while ostensibly conforming to them that Courbet succeeded, not in definitively resolving the issues in question (what would it mean to say that they were so resolved?), but in making them subject to the operations of painting as never before. Thus in the *Man with the Leather Belt* (pl. 2), which epitomizes the self-portraits as a group, the central gesture of the sitter's right hand and wrist contrives to accomplish something one might have thought unattainable within the norms of the genre: to align that right hand with the painter-beholder's right hand, or, more emphatically, to create a situation in which the two hands can virtually be taken to coincide, to become *one* (or one *again*). In sum, I am claiming that the self-portrait became privileged for Courbet not only because it lent itself to his efforts to represent his own embodiedness but also because a certain struggle against his identity as beholder found there what might be called a counter-conventional home. And it remained privileged until, starting in the late fall of 1848, he discovered that he was able to conduct that struggle, and no doubt also pursue those efforts, across a wide range of subjects and in paintings whose dimensions, compared with those of the self-portraits, are sometimes immense.

A last look at the *Man with the Leather Belt* will allow us to make one more round of observations. If we bear in mind the actual process, the specific labor, by which that painting was produced, a further, implicit rationale for the treatment of the sitter's hands becomes apparent. I have

said that the sitter's bodily attitude leads us to imagine two right hands, the sitter's and the painter-beholder's, physically conciding. Now I want to propose that the feeling of extreme tension associated with the sitter's right hand and wrist may be seen as an expression of the physical effort involved *in the act of painting,* of wielding a brush or knife to apply paint to canvas, understood not as an image of a general function by which all paintings are made but rather as a vehicle of the painter-beholder's determination to be "true" to the lived actuality of his embodiedness for as long as was required to produce the painting before him. And this in turn suggests that the sitter's left hand actively gripping his belt may be read as expressing the less intense though indefinitely protracted effort involved in holding a palette and brushes—again, as Courbet did as he worked on the *Man with the Leather Belt.*

Most other self-portraits of the 1840s are less developed in this regard but, for example, in *Courbet with a Black Dog* (fig. 34) the sitter holds a pipe in his right hand much as the painter-beholder would have held a brush, and moreover directs the pipe, obliquely, into the picture space. Indeed the sunlit landscape in the distance at the right appears almost detached from the rest of the representational field, as if it were ultimately to be seen as having been painted by the young man in the picture.* Significantly, a pipe is also held much as a paintbrush might be in the *Draughts Players* (fig. 46), an early work that contains another self-portrait and includes pipes, brushes, and a palette among the paraphernalia of an artist's studio.

A different but related thematization of the act of painting occurs in the imposing *Cellist* (1847; fig. 40), in which the bow in the sitter's *left* hand invites comparison with a paintbrush while the *right* hand's pressure on the strings evokes the effort of holding a palette. This reversal, even confusion, of left and right suggests that Courbet in this instance relied far more than usual for him on his image in a mirror—in actuality

---

*According to Riat, *Courbet with a Black Dog* depicts the artist "seated at the foot of a rock, at the entrance to the grotto of Plaisir-Fontaine," just outside Ornans (p. 34). Toussaint disputes this identification on topographical grounds, no doubt correctly (p. 230). But perhaps partly because the upper corners of the painting bear traces of having once been rounded off, *Courbet with a Black Dog* does convey the sense of having been projected as if from just inside the entrance to a cave, thereby virtually framing the distant landscape as an independent scene. The figures of Courbet and his dog would thus be poised on a threshold between two fundamentally different "spaces," one remote and accessible to eyesight alone, the other, which I associate with the experience of embodiedness, so proximate and enveloping as to be all but unrepresentable.

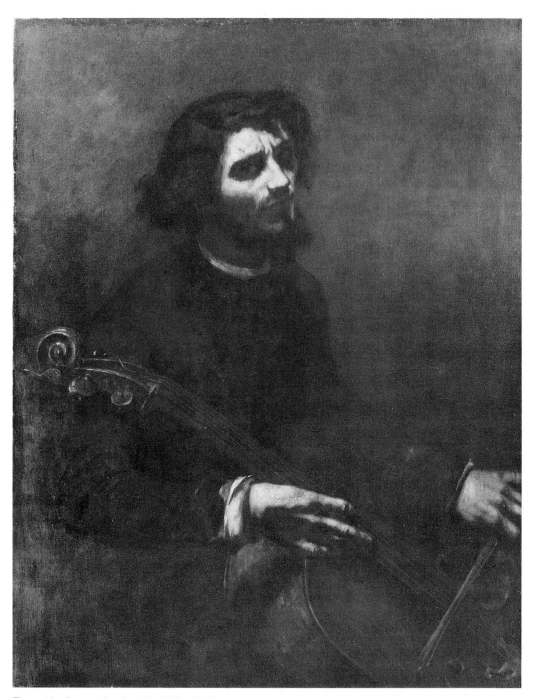

Figure 40. Gustave Courbet, *The Cellist,* 1847.

his right hand would have been wielding the bow and his left one depressing the strings—though he also appears to have gone on to infuse the central image of the right hand on the strings with a sculptural force and executive authority comparable to that of the right hand in the *Man with the Leather Belt*. In fact I attribute much of the discomfort that one feels before the *Cellist* not simply to the mirror-reversal of left and right but to the painter-beholder's attempt to override that reversal by identifying with the reversed image—making left into right—in a way uncharacteristic of his self-portraits.[19] (A similar reversal occurs in a drawing of the mid-1840s, the *Painter at His Easel* [fig. 45].)

Less problematically, in the *Wounded Man* (pl. 1) the protagonist's left hand loosely grasping a fold of his cloak is analogous to the painter-beholder's left hand holding his palette, while the sword just beyond his right shoulder, with which presumably he has been dueling, may be read as a substitute for the painter's brush or knife, and indirectly for his active right hand and arm. (Cf. the sitter's walking stick in *Courbet with a Black Dog*.) This suggests two further analogies: between the fictive sword thrust—the act of wounding and, perhaps, killing—to which both image and title allude and the constantly reiterated act of applying paint to canvas by which the painting was produced; and between the blood staining the sitter's white shirt and paint—pigment—as such.[20] The relationship between painting and violence these imply is amplified in a major canvas of the mid-1850s, the *Quarry*, one of three works I call allegories of realism and examine at length in chapter five, while the thematization of the material stuff of painting is carried furthest in another of those works, the *Wheat Sifters*.

Finally, though, the most nearly explicit of all the self-portraits in its relation to the act of depiction that produced it may be the *Sculptor*, which as I have noted represents an artist who has been making an image that we are also shown. The chisel in his left hand bears no resemblance to a palette, but his elevated right hand holding a mallet clearly dominates his left one in a manner that anticipates the central placement of the right hands in both the *Man with the Leather Belt* and the *Cellist*. The figure of the woman carved in relief into the bank just above the orifice from which water issues is without question his work; it thus can be taken as representing the painting as a whole, a reading that raises questions of gender (to be investigated in chapter six). But what I want to emphasize here is that the woman's position and orientation—lying on her back with her head nearer the picture surface than the mostly unde-

picted rest of her body—are in a general way consistent with what would have been those of the painter-beholder seated before his canvas. (The link suggested between sitting and lying down is confirmed by the poses of the sitters in the *Wounded Man, Country Siesta,* and the sketchbook page with Courbet asleep on a knapsack. It also helps explain one's sense of almost looking up at various of the self-portraits.)[21] In fact the woman's identity both as the product of the sculptor's labors and as only partly realized calls attention to the not quite detached or independent status of the various figures, animals, and objects that often accompany the personage of Courbet in the self-portraits. By now it won't seem surprising that I interpret that status as expressing a certain ambiguity in the painter-beholder's relation to the painting before him, into which on the one hand he labored to project himself—hence the self-portraits' metaphorics of possession—and the separate existence of which on the other hand he strove to undo—hence their metaphorics of merger, incompleteness, even disappearance.

# 3 Painter into Painting: *An After Dinner at Ornans* and *The Stonebreakers*

B ETWEEN THE winter of 1848–49 and the spring of 1850 Courbet painted four large multifigure pictures that mark simultaneously his accession to full artistic maturity and the advent of what he came to call Realism. (For the sake of convenience I shall refer to them as his *break-through* pictures.) Along with the *Painter's Studio* of 1854–55, these works constitute the core of Courbet's oeuvre, and any attempt, such as the present one, to reinterpret and reassess his enterprise can be held to succeed or fail largely on the strength of what it reveals about the break-through pictures both individually and as a group. The earliest of the four, *An After Dinner at Ornans,* dates from the winter of 1848–49; exhibited the following June in the unusually liberal Salon of 1849, it made a strong impression and helped win the young artist a second-class gold medal. (The award placed him *hors concours* in subsequent Salons and so spared him otherwise sure rejection by conservative juries in the years that followed.) Throughout the spring and summer of 1849 Cour-bet seems chiefly to have painted landscapes in the environs of Paris and elsewhere. Then in the fall of 1849, fresh from his success at the Salon, he returned to Ornans for a protracted visit and at once converted a house belonging to his family into a makeshift studio. Around Novem-ber of that year he painted the *Stonebreakers,* another milestone in his development, and immediately afterward began work on his most ambi-tious composition to date, *A Burial at Ornans.* The *Burial,* measuring roughly twenty-two feet wide by ten feet high and comprising more than forty life-size figures, occupied his energies throughout much of the spring of 1850. When it was done he went on to paint the last (and least impressive) of the breakthrough pictures, *The Peasants of Flagey Return-ing from the Fair.* In this chapter and the next I want to consider all these works in turn, in an attempt to show how, although they diverge greatly from the modest scale, narrowly personal focus, and somewhat idealizing

descriptive modality of the self-portraits of the 1840s, underlying and enabling that divergence is not a break with but rather a transformation of the pictorial and ontological strategies that inform Courbet's representations of himself from the first.

On the face of it, the subject matter of *An After Dinner at Ornans* (pl. 3) could hardly be more prosaic. Four men in rough country clothes are depicted sitting casually around a table following an afternoon meal. At the left, in profile, the painter's father, Eléonor-Régis Courbet, slumps in a chair, one leg crossed over the other, his left hand lightly holding a glass that rests on the tabletop, his right hand thrust deep into the pocket of his long jacket. He wears a peaked cap and at first seems almost asleep, but we soon become persuaded that he is listening to the personage on the extreme right, Courbet's musician friend Alphonse Promayet, play the violin. Immediately to the right of Courbet *père,* on the far side of the table, sits a bearded figure who traditionally was identified as Courbet himself, but who recently has come to be seen as another friend, Urbain Cuenot (a note in Courbet's handwriting in the register of Salon entries specifies that the setting is *chez notre ami Cuenot*).[1] Courbet or Cuenot— I accept the new identification—rests his head on his hand and gazes abstractedly toward Promayet as if engrossed in his playing. Almost directly above him a checked cap hangs from a mantelpiece. The next figure, Auguste Marlet (also a friend), has his back to the beholder, though because his body is turned somewhat toward the violinst we are given just a hint of his profile. He wears a broad-brimmed hat, is in the act of lighting his pipe, and, like his companions, conveys an impression of listening to the music. Promayet himself, seated slightly apart from the others, inclines his head in concentration over his instrument as he draws his bow across the strings. Beneath Marlet's chair a bulldog lies sleeping.

The *After Dinner* has always been dark, but its blacks have sunk and in many places it is today almost unreadable. But it remains deeply impressive for its harmony of browns, grays, whites, and blacks within a narrow but marvelously nuanced range of values; for its old-master-like combination of refinement of touch and breadth of effect; and for the conviction as of an independent reality, a life-size corner of the world rendered with perfect scrupulousness, that it continues to inspire. "Have you ever seen anything like it, anything so strong, with no dependence on anyone else?" Eugène Delacroix is reported by Francis Wey to have said. "There's an innovator, a revolutionary, too; he burst forth all of a sudden, without

precedent: he's an unknown."[2] Delacroix's excitement still seems appropriate.

Previous discussions of the *After Dinner* have emphasized its spread out, seemingly disjunctive (the technical term is "additive") mode of composition—T. J. Clark, for example, refers to the "deadpan spacing of the figures in a simple row of four"—and have connected it with several distinct sources in earlier art.[3] These include Rembrandt's *Supper at Emmaus* in the Louvre and Le Nain's *Peasants' Meal,* which may already have belonged to the famous collector Louis La Caze.[4] The Le Nain brothers were at this moment in the process of being rediscovered by Courbet's friend and future critical advocate Champfleury, and certain features of the *Peasants' Meal*—its subject and setting, its hushed monumental air, its additive composition, and of course its realism—have been seen as providing a striking precedent for the *After Dinner*.[5] Recently, however, Toussaint has queried the pertinence of both the Rembrandt and the Le Nain and has proposed instead that Courbet based his composition on that of Caravaggio's *Calling of Saint Matthew,* which she suggests he could have known indirectly through engravings or a drawing by an artist who had visited Rome.[6] (I regard this connection as improbable, though I am not at all convinced that Courbet had the *Supper at Emmaus* in mind or indeed was familiar with the *Peasants' Meal* in 1848–49.)[7] There is general agreement that the smoky chiaroscuro and overall facture of the *After Dinner* owe much to the example of Spanish masters such as Zurbarán and Velázquez. Finally, the *After Dinner* has been associated with two minor works by Courbet himself: the first a page from an early sketchbook depicting two figures at a table, the second a lost drawing of around 1848 of Courbet and two friends at the Brasserie Andler (more on both shortly).

Standard descriptions of even the most admired paintings by Courbet are often inattentive to what is going on within the frame, and those of the *After Dinner* are no exception. For example, it has never been observed that Courbet has taken extraordinary measures to assert the nearness to the beholder not only of the figures of Régis Courbet and Marlet, both of whom inhabit the picture's immediate foreground, but also of the image as a whole—even, I want to say, of the *painting* as a whole. Thus the near leg of the chair on which Régis Courbet sits actually touches the bottom framing-edge; the dog dozing beneath Marlet's seat seems on the verge of tumbling into our space; the one visible leg of the

table can be seen insinuating itself this side of Régis Courbet's feet; the figure of Cuenot isn't in the least diminished relative to that of the older man to his right (if anything the reverse), despite being situated further back in space; and, most remarkably, the checked cap hanging from the mantelpiece above Cuenot's head, which in order to allow room for the table and figures ought to be at some considerable distance from the picture surface, appears instead to approach and perhaps even coincide with that surface, as if between the farthest and nearest objects that meet our eye—the rear wall and the sleeping dog—there exists only the shallowest imaginable spatial corridor within which the entire contents of the painting are somehow compressed. Why and how has all this gone unremarked? In part because, as was earlier suggested, it has almost universally been assumed that realistic paintings are normative in essential respects, but also because the *After Dinner,* like the monumental canvases that follow it, doesn't make a point of its non-normativeness lest it undo what it aims to achieve. My readings of the breakthrough pictures, indeed of Courbet's paintings generally, will therefore often involve directing attention to features that, while plainly there to be seen—the hat hanging from the mantelpiece has hardly been kept out of sight—are also peculiarly inconspicuous.

Similarly, it hasn't been recognized that the pictorial organization of the *After Dinner* is a great deal more complex than appeals to the notion of additive composition would have us believe. Observe, to begin with, how from one figure to the next the painter has simultaneously alternated relatively near and far and varied both angle of access and bodily orientation. Starting at the left, we have Régis Courbet seated on the near side of the table and depicted in profile; then Cuenot on the far side, seen largely from the front while turning to his left; then Marlet on the near side of the table again, seen from the rear while turning to his right; and finally Promayet, seated slightly higher than the others and farther back in space than Marlet, viewed largely from the front but turned so as to face his companions with his left side, not, as is true of all the others, the right, nearest us. A comparable sequence of views—profile, frontal, rear—culminating in a fourth figure more or less facing the other three occurs in an illustration of a musical subject by Alcide Lorentz published in *Le Journal pour rire* in February 1848 (fig. 41), well in time to have helped shape the composition of Courbet's painting.[8] I suggest that Courbet found the basic structural idea for the *After Dinner* in Lorentz's memorable if comic image, though whether or not he did is irrelevant to

my claim that his painting is far more deliberately structured than has hitherto been appreciated. At the very least the affinity between the two images points up the measured, rhythmic character of the relations among the figures in Courbet's painting.[9] (As will be seen in chapter four, other images from the *Journal pour rire* caught Courbet's attention during these years.)[10]

But there is more than this to the composition of the *After Dinner.* Equally important is the fact that each of the four figures comprise several distinct axes—hence their somewhat semaphoric, almost stick-figure-like quality, which becomes more pronounced in the *Stonebreakers*—and that those axes have been arranged so as to repeat each other back and forth across the picture surface. For example, the forward tilt of Régis Courbet's head is parallel on the surface of the picture to the sideways lean of Cuenot's, and both are parallel to the broad brim of Marlet's hat and finally, approximately, to the angle at which Promayet's left leg crosses his right, as well as to the sideways and downward slant of the violin. Or consider the contrasting angle, grave rather than acute, of Régis Courbet's upper body, which has its parallels in Cuenot's left forearm, the gen-

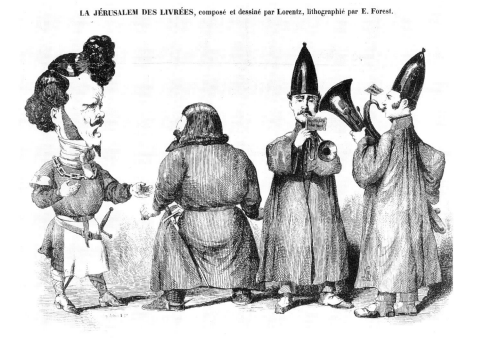

LA JÉRUSALEM DES LIVRÉES, composé et dessiné par Lorentz, lithographié par E. Forest.

Figure 41. Alcide Lorentz, *La Jérusalem des livrées,* lithograph by E. Forest, 1848.

eral vector of Marlet's right arm and shoulder, and the imaginary line connecting Promayet's hands. Now there is a sense in which these and other similar series of parallels and near parallels, with their rhyming of body parts (usually different parts) rather than entire bodies and their sharp divorce between orientation in depth and alignment on the picture surface, are in conflict with the systematic alternation and rotation of individual figures in volumetric space. In another sense, however, the superimposition of the two structural principles yields a more intensive and *consuming* mode of rhythmic connection than either alone could provide, even while their mutual independence serves to mask the active presence of each and hence contributes to the *After Dinner*'s seeming artlessness, its superbly authoritative *effet de réel*.[11]

An analogous and equally unremarked assertion of singleness and continuity over fragmentation and dispersal characterizes the *After Dinner*'s treatment of its theme. On the one hand, the actions and situation Courbet has chosen to depict—performing and listening to music around a table after a meal—may seem to indicate a concern with intensively subjective, in that sense private, states of mind. Thus the figure of Cuenot has struck viewers not only as listening intently to Promayet's playing but also as immersed in reverie; Régis Courbet appears all but overcome by somnolence and in any case is unself-conscious to the point of obliviousness; Marlet's face is mostly turned away from us, making his expression unreadable; and Promayet, the most active of the four men, lowers his deeply shadowed gaze and touches bow to violin in a manner that underscores the inward, concentrated, *hearkening* nature of his action, as if he were playing for himself alone. On the other hand, the manifestly absorptive character of the states of mind and body of all four figures has been exploited by the painter—in this regard the rhythmic relationships analyzed above have an immediate effect on the plane of "content"—to suggest an inner connection amounting virtually to an inner continuity from one figure to another, not excluding the bulldog. (That the bulldog can't be excluded is implied by the fact that the disposition of his body on the picture surface is also governed by the play of acute and grave axes.) Marlet's physically ingestive action of inhaling tobacco smoke underscores the corporeality of the thematics of absorption at work in the *After Dinner*, while here as elsewhere in Courbet's art the depiction of a figure mainly from the rear promotes a sense of the entire immersion of that figure in the world of the representation.

The distinctiveness of Courbet's treatment of absorption in the *After*

Figure 42. Amédée de Lemud, *Master Wolfram*, lithograph, 1838.

*Dinner* can be further brought out by comparing that painting with a work that I believe was in his mind both as a positive source and as a rival to be surpassed: Amédée de Lemud's large lithograph, *Master Wolfram* (1838; fig. 42).[12] This work, based on one of E. T. A. Hoffmann's lesser tales, *Der Kampf der Sänger,* represents the famous *Meistersinger* Wolfram von Eschenbach accompanying himself on the organ while five fellow musicians sitting or half-reclining behind him listen to his performance with an air of profound engrossment. Hoffmann was extremely popular at this time among writers in Courbet's circle such as Baudelaire and Champfleury; we know too that this particular print created a sensation when it was published, soon becoming a kind of talisman for Bohemian writers and artists.[13] We can therefore be sure that the young Courbet would have been familiar with it, and in several respects the relationship between Lemud's medievalizing and romantic image and Courbet's first full-blown Realist masterpiece is tantalizingly close.

There is in the first place a near identity of theme, absorption in music, as well as a general likeness of mise-en-scène. In addition, individual personages in the *After Dinner* may relate specifically to one or more figures in Lemud's print: compare, for example, the figures of Marlet and the

man in the plumed hat seen from the rear, or those of Cuenot and the man listening with chin in hand, or even the profile views of Régis Courbet and Wolfram. And in both works an enveloping chiaroscuro contributes powerfully to the absorptive effect of the whole. In the end, however, certain differences between the two images, apart from obvious ones of costume and setting, are what matter most. No one, I think, would be tempted to describe the arrangement of figures in the *Master Wolfram* as additive or egalitarian or based on mere juxtaposition (all notions that have been applied to the *After Dinner*). But by gathering the five listeners in a serpentine heap and at the same time conspicuously turning each away from all the others (Wolfram himself has his back to his audience), Lemud has succeeded in intimating that each is lost in his own thoughts and feelings—that although all are deeply moved by Wolfram's music, their respective states of mind and/or trains of thought bear no relation to one another. In contrast, the four personages in the *After Dinner* appear joined together in a single psychophysical continuum, one with an almost palpable temporal duration and the limits of which are

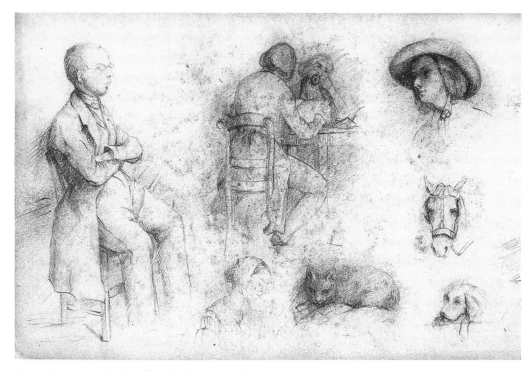

Figure 43.  Gustave Courbet, *Sketchbook Page,* early 1840s.

felt to be coextensive with (or for that matter to exceed) those of the painting itself. The result, in this respect as in others, is a mode of unification that couldn't be more alien to the conception of pictorial unity belonging to the dramatic tradition I began this book by sketching.

Earlier I remarked that two drawings by Courbet have been mentioned in connection with the *After Dinner*. The first is a page from a sketchbook of the early 1840s on which has been depicted, among other images, a scene of two men seated across from each other at a table (fig. 43).[14] (Also on the page is a portrait drawing of the young Courbet, which may subsequently have been a source for his depiction of himself in *Courbet with a Black Dog*.)[15] The near figure has his back to us as he reads a book, while his tablemate leans his head on his fist and gazes off into space as if in reverie or meditation—a conjunction that anticipates, albeit no more than approximately, the figures of Marlet and Cuenot in the later painting. (The relation between the two figures in the sketch is also not unlike that between the man in the plumed hat and his neighbor with chin in hand in the *Master Wolfram*, and of course it's possible that the youthful draughtsman of the sketchbook was already familiar with Lemud's lithograph.)

The second and more important drawing is a finished work of around 1848 representing three men—from left to right, the philosophers Marc Trapadoux and Jean Wallon and Courbet himself—seated around a table at the Brasserie Andler, a simple German-style tavern, located just a few doors from the artist's studio, which became his informal headquarters at about this time (fig. 44).[16] Exactly what is taking place is far from clear: Trapadoux, a bearded giant in a top hat, leans forward aggressively and gazes at Courbet, who, elegantly dressed, appears to be looking out toward the beholder as he rests his right hand palm up on the table. The third figure, Wallon, sits hunched and smoking a pipe between the others, while in the background to the left a woman (the proprietress, Mme. Andler?) reads behind a counter. The overall mood of the drawing, finally indecipherable, differs sharply from that of the *After Dinner:* neither Trapadoux's urgency, Courbet's refinement, nor Wallon's brooding finds an echo in the painting. Nevertheless, a broad affinity between the two works extends even to the depiction in each of a hat hanging on a wall. In particular the relationship between Trapadoux and Courbet in the one can be seen as a rough draft for that between Cuenot and Promayet in the other. (The association of the figure of Promayet with prior images of the painter will be reinforced shortly.) At the same time, the portrayal

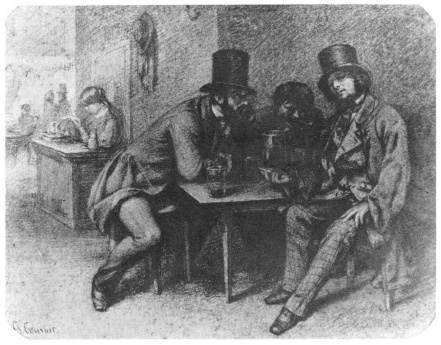

Figure 44. Gustave Courbet, *Brasserie Andler,* drawing, ca. 1848.

of Courbet in the drawing—I am thinking especially of the characteristic tilt of the head—bears, despite obvious differences of age, attitude, and dress, a resemblance of sorts to the second figure from the left, whom we have been calling Cuenot, in the *After Dinner.*

There also appears to be a connection between the two drawings themselves. Courbet's presentation of his features in the scene at the Brasserie Andler has been derived, either directly or via his image in *Courbet with a Black Dog,* from the self-portrait vignette in the upper right corner of the sketchbook page (hence the surprising and anachronistic youthfulness of his image in the former), and it is even possible, given Courbet's obsessive use and reuse of his own previous work, that the image of Trapadoux with his right leg bent back alongside his chair is distantly related to that of the man reading in the early drawing.

Three additional self-portraits throw further light on the genesis and meaning of the *After Dinner.* The first, already familiar to us, is the strongly shaded pencil drawing of the youthful Courbet asleep with pipe in mouth and head pillowed on a knapsack that comes from the same

early sketchbook that contains the drawing of the two men at a table (fig. 38). I have already discussed this image at some length and here wish merely to observe that it can be related not only to the figure of Cuenot in the *After Dinner* but also to the somnolence of Courbet *père* and, for that matter, to the action of Marlet lighting his pipe. (Note too the play of acute and grave axes among the images on the sketchbook page, a structural feature that looks forward to both the *After Dinner* and, as we shall see, the *Stonebreakers*.)

The second work I want to add to our cluster of internal sources for the *After Dinner* is a highly finished charcoal drawing in the Fogg Art Museum of Courbet at his easel (1847; fig. 45). I suggest that this served as a principal model for the figure of Courbet in the Brasserie Andler drawing (note especially the similarity between right hands, between the positions of the legs, even between the checked trousers Courbet wears in each) as well as, shortly thereafter, for the figure of Promayet in the *After Dinner* (the mirror reversal of right and left hands in the Fogg self-portrait now corrected, the right hand made active, by the mechanics of playing the violin, and the position of the legs perhaps closer to the *Painter at His Easel* than to the figure of Courbet in the Brasserie Andler drawing).[17]

Last of all, there is the strange early picture known as *The Draughts Players* (1844; fig. 46) in which two young men, one in contemporary dress and the other in medieval costume, are shown seated at a table in an artist's studio convivially playing a game of draughts. Three points especially deserve our attention: first, the setting and circumstances of the *Draughts Players* are not unrelated to those of the *After Dinner;* second, the figure on the left, with his broad-brimmed hat, long-stemmed clay pipe, and back partly turned to the beholder, has much in common with the figure of Marlet in the later canvas; and third, the figure on the right holds a glass of beer in his right hand in a manner that anticipates without exactly resembling the action of the elder Courbet's left hand as he slumps in his chair listening to the music and perhaps dozing. (When this last is taken in, there emerges also a similarity between their respective profile views and jutting elbows.) But the full complexity of the connection between the two paintings becomes apparent only when it is recognized that while the figure on the right in the *Draughts Players* is unmistakably a self-portrait, the figure on the left, although not at all like Courbet facially, may also be considered to represent the painter by virtue

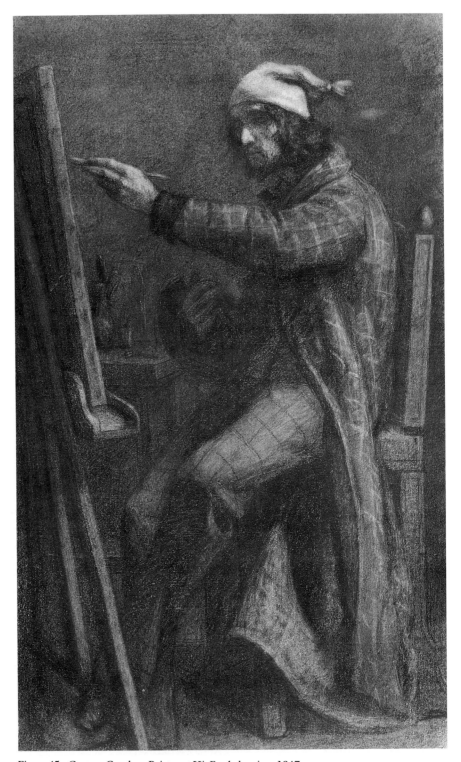

Figure 45. Gustave Courbet, *Painter at His Easel*, drawing, 1847.

of the orientation of his right arm and hand (more or less matching that of the painter stationed before the canvas), the way he holds his pipe (roughly as one might hold a paintbrush and as the sitter in *Courbet with a Black Dog* holds *his* pipe), and the similarity between his costume and that worn in many of the early self-portraits.[18]

What we have in the *Draughts Players,* in other words, is a sort of double self-portrait, which moreover contains significant precedents for two of the figures in the *After Dinner.*[19] (It's as though Courbet began by portraying himself in medieval costume playing draughts with a conventionally attired friend, but soon came to identify with *both* figures in an effort to project his conviction of his embodiedness into the painting as a whole.) And if we now put this finding together with the other connections we have drawn, we arrive at the striking conclusion that *all four figures* in the *After Dinner* have been adapted from or at any rate were

Figure 46.  Gustave Courbet, *The Draughts Players,* 1844.

significantly anticipated by *previous images of the painter.* They are all, one might say, "originally" self-portraits in their own right—an observation that confers new meaning on my earlier suggestion that all four figures may be seen as inwardly linked, indeed as inwardly continuous. In fact the crucial personage in the *After Dinner,* the one who bears the closest, most overdetermined relation to the painter-beholder, isn't Cuenot, who sufficiently resembles the Courbet of the early self-portraits that until recently he was identified as the latter, but Marlet. That is, we have seen in chapter two how in Courbet's self-portraits of the 1840s the painter-beholder strove again and again to transport himself as if corporeally into the painting before him in order both to express his sense of his own embodiedness and to negate or neutralize his status as first beholder of that painting, a pictorially and ontologically remarkable project that generated representations of the sitter in extreme proximity to the picture surface, his bodily orientation aligned to a greater or lesser degree with that of the painter-beholder, and metaphorically if not literally in the act of painting. Viewed in this light, the figure of Marlet seated in the immediate foreground and near the middle of the *After Dinner,* his back turned toward us and his raised right arm angled into the picture, offers a particularly close analog to what must have been the position, orientation, and action of the not quite thirty-year-old Courbet as he sat before his large canvas—so Francis Wey describes him[20]—laboring, in an obscurity that was soon to end, to produce the painting that is today in the Musée des Beaux-Arts in Lille.

Finally, though, it would be a mistake to place too great an emphasis on the figure of Marlet. For there is an important sense in which the basis of Courbet's breakthrough paintings was, first, his disappearance from them *in propria persona* and, second, the replacement of his literal image by a multiplicity of metaphorical or otherwise nonliteral self-representations, all of which moreover tended to be evenly distributed across the pictorial field. (It's that multiplicity and more or less even distribution of self-representations that then led to the oversimple characterization of Courbet's Realist compositions as additive.) Indeed it can be argued that the painter-beholder of the *After Dinner,* being in effect dispersed throughout that field in figures none of which literally portray his features, is more radically "removed" from before the painting than in the case of the self-portraits, each of which, no matter how ingenious its construction, inevitably raises the question of its relation to the painter-beholder who was at once its subject and its maker. Courbet's statement

in the Salon registry of the subject of the *After Dinner* is particularly suggestive in this connection. "It was the month of November," the notice reads; "we were at our friend Cuenot's, Marlet returned from the hunt and we had engaged Promayet to play the violin before my father."[21] Four persons are mentioned specifically, which is partly why it has seemed likely that the bearded figure represents Cuenot and not Courbet. But Courbet's use of the pronoun "we" leaves open the possibility that he is present in the painting along with the others.

WE HAPPEN to know more about the circumstances that led to the painting of *The Stonebreakers* (1849; fig. 47) than about those pertaining to any other of the great pictures of 1848–50. Toward the end of November 1849, Courbet wrote from Ornans to Wey and his wife:

I had taken our carriage and was driving on the way to the Château at Saint-Denis to paint a landscape; near Maisières, I stopped to consider two men breaking stones on the highway. It's rare to meet the most complete expression

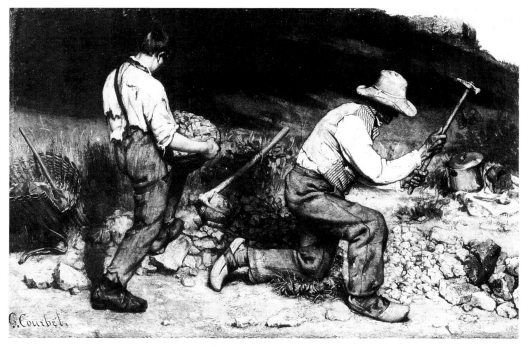

Figure 47. Gustave Courbet, *The Stonebreakers*, 1849.

of poverty, so an idea for a painting came to me on the spot. I made an appointment with them at my studio for the next day, and since then I've been working on the painting. It's the same size as the *Evening at Ornans* [i.e., the *After Dinner*]. Would you like me to give you a description? Over there is an old man of seventy, bent over his task, sledgehammer in air, his skin tanned by the sun, his head shaded by a straw hat; his trousers of rough material are all patched; and in his cracked sabots, stockings that were once blue show his bare heels. Here is a young man with dusty head and swarthy skin; his back and arms show through the holes in his filthy tattered shirt; one leather suspender holds up the remnant of his trousers, and his leather boots, caked with mud, gape dismally in many places. The old man is kneeling, the young man is behind him, standing, bearing energetically a basket of broken rock. Alas, in these circumstances, one begins like this, one ends the same way. Scattered here and there is their gear: a basket, a stretcher, a hoe, a lunch pail, etc. All this takes place in the blazing sun, at the edge of a highway ditch: the landscape fills the canvas.[22]

Courbet seems to have proceeded by making individual studies for the two figures (at any rate, there survives a study for the old man) as well as an oil sketch of the entire composition (fig 48).[23] The final painting, formerly in Dresden and destroyed in World War II, not only was much larger than the oil sketch—as in the *After Dinner*, the figures appear to have been life-size—but departed significantly from it by reversing the direction of the composition so that the figures faced from left to right. Other changes made between sketch and painting include widening the interval between the two figures, reducing the proportion of the canvas given over to the landscape (the upper sixth of the original composition was eliminated), emphasizing the material reality of the figures and in general distinguishing them more sharply from their setting, and introducing the wicker basket and long handle to the left of the young man and the lunch pail and spoon to the right of the old one. In addition, seemingly a minor point, the artist's signature was shifted from the lower right to the lower left.

With one exception, commentators on the *Stonebreakers* haven't come up with sources for either figure or the composition as a whole.[24] It is, however, widely recognized that the *Stonebreakers* was preceded in the 1830s and 1840s by various representations of manual labor by artists such as Philippe-Auguste Jeanron and the Leleux brothers; and it is virtually a cliché to try to bring out the distinctiveness of Courbet's Realism by contrasting the *Stonebreakers* with one or another of Millet's paintings of peasant life of the 1850s and 1860s.[25] On the level of formal or stylistic analysis, Meyer Schapiro has emphasized the "earnest, empirical" char-

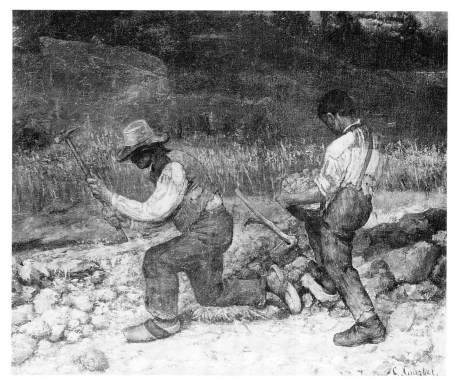

Figure 48. Gustave Courbet, *The Stonebreakers,* oil sketch, 1849.

acter of the drawing of the two figures—"as if [Courbet] were tracing a complicated shape for the first time"—and has drawn attention to the way in which the torn and battered garments thus painstakingly depicted not only fail to reveal but actually mask the underlying construction of the human body.[26] As for the composition, it has been viewed as even more starkly additive than that of the *After Dinner,* the old man and the young one supposedly having been set down alongside one another in their specificity and concreteness, with no gestural or narrative connection between them, indeed with nothing to qualify the flat assertion of their brute physical existence.[27] Finally, writers on the *Stonebreakers* have been impressed from early on by its singular absence of pathos, in which Clark finds evidence that the painter recognized his own class-determined "radical incomprehension" of the psychology of the two men on the road near Maisières and so refrained from imposing on them a "conventional bourgeois reading [of their situation] in terms of a personal tragedy or a generalized, but 'individual,' dignity of labour."[28] (I shall return to Clark's account in chapter seven.)

Most of these are useful observations, and a few, notably Schapiro's

and Clark's, are also provocative. As will become clear, however, the *Stonebreakers,* like the *After Dinner* before it, is far more complex—structurally, thematically, above all with respect to its relation to the painter-beholder—than has been appreciated. Take for example the matter of the apparent proximity of the figures to the surface of the painting. It isn't unheard of for commentators on the *Stonebreakers* to acknowledge this aspect of its structure, so much more perspicuous than in the *After Dinner* because of the character of the illumination and because the hillside rising sharply beyond the two laborers in the final version all but thrusts them into the immediate foreground.[29] But that assertion of nearness has mostly been construed as expressing the artist's desire to present as directly and inescapably as possible the human and material reality of his subject; and such a construal, while not exactly mistaken, ignores the connection between the treatment of nearness in the *Stonebreakers* and the consistent exploitation of it as a vehicle of relationship between painting and painter-beholder in the self-portraits of the 1840s and, of course, in the *After Dinner* as well.

Or consider the fact, which again has not gone unremarked, that the faces of the two laborers are concealed from view: the young man's because it is mostly turned away from us, the old man's because it is cut off below the eyes by the wide brim of his straw hat and then further obscured by the dark shadow cast by that brim. (The high, stiff collar of his tattered vest plays a role in this too.) What are we to make of so eccentric a choice of aspect, and how can it be squared with an alleged concern with directness and immediacy? Is it enough to say that by refusing to show us the two personages' faces the painter has underscored the anonymity—and, Clark would add, the alienness to a bourgeois observer such as Courbet was—of ceaseless backbreaking labor at the bottom of the social scale? Or is it also necessary, as I believe it is, to connect the peculiar facelessness of the stonebreakers with that of Marlet in the *After Dinner* and more broadly with the tendency throughout the early self-portraits to depict the sitter in some measure from the rear?

As in the case of the *After Dinner,* a critique of the notion of additive composition leads quickly to more profound matters. The traditional view, in its most developed form, holds that the two stonebreakers are simply and baldly juxtaposed, placed next to each other without linkage of any sort, and that the effect of this arrangement, even more than in the *After Dinner,* is to emphasize the isolation and self-sufficiency, the pictorial and ontological completeness, of each.[30] And what I want to argue is

that while such a view responds to certain of the *Stonebreakers'* manifest features, above all its eschewal of traditional compositional strategies, it also oversimplifies the issue of structure and by so doing closes the painting to further understanding.

In my analysis of the *After Dinner,* I called attention to the superimposition of two mutually independent structural systems and observed that the particular rhythmic connectedness produced by their interaction has a thematic equivalent in the treatment of absorption in music. Compared with the *After Dinner,* the *Stonebreakers*—a representation, it should be noted, of absorption in work—may seem too simple and stripped down, one might say too minimal, to support a comparable analysis, and in fact the later painting lacks the sheer density of rhythmic relations that makes the earlier one unique in Courbet's oeuvre. Nonetheless, the *Stonebreakers* shares with its darkly splendid predecessor a highly idiosyncratic structural principle: the play of acute versus grave axes within an implicit lateral progression across the surface of the picture (in both cases from left to right). In the *After Dinner,* the progression is merely implicit, a function of the direction of gazes, of the "drift" of acute axes across the pictorial field, and of our awareness that the source of the music is toward the right; and it is countered (though hardly neutralized) by a secondary progression from right to left, the actual vector of the music, suggested by the "drift" of grave axes across the same expanse. At first glance, lateral progression in the *Stonebreakers* seems a simple matter—there are just two figures, both of whom appear to be moving toward the right—but a longer look reveals a more intricate state of affairs.

For one thing, neither figure is shown unequivocally in motion: the old man is kneeling on a bit of turf and so can be going nowhere, while the attitude of the young man may be read as indicating either that he is moving from left to right, striding away from us into the painting, or that he is pausing for a moment with the pannier of stones on his knee.[31] The last of these possibilities is reinforced by the backward or grave lean of his upper back, which itself is seconded (anticipated?) by the even sharper slant of the long handle that protrudes from the wicker basket in the weeds to his left. Immediately to his right, however, and, like the basket and handle to his left, further back in space, a prominent hoe at once repeats the angle of his head, suggests a trajectory for his interrupted stride, and prepares us for the left-to-right alignment and forward or acute inclination of the upper body of the old stonebreaker, whose raised hammer makes still another acute axis—one whose precise angle

of inclination (more vertical than that of the hoe, roughly parallel to that of the older man's upper body) helps create the impression that the hammer is poised motionlessly above the darkish stone on which it is about to fall. (Observe, however, that the effect of this delicately calibrated treatment of the blow about to be struck is not at all one of instantaneousness or for that matter of deliberation but rather one of repetition and automaticity. Thus Max Buchon in 1850 described the older man as "raising a hammer with all the automatic precision that comes with an old habit [*une longue habitude*]," a notion—that of habit—that will become important later in this book.)[32] Finally, to the old man's right and once again removed from the vicinity of the picture plane, the lunch pail, spoon, and loaf of bread (?) on a cloth napkin bring the progression to a halt, in part by means of the slight backward tilt of the shining pail (but note the slight forward tilt of the stone about to be struck). Just how carefully the painter must have calculated these and other such relationships is suggested by the fact that the oil sketch of the composition contains only one accessory, the hoe lying between the figures, and that altogether the interweaving of axes, intervals, and relations in depth is far less developed there than in the final painting.

I don't wish to overstate the similarity between the *Stonebreakers* and the *After Dinner.* The space-evoking chiaroscuro and smoky, palpable atmosphere of the earlier work are absent from the later one and never quite reappear in Courbet's art. Then too the embedding of the figures of the two laborers in the strictly surface organization of the *Stonebreakers* has been carried further—articulated more schematically—than in the *After Dinner,* with the somewhat paradoxical result that the figures in question, although engaged in a common task, seem more nearly self-absorbed than any in the earlier painting. (The play of multiple axes within each of the two figures is so intensive as to be all but self-canceling, which partly accounts for the impression of self-sufficiency mentioned above.) Nevertheless, the composition of the *Stonebreakers* emerges from our discussion as closer to that of the *After Dinner* than seemed possible on first viewing. And if we go on to compare certain aspects of the rendering of the figures in both paintings, the connection is seen to be closer still.

The personages in the *After Dinner* who most significantly anticipate those in the *Stonebreakers* are Régis Courbet and Marlet: Régis Courbet by virtue of being depicted in profile (cf. the old stonebreaker) and of the backward lean of his upper body conjoined with the forward inclination

of his head (cf. the young stonebreaker); and Marlet by virtue of being presented largely from the rear (cf. the young stonebreaker) and of his broad-brimmed hat and raised right arm and hand (cf. the old one). The affiliation between one pair of figures and the other is thus a matter not of simple correspondence but of combination and cross-reference, with Marlet rather than the elder Courbet the more important "original" if only because his facelessness is thematized in the later painting. Indeed I have suggested that the obscuring of faces in the *Stonebreakers* bears an obvious relation to the orienting of Marlet's body in the *After Dinner.* And this, together with my present observations, leads to the further suggestion that *both* stonebreakers, the old man *and* the young one, share something of the deeply motivated, quasi-corporeal connection with the painter-beholder that I have attributed not only to the figure of Marlet in the first of the breakthrough paintings but also to that of Courbet himself viewed to a greater or lesser extent from the rear in a number of the self-portraits of the 1840s.

The next step in my argument looks back specifically to those self-portraits that contain displaced or metaphorical representations of the painter-beholder's hands engaged in the act of painting (e.g., the *Man with the Leather Belt*). I propose that the figures of the old stonebreaker and his young counterpart may be seen as representing the painter-beholder's *right and left hands respectively:* the first wielding a shafted implement that bears a distant analogy to a paintbrush or palette knife, the second supporting a roundish object that might be likened to the (admittedly much lighter) burden of a palette. Viewed in these terms, the decision to reverse the composition of the oil sketch turns out to have been critical, the preliminary right-to-left arrangement tending to run the two figures together, misaligning those figures with the painter-beholder's right and left hands, and altogether containing no more than the germ of the metaphorical representation of the painter-beholder at work on his painting that we find in the final version of the *Stonebreakers.* Or perhaps what the *Stonebreakers* metaphorically represents is not the painter-beholder himself but *specifically* his hands: as though its implied perspective is ultimately that of the drawing of Courbet's left hand portrayed from the point of view of his body in the sketchbook page we looked at briefly in chapter two (fig. 38). (Note how the angle at which the young stonebreaker stands relative to the picture plane matches that of the left hand in the early drawing.)[33]

All this may seem to go quite far, but there is still more that can be

said. Toward the beginning of my discussion of the *Stonebreakers,* I remarked that among the changes made between the oil sketch and the final painting was the shift of the artist's signature from the lower right to the lower left corner of the canvas. This in itself may not be important, but focusing on the signature helps bring out certain correspondences between its form or structure (fig. 49) and what I have tried to show is the rhythmic composition of the final version. In the first place, both involve a progression from left to right with backward leanings, though plainly the strength of those leanings in the signature is greater than in the painting as a whole. (The *After Dinner* more nearly resembles the signature in this regard.) Moreover, the graphic essence of Courbet's signature—a succession of detached, carefully delineated letters constituting a single signifying entity—is formally analogous to the seemingly merely additive but in fact continuous and integral structure of both the *After Dinner* and the *Stonebreakers.* But of course we aren't dealing here with just any signifying entity. The proper noun "G. Courbet" is still another representation of the painter-beholder. And this makes all the more compelling a simultaneously phonic and visual analogy, which Courbet couldn't consciously have intended, between the figures of the old man and the youth, both of whom (or both together) I have characterized in those terms, and *Courbet's name,* which turns up in barely disguised form at a vital juncture in his letter to Wey. "Là est un vieillard de soixante et dix ans," Courbet writes, "*courbé* sur son travail" (emphasis added).[34] The old stonebreaker is in fact depicted stooping over his task, and for that matter the young stonebreaker is shown with head bent forward as well, which suggests that in this regard also the two figures may be read as representing the painter-beholder, or at any rate as representing in a pictorial rebus that privileged representation of the painter-beholder, his proper name.[35]

Figure 49.  Gustave Courbet, *The Stonebreakers,* detail of signature.

In this connection I want to pursue a speculation drawn from Jacques Derrida and Geoffrey Hartman that an artist may be productively if unconsciously *in conflict* with his own name, in this case with the name "Courbet," the homonym of which has connotations that, applied to himself, the notoriously proud painter can only have found derisive. Thus we might describe the *Stonebreakers* as the scene of a psychomachy in which those connotations are simultaneously allowed expression, in the postures of the two figures, and mastered, not only by the act of painting but also by the metaphorical image of the painter-beholder's right and left hands at work on the picture, and perhaps by another image that I shall come to in a moment. That Courbet at least later actually was aware of such connotations is shown by a letter he wrote to Victor Hugo in 1864 which begins: "Dear and Great Poet, As you've said, I have the fierce independence of the mountain-born. I think one could boldly put on my tomb, in the words of our friend Buchon, *Courbet without Courbettes* [bowing and scraping]."[36] We know too that as early as 1855 rebuses on Courbet's name appeared in the popular press, as well as the punning sentence, "Courbet bows his head only before Courbet"— *Courbet ne courbe la tête que devant Courbet.*[37] The sentence is intriguing: figures with bent heads such as the young stonebreaker occur frequently in Courbet's art, and it often happens that the same figures—the young stonebreaker is a case in point—are also backward-leaning (i.e., anything but *courbé* in their overall posture), which suggests that the psychomachy I detect in the *Stonebreakers* is perhaps in play throughout Courbet's oeuvre. I shall touch on this again in chapter seven in discussing a painting that I see as resolving that psychomachy in terms even more (unconsciously) gratifying to the artist.

And a related proposal. I have characterized the figures of the two stonebreakers as a metaphorical representation of the painter-beholder's hands at work on the painting. Now I want to raise the possibility that they may also be understood as governed by a very different though ultimately equivalent schema, namely *the painter-beholder's initials, the first letters of Courbet's Christian and family names,* as those letters have been delineated by him in this and other roughly contemporary paintings and drawings. Thus the young man resting the pannier of stones on his knee can be seen as a fleshing out of the backward-leaning but forward-bending "G," while the old man about to strike a blow with his hammer, although by no means simply describing the letter "C," nevertheless hints

at that letter within his own more complex configuration. (The possibility of such a reading goes back to the decision to reverse the composition of the preliminary oil sketch and so accept the directional logic of the signature as basic to the painting as a whole.) Extending the argument of the previous paragraph, the image of Courbet's initials might then be thought of as simultaneously glorifying his proper name and evacuating its phonic substance and therewith the latter's derisive connotations.[38] If these last suggestions appear extreme, I would simply observe that from the mid-1840s on Courbet seems to have been fascinated by his signature—by the convention that called for him to affix that further, supplementary, representation of himself to the products of his art. (He almost always did so in carnal red, in letters that have an obdurate corporeality of their own: the signature in Courbet's paintings and drawings is never merely a verbal signifier.) The *Burial at Ornans,* for example, to which he turned immediately after finishing the *Stonebreakers,* originally bore in its lower left corner a gigantic signature only traces of which remain;[39] while the curiously dilated "G. C." in still another self-portrait drawing of the mid-1840s (fig. 50) may be a first step toward the large-scale fusion of initials and realistic representation that hovers as if fantasmatically before our eyes in photographs of the destroyed *Stonebreakers.*

Finally, two general observations. The first is that the impression of protracted and/or repetitive temporality that marks both the *After Dinner* and the *Stonebreakers* is characteristic of Courbet's art throughout his career. In a sense this had always been one of the hallmarks of absorptive painting (we find it in both Chardin and Millet), but in the case of Courbet it will increasingly become plain not only that time is required for his paintings to be made to yield their structures and meanings but also that those structures and meanings in turn imply—they all but enforce—an experience of temporal duration.[40] An experience of duration is also strongly posited by Courbet's version of dark-ground painting, with its implicit temporal metaphorics of light emerging from darkness and form from formlessness:[41] indeed some paintings in which that technique is most in evidence, notably certain landscapes of forest scenes, allow their representational content to be fully made out only gradually, in and through acts of attention, of reading, that need time to achieve their ends. (There may be no *slower* picture in all Western art than the magnificent *Stream of the Black Well, Valley of the Loue (Doubs)* in Washington D.C. [fig. 111].) The full implications of all this will emerge as we proceed.

The second observation is that both the *After Dinner* and the *Stone-breakers* invite a kind of attention that in important respects has more in common with listening to than with looking at. This is most evident in the *After Dinner* by virtue of its evocation of absorption in music, but the

Figure 50.  Gustave Courbet, *Portrait of the Artist with a Pipe*, drawing, mid-1840s.

*Stonebreakers* at least suggests the sound of the older man's hammer striking stones, and, as we shall see, many other paintings by Courbet, including the *Burial at Ornans* and the *Quarry* as well as pictures of favorite subjects such as the Source of the Loue and breaking waves, must also be imagined filled with sound. (This is true of the *Stream of the Black Well* mentioned above.) All those paintings are of course *literally* silent, and it remains an open question whether the imagination of sound or the experience of silence is more important to their overall effect.[42]

# 4   The Structure of Beholding in
## *A Burial at Ornans*

IN THIS chapter I want to continue my reading of Courbet's break-through pictures by analyzing intensively what I think of as the structure of beholding in the monumental *A Burial at Ornans* (1849–50; pls. 4, 5), and then by commenting briefly on both the *Peasants of Flagey* (1850) and the unfinished, or rather abandoned, *Firemen Rushing to a Fire* (1851). (In the register of entries for the Salon of 1850–51, Courbet gave the *Burial* the title *Tableau de figures humaines, historique d'un enterrement à Ornans,* a formulation that proves, if there were any doubt, just how great were his ambitions in that canvas.)[1] As in the previous chapters, I shall be concerned primarily with the strategies by which Courbet's paintings seek to establish a particular relationship, antitheatrical in essence, between themselves and at least one beholder, whom I have been calling the painter-beholder. And as before, my attempt to reconstruct those strategies will involve bringing to light various affinities between the paintings that are the focus of this chapter and previous works by Courbet, including now the *After Dinner* and the *Stonebreakers,* as well as assigning significance to features of the *Burial* that either have never been remarked or have not been made matter for reflection: to cite just a few, the serpentine path followed by the mourners, the slightly skewed orientation of the open grave, and the exact location within the composition of Courbet's closest friend, Max Buchon.

The subject of the *Burial* is a graveside funeral in the new cemetery at Ornans, which had been in use only since September 1848.[2] Eventually we shall have to consider exactly what is going on, but at present it will do to say that the painting depicts a moment shortly before the start of the ceremony proper: the curé, crucifix-bearer, beadles, choirboys, and a few leading citizens have reached their appointed stations (the curé appears to be finding his place in the prayer book) while the pallbearers seem still to be approaching from the left (though they too may just have

come to a halt) and the rest of the mourners walk slowly in a serpentine progression toward the open grave. Because Courbet's maternal grandfather Oudot, a veteran of the Revolutionary wars and a man he greatly admired, had died in August 1848, the suggestion has been made that it is his interment that the painting commemorates.[3] More recently, Claudette Mainzer has argued, persuasively in my view, that the funeral is most likely that of Courbet's granduncle Claude-Etienne Teste, the first person buried in the new cemetery,[4] though of course it's possible that Courbet had no particular death in mind. What can be specified with certainty are the identities of many of the mourners and officiants: for the purposes of this chapter I need mention only that the hatless figure at the extreme left is the recently deceased Oudot; that the next hatless figure we encounter is Buchon; that the two figures in breeches to the right of the grave are also veterans of 1793; and that among the other mourners are Courbet's father, mother, and three sisters as well as various friends, including Cuenot, Marlet, and Promayet (all of whom appeared in the *After Dinner*). In the distance, to quote Jack Lindsay, "run level lines of cliffs characteristic of the area, the Roche du Mont and the Roche du Château, with a gap over the priest and beadles into which the staff of the Cross reaches. A dull heavy sky weighs down over all."[5] The landscape setting thus complements the proceedings, and I shall soon be suggesting that the relationship between the two is even closer than has been supposed.

Something too should be said at the outset about the overall stylistic character of the *Burial* as perceived by generations of historians. Briefly, those who have written about this most discussed of all Courbet's pictures have emphasized its aspect of brute material presence both as representation and as artifact. In the words of two recent commentators, Charles Rosen and Henri Zerner, the viewer of the *Burial* "is entirely occupied by the aggressive presence of the personages—paralleled, mediated, and guaranteed by the aggressive presence of the paint. A genre scene is raised, by this aggression and by the life size of the figures, to the dignity of a history painting."[6] In a similar vein, Linda Nochlin has described the breakthrough pictures as lacking all suggestion of "beyondness," that is, as "imply[ing] nothing in formal terms beyond the mere fact of the physical existence of the [personages] and their existence as painted elements on the canvas."[7] And T. J. Clark has drawn attention to the way in which, toward the right of the *Burial*, Courbet "has let the

mass of mourners congeal into a solid wall of black pigment, against which the face of the mayor's daughter and the handkerchief which covers his sister Zoë's face register as tenuous, almost tragic interruptions."[8] Meyer Schapiro for his part long ago seconded those early critics who saw a kind of primitivism in the breakthrough pictures' emphasis on bodies over space and eschewal of traditional modes of composition.[9] And of course it can be argued that the *Burial*'s claim on our attention is further underscored (Rosen and Zerner might say it is made all the more aggressive) by the crowding of so many life-size figures—actually they are scaled slightly larger than life, the nearer of the two veterans of 1793 standing more than seven feet tall—into a spatial arena that, despite its monumental dimensions, seems barely adequate to contain them.

Implicit in all these observations is a notion of confrontation we may gloss by saying that whereas all paintings naturally (i.e., conventionally) face their beholders, the *Burial* has consistently been seen as facing *its* beholders with a vengeance—massively, conspicuously, overwhelmingly. And yet, as I shall try to show, that perception turns out to require radical revision (by which I don't mean simple repudiation) once we have come to terms with the structure of beholding that animates this extraordinarily sophisticated work. Rather than broach that topic directly, however, I want to begin by summarizing four cruxes that have been the focus of previous commentaries on the *Burial*. I shall then conduct my own analysis, touching as I go on each of those cruxes, the aim of which will be not only to bring to light—almost literally to reenact—the *Burial*'s engagement with the issue of beholding but also to consider the implications of that engagement for our understanding of Courbet's enterprise at a vital juncture in his career.

1. Like the *After Dinner* and the *Stonebreakers,* the *Burial* has traditionally been described as exemplifying an additive mode of composition, one based on mere juxtaposition, the placement alongside one another of discrete, self-sufficient entities with no rhythmic, gestural, or other formal or expressive connection between them. Such a mode of composition is by definition antihierarchical—in an extreme form it would give equal emphasis to all portions of the canvas—and Nochlin for one hasn't hesitated to associate what she calls Courbet's "compositional *égalitarisme*" and "pictorial democracy" with analogous tendencies in progressive social thought in the years around 1848.[10] There is also in Nochlin the suggestion (recalling Roman Jakobson's contention that realist art privi-

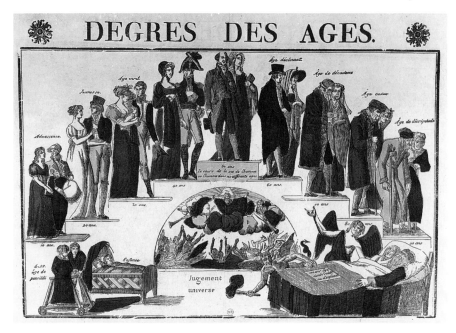

Figure 51. *Degrés des âges,* woodcut, ca. 1830?

leges metonymic over metaphoric structures) that additive composition, by virtue of its seeming artlessness, is especially suited to convey an impression of the "haphazard, random structure of everyday, down-to-earth reality itself."[11] This ideological overdetermination helps explain why the concept of additive composition as applied to Courbet's breakthrough pictures has gone unchallenged for so long.

2. Like the *After Dinner,* the *Burial* has given rise to much discussion of possible sources, two main types of which have been viewed as contributing more or less equally to the final result. First, Robert Fernier, Nochlin, Clark, and others have suggested that the composition of the *Burial* is largely based on that of a seventeenth-century Dutch group portrait, Bartholomeus Van der Helst's *Banquet of Captain Bicker* (1648), which Courbet could have seen on a visit to Amsterdam in 1847.[12] Toussaint argues, however, that the animation of Van der Helst's picture is at odds with the stiffness and severity of Courbet's and proposes as likely sources for the *Burial* two other Dutch group portraits: Thomas de Keyser's *Company of Captain Allaert Cloek* (1632) and Frans Hals's *Meagre Company* (1637).[13] In addition, Nochlin, Clark, Toussaint, and others have seen in the austere colorism and robust execution of the *Burial* the influence of seventeenth-century Spanish painting, Velázquez and Zurbarán in particular.[14]

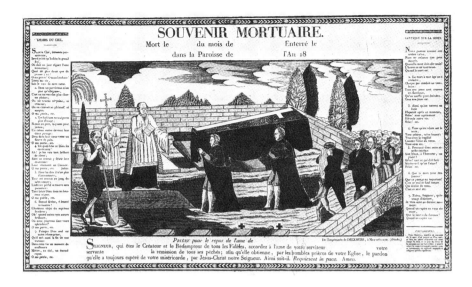

Figure 52. *Souvenir mortuaire,* woodcut, ca. 1830.

The second type of source, first analyzed by Schapiro, is the crude popular woodcut produced during the 1830s and 1840s in Epinal and other provincial centers. Examples that have been associated with the *Burial* include the *Degrés des âges* (fig. 51), *Souvenir mortuaire* (fig. 52), *Mort et convoi de Marlborough,* and *Convoi funèbre de Napoléon,* though it is usually stressed that broad similarities rather than specific correspondences are the point of the comparison.[15] Later in this chapter I shall suggest that the *Burial* bears a closer relation to another sort of popular image, the product of a distinctly Parisian milieu, but I don't wish to deny that Courbet himself was willing for his art to be likened to the humble productions of the provincial *imagier.* "The effect is the same because the execution is equally simple," Champfleury wrote in 1851. "Sophisticated art finds the same *accent* as naive art."[16] Subsequent painters of high ambition—Manet, Seurat, Gauguin, Van Gogh, Picasso, and others—followed Courbet's initiative, making the *Burial* a landmark in the evolution of modern art on those grounds alone.

3. A third crux concerns the black costumes worn by almost all the mourners. Champfleury, in an article published shortly before the opening of the Salon of 1850–51, identified those costumes as bourgeois and connected them with a passage from a then little-known text, Charles Baudelaire's "Salon of 1846":

But all the same, has not this much abused garb its own beauty and its native charm? Is it not the necessary garb of our suffering age, which wears the symbol of a perpetual mourning even upon its thin black shoulders? Note, too, that the dress-coat and the frock-coat possess not only their political beauty, which is an expression of universal equality, but also their poetic beauty, which is an expression of the public soul—an immense cortège of undertaker's mutes (mutes in love, political mutes, bourgeois mutes). We are each of us celebrating some funeral.[17]

Champfleury credited Courbet with having understood perfectly the ideas put forward in Baudelaire's "rare and curious" little book and went on to praise the painter for having had the audacity to meet the challenge of contemporary dress by depicting bourgeois personages in their characteristic *habit noir*.[18] There is no need to rehearse what we know about the somewhat obscure relations among Courbet, Champfleury, and Baudelaire, but it seems clear that the three were never closer than during the late 1840s (Courbet's *Portrait of Baudelaire* is now thought to date from around 1849) and that the painter of the *Burial* may well have been familiar with Baudelaire's ideas on the representation of modern life.[19] It doesn't follow, however, that Courbet's procession of mourners was Baudelairean in inspiration; as we shall see, there exists a missing term that may account for the affinity between the two.

4. Finally, there is the overarching question, pursued most resourcefully by Clark, of the relation of the breakthrough pictures as a group and the *Burial* in particular to the social and political developments of the years 1848–51. The basis of Clark's work is the discovery by recent French historians that the countryside was not simply a bastion of conservatism, as had previously been thought, but that on the contrary rural France was the site of a deadly struggle, largely organized along class lines, between Bonapartists and the Left. Against that background Clark emphasizes what he takes to be the Courbet family's ambiguous social situation, its "status between the peasantry and the rural bourgeoisie," at a moment when antagonism between the two classes was at its peak, and suggests that the ambiguity is represented, "in an almost secret manner," in the *Stonebreakers, Burial,* and *Peasants of Flagey:*

In the course of a few months Courbet moved from an imagery which pictured the family from the inside, in its own terms—as an inevitable frame of reference for experience—to an image in which the family is pulled apart and reassembled in the context of a class, a community. He moved from [the] *After Dinner* to the *Burial:* from being a "painter of the family," in Champfleury's reassuring,

neutral sense, to showing a whole society, and the curious place of his family within it. It does not concern us whether the ambiguities I have pointed out [e.g., Courbet's father wears a black frock coat in the *Burial* and a peasant smock in the *Peasants of Flagey*] were consciously or unconsciously devised: they are nonetheless *there*. And they are, I think, at the centre of Courbet's painting in 1850–51; they are the key to his pictures' irony and equivocation.[20]

Those pictures, he continues,

are neither affectionate nor hostile to the material they portray. The *Burial* is a portrait of the small-town bourgeoisie, and in 1850 that was a subject that called for taking sides. But the picture does not take sides, any more than it lays down the law one way or another on the state of religion in the Doubs. These pictures share, as it were, the equivocal position of the bourgeoisie itself in 1850: on one level, the target of peasant hatred and distrust; on another, providing from its lower ranks the leaders of radicalism in the countryside.[21]

In this connection Clark cites an *annonce* written by Max Buchon to prepare the way for the exhibition of the *Stonebreakers* and the *Burial* in Besançon and Dijon in the late spring and summer of 1850. There Buchon identified the gravedigger as a *vigneron* (hence a peasant), imagined him presiding over the *Burial* like the figure of death in a *danse macabre,* and characterized him as "the psychological antithesis, the counterweight, I will almost say the avenger" of the old man in the *Stonebreakers.*[22] Clark concludes:

Faced with this version of Courbet's meaning, we can admire *and* disbelieve. This is not "what is in the painter's mind," exactly; it is too definite and circumstantial for that. But the concerns it works with, the world of meaning it inhabits, *are* Courbet's. Buchon may shape the implications too firmly, and give form to shifting significance. But one thing is clear: the prime subject-matter of Courbet's Realism was at this point the social material of rural France, its shifts and ambiguities, its deadly permanence, its total structure.[23]

Or as Clark says somewhat earlier, Courbet during these years "was not a painter of conflict or even of movement. He gave us images of a massive and stifling stillness, images which exposed the structure of his society rather than its disruption."[24]

I have quoted at length from Clark because it's widely assumed that the politics of the time exerted a powerful shaping influence on Courbet's art and because Clark's reading of the *Burial* and related works in terms of the struggle for the countryside is by far the most original, rigorous, and subtle attempt to give a sociopolitical interpretation of those paintings that has been made. And yet it should be noted just how modest

Clark's claims for the political significance of the breakthrough pictures ultimately are. What, after all, is the precise force of the statement that the subject matter of the *Stonebreakers, Burial,* and *Peasants of Flagey* is the total structure of rural French society, if it is also true, as Clark contends, that the works in question are noncommittal with regard to that subject matter? Isn't this essentially to frame those paintings in a certain way—to insert them in a political context—and at the same time to acknowledge that their relation to that context defeats exact analysis? Nor is it clear that terms like "irony" and "equivocation" are properly assigned to them. To confine my remarks to the *Burial,* what is most immediately perplexing about it, as Clark is well aware, is its deadpan affective atmosphere, or, to quote him again, "its lack of open, declared *significance*."[25] But this isn't to say—on the basis, for example, of the ruddy faces of the two beadles, or of the allegedly insecure social identity of the figure of Régis Courbet[26]—that the *Burial* adopts an ironic or equivocal stance toward the personages it depicts. (Buchon was struck by "the contemplative atmosphere that hovers over all.")[27] For that matter, is it plain that the later breakthrough pictures are best described as "images of a massive and stifling stillness," or is such a description colored if not determined by a prior notion of the "deadly permanence" of French rural life?

These remarks hardly amount to a searching critique of Clark's pathbreaking study. Even less are they intended to prove that the *Burial* bears no significant relation to the politics of its time. They are meant to suggest, however, that by Clark's own account all four breakthrough pictures are surprisingly resistant to being unpacked—understood in detail—in political terms, and they are also meant to prepare the ground for an altogether different interpretation of the *Burial,* one in which the relation of frame to painting, of context to content, is nothing if not specific.[28]

I want to begin my reading of the *Burial* by emphasizing something which, although obvious, has never been given its due: the composition's *processional* character. Most of the figures Courbet has depicted are perceived as walking slowly, as if somnambulistically, in the ultimate direction of the open grave. (For many this means following a serpentine path, a point I shall return to more than once.) Other figures, notably the curé, beadles, gravedigger, and group of male mourners standing before the grave, are seen as stationary, but the overriding impression the picture conveys is of slow continuous movement—predominantly to the right but also, not at all negligibly, to the left—across a broad expanse. A

comparable but simpler impression is conveyed by the preparatory draw-
ing in Besançon (1848?; fig. 53), in which the procession of officiants
and mourners seems at first glance to troop without interruption from
one edge of the sheet to the other. (Our subsequent realization that there
too the male mourners in the middle portion of the composition are
standing still doesn't annul the initial effect.) In both the drawing and the
painting, an unorthodox format, wider by far than high, reinforces the
suggestion of lateral movement, though it should be noted that the ex-
treme proportions of the drawing have been moderated in the finished
work.

One implication of these remarks is that the standard view of the *Buri-
al*'s composition leaves a lot to be desired. In chapter three I objected to
the concept of additive composition as applied to the *After Dinner* and
the *Stonebreakers,* but it is even more conspicuously inappropriate to the
*Burial,* in which the effect of procession I have just described calls into
question the separateness and distinctness of individual personages.
Much has been written, for example, about the significance of the virtual
wall of black pigment formed by the costumes of the mourning women
in the right-hand third of the canvas, but what hasn't been remarked is
that the fifteen or so figures it comprises are in effect run together, all but
physically merged, in an image of collective "drift"—above to the right,
below to the left—that wouldn't be nearly as compelling as it is if our
attention were allowed to rest on one figure at a time. Nor has it been
remarked how the frequent *pairing* of figures—the double row of
mourners, the coupled pallbearers, the choirboys, the veterans of 1793 at

Figure 53.  Gustave Courbet, *A Burial at Ornans,* preliminary drawing, 1848?

graveside, the two imposing male figures to their right, and, most striking of all, connecting the two principal sections of the painting like a great hinge, the twinned beadles in bright red—functions to suppress or at least to blur the individuality of the personages in question and by so doing to promote a sense of overall movement across the pictorial field.[29] (Of course, certain personages—the crucifix-bearer, the curé, the grave-digger, several of the mourners—stand out as conspicuously single: presumably it's on the strength of these that commentators have ascribed to the painter of the *Burial* an exclusive preoccupation with the concrete reality of specific individuals that I would argue the painting as a whole does much to subvert.)

In any event, the thematizing of lateral movement in the *Burial* and, soon to come, the *Peasants of Flagey* is a major strand of continuity between the later breakthrough pictures and the earlier ones, in which, as we have seen, an impulse toward such movement found expression in the play of grave and acute axes back and forth across the picture plane, as well as, in the *Stonebreakers,* in the implied directionality of the composition as a whole. In other respects too the *Burial* bears a close relation to the *After Dinner* and the *Stonebreakers,* but before exploring those affinities I want to call attention to a hitherto not fully appreciated connection between the *Burial* and another group of pictures by Courbet—his landscapes of the late 1840s.

It's generally held that landscape as a genre became important to Courbet only after 1855, and with respect to volume of production there are grounds for this view. But even a casual inspection of his oeuvre reveals that he took landscape seriously as early as 1847–48, and furthermore that he painted a number of significant works in that genre during the same years that he was making the breakthrough pictures. The first of three examples I want to consider is a little-known canvas, *View of Châtel Saint-Denis (Sçey-en-Varais)* (ca. 1848; fig. 54), which depicts in the near foreground a peasant leading an ox-drawn wagon followed by another peasant across a bridge and onto a road that, starting parallel with the bottom framing-edge, curves back into the middle distance toward a few houses enveloped by trees.[30] Immediately beyond the bridge, the river Loue forms a broad bend (perhaps the *miroir de Sçey,* one of the attractions of the region) before disappearing behind the hillside at the left. A succession of further hills topped by rocky bluffs indicates subsequent windings of the river, and in fact our eye is drawn to the ruin of the

medieval castle of Saint-Denis, aglow with the last rays of the sun, from whose tower it would be possible to survey distant reaches of the valley of the Loue. But we don't entertain this possibility so much as we respond instinctively to the different suggestion, conveyed by both the peasant group and the river, of slow, methodical, serpentine movement back into the picture space (though for all we know the river may be flowing toward us, as will be the case in Courbet's later landscapes). Put more strongly, it is as if the scene represented in the painting were essentially one of imaginary activity, the *viewer's* activity of journeying through the landscape in a measured and comprehensive fashion and, in the process, occupying every portion of it in turn.

Other paintings of these years make similar use of typical features of the countryside around Ornans. For example, in the fine *Valley of the Loue*

Figure 54.  Gustave Courbet, *View of Châtel Saint-Denis (Sçey-en-Varais)*, ca. 1848.

*in Stormy Weather* (ca. 1849; fig. 55), we look down from a brushy elevation across much of the valley: to the left in the middle distance a rocky bluff rises massively; starting from the right-hand edge of the canvas, a succession of deeply shadowed hills marches toward the horizon; in the depths of the picture, at ground level, the bright ribbon of the Loue winds its way back into space before disappearing from sight; finally, straddling the river at a bend, almost lost in shadow and unexpectedly minute in scale, we find a village I take to be Ornans.[31] As in the *View of Châtel Saint-Denis,* though by different means, great compositional weight is given to the topography of the river valley. What is more, the distanced yet concentrated evocation of the serpentine progress of the Loue through its magnificent setting may be seen as inviting the viewer to identify imaginatively with that progress, an invitation that receives

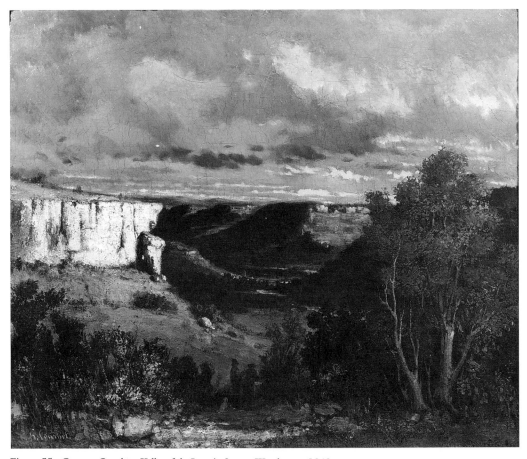

Figure 55.  Gustave Courbet, *Valley of the Loue in Stormy Weather,* ca. 1849.

strong reinforcement from what seems the excessive smallness, almost the miniaturization, of the view of Ornans. That is, although the rendering of the latter may be faithful to optical truth, it is, I think, difficult to reconcile that truth, or at any rate the vast spaces and towering altitudes it implies, with what we feel to be the far more intimate (or *proximate*) internal scale of the representation as a whole. And that disparity, whether recognized as such or not, weakens the hold of any single, removed point of view and by so doing liberates the viewer to respond unstintingly to the quasi-physical "pull" of the river. Seen in this light, the figures of the two men sketching in the near foregound, conventional stand-ins for the painter and/or the beholder, aren't only superfluous but beside the point: whereas they remain remote from the valley, in my account the viewer of the painting is precipitated beyond them into the valley's (and the painting's) heart. Nevertheless, they bear witness to Courbet's characteristic determination to affirm his active presence not merely at but *in* the scene of representation.[32]

Shortly afterward Courbet painted the *Castle of Ornans* (ca. 1849–50; fig. 56), a relatively large and altogether magnificent picture both like and unlike the *Valley of the Loue in Stormy Weather*.[33] It's like the *Valley of the Loue* in that it appears to represent almost exactly the same vista from a slightly more elevated vantage point. And it's unlike it in that, while in obvious respects channeling our gaze toward the distant river (a single serpentine "path" leads from the immediate foreground to the valley floor), it also divides our attention among three equally compelling centers: the village of Ornans, depicted in greater detail than in the earlier work; the modest hamlet in the left middle distance, comprising perhaps a score of closely grouped houses, which then as now occupied the top of the rocky bluff; and, in the near foreground, the squarish stone basin fed by a rivulet in which the women of the hamlet, one of whom is shown to the right of the basin hanging up washing, did their laundry. The hamlet was built on the ruins of the medieval castle of Ornans (hence the name it continues to bear); apparently Courbet omitted it from the *Valley of the Loue in Stormy Weather,* no doubt to forestall the tension between competing centers that he exploits here. And that tension is made all the more acute not only by the even lighting and uniformly sharp focus but also by the fact that the three centers, so near one another on the picture surface, are perceived as lying at vastly disparate distances from the picture plane.

These and other landscapes of the period relate to the *Burial* in several

interesting respects. To begin with, the locale of the *Burial,* the new cemetery of Ornans, belongs roughly to the terrain of the landscapes, and in fact the leftmost of the two bluffs in the background, the Roche du Château, figures prominently in both the *Valley of the Loue in Stormy Weather* and, its hamlet restored, the *Castle of Ornans.*

More important, there is, I suggest, a telling affinity between Courbet's depiction in the landscapes of the winding course of the Loue and his treatment in the *Burial* of the serpentine procession of mourners approaching the grave. To be sure, the direction implied by the one is into depth and by the other toward the surface of the picture, and there is no equivalent in the landscapes, except perhaps the *View of Châtel Saint-Denis,* to what might be called the lateralization of the motif that takes place in the *Burial* (more on this presently). But the actuation of serpentine movement is strong in both cases, and this should alert us to the possibility that Courbet's use of such movement in the *Burial* was grounded in his landscape practice—specifically, in his seeing in the un-

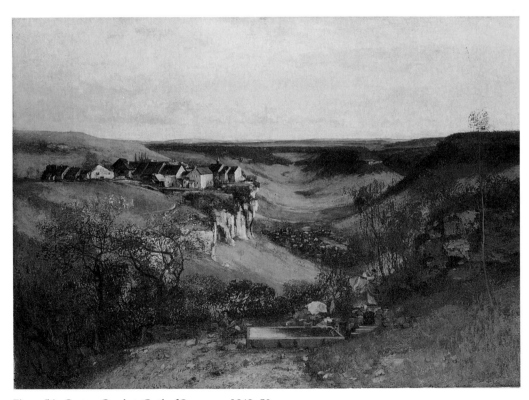

Figure 56.  Gustave Courbet, *Castle of Ornans,* ca. 1849–50.

dulating progress of the Loue through its powerfully sculpted environs a means of evoking an experience of journeying corporeally through space as opposed to merely viewing a world present to eyesight but fundamentally out of reach.

In this connection it should be stressed that although the immense declivity of the river valley isn't actually depicted in the *Burial,* it is in effect alluded to by the gap between the Roche du Château and the Roche du Mont. In fact if one goes to Ornans and stands today where the painter must have stood in order to visualize the *Burial,* it instantly becomes clear that the village would have lain on lower ground just beyond the mourners and that running through the village from right to left, and therefore in a sense through the painting, is the Loue itself, the steady sound of whose waters are audible to the visitor. (I take this to be pertinent even though Courbet didn't paint the *Burial* on the spot. He *projected* it from that spot, and because of the importance of corporeal experience in Courbet's art, what couldn't be seen because it was blocked from view, indeed what couldn't be seen but could be *heard,* is part of that projection as well. I know of no painter the nature of whose enterprise makes it as imperative for the historian to visit the sites he painted.) Furthermore, something of the formal and expressive character of the valley of the Loue as represented in Courbet's landscapes—the suggestion of a central hollow or void that refuses to remain wholly unfilled—surfaces also in the rendering in the immediate foreground of the *Burial* of the open grave, about which I shall have a lot more to say. I don't mean by this that the grave is to be understood as a displacement of the valley of the Loue any more than I wish to claim that the *Burial* is essentially a peopled landscape. My point is rather that both valley and grave as they appear in the paintings we have been considering answer to a certain desire for excavation *and filling in,* a desire that receives its most direct expression in all Courbet's art precisely in the *Burial.* (The special relevance to the *Burial* of the *Castle of Ornans* with its competing centers of interest and stone basin filled with water will emerge in due course.)

At this point I want to shift the discussion in another direction by introducing a different sort of image, one in the public domain, that I believe contributed to Courbet's decision to replace the unidirectional composition of the preliminary drawing with the more complex structure of the finished painting. I refer to a type of caricature, popular throughout the later 1840s and 1850s, in which a host of figures are represented walking

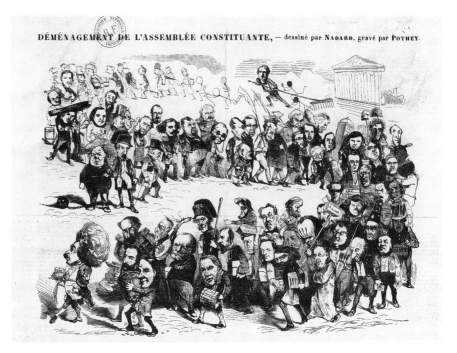

DÉMÉNAGEMENT DE L'ASSEMBLÉE CONSTITUANTE, — dessiné par NADARD, gravé par POTHEY.

Figure 57. Nadar, "Déménagement de l'Assemblée constituante," engraved by Pothey, 1849.

slowly, sometimes four or five abreast, in a long serpentine cortège. The most famous versions of that image are Nadar's two large *Panthéon* lithographs of 1854 and 1858, each of which comprises well over two hundred *portraits-charges* of leading writers of the day (the second adds a number of painters and musicians).[34] An earlier version of the same basic image, also by Nadar, is the caricature titled "Déménagement de l'Assemblée constituante" (fig. 57), which appeared on the front page of the *Journal pour rire* for 26 May 1849, just a few months before Courbet retreated to Ornans to begin work on the *Burial*. As we have seen, Courbet was already interested in serpentine movement, and at some point that fall or early winter, dissatisfied with the simple linear deployment of figures in the preliminary drawing, he appears to have found in Nadar's S-shaped procession of politicos the answer to his needs. This wouldn't have been his first use of an image from the *Journal pour rire:* in chapter three I proposed that the composition of the *After Dinner* was partly based on an illustration by Lorentz that appeared there in February 1848. In addition, still another illustration published there, Bertall's "Le Jubilé des culottes de peau" of 9 December 1848 (fig. 58), seems to be the source for several figures in the preliminary drawing (e.g., the

crucifix-bearer, the curé, the kneeling gravedigger) and, at a remove, in the *Burial* itself.

It follows that the *Burial* is less closely tied to popular images of the *Degrés des âges* or *Souvenir mortuaire* stamp than has been thought. Nadar's, Bertall's, and Lorentz's illustrations exemplify another species of popular image—urban, quotidian, ironic—and Courbet's use of those

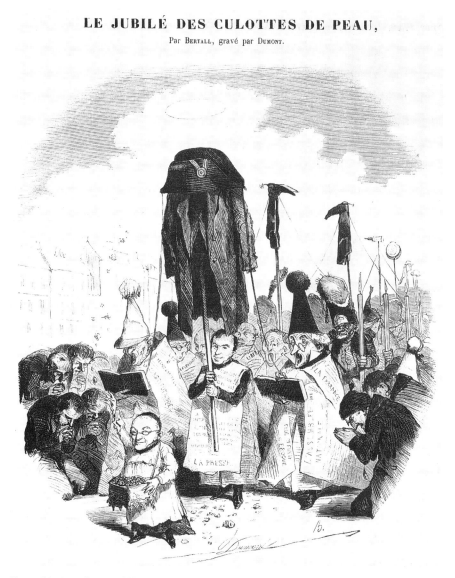

Figure 58. Bertall, "Le Jubilé des culottes du peau," engraved by Dumont, 1848.

illustrations in the *After Dinner* and the *Burial,* while not invalidating the connections that have been drawn between his art and *images d'Epinal,* is further evidence that the issue of his sources has been too narrowly conceived.[35] On the other hand, it doesn't seem to be the case, as might have been supposed, that the sharply ironic stance and explicitly political content of an image such as Bertall's "Jubilé," which portrays the dwarfish Thiers in priestly dress leading a mock-religious procession of supporters while frock-coated bourgeois kneel in adoration, are carried over into either the preliminary drawing or the final painting. Indeed we might describe Courbet's adaptation of Bertall's image to his own purposes as an act of depoliticization if it were not that such an act is hardly devoid of political connotations in the broader sense of the term. (It may be that a still earlier illustration of the cortège type inspired the passage in Baudelaire's "Salon de 1846" that evokes the image of an immense procession of undertaker's mutes.[36] The mysterious affinity between that passage and Courbet's *Burial* that Champfleury was the first to comment on would thus reflect a common type of visual source rather than the direct influence of the writer on the painter.)

In Nadar's "Déménagement," as in similar images of the period, the cortège of figures makes its way from the top toward the bottom of the page, which is to say from far to near. Courbet appears to have seized upon this aspect of such images, which enabled him at a stroke to reverse the directional emphasis of the landscapes, and to have sought to exploit it to the fullest by asserting the extreme proximity to the beholder not just of the foremost units of the cortège but of the entire scene. Toward this end he did away with the elevated perspective of Nadar's illustration and compressed the rightward- and leftward-facing segments of the procession of mourners into nearly a single plane, Clark's "solid wall of black pigment" punctuated by faces, bonnets, handkerchiefs, and, most important, the two veterans of 1793. The pressure toward the picture surface is even more intense elsewhere in the composition: notably at the place, roughly a quarter of the way over from the left-hand edge, where the lead pallbearers, the choirboys, the crucifix-bearer, and at least three other figures including Buchon are crowded into a section of the canvas no more than a few feet wide; and at the bottom middle of the picture, where the open grave into which the coffin will shortly be lowered is truncated by the bottom framing-edge. (Courbet's mastery as a colorist is evident in the olive, turquoise, and gray-green costume of the nearer veteran, a gathering of cool tones and subtly contrasting textures that counterbal-

ances the crush of figures to the left of the grave and in the process makes the blacks of the procession seem warm and "advancing.") Also near the picture surface is the anarchic dog to the right of the grave: enjoying the freedom of animals he stands as if on the bottom edge of the canvas, and demonstrating their physical flexibility he simultaneously faces toward and away from the grave, combining in a single "figure" not only the rightward and the leftward movement of the mourners but also something of the serpentine character of their progression through space.

In my discussion of the *After Dinner* and the *Stonebreakers* I called attention to a similar emphasis on proximity as well as to the deployment in the immediate foreground of at least one figure which, by virtue of having been depicted largely from the rear, is felt to resist the closure of the picture space relative to the painter-beholder and thus to suggest the possibility that the painter-beholder succeeded in absorbing himself as if corporeally in the painting. The preliminary drawing for the *Burial* contains one figure of this type, the kneeling gravedigger in the lower left-hand corner, and among the decisive changes made between the drawing and the final composition was the elimination of that figure and, it would seem, the abandonment, for the time being, of the specific designs on the beholder it may be taken to express.[37] Another important change was the shifting of the open grave, and with it the main narrative focus of the proceedings, from the extreme left—the patch of dark shading just beyond the kneeling gravedigger in the drawing—to the bottom middle of the composition. (The shift is anticipated in the drawing by the whitish rectangular form, sometimes described as a gravestone, inserted where the grave will lie in the painting.) It's tempting to view the two changes as complementary—to regard the open grave truncated by the bottom framing-edge as taking the place of a foreground figure depicted from the rear in that it too is a means, more nearly explicit than any we have so far encountered, of resisting closure and thereby of facilitating the quasi-corporeal merger of painter-beholder into painting that I am arguing was an overarching and obsessive aim of Courbet's enterprise. But something more must be said about Courbet's treatment of the grave before the exact force of these remarks can be registered.

In a well-known discussion of Caravaggio's *Supper at Emmaus* (ca. 1597; fig. 59), Rudolf Wittkower characterizes the expansive gestures of Christ and his disciples as in part "a psychological device . . . to draw the beholder into the orbit of the picture and to increase the emotional and

dramatic impact of the event represented: for Christ's extremely fore-shortened arm as well as the outflung arm of the older disciple seem to break through the picture plane and to reach into the space in which we stand."[38] Wittkower observes that "the same purpose is served by the precarious position of the fruit-basket which may at any moment land at our feet," and goes on to say that in other works of Caravaggio's middle period (1597–1606) similar methods are used "in order to increase the participation of the worshipper in the mystery rendered in the picture."[39] Caravaggio is thus seen as the inventor of a heightened mode of illusion-ism, based on dramatic chiaroscuro and extreme foreshortening and cru-cially involving elements in the immediate vicinity of the picture plane, by which the painter aimed to dissolve, one might say to shatter, the boundary between the space or world of the representation and that of the beholder and by so doing to enforce the suggestion that both are equally actual, equally present to his astounded senses. Now it may seem that this is what I have suggested Courbet sought to accomplish by

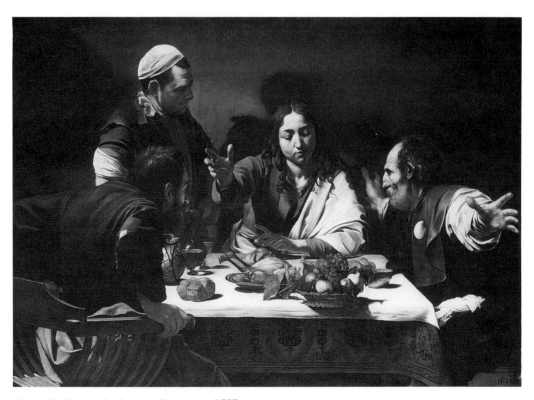

Figure 59.  Caravaggio, *Supper at Emmaus,* ca. 1597.

means of the placement of the open grave in the immediate foreground of the *Burial,* but in fact the difference between Courbet's treatment of the grave and what I shall call "baroque" illusionism of the Caravaggio type is fundamental.[40] Two points in particular should be stressed.

First, nothing is more striking about the manner in which the grave has been depicted than the minimizing, the active suppression, of illusionistic effect. Foreshortening of a sort may be present but is scarcely felt; while chiaroscuro—sculptural modeling—has mostly been avoided in favor of a uniform brownish tonality that evokes the clammy texture of earth but in no way suggests the brute physical immediacy of a large rectilinear trench gaping open at our feet. (No wonder commentators have sometimes failed even to mention the grave and have never paid it the attention it deserves.) Nor is this aspect of Courbet's rendering of the grave at all exceptional for him: a similar suppression of illusion in the immediate foreground is one of the hallmarks of his art, as for example in the *Man with the Leather Belt* (pl. 2), in which the leather-bound portfolio jutting past the table edge has none of the sculptural authority of the sitter's right hand and wrist, or as in the *Wounded Man* (pl. 1), in which the shapeless brown cloak covering the sitter's lower body largely obscures the body's bulk and gives no purchase for foreshortening to dramatize the body's nearness. Also in the *Wounded Man* the sitter's left hand gripping a fold in his cloak appears surprisingly small, a restraint of scale that is another recurrent feature of Courbet's art (look again, for example, at the sitter's right hand in the early *Small Portrait of Courbet* [fig. 30]). The contrast between that restraint and the exploitation of the opposite effect by Caravaggio and other "baroque" masters points up just how *counter*illusionistic Courbet's treatment of foreground objects frequently is.[41]

Second, what I earlier described as Courbet's propensity for calling into question the ontological impermeability of the bottom framing-edge, visible in both the *Man with the Leather Belt* and the *Wounded Man* and epitomized by the open grave in the *Burial,* is not at all the same as the "baroque" illusionist's assault on the impenetrability of the picture plane. The bottom of the picture is subjected to exceptional pressures in Courbet's art because, considered as part of the representational field, it lies nearer the painter-beholder than other portions of that field and so is the threshold that must be crossed, placed "behind" him, if the separation between painting and painter-beholder is to be undone and the two are somehow to be merged in a single quasi-corporeal entity. Its problematic

status thus undermines the traditional authority of the picture plane and, equally important, implies a fundamental difference between the painter-beholder of the *Burial* and the vicarious participant posited by the illusionistic mode of the *Supper at Emmaus,* the latter of whom, although more than simply an "eye," is nevertheless conceived both as witnessing a dramatic event and as occupying a definite point of view.

Put slightly differently, a painting like Caravaggio's *Supper at Emmaus* doesn't seek to draw the beholder into itself (nor does Wittkower quite say it does) so much as it leaves the beholder where he is and seeks to project toward him—to fictively break through the picture plane in order to include him as viewer-participant in an expanded illusion. Indeed if we consider the implication of devices like the basket of fruit resting partly off the table or the outflung arms of the older disciple, it becomes clear that a certain irreducible *distancing* effect is inherent in "baroque" illusionism, and that this is never more palpably the case than when an effort is made to allow the illusion free reign. In Courbet's self-portraits of the 1840s as well as in the *After Dinner* and the *Stonebreakers,* however, the overriding ambition, as I have construed it, is very nearly the opposite: to absorb the painter-beholder as if bodily into the painting; and to do this, so I have argued, at least partly in the interests of combating theatricality at a basic level—that of beholding as such, *of the impersonal or objective conditions constitutive of the very possibility of spectatorship.* (A beholder literally absorbed into a painting, made physically one with it, would no longer be a beholder in any meaningful sense of the term.) Given this ambition, it isn't surprising that the bottom of the picture emerged early on as a zone of special sensitivity nor that illusion there turned out to require attenuation: the general effect Courbet often achieves in his foregrounds can be likened to the way an object close at hand and low in our field of vision tends to appear insubstantial, to lose its definiteness, when we look beyond it at something even slightly further away. Thus not only the placement of the grave in the immediate foreground of the *Burial* but also the self-effacing neutrality with which it has been rendered are consistent with the notion of an effort by the painter-beholder to assert what might be called his *absolute proximity* to the painting before him, a condition that, for reasons that require no further elaboration, lay beyond the power of illusionism to evoke.

In this connection it is striking, to say the least, that the dimensions of the makeshift studio in which Courbet painted the *Burial* allowed him little room to step back and survey his progress. "One has to be crazy to

work in the conditions in which I find myself," Courbet complained in a famous letter to Champfleury in the spring of 1850. "I'm working blindly [*Je travaille à l'aveuglette*], I have no room to stand back."[42] As Nochlin has remarked, the *Burial* owes neither its originality nor its power to the circumstances of its creation;[43] but this doesn't rule out the possibility that Courbet discovered in those circumstances—in his near-ness and, to use his figure of speech, his "blindness" to the monumental canvas before him—an anticipation of, almost a model for, the relation-ship between painting and painter-beholder that I have tried to show is embodied in his handling of the open grave.

Along the same lines but responding to the fact that it's an image of excavation on which all this turns, we might say that both the location and the treatment of the grave bear witness to a resolve to cut the ground out from under the painter-beholder's feet and by so doing to leave him nowhere to stand outside the painting. Part of the tool by which that labor was accomplished can be made out just to the left of the grave: the blade of a shovel, crusted with dirt and, like the grave, truncated by the bottom framing-edge. This is suggestive, all the more so in that the shaft of the shovel must be imagined to extend obliquely beyond the framing-edge much as if it were the shaft of a paintbrush and as if the fictive labor of excavating the grave (of excavating this grave precisely here) and the actual labor of painting the *Burial* were in crucial respects equivalent.

A particular affinity in this regard between the *Burial* and the *Stone-breakers* deserves emphasis. In my discussion of the latter I argued that the figures of the old and the young stonebreakers may be seen as repre-senting the painter-beholder's right and left hands, the old man's hammer being analogous to a paintbrush or palette knife and the young man's basket of stones loosely resembling a palette. The shovel alongside the grave is another shafted implement (if anything it's closer than the old stonebreaker's hammer to the painter-beholder's primary tools), but what I find especially intriguing is the possibility that the depiction in the leftmost portion of the *Burial* of the pallbearers carrying their heavy bur-den might possess a comparable significance to the depiction in the *Stone-breakers* of the young laborer struggling to manage his basket of broken stones. If the analogy holds—if the men supporting the coffin may be likened to the painter-beholder's left hand bearing the palette—it goes a long way toward assimilating the *Burial* in its entirety to a metaphorics of pictorial production.

(Such an analogy also implies a sharp break in the internal scale of the

*Burial* considered as a mixture of "real" and metaphorical elements. And this in turn draws attention to the crucifix with its tiny sculpture of Christ, which jarringly introduces a *third* scale into the picture. I'm tempted to relate this copresence of mutually disparate scales to the juxtaposition of multiscalar images on the early sketchbook page that included a drawing of Courbet's left hand, which would mean that the *Burial* allows us to glimpse the persistence of a "naive" expression of embodiedness within a painting that has always been seen as the *ne plus ultra* of Courbet's Realism.)

At this juncture it becomes necessary to put in question everything I have said about the nature of the relationship between painting and painter-beholder posited by the *Burial*. For there is an important sense in which the *Burial* may be seen as specifying a place for the beholder (for *a* beholder) *outside* the painting—"this" side of the picture surface—which of course is the opposite of what I have been claiming until now. And yet it would be premature to conclude that my interpretation of the *Burial* as seeking to absorb the painter-beholder into itself is simply mistaken. Rather, what we discover in this most ambitious of the breakthrough pictures, if we have the patience to continue as we have begun, is the conjunction of two distinct, apparently antithetical, modes of engagement with the issue of beholding. And we discover too that that conjunction, far from indicating mere inconsistency or confusion, may be understood as the result of an attempt to come to terms with certain difficulties and ambiguities that were inherent in Courbet's antitheatrical enterprise virtually from the first. Several considerations lead to the belief that a place has been prepared for the beholder this side of the picture surface:

1. The unmistakably skewed orientation of the open grave—we are shown the right but not the left inside wall while the far inside wall runs parallel to the picture plane—implies a point of view not directly in front of the grave but distinctly to the left.

2. The figure bearing a crucifix (the *vigneron* Colard-Claudame) gazes intently out of the painting as if at someone, an onlooker, standing before it (pl. 5). This is a rhetorical device: nothing guarantees that Colard-Claudame's gaze rests on anyone at all; but especially once we have become aware of the slant orientation of the grave, some such inference seems unavoidable. At any rate, the orientation of the grave makes sense if imagined as beheld (as represented) from a point of view more or less directly in front of the crucifix-bearer.

3. Immediately to the left of the figure of Colard-Claudame (i.e., to his right) there occurs the lone incident—small, undramatic, wholly unremarked in the vast literature on the painting—in the *Burial:* a near collision between the fair-haired choirboy, who holds aloft a tall candle in a candlestick, and the more distant of the two lead pallbearers, whose widebrimmed hat has, it seems, been jostled by the candle. Whatever the precise nature of the physical contact between the two figures, the young boy looks up in surprise as the pallbearer, eyes hidden from view much like those of the old stonebreaker, appears to look down at the boy (the total effect, a marvel of nuance, is not quite of an exchange of glances). Moreover, there are witnesses within the painting to this trivial event. A few feet to the right, the other side of Colard-Claudame, the leftmost of the two beadles, holding a candle of his own, glares open-mouthed in evident consternation across the intervening space, while further afield the kneeling gravedigger, sometimes described as listening to the curé read the service for the dead, is better understood as having turned his head in the direction of the disturbance.[44] I believe all this carefully orchestrated activity has a purpose: to direct the beholder's attention to the general vicinity of the crucifix-bearer and so increase the likelihood of encountering the latter's gaze, becoming aware of the skewing of the grave, and so on.

4. I noted earlier that the sector of the canvas in which these events transpire is conspicuously crowded and that it is one of two places in the painting, the other being the grave, where the pressure toward the picture surface is most intense. But it is also here we discover, between the curé and the draped coffin, a deep and narrow spatial cleft or fold into which our gaze, already attracted to the area, inevitably strays (Colard-Claudame himself stands well within it) and at the farthest limit of which is depicted in profile the robust, isolated, absorbed-seeming head of Courbet's intimate friend, Buchon. And this too, while in no way demanding the presence of a beholder, lends support to the proposition that a vantage point this side of the picture surface and more or less directly in front of the cleft or fold is in some sense privileged.

The question that now arises is whether these considerations are simply at odds with the reading of the *Burial* and its relationship to the painter-beholder I have been expounding in this chapter or whether we are instead dealing with a far more complexly structured version of that relationship than can be found in Courbet's work up to this time.

The first thing to stress is that although the orientation of the grave

implies a point of view somewhere to its left, the attenuation of illusion in the rendering of the grave makes that implication anything but emphatic.[45] Consequently, a beholder who approaches the *Burial* by centering himself before it (one's natural impulse for a number of reasons), and in so doing exposes himself to the full force of its solicitations toward merger, will very likely not even notice that the grave is skewed relative to the picture plane (no previous writer has found it worth mentioning). Furthermore, the fact that the point of view implied by the orientation of the grave lies opposite the most active and, at first glance, the most confusing portion of the composition also serves to forestall an awareness that such a point of view may be in force.

Here it is useful to compare the finished painting (pl. 4) with the preliminary drawing (fig. 53). In the latter the grave is at the far left; a single procession, to be joined by the pallbearers, makes its way across the sheet; and two figures, the crucifix-bearer and the hatless man at the center (and perhaps two other figures as well, the officiant in a conical hat slightly to the right of the crucifix-bearer and the mourner in a stovepipe hat immediately to the right of the hatless man), appear to gaze out of the drawing as if at a spectator centered before it. In the finished painting, on the other hand, the grave has been shifted to the bottom center of the composition; the various processional units are shown converging there; and yet not only does no outward gaze place the beholder directly before the grave, it appears that the center of the composition has deliberately been kept blank, as if to install at the apparent heart of the painting a structural/ontological equivalent to the understated emptiness lying open below it. Thus both the gravedigger and (an inspired touch) the dog turn their heads away from the vicinity of the grave; the mourner to the right of the gravedigger weeps facelessly into a handkerchief; and a barely modulated expanse of black pigment looms like a great blind spot (*Je travaille à l'aveuglette*) between the gravedigger and the two veterans of 1793. It's as though the *Burial*'s curiously indeterminate affective atmosphere (Clark comments aptly on its "peculiar, frozen fixity of expression" and uses terms like "distraction," "inattention," and "blankness" to characterize both the states of mind of the mourners and the overall mood of the image)[46] comes to a head in this portion of the canvas. And of course the avoidance of overt address to the beholder that such a strategy implies also helps to reduce the risk of conflict between the generally centering character of the composition as a whole and the slant orienta-

tion of the grave with its implication of another point of view somewhere
to the left.

But although outright conflict may be avoided, the fact remains that
the changes introduced between the preliminary drawing and the *Burial*
combine to impose a distinction *between two seemingly separate and differ-
ent points of view:* that of a beholder standing before the grave and sub-
jected to various strategies designed to draw him as if bodily into the
painting (it is in this sense ideally not a point of view at all), and that of
someone else, *another* beholder suggested by the orientation of the grave
and seemingly reaffirmed, given added "presence," by the outward gaze
of the crucifix-bearer—a beholder who occupies a position roughly half-
way between the center and the left-hand edge of the painting and at
some distance, we cannot say how much, this side of its surface. I want to
go further and associate the first point of (no) view with the beholder
*tout court,* who I will provisionally gloss as standing for spectatorship as
such, and the second point of view specifically with the painter-beholder,
who we would be both right and wrong to think of as the historical
individual Gustave Courbet: right in that he is no one else; and wrong in
that the painter-beholder of the breakthrough pictures, like the painter-
beholder of the self-portraits, the *After Dinner,* and the *Stonebreakers,* is
in essential respects a role or function, at once the operator and the prod-
uct of a network of relationships that the historical individual Courbet
neither created nor controlled, that existed before him and in one form
or another would survive his disappearance.

That the second point of view has something keenly personal about
it—a strong tie to the historical Courbet—is indicated by the fact that it
is his closest friend, virtually a second self, who has been carefully planted
at the far end of the cleft or fold in the proceedings.[47] But perhaps the
strongest reason for associating the second point of view with the
painter-beholder concerns the presence in the immediate foreground,
carried by the dark-haired choirboy, of a brass holy water stoup (or *béni-
tier*) in which rests, angled toward the right, an implement that, like the
shovel near the grave, may be compared with the painter-beholder's
brush or knife. The Latin names of the implement, with which the curé
will soon sprinkle holy water on the lowered coffin, are *aspersorium, asper-
gillus,* and *aspergillum;* in French it is called a *goupillon,* a word that, strik-
ingly in this context, also means "brush." In fact one common type of
*goupillon* was brushlike in form.[48] (Obvious pentimenti show that Cour-

bet took great pains over the exact size and position of that implement as if uncertain just how prominent to make it, perhaps because of its near-ness to the pallbearers-plus-coffin group that I have associated with the painter-beholder's other tool, his palette.) Furthermore, the bright yel-low sheen of the uppermost portion of the *bénitier* appears to hold out the promise of reflecting the image of anyone standing before it; al-though no such image can be discerned (it would be startling if one could be), motifs of reflection figure prominently in Courbet's paintings of streams and grottos of the 1850s and 1860s, where they evoke—so I shall claim—the notion of an antitheatrical, because ostensibly natural, mode of representation (see the discussion of the *Source* in chapter five and of various landscapes in chapter six). It's in these terms too that I see the reflective surface of the water in the rectangular stone basin in the *Castle of Ornans,* a work I have already suggested bears an intimate rela-tion to the *Burial.*[49]

At the same time, it must be acknowledged that the identification of the two points of view as belonging respectively to the beholder *tout court* and the painter-beholder is far from absolute: for one thing, my earlier claim that the shovel may be likened to the painter's brush or knife associates the grave and more broadly the first point of (no) view with the activity of painting; for another, my observation that attention is di-rected toward the minor accident to the left (and therefore also toward the crucifix-bearer et al.) suggests that the beholder *tout court* may be meant to become aware of the second point of view and perhaps even to occupy it physically (to say this is of course to personify a notion that I have as much as said is an abstraction).

It may seem that the line of argument I am now pursuing raises more questions than it answers, but before trying to improve matters I want to look still more closely at the section of the composition that lies opposite the second point of view in order to draw a distinction, which will soon become crucial, between the respective relationships to the painter-beholder implied by the personages of the crucifix-bearer and Buchon. I suggest that whereas the crucifix-bearer may be understood as gazing out at the painter-beholder, the painter-beholder is to be imagined not as returning that gaze but as gazing instead at the more remote, in a sense artfully concealed, yet partly for that reason magnetically attractive head of Buchon. (This avoidance of reciprocity between gazes resembles that between the fair choirboy and the pallbearer whose hat has been jostled, one marvel of nuance confirming the other.) The juxtaposition in the

same narrow portion of the canvas of the figures of the crucifix-bearer and Buchon may thus be taken as positing a distinction between the two acts of mutual facing that together constitute the conventional relationship between painting and beholder, or, more pointedly, as effecting a separation between what might be described as the *painting's gaze out at the beholder-"in"-the-painter-beholder* and the *painter-"in"-the-painter-beholder's gaze into the painting,* a feat tantamount to driving a wedge between the two components of the painter-beholder's compound identity.

One more reference back to the *After Dinner* and the *Stonebreakers* will help propel this reading to a close. In my discussion of those paintings I called attention to the play of acute versus grave axes across the pictorial field, a structural motif that turns up also in the important sketchbook page that includes a portrait of Courbet asleep with a pipe in his mouth and a close-up drawing of his own left hand. Now I want to suggest that this and similar structural devices in Courbet's art involve what I think of as a process of *lateralization,* a displacement from three into two dimensions, of an "original" oblique relationship between painter-beholder and painting. Obliqueness as such figures prominently in Courbet's self-portraits of the 1840s (both the *Man with the Leather Belt* and the *Wounded Man* are cases in point), where it serves as one of several means by which the mutual facing-off of painting and painter-beholder is subverted in the interests of a new, intensely corporeal mode of self-representation and, ultimately, of a fundamental antagonism to the theatrical. In a later self-portrait, the famous image at the center of the *Painter's Studio* (pl. 7), Courbet has depicted himself seated almost sidelong to the large squarish canvas on the easel before him, on which is represented a river landscape whose organization, for all the obvious differences, isn't without analogy to that of the *Burial* (the basis of that analogy will become clear with my discussion of the *Studio* in the next chapter). And although we can hardly take the central group from the *Studio* as a veridical description of the artist in the act of painting, its many affinities with the earlier self-portraits and other works in Courbet's oeuvre, to say nothing of its programmatic significance for Courbet himself, lend particular weight to its thematization of the relationship between painter-beholder and painting as radically, all but impossibly, oblique.

In contrast to the first two breakthrough pictures, the *Burial* makes only limited use of the reflection back and forth of angled axes as a prin-

ciple of pictorial coherence (to be precise, only the region opposite the second point of view can be represented diagrammatically by a network of crisscrossing grave and acute lines of force); instead, as has been noted, the element of lateral procession that remains mostly implicit in its monumental predecessors is in the *Burial* brought to the fore in and through the depiction of the serpentine cortège of mourners that dominates the right-hand half of the composition. And what I now wish to show is, first, that the same process of lateralization that may be detected in the *After Dinner* and the *Stonebreakers* is at work in the *Burial,* and second, that by tracking that process, which in this instance means conceiving how an "original" obliqueness helped engender a hypnotically persuasive representation of lateral movement across a truly vast pictorial field, we are at last able to broach the question of the structure of beholding in the *Burial* as a whole.

As evidence within the painting of that "original" obliqueness I would mention, to begin with, the by now familiar skewing of the grave, which is roughly analogous to, though it falls short of parallelling, the depiction in the *Studio* of the painter-beholder's bodily orientation relative to the canvas on his easel. (It also parallels the treatment of obliqueness in the *Man with the Leather Belt, Wounded Man,* and other self-portraits of the 1840s.) There is also the surprisingly steep vector of entrance of the pallbearers and the coffin, a group already associated with the painter-beholder's left hand gripping his palette. Finally, most important, there is the sharply acute angle subtended, if my reading is correct, by the crucifix-bearer's gaze out at the beholder-"in"-the-painter-beholder and the painter-"in"-the-painter-beholder's concentration on the head of Buchon, an angle I have associated with the not-quite exchange of glances between the fair choirboy and the pallbearer whose hat has been jostled. (For the sake of simplicity I shall refer simply to the painter-beholder in both contexts from here on out.) Indeed the "original" oblique orientation all these imply is what enables the painter-beholder, *without averting his eyes,* to escape Colard-Claudame's potentially transfixing gaze and to fixate instead on the sculptured profile of his friend. The same "original" state of affairs thus lies behind both points of view—but the connection between them is even closer than this suggests. For not only does the skewing of the grave provide a vital indication of the second or painter-beholder's point of view; the intimation of an "original" obliqueness in and by that skewing calls for the articulation of that sec-

ond point of view, at least to the extent that traditional conventions of perspective remain in force—always a delicate issue in Courbet's art.

It remains to be shown how an "original" obliqueness such as I have been describing may be understood as helping to generate the serpentine procession of mourners toward the open grave. Here the crucial step is to remark that what I have described as the painter-beholder's fixation on the partly hidden figure of Buchon expresses a desire to identify more than just imaginatively with that figure—to project himself as if corporeally into the representation of his friend as well as, by no means incidentally, into both the depicted depths and the material substance of the painting.* Moreover, although the figure of Buchon brings up the extreme rear of the funeral procession (the figure of Oudot at the far left scarcely seems to belong to it at all), in another sense he may be seen as bearing an altogether different relation to its progress: that is, if we yield to what I find to be a strong inclination to survey the procession as it unfolds from left to right and back toward the grave, then we *begin* with Buchon, or at any rate we do so once we connect him, along with several nearly vanished figures, with the rest of the cortège.

To think of the painter-beholder projecting himself quasi-corporeally into the representation of Buchon is thus to envision him joining the cortège *at its source*. And this suggests that the act of projection itself may *be* that source—that the painter-beholder's quasi-corporeal insertion of himself into the *Burial* via the figure of Buchon may be not only what *impels* the procession of mourners across the vast expanse of canvas to the right but also, in effect, what *generates* the procession: as if nothing less than all those life-size, black-garbed, self-reiterating bodies or quasi-bodies could sufficiently absorb, could manage to contain, the heavy urgency of the painter-beholder's determination to achieve union with the painting before him and by so doing to annul every vestige of his spectatorship. (One might even speculate that what sets the entire process going is *an initial act of beholding* on the part of the painter-beholder, an

*The importance I attribute to this act of projection and more broadly to the strategic placement of the figure of Buchon brings my interpretation of the *Burial*, so remote from Clark's in its central concerns, into contact with his after all. Not that Clark is concerned with where Buchon is located in the composition or how he is depicted. But Buchon's politics are for Clark an important key, if not quite to the meaning of the *Burial*, at least to the meaning of its primary context, and one implication of my account is that the figure of Buchon, for all its inconspicuousness, plays a decisive role in the structure I have been analyzing.

act at once reflected and occluded, represented and displaced, in the crucifix-bearer's steady stare.) Insofar as the procession leads ultimately to the grave, or at least to the blank black area above the grave, the destinies of the painter-beholder and of the beholder *tout court* may be taken to coincide: thus the composition of the *Burial,* which as we have seen enforces a (never quite complete) separation between the two points of view, turns out to reconcile them in the end. Or perhaps it only does so for the painter-beholder, who alone is qualified, in virtue of the historical individual Courbet's friendship with Buchon, to identify with the figure of the latter, and who moreover is uniquely able to undertake that feat of identification in virtue of an "original" obliqueness that positions him to ignore the crucifix-bearer and thereby to avoid a mutually distancing and hence theatricalizing mirroring of gazes. For the rest of us (not to be equated with the beholder *tout court*) the reconciliation in the *Burial* of the two points of view remains a deduction from the various structural clues I have been insisting we take seriously—unless of course we find ourselves assuming the role of the painter-beholder (and aren't we invited to do just that? and yet how limited is our capacity to do so) as we stand before the painting and subject ourselves to its multifarious beckonings, postings, and solicitations.

As the most monumental of the breakthrough pictures and the most extreme affirmation of Courbet's early Realist esthetic, the *Burial* has always been accorded a special place in his oeuvre. This seems right. But it's in the *Burial* too that we find surfacing for the first time certain deep ambiguities that until then his art had managed largely to suppress.

I am thinking primarily of what our analysis has revealed to be a structural uncertainty as to the ultimate identity of the beholder posited by the *Burial*—to be more precise, as to the meaning of the distinction between the painter-beholder and the beholder *tout court* that I have tried to show the painting seeks to establish. Or perhaps the uncertainty mainly concerns the identity of the beholder *tout court,* who on the one hand would seem to represent a more general function than the painter-beholder but who on the other can't be equated with any actual, empirical beholder or collectivity of beholders, whether in Courbet's time or in ours. It's as though in the *Burial* Courbet attempted to go beyond what until then had been the painter-beholder-specific focus of his antitheatrical project by enforcing a separation between the painting's relationship to himself as painter-beholder (the phrase is awkward but I see no other

way of saying what I mean) and its relationship to an unspecified be-
holder or collectivity of beholders other than himself; and as though the
ultimate failure of that attempt—at any rate, the mutual implication of
painter-beholder and beholder *tout court* in *both* points of view—suggests
that no such going beyond was possible, that there was to be for Courbet
no alternative to working with the primary material of his own spectator-
hood, however limiting or even solipsistic the consequences might prove
to be. What this actually meant in practice will emerge in chapters five
and six.[50]

A similar uncertainty attends the fact that the *Burial* originally bore in
its lower-left corner an enormous signature in reddish-orange paint that
today is almost wholly effaced. On the one hand, it's possible to regard
that signature as a further, supplementary self-representation, related in
kind to the fantasmatic initials I have claimed to read in the figures of the
two laborers in the *Stonebreakers*. On the other hand, the signature in the
*Burial* struck contemporary viewers as an act of blatant self-advertise-
ment (we know this from caricatures such as Bertall's), and thus would
inevitably have compromised the antitheatrical aims I have been attrib-
uting to the painting as a whole (more on this in chapter seven).[51] The
subsequent removal of the signature is therefore intriguing. Did Courbet
himself efface it? If so, why and when? All this raises the larger question
of the *Burial*'s notoriously physical paint handling, which not unlike the
outsize signature may be viewed as enacting or at least as confirming the
painter-beholder's quasi-incorporation within the painting, but which
from the first has inspired commentators (Rosen and Zerner among the
latest) to describe the painting in terms of metaphors of confrontation
and aggression. The size and scale of the *Burial* are themselves open to
this double interpretation. And my point, to be generalized in chapter
seven, isn't that those who emphasize the *Burial*'s confrontational aspects
are simply mistaken, but rather that something radically different and
fundamentally important is also going on—indeed that that something
may be precisely what explains the features of the *Burial* that have been
seen unequivocally as overbearing the beholder.

SIGNIFICANTLY, THE monumental canvas that Courbet went on
to paint after the *Burial, The Peasants of Flagey Returning from the Fair*
(fig. 60), marks a withdrawal from such complexities on several counts.
(In fact the work that survives under that name is not the original of 1850

but a new version done in 1855 and embodying several changes, none of which, it seems, altered the painting's fundamental character.)[52] First, neither the composition of the new version nor, as far as one can tell, that of the original painting contains anything that could be described as specifying different points of view. Second, although the central rider in a tall hat and peasant's smock depicts Courbet's father, an identification that links the *Peasants of Flagey* with the *After Dinner* and the *Burial*, no figure, element, or motif in the last of the breakthrough pictures can be associated with the painter-beholder at work on the painting. (As regards actions alone, the likeliest candidate might seem to be the man in the right foreground who strides toward the left while smoking a pipe, holding an umbrella and a string leading to a pig in his right hand, and gripping in his left hand a strap that supports the container on his back, but the overall impression he creates differs sharply from that of figures in other paintings whom I have described as self-representations.) Third,

Figure 60. Gustave Courbet, *Peasants of Flagey Returning from the Fair,* original version 1850, new version 1855.

the composition of the *Peasants of Flagey* is based chiefly on the motif of slow continuous movement toward the left foreground, only slightly complicated by the more nearly lateral leftward movement of the man with the pig. (Originally a woman balancing a basket on her head was shown behind him and further back in space walking in the same direction; the silhouette of her basket can just be discerned above the horizon toward the right-hand framing-edge.) This is to say that we find in the *Peasants of Flagey* an extension of the processional theme of the *Burial,* but with none of the latter's subtlety or complexity. Instead there is an emphasis on the repetitive and automatistic movements of the animals plodding wearily along at day's end: with every step they draw nearer to the picture surface and by implication to the beholder (I am deliberately referring neither to the painter-beholder nor to the beholder *tout court*), obliquely closing a gap that the angle of the road suggests won't quite be closed within the painting, while at the same time the trancelike state of all the figures except the young man riding at Régis Courbet's side not only evokes their obliviousness to being beheld but is perhaps intended to dull the beholder's awareness of such a gap. The mechanical-seeming walking man in the right foreground, who appears to have been present in the earlier composition as well, reinforces the suggestion of something like somnambulism (as does his pig, floppy ears obscuring its eyes), while the sheer consistency of the heavy pigment across the entire expanse of the canvas produces an effect as of a material surface in which the beholder's gaze *sinks,* not to emerge again.[53] (As though the painting's presence to the gaze could be offset by refusing to allow the latter to return to its source.) All in all, the *Peasants of Flagey*—the version that survives—is by common consent much the least satisfactory of the breakthrough pictures, and I suggest that a main reason this is so is because it represents an attempt to deal with the issue of beholding by strictly "impersonal" means that in the end weren't nearly adequate to the task, or rather that needed to be carried to bizarre, hence disruptive, extremes of simplification (e.g., the treatment of the animals and figures) or exaggeration (e.g., the handling of pigment) in order to make themselves sufficiently felt. The result is a work that, like the *Burial,* has always been compared with *images d'Épinal,* but in this case the comparison points to an element of willfulness that the pervasive somnolence of the proceedings denies but can't undo.

One last work should be seen in this connection: an enormous, unfinished picture, *Firemen Rushing to a Fire* (fig. 61), that Courbet began

following his return to Paris in the summer of 1850 and abandoned definitively some time the following year.[54] It differs from the breakthrough pictures in that it was intended to represent an urban rather than a rural subject. But what links it to the *Peasants of Flagey* in particular is that it exploits the motif of a massive and repetitive movement of bodies toward the picture surface as a means of eliding the gap between painting and beholder, and what is more, that it does so with an uncharacteristic violence that suggests extraordinary measures were needed and also with an emphaticness in one crucial detail that has no precedent or sequel in Courbet's art. Thus the firemen are depicted rushing forth in pairs (actually in pairs of pairs, units of four men abreast pulling the fire wagon with its pumps and hoses) ostensibly toward the left foreground; but as Toussaint and others have remarked, two conspicuous figures in the right-hand portion of the picture, the captain and another personage in a peaked cap and a smock, gesture authoritatively toward the right foreground and are already striding in that direction, which indicates that the firemen *en masse* are in the process of executing a powerful wheeling

Figure 61. Gustave Courbet, *Firemen Rushing to a Fire*, 1850–51.

movement that will carry them not only across the immediate foreground but also, inevitably it would seem, beyond the picture surface into our space. There is even the further suggestion, conveyed by the pointed opposition between the working-class woman holding a baby seen from the front in the left foreground and the bourgeois couple seen from the rear further back at the right, that the *painting itself* participates in that movement, which therefore threatens to sweep the beholder off his feet, indeed to render unoccupiable the entire region in front of the canvas. And in fact we discover in the center foreground, nearer to us than any other personage, a violently gesticulating figure of a man, presumably a bystander, being tumbled nearly out of the picture by the charging *pompiers*. Naturally I associate that figure with the beholder; I regard the strategy of expelling him from the picture as a mark of desperation, a throwback to the comparatively primitive measures we noted much earlier in the *Desperate Man* and the *Man Mad with Fear;* and I see in the *Firemen* as a whole, which in its impenetrable obscurity and permanently unfinished state remains little more than a gigantic oil sketch, perhaps *the* exemplary failure in all Courbet's art.

(Is it possible to be more precise? Are we dealing here with the painter-beholder or beholder *tout court* or perhaps some other function? It's impossible to say: as in the *Peasants of Flagey* there is no hint of a specific relation to the painter-beholder; but the notion of the beholder *tout court* was introduced by me in order to account for a separation between points of view in the *Burial,* a structure conspicuously absent from both the *Peasants of Flagey* and the *Firemen*. It may be, then, that what particularly defines the antitheatrical modality of the latter pictures is just this attempt to come to grips with the issue of beholding not merely as "impersonally" as possible but also with a certain deliberate coarseness or generality. If so, the failure of the *Firemen* seems to have been definitive in this regard too.)

# 5    Real Allegories, Allegories of Realism: *The Wheat Sifters, The Painter's Studio,* and *The Quarry,* with an Excursus on *The Death of the Stag*

T HIS CHAPTER focuses primarily on three major paintings of the middle 1850s—the *Wheat Sifters* (1853–54), the *Painter's Studio* (1854–55), and the *Quarry* (1856–57)—each of which lends itself to being read, in a phrase that Courbet applied to the *Studio,* as a "real allegory" of his enterprise. Taken together they constitute a remarkable sustained meditation on the nature of pictorial realism, a meditation whose content, one might almost say whose conclusions, I find the more compelling in that the manifest subject matter of the *Wheat Sifters* and the *Quarry* has nothing to do with painting; while in the case of the *Studio,* a painting about painting if there ever was one, the account of Courbet's enterprise I shall extract from it both can and can't be said to have been authorized by the work itself. In the course of my discussion of these magisterial canvases I shall also have something to say about the *Bathers* (1853), the drawing known as the *Seated Model* (ca. 1853–54), the *Source* (1868), and the *Death of the Stag* (1866–67).

Painted in Ornans during the winter of 1853–54, *The Wheat Sifters* (pl. 6) depicts a rural subject, the sifting of grain in a *bluterie* or bolting room.[1] It is horizontal in format and, although only about two-thirds the dimensions of the *After Dinner,* conveys an impression of grandeur. The scene comprises three figures: the principal sifter, a powerful woman depicted mostly from the rear, who kneels in the foreground and wields with both arms extended a large round sieve through which grain is falling onto a canvas ground cloth; a second, perhaps younger woman, seated cross-legged on the ground cloth to the left, who drowsily picks bits of chaff out of a large white dish in her lap; and a young boy with dark hair, sitting toward the kneeling sifter's right on what appears to be an overturned bowl, who peers intently into the dark interior of a wooden *tarare,* an early mechanical device for cleaning grain, the door to

which he holds open with his right hand.[2] (The model for the kneeling sifter has traditionally been assumed to be Courbet's sister Zoë; another sister, Juliette, has been recognized in the seated sifter; and Hélène Toussaint has suggested that the boy depicts Courbet's illegitimate son, Désiré Binet, who would have been six years old when the painting was begun.)[3] Against the wall behind the sifter at the left stand three bulging sacks of grain, and slightly nearer to us and to their right, in the interval between the two women, a sleeping cat lies curled up behind a bowl. Although the setting is plainly an interior, the room is flooded with light and the painting as a whole is brighter and coloristically more adventurous than any other work of comparable size in Courbet's oeuvre. The kneeling sifter wears an orange-rose jerkin and skirt, a white blouse, and a yellow kerchief; the other woman wears a simple gray dress and a white bonnet; the young boy's shirt is blue; and most of the other colors in the painting are variations of grey, white, cream, and beige except for the dark brown of the *tarare* and the boy's trousers, the lighter brown of the door to the room, and the pervasive brownish ochre of the fallen grain. Toussaint rightly stresses the originality of the *Wheat Sifters* in this and other respects, though I don't agree with her suggestion that its unique color harmony and bold linear layout reveal the influence of Japanese prints;[4] nor, as we shall see, can it finally be said either of the actions the painting depicts or of its general mise-en-scène that they are "without precedent or comparison in Courbet's previous work."[5]

The most interesting discussion of the *Wheat Sifters* to date is by Linda Nochlin, who finds its subject "extraordinarily opaque" ("No one has ever even defined the precise nature of the subject, much less its broader ramifications," she adds) and goes on to speculate that the painting may be in part "an image of progress in the realm of agricultural operations":

On the left, one may hypothesize, we have lazy, retrograde and inefficient hand separation of wheat from chaff; in the center, the more progressive and energetic use of the *crible* or sieve. . . . To the right . . . would be the final stage of sifting, or milling progress—mechanization taking command, albeit on a rather simple level—with a device so simple a child can run it: the *tarare,* an implement into which grain is poured through a funnel at the top and falls through a series of graduated meshes which divide the grain from the heavier chaff.[6]

Such a theme would be implicitly political in that "by suggesting that methods of agricultural work do in fact change, Courbet is automatically taking the woman agricultural worker out of the realm of transcendent, unchanging nature and reinserting her into the realm of history—a realm

in which there can be change and progress."[7] One difficulty with this interpretation, as Nochlin recognizes, concerns the compositional centrality, coloristic dominance, and "confident muscular expansiveness" of the kneeling sifter, who isn't in any sense subordinated to the young boy and the *tarare*.[8] More generally, the kneeling sifter provides, to quote Nochlin once more, "an extremely compelling image of the woman agricultural worker";[9] but it's an image that largely resists being understood in sociohistorical terms, and one of the merits of Nochlin's article is its acknowledgment of the extent to which Courbet's figure frustrates such a project. Thus she contrasts the sifter with Millet's contemporary images of virtuous working women, which she characterizes as "quasi-religious icons of domesticity" and, in the crucial instance of the *Gleaners* (1857; fig. 25), as transforming "the genuinely problematic implications surrounding the issue of gleaning . . . into what might well be called a nineteenth-century realist 'version of the pastoral.'"[10] But this by itself merely points up the difference between Millet and Courbet without yielding even the rudiments of a social or political account of the *Wheat Sifters*, and Nochlin soon turns to Käthe Kollwitz's *Losbruch*, an etching of 1905, in an effort to find an analogy, which she knows to be inexact, to Courbet's painting of more than fifty years before. (A not dissimilar sense of bafflement marks Toussaint's discussion of the *Wheat Sifters* in her catalog of 1977–78: thus she doubts that any peasant woman of the period would have sat directly on the floor like the figure at the left, and, it seems partly for that reason, goes on to associate the gesture of the kneeling sifter's outstretched arms with the attitudes of figures in Japanese woodcuts of the Kabuki theater.)[11]

A different approach would seem to be in order, and by now it will come as no surprise that I want to juxtapose the *Wheat Sifters* not with images by Millet, Kollwitz, or Jules Breton (another of Nochlin's comparisons) but rather with Courbet's own *After Dinner* (pl. 3) and *Stonebreakers* (fig. 47).

To begin with the first of these, the central figure in the *Wheat Sifters* is closely analogous both in general orientation—facing into the picture and slightly to the right—and in aspects of her pose—kneeling and sitting both being alternatives to standing—to the figure of Marlet in the *After Dinner*. In addition Marlet's action of lighting his pipe anticipates in milder form that of the sifter whose right arm is not only elevated but extended in the performance of her task. The kneeling sifter differs from Marlet both as regards her sex (I am deferring all discussion of issues of

gender until the next chapter) and by virtue of the strong backward sway of her upper body and the complementary forward lean of her head, but there is something of this combination in another figure in the *After Dinner,* the elder Courbet slumped in his chair at the extreme left. By the same token, although the sheer physical effort being put forth by the kneeling sifter goes beyond anything to be found in the *After Dinner,* there is a parallel of sorts between what we register as her sustained physical engagement in her work and Promayet's equally concentrated and by no means unphysical absorption in his playing. And there is a further sense in which, despite the contrast between the peculiar radiance of the *Wheat Sifters* and the smoky chiaroscuro of the *After Dinner,* the later painting, with its drowsy farm girl and its dozing feline, not to mention its sacks of grain the tops of which droop limply like so many heads of sleepers, is just as strongly marked by a thematics of sleep as the earlier one.

As for the resemblance between the *Wheat Sifters* and the *Stonebreakers,* in the first place it's a matter of the close similarity between the figures of the kneeling sifter and the young laborer. Both face obliquely into the picture at approximately the same angle; both have upper bodies that lean backward and heads that bend forward; both are manipulating large round implements that in turn enable them to process raw or "brute" materials (unsifted grain, broken rocks); and both strike us as absorbed in routine repetitive operations, though the sifter's actions are felt to evince an energy and a purposefulness absent from the young stonebreaker's. There is also a visually more attenuated but equally important affinity between the figures of the sifter and the older stonebreaker by virtue of the latter's posture—kneeling, if only on one knee—as well as of his action of raising a hammer, which in a general way is akin to the elevation of the sieve in the later canvas. This becomes especially evident if we consider the two wheat sifters as a unit, the relationship between the seated and kneeling figures being loosely analogous to that between the young and old stonebreakers, though there continues to be a sense (in fact more than one) in which we should probably think of the action of the sifter wielding her sieve as combining those of both laborers in the earlier picture.

I find it impossible to believe that the affinities between the *Wheat Sifters* and the first two breakthrough pictures were intended as such by the painter. Far more likely, they are another manifestation of Courbet's instinctive predilection for a particular array of themes, figural motifs,

and compositional structures, which in the previous chapters of this book I have interpreted as representing, indirectly or metaphorically, the painter-beholder's physical and psychical engagement in the activity of painting and, ultimately, his desire to transport himself as if bodily into the work taking shape before him. These are exactly the terms in which I understand the *Wheat Sifters,* which in this regard marks a return to the pictorial strategies and ontological commitments of the first two break-through pictures, but which goes far beyond the latter in the direction of a new density of reference and consistency of implication.

Thus for example it's possible to see the central, kneeling female figure as a surrogate for the painter-beholder by virtue of her posture (analogous to though not identical with his posture when seated in a chair before the picture), her orientation (facing into the picture and so roughly matching his), and the character of the effort she is putting forth (concentrated, physical, requiring the use of both hands). The seated, drowsy sifter plucking bits of chaff from a dish can also be considered such a surrogate; in fact I would go further and propose, by analogy with the *Stonebreakers,* that her relative passivity, subordinate status, and place in the composition make her a figure for the painter-beholder's left hand holding his palette in distinction to the kneeling sifter understood now as representing specifically the painter-beholder's right hand wielding a brush or knife. (This despite the fact that her upraised sieve in no way resembles a brush or knife, a point I shall qualify somewhat in chapter six.) But whereas the smashing of large stones into a profusion of smaller ones in the *Stonebreakers* appears to bear no relation to the physical production of a painting, the kneeling figure in the *Wheat Sifters* deposits a steady shower of grain onto a whitish ground cloth, an action that invites being read, once the context I have been elaborating is even tentatively accepted, as a representation of the project of transporting and applying paint to canvas. This would be true, I think, even if the grain weren't depicted falling onto a large rectangle of canvaslike material, but the perfect appropriateness of the ground cloth to my reading amounts to a separate argument in its favor. Furthermore, the position of the kneeling sifter on top of and encompassed by the ground cloth may be seen as enacting the incorporation of the painter-beholder within the painting that I have claimed was a prime, if strictly speaking impossible, objective of Courbet's antitheatrical enterprise. (That the other figures in the *Wheat Sifters* are also encompassed by the ground cloth is to the point as well.) Finally, the falling and fallen grain has been rendered by Courbet

as a multiplicity of flecks and granules of brownish ochre pigment that even a viewer unaware of any metaphorical dimension to the *Wheat Sifters* might well see as calling attention to its existence as mere stuff—the paint in those areas actually looks *sticky*—which is to say as the means rather than the product of the representational act. (Taken by itself, such a perception is within the bounds of traditional accounts of Courbet's alleged materialism.) All this isn't to deny that the physical process by which the grain/pigment is shown being precipitated onto the ground cloth/canvas bears only a distant analogy to the specific operations by which the *Wheat Sifters* was made. And yet a century later ambitious paintings *were* being made by procedures similar to those the *Wheat Sifters* represents (I'm thinking of the works of Jackson Pollock and Morris Louis, among others)—a coincidence, certainly, but one not without a certain allure.

Nor do we find an equivalent in the *After Dinner* or the *Stonebreakers* to the figure of the young boy peering into the *tarare*. I take the boy to exemplify a mode of visuality that can't quite be called beholding: first, because he is too near the object of his looking for that notion to apply; and second, because the absolute blackness of the *tarare* interior suggests that nothing can be seen within it. To put the second point more strongly, the blackness of the *tarare* interior implies a denial of beholding in the very act of looking, much as in the *Burial* the great black "blind spot" hovering above the open grave represents the denial or, better, the eclipsing of vision that would inevitably accompany the painter-beholder's quasi-corporeal absorption into the painting. Where the *Wheat Sifters* goes beyond the *Burial* is in its use of the boy to reflect or amplify the status of the kneeling and seated sifters considered as surrogates for the painter-beholder: that is, to the extent that we can regard the two sifters as not just representing but virtually embodying the painter-beholder (and the falling and fallen grain as not just representing but epitomizing the pigment out of which the picture is made, etc.), the relation of the painter-beholder to the product of his labors is no longer one of beholding but a mode of identification in which vision as such is all but elided. And it's that all-but-elision that the young boy looking into the *tarare,* and perhaps also the slightly too abrupt featurelessness of the kneeling sifter's lost profile, may be read as thematizing. Indeed the rectilinearity of the *tarare* suggests an analogy with that of the painting itself, just as the implements on top of the *tarare* may be associated, along with the kneeling sifter's sieve and the seated sifter's dish, with the painter-

beholder's tools—further indications that the sifter and the boy are intimately linked. Note too that tacked to the door behind the *tarare* (and like the latter cut off by the right-hand framing-edge) is an *image d'Epinal,* which would seem to reinforce a general thematics of representation while looking forward to the depiction of an actual painting in the *Studio.*

All this may seem to invest the *tarare* with as much significance as it can bear, but a further aspect of its meaning emerges when it is viewed in apposition to the bright patch of sunlight falling slantwise on the wall above and to the right of the sacks of grain. (The shadow pattern of latticework plus foliage of some sort within the patch indicates that the light has entered the room through a high window or skylight, the exact location of which is impossible to determine.) In the context of the reading of the *Wheat Sifters* I have been pursuing, it's tempting to construe the relationship between the *tarare* interior and the patch of sunlight—mediated compositionally and thematically by the upraised sieve—as expressing the obvious but important truth that the quasi-corporeal absorption of the painter-beholder into the painting not only didn't put an end to representation (as did the virtual expulsion of the beholder-surrogate from the *Firemen*) but rather gave rise to a specific representational effect. The hallmark of that effect, we can further state, is a certain tension, basic to Courbet's Realism, between a seeming gratuitousness and unconditionedness—what more vivid emblem of the "natural" could there be than sunlight on a wall?—and an implicit insistence on the actual production of the painting, as expressed in the shadow-lattice that reveals the patch of sunlight itself to be in that respect a human artifact. Indeed I suggest that the shadow-lattice can be read as representing the rectilinear wooden stretcher that supports the painting from the other side, which if true would mean that the *Wheat Sifters* contains what might be called corporeal metaphors for all three primary components that went into its making: pigment, canvas, and stretcher. In view of the larger issue of antitheatricality framing Courbet's enterprise from the first, it seems wholly fitting that the kneeling sifter and her companions are unaware of the patch of sunlight, which on the face of it bears no relation to their actions but allegorically may be understood as the product of nothing else.

It follows that the figure of the kneeling sifter baffles Nochlin's sociohistorical categories because it is crucially a metaphor for the painter-beholder painting the *Wheat Sifters.* At the same time, that Courbet in

1853–54 represented the making of the *Wheat Sifters* through the vehicle of a mostly female cast of characters has its own undeniable and, in a sense, political importance, about which I shall have more to say in chapter six.

Finally, I want to note one more common point between the *Wheat Sifters* and the *Stonebreakers*. In my discussion of the latter I called attention to the way in which the two protagonists could be read as delineating (embodying? personifying?) the letters "G" and "C", the painter's initials, which I characterized as still another mode of self-representation. Now I want to suggest that the same two letters can be found in the later picture in almost monogram form, with the principal sifter, or her head, body, and legs, describing Courbet's typically backward leaning "G" and the sieve, the sifter's torso and thighs, and the grain on the ground cloth in front of her making a similarly inflected "C." (This would be another sense in which the action of the principal sifter combines those of both figures in the earlier picture.)

NATURALLY I'M aware that some readers will be unpersuaded by my interpretation of the *Wheat Sifters* as an allegory of its own production, especially in view of my claim that Courbet himself wouldn't, in fact couldn't, have expressed his intentions in those terms. It's therefore potentially significant both for that interpretation and for my larger argument that his next large-scale multifigure painting, *The Painter's Studio* (1854–55; fig. 62), was designated by him as allegorical and that it depicts at its center Courbet seated before a picture on which he is working: *potentially* significant, because the mere fact that it bears an intriguing title and includes a self-portrait of the artist in the act of applying paint to canvas neither supports nor disproves the account of Courbet's enterprise I have been developing in this book. One might even say that the presence in Courbet's oeuvre of a painting that ranks with Velázquez's *Las Meninas* and Vermeer's *Artist in His Studio* as one of the three supreme representations of representation in all Western art raises the stakes of my argument in at least this respect: if there is no significant payoff here, the reader will be even less likely than before to be persuaded by my other readings; by the same token, a compelling demonstration of the relevance of my approach to this particular painting will inevitably lend added force not just to my larger argument but also to those interpreta-

tions of individual works (e.g., the *Man with the Leather Belt*, the *Stone-breakers*, the *Wheat Sifters*) that until now may have seemed to go too far.

The painting in question, whose full title is *The Painter's Studio, Real Allegory Determining a Phase of Seven Years in My Artistic Life* (*L'Atelier du peintre, allégorie réelle déterminant une phase de sept années de ma vie artistique*), was done in great haste during the late fall and winter of 1854–55. Courbet had hoped to exhibit it, along with a selection of other works of his maturity, in the Exposition Universelle des Beaux-Arts to be held in Paris later in 1855; but the official jury rejected both the *Studio* and the *Burial,* arguably his most important canvases to date, and rather than submit tamely to their exclusion he arranged to hold a counter-exhibition devoted solely to his art in a temporary structure built, at his expense, as near to the Exposition Universelle as he could get. Character-istically, he expected to draw vast crowds and, at twenty sous a head, to make a financial killing while embarrassing the government. In the event he was disappointed: by all accounts attendance at his Pavillon du Réal-isme was sparse, so that far from coming out flush he ended up taking a loss.[12]

Although the *Studio* too was painted in Courbet's makeshift studio in

Figure 62.  Gustave Courbet, *The Painter's Studio*, 1854–55.

Ornans, the studio it depicts is the one he occupied on the Rue Haute-
feuille in Paris from the late 1840s until 1871. The composition com-
prises roughly thirty figures, divided, to a casual glance, into three or
more distinct groups: on the left, an assortment of figures who until re-
cently have been seen as representing various general types rather than
specific individuals—a Jew, a curé, a veteran of 1793, a huntsman, an
undertaker's mute, and so on; on the right, a number of persons who for
the most part are identifiable as friends and supporters of the artist, in-
cluding Baudelaire (seated reading at the far right), Champfleury,
Buchon, Promayet, the political philosopher and fellow Franc-Comtois
Pierre-Joseph Proudhon, and his most important patron, Alfred Bruyas;
and, in the middle of the canvas, Courbet himself seated painting a land-
scape under the attentive gazes of a naked woman and a peasant boy.

The full title of the *Studio* and especially the seeming oxymoron, *allé-
gorie réelle,* have led numerous scholars to try to unlock its iconographic
program. In these attempts they have relied on a long, undated letter
from Courbet to Champfleury in which the painting is described in some
detail. Indeed they have owed to that letter and a few others much of
their understanding of the general significance of the figures on the left;
and certain broad distinctions the letter sketches, most importantly be-
tween "all the shareholders, that is, friends, workers, and art lovers" on
the right, and "the other world of ordinary life, the people, misery, pov-
erty, riches, the exploited, the exploiters, those who live on death" on the
left, have been fundamental to most exegeses of the composition as a
whole.[13] Not that the existence of such a document has produced consen-
sus—far from it. Thus the *Studio* has been characterized by Nochlin as a
Fourierist allegory; by Alan Bowness as "the modern artist's declaration
of independence, of absolute freedom to create what he wants to create";
by Werner Hofmann as a dense layering of fundamental themes such as
the ages of man, the social tensions of the mid-nineteenth century, the
metamorphosis of womanhood, the conflict between the claims of higher
truth and fidelity to objective fact, etc.; by James Henry Rubin as a
mainly Proudhonian meditation on work, nature, the artist, and the so-
cial question generally; by Toussaint as a complex, possibly subversive
political statement charged with Masonic symbolism; and by Klaus
Herding, building on Toussaint's discovery that most if not all of the
figures in the left-hand half of the composition represent specific histori-
cal personages, as an *adhoratio ad principem* or an exhortation to the ruler
calling for reconciliation between contending nations and parties.[14] To

expand slightly on the last two contributions, which have transformed our understanding of the *Studio's* allegorical program, the most momentous of Toussaint's discoveries is that the seated poacher (or *braconnier*) wearing high boots and attended by dogs in the left foreground is a barely disguised portrait of Napoleon III, whose devotion to dogs was legendary, who was often symbolized by a jackboot, and who Courbet would have regarded as having seized the Republic for his own private gain.[15] Herding in turn has gone on to relate the inspiration of the *Studio* to the internationalist project of the Exposition Universelle, and to propose that it was intended by Courbet as both an appeal for peace and reconciliation addressed to Napoleon III and an assertion of the healing power of his own art by virtue of its special relation, emblematized by the landscape on the easel, to what Herding calls "primary nature."[16] In a recent essay Nochlin has emphatically endorsed Herding's interpretation, which seems to be on the way to being widely accepted as the definitive solution to the puzzle that the *Studio* has always represented to its commentators.[17]

My own reading of the *Studio* has a different focus. I shall concentrate on just one portion of the *Studio,* the central group organized around the self-portrait of Courbet at his easel (pl. 7), in order to analyze more closely than has previously been done Courbet's representation of the act, the immediate context, and the emerging artifact of representation; and by so doing to bring to light another allegory, one whose operative principles—not simply whose meaning—are altogether different from those presumed to be at work in the painting even by such sophisticated iconologists as Toussaint and Herding. I take the central group to comprise the following elements:

1. The figure of the painter, seated on a high-backed wooden chair (more precisely, on a cushion on the chair), holding in his left hand a rectangular palette, several brushes, and a palette knife, and in his right hand a long, rather fine-tipped brush with which he is adding a stroke to the almost completed picture on the easel before him.

2. The figure of a naked woman, said by Courbet in his letter to Champfleury to be a model watching him paint and described by Silvestre as a personification of truth.[18] She stands directly behind the painter's chair and with her left hand holds against her upper body a sheet of white cloth, which however fails to cover her breast and flank. Almost lost in shadow, the woman's right forearm and hand are raised to her

paintings by Courbet we have examined, and *a fortiori* the central group interpreted as an image of relationship between painting and painter-beholder, are not. At the same time, that the boy's attention appears riveted not on the painting on the easel but rather on the painter-beholder's active, productive right hand is perhaps emblematic of an enterprise that called for the painter-beholder to follow that hand into the painting.

(Another point that emerges in the X-rays is that the figure of the model was originally depicted largely from the rear. This suggests that Courbet began by conceiving of the model along the lines of Marlet in the *After Dinner* or the kneeling sifter in the *Wheat Sifters,* and that only when he came to align her with the painter at his easel—the painter-beholder in, not of, the *Studio*—did he feel the need to add another figure, the peasant boy, that would establish a connection of sorts between the painter-beholder of the *Studio* and the *Studio* as a whole.)

Finally, it hardly needs saying that the relationships we have noted among the figures and the painting on the easel in the central group are consistent with my readings of previous works by Courbet. But it should be emphasized that the central group, for all its seeming explicitness as a statement of Courbet's representational project, has required interpretation no less than the other pictures and drawings we have considered in this and earlier chapters, and moreover that my account of the central group was made possible by the readings that preceded it. But this in turn in no way implies that that account isn't deeply confirming of the larger view of Courbet's enterprise that I have been developing from the outset; rather, it underscores the point that in an interpretive study such as the present one, confirmation when achieved is never a matter of reaching bedrock, a level of explicitness that isn't itself the product of interpretation, a primal scene whose meaning is self-evident and whose position at the origin of a chain of substitutions and transformations is beyond all doubt.

Before moving on to engage the *Quarry,* I want to look briefly at three works, two paintings and a highly finished drawing, all of which relate importantly to the *Wheat Sifters* and the *Studio.* The earlier of the paintings is the large and in many respects uncharacteristic *Bathers* (1853; fig. 63), which preceded the *Wheat Sifters* by roughly a year. What I want to call attention to is, first, the close similarity in general orientation as well as in the posture of the upper body between the standing bather and the kneeling sifter, and second, the fact that, like the central group in the

invariably cited as true Delacroix's observation that the picture on the easel "creates an ambiguity: it has the character of a *real sky* in the middle of the painting."[21] The import of that ambiguity, to the extent that it is one, has mostly been ignored. But of course what interests me about Delacroix's remarks is the implication that the picture on the easel bears a far from conventional relation to the rest of the painting.[22]

Second, the permeability, not just of the apparent physical limits of the picture on the easel but also of that picture considered as a physical barrier separating the contents of the right half of the *Studio* from that of the left half, is further suggested by the chiasmic relationship between the figures of Courbet and the model and the two figures just the other side of the easel, the Irishwoman nursing her infant and the partly draped manikin. By that I mean that in both cases a male and a female figure are paired, but that whereas on one side of the painting the male figure is clothed and seated and the female figure naked and standing, on the other side the terms are reversed, a structure that simultaneously asserts and suppresses an analogy between the two pairs. More broadly, the double movement into and out from, indeed through and beyond, the picture on the easel that my reading of the central group has brought to light implies an interchangeability of pictorial elements and in indeterminacy of position at odds with the thematic antithesis between the left and right halves of the composition emphasized by Courbet in his letter to Champfleury. This helps explain one of the oddest features of the *Studio*—the similarity of pose and mood between figures who, like the *braconnier* (or Napoleon III) on the left and Champfleury on the right, seem as if they ought to contrast programmatically with one another.

Third, one consequence of the identification of the naked model with the picture on the easel is that her status as an independent beholder of that picture is implicitly neutralized. By the same token, her relation to the seated painter suggests that she may represent if not the beholder *tout court* at any rate what in chapter four I referred to as the-beholder-"in"-the-painter-beholder ("in" here being defined phenomenologically as "behind"). But what of the figure of the peasant boy standing in front of the painter? He isn't mentioned in Courbet's letter to Champfleury, and in fact X-rays reveal that he was a late addition.[23] Perhaps we should think of him as representing the painter-beholder *of,* as distinct from *in,* the *Studio*—more precisely, as expressing the distancedness and separateness of the painter-beholder *from* the *Studio,* which considered as a whole is scenographically and ontologically conventional in ways that other

the idea of nature and whose body disappears from view roughly at the level of the bottom of the picture on the easel, may be regarded as a synecdoche for that picture: seen in that light, her position directly behind the figure of the painter as much as asserts that the latter is physically enclosed, one might say subsumed, within the painting he is making, wherever the ultimate limits of that painting are taken to lie. Certain partial accords, amounting to visual rhymes and off-rhymes, between the figures of the model and the painter—for example, between the contours of her hip and buttock and his left shoulder, or between her naked breast and his head—further hint at an overcoming of physical boundaries between both persons and things (more on this in connection with the *Quarry*). And we are all but compelled to read the figure of the model as bearing an intimate relation to the painting on the easel, not only by the role she plays with respect to the waterlike representations of the white sheet and discarded dress, but also by the exquisite series of parallels, unmistakable as soon as discerned, between, on the one hand, the familiar forward tilt of her head as well as the precise curves of her neck and hairdo and, on the other, the trees emerging at an angle from the hillside and spreading their branches in the upper portion of the canvas.[19] (The central group thus evokes a classical-seeming ideal of harmony between human figure and natural scene. But it must be stressed, first, that in this instance the natural scene is manifestly a work of artifice; and second, that the evocation of an apparent harmony has been brought about by an enterprise with other ends in view than the imaging of a relationship between human beings and nature, to say nothing of that "primary nature," conceived as a source of artistic power and moral authority, that Herding has associated with the landscape on the easel.)[20]

We see now why it's misleading to think of the painter in the central group as engaged in painting a landscape in the ordinary definition of the term: it would be nearer the truth of our findings to claim that he is portrayed representing the central group as such, wherever *its* ultimate limits are taken to lie. We also see why it's no less misleading to think of him as doing this in the absence of the scene "itself": there is an important sense in which a certain scene of representation—comprising at least the canvas on the easel and the painter-beholder seated before it, and grounded in a vital problematic within French painting from the mid-eighteenth century on—must be imagined to have been in place all along.

A few further observations. First, commentators on the *Studio* have

struck by the fact that only after 1855 did landscape as a genre come to play a major role in Courbet's art, so that by giving pride of place to the picture on the easel he was not so much reviewing a phase in his artistic life as looking forward to a phase to come. They have also found it deeply puzzling that Courbet the avowed Realist, in an immense canvas intended as a public manifesto, should have portrayed himself at work on a painting of a natural scene without having the original, the scene "itself," before his eyes. These are important cruxes, but rather than address them directly I want to make a few observations concerning the relationships among the painting, the painter, and the model. I have remarked that the painter's lower body appears virtually to merge with the dark bottom portion of the painting on the easel. Now I want to suggest that the painting on the easel, representing as it does a river landscape issuing, in the immediate foreground, in what seems to be a waterfall, may be seen in turn as *flowing into* the figure of the painter: as if the implied movement of the painter's lower body *into* the painting is reciprocated, or perhaps anticipated, by a countermovement of the painting *out toward* the painter. What's more, the outward flow of water (or waterlike representations) doesn't cease when it reaches the painter; on the contrary, the falling, spreading folds of the white sheet that the standing model presses to her breast, the seething pinkish whirlpool described by her discarded dress, and, finally, the minor rapid or cascade suggested by the white cat playing at the painter's feet, are all visual metaphors for the outward flux, descent, and eddying of waters whose source is the very painting that the painter has been depicted bringing to completion.*

All this implies that the figure of the painter in the central group is as it were *already* immersed in the painting on which he is working (just as the kneeling woman in the *Wheat Sifters* is from the start encompassed by the canvas ground cloth) and that the painting on which he is working can't be identified merely with the canvas rectangle on the easel. These implications are given added force when we consider that the figure of the artist's model, whose nakedness has traditionally been associated with

---

*Note, however, the thin strip of land with trees on it that extends across the foreground of the picture on the easel, which suggests that Courbet hesitated to allow the river to flow too directly into the seated painter's lap (even as he allowed it metaphorically to surge beyond the painter in the ways I have described). Similar "damming" structures appear in the foregrounds of the Zurich, Hamburg, and Washington, D.C., versions of the *Source of the Loue* (see fig. 80), also without arresting the implied flow of water out from the painting.

tween the worlds of painting and painter-beholder that I first called attention to in my comments on the bottom framing-edge in self-portraits like the *Sculptor,* the *Man with the Leather Belt,* and the *Wounded Man,* and that we saw taken further in the breakthrough pictures and the *Wheat Sifters.*

Or consider the fact, mentioned in chapter four, that the relationship between the figure of the painter and the picture on the easel in the central group, far from being the natural (i.e., conventional) one of mutual facing, is peculiarly oblique, sidelong, averted. This is sometimes rationalized as an attempt by Courbet, whose vanity was legendary, to display his fine "Assyrian" profile (his adjective in the letter to Champfleury) at whatever cost to verisimilitude. But such an explanation is obviously unsatisfactory, and it soon becomes necessary to remark, first, that nearly the whole of the painter's body is projected against and in effect comprehended by the landscape he is in the act of painting, exactly as if he were meant to be perceived leaning back against the hillside rising above the riverbank at the right (cf. *Courbet with a Black Dog,* the *Sculptor,* the *Wounded Man*); and second, that the painter's posture relative to the canvas on which he is working is similar in crucial respects to the posture of key figures in other paintings we have discussed. For example, in the *Man with the Leather Belt* (pl. 2) the sitter turns his right shoulder toward the picture plane, tilts his head back and toward the side, and seems to slide forward in his chair, an impression enhanced by the unexpected congruence between the forward thrust of the portfolio beneath his elbow and the pillow on which the painter is seated in the central group. (The affinity between the respective depictions of the sitter's hands in the *Man with the Leather Belt* and the painter's hands in the central group hardly calls for comment.) Similarly, in the *Wheat Sifters* (pl. 6) the central sifter's extended right arm, backward-swaying upper body, and kneeling, upraised posture are all extremely close in feeling to the attitude of the painter reaching toward his canvas as he leans back in his chair with his legs jammed uncomfortably beneath him—a complex of resemblances that retroactively supports my reading of the *Wheat Sifters* as an allegory of the enterprise that produced it while at the same time underscoring the need to see in the portrait of Courbet in the central group something other than a photographically accurate depiction of himself at work on a painting.

This becomes even more evident if we turn our attention to the depicted painting itself. Previous commentators on the *Studio* have been

head. On the floor alongside her, in the near foreground and partly obscuring a low wicker stool, her clothes lie crumpled in a heap.

3. The figure of a small boy in simple peasant dress who stands as nearly as possible in front of the painter and seems to be gazing up at the latter's extended right arm and hand. Because he has been depicted largely from the rear, we see almost nothing of his face.

4. The unfinished picture itself, a large squarish canvas placed low on an upright easel and angled slightly back into space, on which the painter has represented a river landscape reminiscent of the countryside around Ornans, with cliffs, trees, and, in the immediate foreground, what appears to be a waterfall. There is also a small house (a mill?) on the riverbank to the left, and it may be that which the painter is in the process of brushing in.

5. Other items that should at least be mentioned are the white cat playing with a ball at the painter's feet and two figures on the margin of the central group proper—the impoverished Irishwoman nursing an infant seated on the floor to the left of the easel and, above and behind her, the plaster manikin whose awkward pose recalls images of martyred saints. In this connection it should be noted that Courbet in his letter to Champfleury describes the *Studio* as divided into two rather than three parts and associates the image of himself and the naked model with the gathering of his supporters or *actionnaires* (shareholders) on the right— a logical association with respect to the painting's ostensible theme. But this book is concerned with another sort of logic that cuts across the grain of many seemingly plausible thematizations, and the articulation of the central group as a pictorial entity in its own right, as well as the shadowy annexation to the central group of the Irishwoman and the manikin, already show that second logic at work.

To begin my reading of the central group with the figure of the painter, it's both inconspicuous and, once remarked, striking that he has been represented seated in such close proximity to the canvas on which he is working that he scarcely seems to have room for his legs. His right leg especially appears to have nowhere to go except into the canvas, and it comes as a shock to realize that his right lower leg and foot are angled back under his chair (an impossible arrangement, as anyone who tries it quickly discovers). The impression that results, of an obscure merging of the painter's lower body with the dark bottom portion of the picture on his easel, is consistent with the implied dissolution of the boundary be-

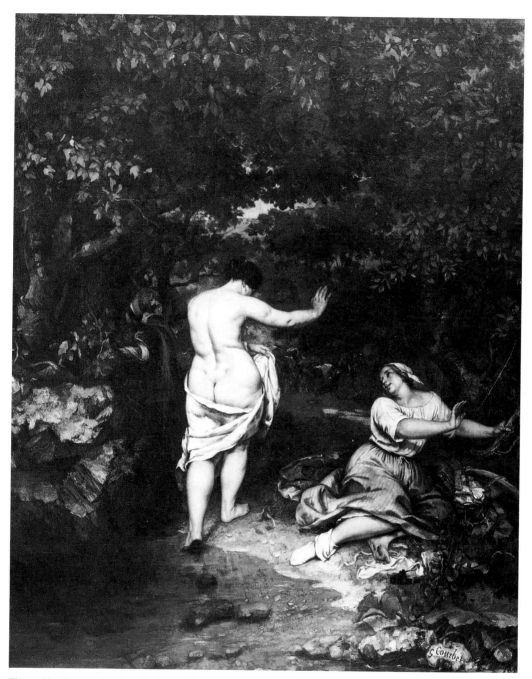

Figure 63. Gustave Courbet, *Bathers*, 1853.

*Studio,* the *Bathers* depicts a scene of beholding, in this case one in which the standing bather is beheld from a side we can't see—more or less from the front—by her seated companion. (The *Wheat Sifters* too depicts visual activity, the farm boy's peering into the *tarare,* but I have disqualified that activity as one of beholding.) The "exchange of thoughts" between the two women that Delacroix was the first of many to find unintelligible is to this extent readable: the companion's gesture expresses surprised admiration while that of the standing bather conveys a sense of modesty.[24] And if we now adapt to the *Bathers* a notion first proposed in connection with the central group in the *Studio* and consider the standing bather a synecdoche for the painting as a whole, it follows that the *Bathers* suggests a relationship between itself, imagined to be facing away from us, and a beholder who views it not from our side of the picture surface but from the other side, imagined to be the painting's front. It isn't clear whether such a relationship, which has something in common both with Géricault's strategy in the *Raft* (fig. 16) and Courbet's in the *Firemen Rushing to a Fire* (fig. 61), involves an attempt to remove the painting from the ambit of the painter-beholder seated before the canvas: several features of the *Bathers*—the implied movement of the principal figure back into illusionistic space, a certain airlessness owing to an unusually high degree of technical finish, the conspicuously distanced feeling of the entire scene (note in particular the treatment of the pool in the immediate foreground, so foreign to the way in which water is usually rendered by Courbet)—encourage us to think along those lines. On the other hand, the resemblance between the respective orientations and (upper) bodily positions of the standing bather and the kneeling sifter, as well as between that bather and the compound "figure" of the seated artist and the standing model in the central group, suggests a link with the painter-beholder after all, but one that has been stretched past the breaking point both by the features I have just cited and by the rhetorical as opposed to "actional" nature of the bather's gesture. The equivocation that such a reading uncovers, between a desire to sever relations with all external beholders and a compulsion to translate the painter-beholder into the painting, may help explain the special discomfort that viewers have always felt in the *Bathers'* presence. Another sort of equivocation concerns the way in which the standing bather's richly sensuous back and posterior can be seen as facing the beholder in their own right; it may have been a partial awareness of this, quite apart from qualms about the

likely reception of his picture, that led Courbet to add the drapery around her haunches shortly before the opening of the Salon.[25] In any case, the "failure" of the *Bathers* in these and other respects should be seen as having led directly to the shift back toward both metaphorical and literal self-representation which soon took place in Courbet's art.[26]

The second work I want to glance at is the impressive drawing known as the *Seated Model* (ca. 1853–54; fig. 64), which relates still more closely than the *Bathers* to both the *Wheat Sifters* and the *Studio*. (Exactly when it was made isn't clear: possibly between the *Wheat Sifters* and the *Studio*, but this is a guess.)[27] Thus the figure of the model evokes those of both women in the *Wheat Sifters:* her bodily position and facial expression are similar to those of the seated sifter, but her left hand grasping a book, her stockinged feet in and out of a pair of slippers, and something in the quality of her absorption in reading—a kind of bodily attentiveness—suggest a connection with the kneeling sifter as well. An even denser network of correspondences associates the model with the central group in the *Studio*. The model, like the painter, is seated; she holds a book in her left hand much as he holds a palette in his (note the analogous tilts of both objects); her elevated right hand plays with strands of her hair (in the next chapter I shall suggest that women's hair in Courbet's paintings is often a metaphor for his paintbrush); and her absorption in reading, the sense we have that her entire body participates in that act, may be compared with his absorption in the act of painting. There are also obvious analogies between the seated model in the drawing and the standing model in the central group, as well as between their respective discarded clothes. But even apart from these the Chicago drawing, precisely because it is *of* a model who in the ways I have suggested may be associated with the painter-beholder, anticipates the implied merger of seated painter and standing model in the central group. Finally, the seated model reading as if between poses looks forward to the figure of Baudelaire absorbed in his book at the extreme right of the *Studio*. Not that the figure of the model was a source for that of Baudelaire: the latter was adapted from Courbet's brilliant *Portrait of Baudelaire* (ca. 1849?; fig. 65), which in turn I see as based in part on Rembrandt's *Bathsheba* (1654; fig. 66), a possible source of inspiration for the figure of the standing model in the central group as well.[28] (But note the shift in the angle of Baudelaire's book between the portrait and the *Studio*, which perhaps suggests the influence of the drawing.)[29]

Figure 64. Gustave Courbet, *Seated Model*, drawing, ca. 1853–54.

Figure 65. Gustave Courbet, *Portrait of Baudelaire*, ca. 1849?

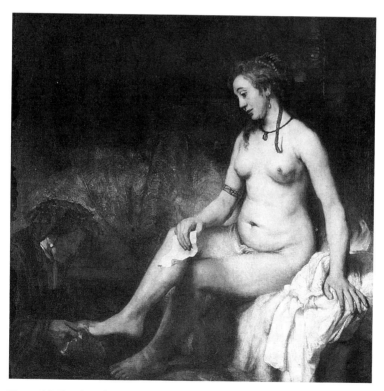

Figure 66. Rembrandt van Rijn, *Bathsheba*, 1654.

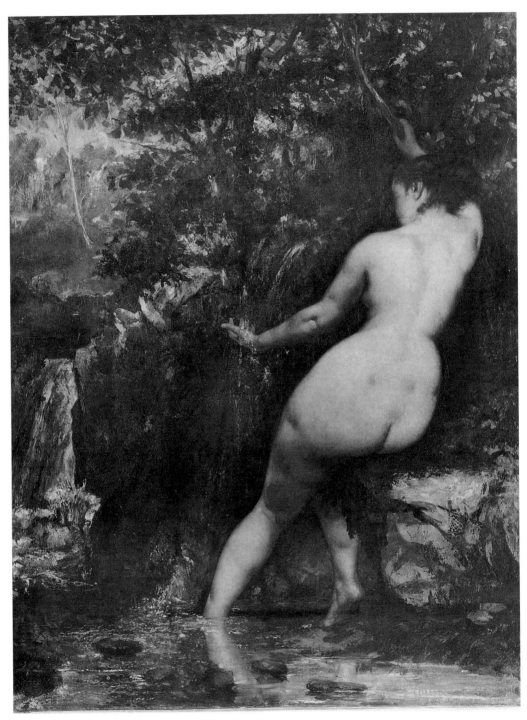

Figure 67. Gustave Courbet, *The Source*, 1868.

Third and last, a superb painting of the later 1860s, *The Source* (1868; fig. 67), recapitulates and condenses the central group in the *Studio* by 1) eliminating the peasant boy; 2) replacing the picture on the easel by an "actual" forest scene with trees, rocks, waterfalls, a stream, and so on; 3) merging the figures of the painter and the model into that of a seated nude woman depicted from the rear; 4) juxtaposing the woman's up-turned left (palette) hand with her right (brush) hand lightly gripping the branch of a tree (and note that here as so often in Courbet's meta-phorical representations of the act of painting the brush hand is elevated above the palette hand); 5) depicting in no uncertain terms the flow of water past the woman toward, and by implication beyond, the surface of the painting; and 6) providing an image of representation comparable to the picture on the easel in the partial reflection of the woman's body in the surface of the stream in the immediate foreground. There could be no more convincing demonstration of the persistence of Courbet's pictorial and ontological obsessions than these multiple resemblances between the two works, resemblances that plainly are not the result of a deliberate attempt to redo the central group thirteen years later.

THE THIRD "allegorical" picture I want to examine, known in En-glish as *The Quarry* (pl. 8), was painted in 1856–57 and was exhibited at the Salon of 1857 where it bore the title, *La Curée, chasse au chevreuil dans les forêts du Grand Jura*.[30] The *Quarry* is the first full-dress hunting scene in Courbet's oeuvre and is one of two ambitious paintings (the other being the *Young Women on the Banks of the Seine*) that immediately postdate the *Studio*. (The *Young Women* will be discussed at length in chapter six.) It is also another of Courbet's expanded self-portraits, the hunter in boots and a brimmed hat leaning back against a tree while smoking a pipe in the center of the composition being beyond question an image of the artist.[31] Since the implicit narrative of the scene suggests that it is that figure who has killed the roe deer (or *chevreuil*) hanging from a branch to his right (our left), it will be necessary to explore ques-tions of linkage between the theme of hunting and the act of self-representation in Courbet's art as well as between both of these and Courbet's Realism. Another feature of the *Quarry* that should be men-tioned at the outset is that it was composed in stages, by a process that involved joining pieces of canvas to one another. The largest segment, undoubtedly the first to be painted, comprises the roe deer and hunter;

to that segment Courbet added another, on which he depicted the young man in a bright red vest blowing a hunting horn and the two dogs in the right foreground; finally, additional strips of canvas were attached at the extreme left and, later, across the upper portion of the picture.[32] The *Quarry* isn't unique in Courbet's oeuvre in having been constructed in this fashion, but it is a particularly clear instance of the method and, as we shall see, yields special insight into the forces at work in his art.

To begin my reading with the central figure, it seems clear that the hunter is meant to strike us as absorbed—lost—in reverie or reflection: his gaze appears directed downward, and his expression, what we can tell of it, suggests a prolonged moment of inward recoil after the excitement of the hunt. The mood is a familiar one: the sitter's expression in the *Man with the Leather Belt* bespeaks a similar state of mind, and in other self-portraits, notably the *Man with the Pipe,* the sitter's self-absorption is even more palpable. At the same time, a comparison with the *Man with the Leather Belt* or, a more nearly contemporaneous image, the seated painter in the *Studio* helps bring out the most distinctive feature of the self-portrait in the *Quarry*—the hunter-painter's passivity. Not only is the figure of the hunter not engaged in any action whatsoever (unless we consider smoking a pipe an action, as probably we should); his hands have been banished from view, tucked away under his arms, while the slightly concave lines of his legs and the backward pressure of his weight against the tree emphasize his seeming withdrawal from the events around him. Furthermore, that mood of withdrawal finds expression in the actual rendering of the figure—in its shadowiness, its lack of sculptural definition, in short its ideality (a strange term to apply to Courbet but in this instance an appropriate one). We feel this especially keenly when we compare the hunter, as sooner or later we must, with the young man to his left (our right): traditionally called a *piqueur*—technically, a master of hounds at a hunt—the young man seems to put his whole being into sounding his horn, and in fact he has been depicted with commensurate painterly vigor, coloristic brilliance, and sculptural force.

These observations lead me to suggest, in keeping with my readings of earlier paintings like the *Man with the Leather Belt,* the *Stonebreakers,* the *Wheat Sifters,* and of course the *Studio,* that the *piqueur* in the *Quarry* may be seen as another of Courbet's displaced and metaphorical representations of the activity, the mental and physical effort, of painting. Thus the young man's strange, half-seated pose (with nothing beneath him but his folded jacket!) may be taken as evoking the actual posture of

the painter-beholder seated before the canvas. The hunting horn, held in his left hand, combines aspects of a paintbrush (I am thinking of the horn's narrow tubular neck) and of a palette (I mean its rounded shape, though the palette used in the *Studio* is rectangular)[33] while strictly resembling neither, and of course a horn being blown is also a traditional image of the fame Courbet aspired to win by his art. Significantly, too, the mouth of the horn faces into the painting—it thus matches the orientation of the painter-beholder's right hand thrusting toward the surface of the painting—in addition to which the *piqueur*'s right wrist has been turned back into the picture space, a motif we have seen play a crucial role in the *Man with the Leather Belt*. Finally, the *piqueur*'s bright red vest, coloristically the most vivid element in the picture, associates that figure with the color Courbet almost always used (and uses here) to sign his canvases as well as with one of the main signifiers in his art both of carnal presence and of pigment as such (cf. the *Wounded Man*).

All this isn't to say that the figure of the hunter is only nominally or trivially a self-portrait whereas that of the *piqueur* truly or essentially represents the painter-beholder at work on the painting. In the first place, the implied pressure of the tree against the hunter's back (to reverse the terms in which I put it earlier) may be taken as registering the pressure of the painter-beholder's chair against *his* back and rear—as I have been emphasizing from the first, Courbet habitually sat as he painted—so that even as regards bodily position the distinction between hunter and *piqueur* is less acute than at first it seems. (The absence of a seat beneath the *piqueur* alerts us to look elsewhere—to the tree behind the hunter—for the missing support.) Equally important, the apparent contrast between hunter and *piqueur* is only a more emphatic version of the virtual disjunction *within* the *Man with the Leather Belt* (other examples could be cited) between the sitter's averted, dreamy head and powerful, active hands, a disjunction that can hardly be taken as opposing nominal and essential modes of self-representation. Then too there is a strong analogy between the *piqueur*/hunter dyad and the seated painter and standing model in the central group in the *Studio,* and perhaps also between that dyad and the kneeling and seated sifters in the *Wheat Sifters,* though in view of the fact that the seated sifter is shown working at her task, a better comparison might be between the two sifters considered as a unit and the boy peering into the *tarare* (another conspicuously dark personage, like the hunter). Eventually I shall want to give a fuller and more nuanced account of the relations between hunter and *piqueur* and in particular of their connec-

tion as representations of the painter-beholder, but first it's necessary to consider the significance of other elements in the *Quarry*, starting with the dead roe deer.

In an obvious sense, the prominence in the left-hand portion of the *Quarry* of the roe deer's carcass awkwardly hanging by its right rear leg from the branch of a tree identifies the hunter-painter as an agent of pain and death and the enterprise of painting as a kind of killing. What must be stressed, however, is that the *Quarry* makes almost nothing of these identifications, indeed it suppresses potentially painful or brutal aspects of its subject. In addition to presenting the hunter as tranquil and detached, it depicts the roe deer as dead but not bloody; the weapon that killed the roe deer is nowhere in sight; and although the French title of the painting refers to a gory procedure, the traditional feeding of the slain animal's entrails to the hounds,[34] not only is that procedure not depicted, one might argue that the looming presence of the two dogs in the right extreme foregound draws attention away from the roe deer's carcass and thereby reinforces the contemplative mood of the scene as a whole.

At the same time, what the *Quarry* elides it also finds means to express, at least indirectly. For example, blood having fallen on the ground to the right of the roe deer, the brown-and-white dog nearer the carcass straddles an especially bright spill (telltale strokes of red around his mouth indicate he has been lapping at it, while his posture suggests he is warning the other dog away from his find); the vermilion waistcoat of the *piqueur* flashes the color of the roe deer's gore; in place of the missing musket there is the *piqueur's* hunting horn, previously described as symbolizing the painter's tools (and therefore linking those tools with the absent weapon); and although we are not shown a disembowelment, I for one am struck by the implied violence of the exposure to the hunter's position—I don't quite want to say point of view—of the dead roe deer's underside, specifically including its genitals.

This last observation may seem excessive. For one thing, I am attributing considerable significance to a side of the roe deer we can't see as well as to a bodily organ that isn't depicted. For another, the hunter isn't looking at the roe deer and indeed faces in a different direction. But I would counter that we are led to imagine the roe deer's genitals or at any rate to be aware of their existence by the exposure to our gaze of the roe deer's anus, a metonymy for the rest. I would also argue that the strategic placement of the anus, by which I mean its visibility (its exposure) *both* to the figure of the hunter within the painting *and* to the beholder (the

painter-beholder) before the painting, implies an equivalence or translatability between the two positions. I would further suggest that, precisely because the roe deer's anus stands for so much we can't see—not simply its genitals and wounded underside but an entire virtual face of the painting—such an effect of equivalence or translatability may be taken as indicating that the first, imaginary position is fully as important, even as "real," as the second. All this goes far beyond the not dissimilar but fatally compromised strategy we saw at work in the *Bathers,* a picture that anticipates the *Quarry* in more than a few respects.

In this connection it's surely relevant that our attention is drawn to the roe deer's anus by the white fur surrounding it, a bright patch that stands out in turn against the dark tree trunk beyond. And we are further led to reflect on the significance in the *Quarry* of what in a sense we are shown but can't see by the perspicuous representation of something we can't *hear*—the blast of sound produced by the *piqueur* on his hunting horn, an instrument that, like the roe deer's underside, is turned away from us toward imaginary depths. What's more, the exact curve and orientation of the horn are echoed by the tail of the rightmost of the two hunting dogs, whose black patches suggest a connection with the dark-clad hunter and who gazes pointedly across the extreme foregound toward the slain roe deer.[35] The dog thereby links *piqueur* and hunter even as it redirects—activates and relays—the hunter's latent, errant gaze back toward the dead animal.[36]

It follows that the figure of the hunter, whom I have also called the hunter-painter, may read as representing if not a certain beholder at any rate a certain theoretical entity: not, I think, the beholder *tout court,* but rather the beholder-"in"-the-painter-beholder—the ostensibly passive half of the painter-beholder's compound identity—which in turn means that the *piqueur* represents the other, manifestly active half of that identity, and that the *Quarry* as a whole pictures the splitting of the painter-beholder into separate components that in chapter four I claimed is implied by the slight deviation between the painter-beholder's concentration on the figure of Buchon and the crucifix-bearer's gaze back at the painter-beholder in the *Burial at Ornans.* I went on to detect a similar splitting in the relationship between the figures of the artist and the model in the central group in the *Studio,* an image whose profound affinity with the *Quarry* may be only now becoming apparent. Where the *Quarry* differs from the central group, however, is in its displacement of the painter component away from the picture's center, which instead is

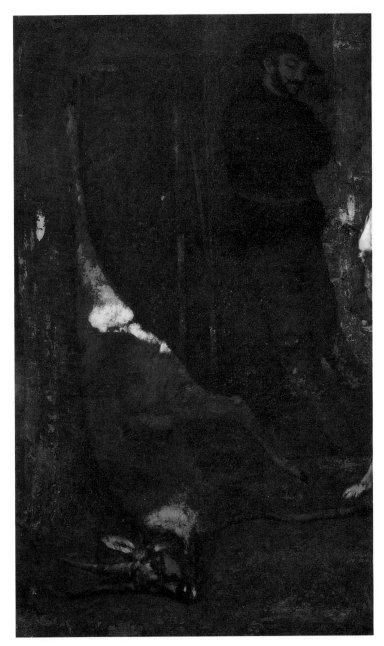

Figure 68. Gustave Courbet, *The Quarry*, detail of core image.

occupied by a figure for the beholder component who is recognizably a portrait of Courbet himself. The full implications of this shift of emphasis can be brought out through a consideration of the original or *core* image of the *Quarry* (fig. 68), which juxtaposes hunter and roe deer in a rectangle of canvas barely large enough to contain them both.

On first view, the relations between the two elements of the core image may seem contrasting, even antithetical. For example, it's impossible not to be struck by the opposition between the extreme vulnerability, as if to sexual assault, of the body of the slain roe deer and the self-containedness verging on impregnability of the figure of the hunter. There is also a contrast between the hunter's shadowiness and recessiveness and the roe deer's definiteness and sensuous immediacy, a contrast diminished in the completed painting by the still greater definiteness of the *piqueur* and hounds. And of course there is the obvious difference in orientation between hunter and roe deer, the first being upright or nearly so and the second pretty much upside down, its hindquarters in the air and its head and forequarters resting on the ground.

But the longer we contemplate these oppositions, the less straightforward they become. To begin with, we gradually become attuned to a certain analogy between the hunter's and the roe deer's respective conditions, as if the hunter's immersion in reverie makes him dead to the world, or as if the lifeless stare of the roe deer epitomizes the extinguishing of outward awareness that marks intensely absorptive states. Then too there is a point of similarity between the hunter's and the roe deer's respective bodily positions, namely the fact that neither the one nor the other stands freely on his own legs (this will also be true of the *piqueur*). Earlier I suggested that the hunter's posture of leaning back against the tree should be understood as closer to sitting than to standing, and I related that posture to the physical circumstances of the painter-beholder seated before his canvas. Although I hardly wish to suggest that the roe deer too may be seen in these terms, I do want to propose that the relationship between the hunter's and the roe deer's respective situations is more nearly complementary than antithetical. Thus if we imagine the painter-beholder seated before the core image of the *Quarry,* the position of the dead roe deer may be taken as implying a quasi-material movement from within the picture out toward its maker, much as in the central group in the *Studio* a succession of waterlike representations originating within the river landscape on the easel flows toward and beyond the seated figure of the painter. Among those representations, the white cat playing at the painter's feet with its rump held high and its tail curving in the air may be thought of as ancestral to the dead roe deer or at least as expressing a comparable directionality, one reciprocal to the painter-beholder's quasi-corporeal absorption in and by the painting before him.[37]

Where the analogy with the central group in the *Studio* breaks down, however, is in the absence from the core image of any obvious thematization of the act of painting by the figure of the hunter, whose shadowy apparition alongside the dead roe deer has somewhat the character of a magical operation, a feat of pure psychophysical projection rather than of self-representation as we have seen it at work in his art until now. It's therefore suggestive that supplementing the structure I have just described is another, equally magical-seeming one in which the opposing vertical orientations of hunter and roe deer, head-up versus head-down, evoke those of an object—here a "subject"—and its *reflection in water,* a motif that occurs frequently in Courbet's oeuvre, often, as in the *Source,* in conjunction with motifs of absorption. (I shall have more to say about reflections in Courbet, indeed about the interplay between the two sorts of motifs, in chapter six.) Still restricting ourselves to the core image, what might be called the reflective relationship between hunter and roe deer seems to imply that the initial apparition of the figure of the hunter had the immediate consequence of giving rise, as if naturally or automatically, to the image of the dead animal. What is mysterious here, taking this figurative reading literally, is the *nature of the medium* of that implied process, that doubled or supplementary self-representation. That is, in the absence of a body of water or other mirrorlike surface to "support" such a reflection, the doubling effect emerges, when at last it is seen, as positively *un*natural, all the more so given the accord between the hunter and roe deer's respective conditions to which I have alluded. In fact the greater vividness of the roe deer suggests that *it* might be the original and the hunter the reflection, a possibility that makes the medium of their relationship even more unfathomable.[38]

It may be, then, that we have detected in the core image of the *Quarry* an "ontological" lack or instability that in the end demanded the addition of a third major term, the *piqueur* sounding his horn, as a means of accounting for the activity of self-representation that produced the core image to begin with. Accompanying that change, the reflective relationship between hunter and roe deer was displaced, shifted in space and rotated through approximately ninety degrees, in the pairing of not quite identical hunting dogs. This last transformation has the double effect of making the likeness between the two terms almost complete and yet of naturalizing it to the point of almost total inconspicuousness. In other respects as well the mysterious, unstable relationship between hunter and roe deer that prevailed in the core image was fundamentally altered by

the addition of the *piqueur* and hunting dogs and the enlargement of the painting to its final dimensions. Hence it was only by working our way back to the core image that the internal pressures leading to its supersession could be made manifest.

I have just described those pressures as demanding that the activity of self-representation be accounted for by the addition of the figure of the *piqueur;* but there is also a sense in which the painter-beholder seems to have been under a comparable pressure to declare his identity *as beholder* (i.e., as beholder-"in"-the-painter-beholder), which by virtue of the contrast between passive hunter and active *piqueur* became readable only at this juncture and indeed only now came to occupy the center of the composition. Considered in this light, the hunter's looking away from the dead roe deer's exposed underside may be taken as asserting an antitheatrical stance toward the painting as a whole, though as we have noted the metaphoric and analogical structure of the composition redirects the hunter's gaze back toward the slain animal. In sum the *Quarry* both denies and affirms the painter-beholder's identity as first beholder of the *Quarry,* or to put this another way, it constructs a sort of delay mechanism whereby an initial conspicuous act of disavowal (the hunter's refusal to look at the roe deer) is subsequently disavowed in turn by its implication in a larger structure of relationships involving the roe deer, *piqueur,* and black-and-white-dog. What makes the notion of such a delay mechanism especially attractive is the realization that the *piqueur* sounding his hunting horn can be viewed as summoning an audience of beholders and therefore not only as expressing the physical effort of painting but also as heralding the inevitable theatricalization of the *Quarry* itself. But because the "moment" depicted in the *Quarry* is thus defined as one before that audience has arrived, we are led to understand it as an antitheatrical or, better, a *pre*theatrical one, which is to say that a certain denial of beholding is achieved by way of a temporal strategy that concedes the impossibility of indefinitely sustaining that denial in the face of what I earlier called the primordial convention that paintings are made to be beheld. Such a strategy is in accord with Courbet's consistent eschewal of instantaneousness in favor of effects of duration, of slow or repetitive or continuous actions, the very perception of which is felt by the viewer to take place over time. In fact, as was remarked earlier, these terms characterize the temporal modality of all essentially absorptive painting in the Western tradition from Caravaggio and Rembrandt through Chardin, Millet,

Courbet, and Eakins.[39] What makes Courbet's version of that modality distinctive is that in his art, more than in that of any other absorptive painter, effects of duration are associated with and indeed are indistinguishable from *effects of reading* that involve the radical transformation of what, apparently self-evidently, is there to be beheld. And yet the ultimate significance of the *Quarry* turns out to be an admission that beholding, hence theatricality, is inescapable.

Or perhaps this is true only to the extent that the differences among hunter, roe deer, and *piqueur* are emphasized at the expense of what those figures have in common. Thus, for example, hunter and roe deer have emerged as related by a metaphorics of reflection, and there is also a parallel of sorts between the passivity and recessiveness of the first and the lifelessness and implicitly castrated (anyway eviscerated) condition of the second. Similarly, I have linked the *piqueur*'s scarlet waistcoat with the roe deer's blood and the spatial orientation of the hunting horn with that of the dead animal's underside, associations that qualify the apparent opposition between the one and the other. In addition my earlier claim that the implied pressure of the tree against the hunter-painter's back registers the pressure against the painter-beholder's back of the chair in which he sat while painting the *Quarry* dulls the sharpness of the distinction between active *piqueur* and passive hunter, which I have read in turn as a contrast between painting and beholding functions. For that matter, is there not something willed, hence active, in the gesture by which the hunter has placed his hands out of view, as if to assert a greater passivity than he actually feels? Even the hunting dogs take part in the process of simultaneously reiterating and counteracting a certain thematization of difference: each of them could be shown to embody key features of at least two and perhaps all three principals, and moreover to do so in ways that help disseminate those features across and about the pictorial field.

All this suggests that a fuller interpretation of the *Quarry* must seek to account not only for the differentiation of the painting's "subject" into three principal components, which is what I have mainly done until now, but also, finally more important, for the double process of *producing and undoing* that differentiation, which my reading has also attempted to track and which ideally it would in no way arrest.

Earlier I claimed to see an analogy between the respective conditions of hunter and roe deer, as if the immersion in reverie of the one and the lifeless stare of the other could equally be characterized as images of ab-

sorption. To this I want to add that the *piqueur* too appears deeply absorbed in what he is doing—I have implied as much by describing him as putting his whole being into his task—and that, as in the case of the hunter, a shadowing of his features not only confirms our sense of his engrossment and therefore of his obliviousness to his surroundings but also hints at a sinking into or merging with those surroundings, which in this regard as in others may perhaps be considered absorptive in their own right. (Bright sunlight strikes the young man's cheek and ear, but his profile, inflected away from the viewer, is comparatively dim. Among the features of his environment he seems unaware of is the absence beneath him of a seat, the inconspicuousness of that absence testifying to an integration of figure and setting that has nothing to do with traditional norms of stylistic unity or dramatic mise-en-scène.)[40]

As in other Realist works by Courbet, the outcome of this subtle but pervasive concord among the *Quarry*'s principals and between the latter and their environment is the evocation of an absorptive continuum, a single psychophysical mood or condition coextensive with the painting and seeming almost to materialize, to find concrete expression, in the figures of hunter, roe deer, and *piqueur*. What makes the *Quarry* unique, however, is that more perspicuously than in any previous painting that continuum *embraces two extremes,* the straining youth and the dead animal, with a middle term, the abstracted hunter, at once separating those extremes and binding them together. To the extent that the first extreme demands to be read as representing the effort of producing the *Quarry,* of actually painting it, the second extreme must be understood as representing something "deathly" that nonetheless is continuous with that effort, that shadows or accompanies or transfuses it, that even perhaps is a condition of its possibility. And *that,* I suggest, can only be a specific body of habits and automatisms (to use their most "deathly" designation, mechanisms) such as are involved in *all* actions and functions of the living being from the most primitive, instinctual, and unconscious to the most developed, intentional, and self-reflective. Seen in this light, the hunter's ostensible passivity and *a fortiori* his ties with the dead roe deer express the fact that the automatisms in question were independent of the painter-beholder's control; conversely, the manifold affinities between hunter and *piqueur* bear witness to the equally important fact that those automatisms were mainly activated in and by the effort of painting the *Quarry,* an effort that couldn't have succeeded—that couldn't have begun—except by bringing automatism into play. Recalling the brief dis-

cussion of Millet in chapter one, the difference between Millet's and Courbet's respective treatments of absorption is thus not only a matter of staging, as crucial as I have claimed such matters are. Taking the *Quarry* as typical of Courbet's Realist canvases in this regard, an equally crucial difference (actually it's another aspect of the same difference) is that in Courbet but not in Millet *an absorptive thematics comprising a range of states from (relatively) active to (relatively) passive is grounded in the painter-beholder's vigorous yet also automatistic engagement in a sustained act of pictorial representation that the painting itself, virtually in every feature, can be shown to represent.* Thus, for example, in the *After Dinner* the figure of Promayet playing the violin is at the opposite end of the table from the slumped and somnolent figure of Courbet's father; in the *Wheat Sifters* the kneeling sifter in the center foreground exerts herself far more energetically, though perhaps not much less mechanically, than the seated sifter at the left abstractedly picking bits of chaff out of her dish; and in the *Studio* there is a palpable distinction between the seated Courbet working on his canvas and the subdued demeanor of most other personages in the composition, a number of whom appear almost stuporous in comparison. (Note too the sleeping dog in the *After Dinner* and the sleeping cat in the *Wheat Sifters*.) What distinguishes the *Quarry* from these predecessors is the wider range of absorptive states it depicts and especially the near juxtaposition of straining *piqueur* and lifeless roe deer, which together with the roughly circular organization of the figures-plus-animals group as a whole raises the question of the meaning of the continuity between extremes more insistently than anything in the earlier pictures.

A fascinating text by a French philosopher only slightly older than Courbet, Félix Ravaisson's *De l'Habitude* (1838), provides an unexpected gloss on these operations.[41] Briefly, Ravaisson holds that what might be called the primordial mediateness of habit across the entire gamut of activities from the highest and most conscious to the lowest and most instinctual illustrates or (his term) "figures" the essential unity of the world.[42] Thus will and nature are described as essentially, infinitesimally continuous with one another, expressions of a single indemonstrable but fundamental principle to which the concept of habit or automatism holds the key. In Ravaisson's words:

> . . . habit is the common limit, or the middle term, between the will and nature; and it is a mobile *middle term,* a limit which ceaselessly displaces itself, and which advances by insensible degrees from one extreme to the other.
> Habit is therefore so to speak the infinitesimal *differential,* or, again, the dy-

namic *fluxion* between the Will and Nature. Nature is the *limit* of the movement of diminution of habit.

Consequently, habit may be regarded as a method, as the sole real method, by an infinite *converging series,* for the approximation of the relationship, real in itself but incommensurable in the understanding, between Nature and the Will.[43]

Indeed, Ravaisson argues, the will is something other than the simple origin of conscious action; rather, precisely because we become aware of its operations only through the overcoming of resistance by an effort, it is preceded by and in effect dependent on an involuntary (hence quasi-habitual, quasi-automatistic) impulse Ravaisson calls desire and equates with nature itself (which is to say that he understands nature as the ultimate source of all spontaneous activity).[44] But this in turn means that the analogy of habit is able to "penetrate [nature's] secret and deliver up [its] meaning,"[45] illuminating even those abysses of organic life that appear closed to habit itself by virtue of their primitiveness.[46]

More than anything else, habit is for Ravaisson both the principle and the sign of the fundamental *continuity* of beings and nature:

The entire series of beings is therefore only the continuous progression of the successive powers of one sole principle, which subsumes them all in the hierarchy of forms of life, which [in turn] develop inversely to the progress of habit. The lower limit is necessity, Destiny, if one wishes, but in the spontaneity of Nature; the higher limit, the Freedom of the understanding. Habit descends from one to the other; it brings together these contraries, and, in bringing them together, it reveals their intimate essence and necessary connection.[47]

And in a remarkable passage on the radical unrepresentability of the absolute continuity of nature, Ravaisson explains that the existence of determinate forms in space—of objects of all kinds—appears to imply discontinuity and limitation. "[N]othing, therefore, " he writes, "is able to demonstrate between the limits [of those forms] an absolute continuity, and, by virtue of that demonstration, from one extreme of the progression to the other, the unity of a single principle. The continuity of nature is only a possibility, an ideality indemonstrable by nature itself. But this ideality has its archetype in the reality of the progress of habit; it finds there its proof, by the most powerful of analogies."[48]

My point in introducing Ravaisson's treatise at this juncture isn't to claim that Courbet was aware of his thought, or even that I see a perfect correspondence between Ravaisson's doctrines and Courbet's paintings. I suggest, however, that Courbet's predilection for pictorial structures

that evoke an inner continuity between absorptive states and conditions, and even more his tendency to thematize the mutual interpenetration of action and passivity, will and automatism, have much in common with Ravaisson's views. (According to Francis Wey, Courbet answered criticisms of the smoky tonality of the *After Dinner* by claiming that that was how he saw the scene. "If brighter illumination is necessary," he went on, "I'll think of it and when I see it the thing will be done *without my willing it*" [emphasis added].[49] And Buchon, in a famous statement, compared Courbet producing paintings to an apple tree producing apples, then glossed this by saying, "As rapidly as Courbet paints, so copiously he sleeps," an equivalence that hints at a mingling of will and automatism where there might seem to be only the latter.)[50] In fact I would go further and propose that Courbet's Realism can usefully be understood in relation to what Ravaisson later called a "spiritualist realism or positivism"[51] as opposed to the usual notions of his art as simply positivist or materialist that have prevailed until now. ("I even make stones think," Courbet boasted to Silvestre.)[52] Finally, I detect an affinity between Ravaisson's speculations on the unrepresentability of the continuity of nature and what has emerged, most notably in the *Quarry,* as Courbet's determination to represent that continuity by the only means by which it *could* be represented: in figures of ostensible individuation that ultimately demand to be read as I have been reading them in these pages. It's as though the indemonstrable ideality of which Ravaisson writes found a further archetype in Courbet's Realist paintings, and that there too what is required of the interpreter, if their metaphysical meaning is to be understood, is a capacity for discerning powerful analogies.[53]

A FURTHER perspective on these issues is provided by later hunting pictures in which the depiction of pain and violence becomes increasingly explicit, with disturbing consequences for Courbet's art. This is especially evident in the most ambitious of those pictures, the enormous *Death of the Stag* (1866–67; fig. 69).[54] In a winter landscape, under an overcast sky, a great stag sprawls on the snowy earth surrounded by more than a dozen hounds. Its magnificently antlered head, profiled against the grayish hills in the distance, arches back in agony as one dog sinks its teeth into its breast and another attacks its right hind leg. To the right of the stag, almost directly in front of it, a bearded hunter (a friend named Jules Cuisinier) cracks a whip in an effort to detach the dogs from their prey

and physically restrains another dog who tries to get at the stag as well. Further to the right and somewhat nearer to us than either the first hunter or the stag, a second, beardless hunter (another friend, Félix Gaudy) in a fur jacket and hat, depicted largely from behind, is seated on a rearing horse. Finally, in the lower left corner of the canvas, just above the artist's initials, a wounded dog writhes on its back in the snow.

The contrast between the *Death of the Stag* and the *Quarry* could hardly be more acute. In the first place, neither of the two hunters in the later work invites being read as a surrogate for the painter-beholder, whether directly—neither is a self-portrait—or indirectly—we are not immediately drawn to regard one or the other as embodying the act of painting. (The notion of absorption seems inapplicable to both.) Furthermore, the *Quarry*'s mood of hushed inwardness, which the silent blast of the *piqueur*'s hunting horn seems only to confirm, has given way in the *Death of the Stag* to an almost hallucinatory effect of audio-visual

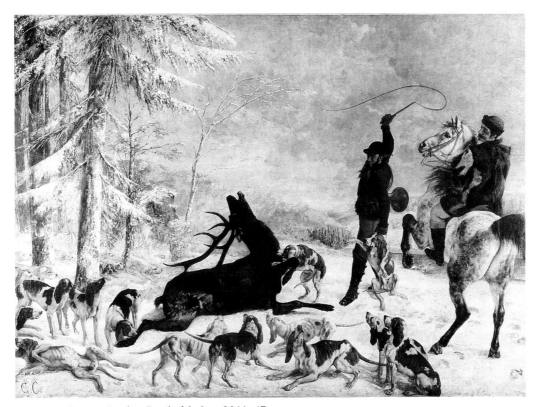

Figure 69.  Gustave Courbet, *Death of the Stag,* 1866–67.

cacophony, both thematically, through images of the bellowing stag, baying dogs, rearing and perhaps whinnying horse, and whip about to be cracked, and formally, by virtue of the too emphatic silhouetting of irregular, awkwardly spaced, in all respects inharmonious dark shapes (and in the case of the dogs and horse, dark and light shapes) against a bluish white ground. More precisely, the dominant notes of the *Death of the Stag* are, first, an extreme pathos, centered on the agony of the stag, and second, an ungovernable excitement, a condition which, keyed to the intensities of the chase, colors the image as a whole, finding explicitly sexual expression in the depiction of the erect penises of three of the more conspicuous dogs and the wholly exposed and vulnerable genitals of the sprawling stag. To these notes we should probably add a third, the chilling impassiveness of the two hunters. But the crucial difference between the *Death of the Stag* and the *Quarry*, one that goes a long way toward accounting for all the rest, concerns the issue of self-representation.

I have observed that neither of the hunters in the *Death of the Stag* invites being read as a figure for the painter-beholder. But if we shift our attention from the human actors to the dying beast, it becomes apparent, at least I claim it does, that Courbet has identified massively and unreservedly with the latter—with its struggles, its exhaustion, its agony, its imminent death. This is to say that the content of the *Death of the Stag* is fundamentally masochistic, the contrast between the sheer intensity of the stag's pain and the alienating indifference of the hunters expressing an empathy with the suffering animal that simply disregards, has no time for, the pictorially disruptive consequences of so stark and unmodulated an opposition of emotional registers. From here it is only a step to conclude that the decisive difference between the *Death of the Stag* and the *Quarry* is that between the exclusiveness and immobility of Courbet's identification with the dying stag and, in the earlier canvas, the multivalence and mobility of the painter-beholder's plural and partial acts of self-representation. And it requires only a slightly greater step to suggest that the essence, or one essence, of Courbet's Realism, not only in the *Quarry* but in the other post-1848 pictures we have considered as well, lies in the *resistance* they offer to any massive, immobile, and thus self-transfixing identification with a single protagonist, even when, or especially when, as in the *Studio* and the *Quarry*, the pictures in question include a portrait of the artist himself. Because such resistance involves a refusal to allow image and painter-beholder simply to confront one another, it powerfully serves Courbet's antitheatrical aims.

Indeed the somewhat frenzied sexuality that glares forth from the *Death of the Stag* may have its origin precisely in the artist's introjection, in the course of painting the picture, of his own representation of the agonized stag. I allude here to the psychic scenario first proposed by Sigmund Freud in "Instincts and Their Vicissitudes" and recently reformulated by Jean Laplanche and Leo Bersani, according to which an act of primary or nonsexual aggression, when turned back against the self through the introjection of a representation of the *effects* of that aggression, gives rise to sexual masochism and, Bersani would add, to sexuality as such.[55] So interpreted, the sexual excitement of the hounds reflects an excitation taking place *within* the painter-beholder, as the juxtaposition of writhing dog and Courbet's initials perhaps signals.[56] There is even a sense in which the moment of turning—of self-aggression—is not just reflected but delineated in the *Death of the Stag:* at any rate, the depiction of the mounted horseman largely from the rear may be held to link that figure with typical representations of the painter-beholder in Courbet's art, just as the stylized line drawn by the bearded hunter's whip against the sky suggests that the action of cracking that whip may be still another metaphorization of the activity of painting. To this extent the two hunters are figurations of the painter-beholder after all. But their status as such remains meager and uncompelling, a matter of ideation rather than of identification (and certainly not of quasi-corporeal merger): as if an impulse to declare their connection with the painter-beholder fell far short of overcoming a prior, massive identification with the agonized stag. (An astonishing photograph by Etienne Carjat shows Courbet at work on the *Death of the Stag* [fig. 70]. He is seated horseman-fashion on a reversed chair, which in order to provide the necessary elevation has been placed on the top of a wooden crate, while the unfinished canvas before him contains *only the image of the stag* on an otherwise blank field. Nothing could be more supportive of the notion that it was Courbet's introjection of that image that gave rise, through the scenario just summarized, to the rest of the composition.)[57]

Finally, it isn't only the activity of self-representation that has been metaphorized, mobilized, and disseminated throughout the *Quarry.* On the strength of my previous arguments, in particular my account of what by analogy with Ravaisson might be called Courbet's metaphysics, I want to suggest that the theme of hunting that appears for the first time in the *Quarry* as much as declares that the painter-beholder was able to begin his work of representing the continuity between himself and nature only

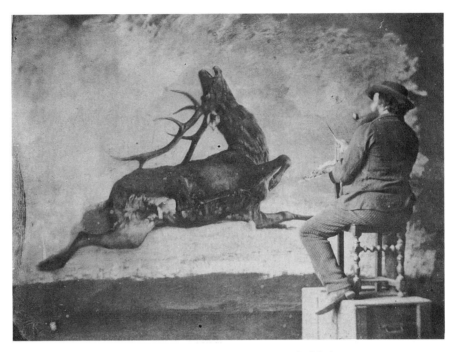

Figure 70. Etienne Carjat, photograph of Courbet painting *Death of the Stag*.

by representing the *shattering* of that continuity—the introduction of just those seeming gaps in it that my reading of the *Quarry* has been led largely to overcome. Or perhaps I should say, bearing in mind the smashing of stones in the *Stonebreakers,* the excavation of the grave and the ceremony of interment in the *Burial,* and conceivably even the separation of wheat from chaff in the *Wheat Sifters,* that the *Quarry*'s distinction in this regard is that it thematizes that shattering of continuity as an act of aggression, not to say of killing. But as we have seen, it also elides, displaces, and disperses the evidence of that act, and moreover goes to great lengths to assert the hunter-painter's passivity (i.e., innocence), thereby disenabling both any detailed narrative reconstruction of the act itself and any settled, motivated, incipiently masochistic identification with the dead roe deer. In the *Death of the Stag,* by contrast, a narrativizing of aggression underwrites a theatricalizing of pain and suffering that nothing in Courbet's biography at the time suffices to explain. What we witness in the *Death of the Stag* is the breakdown of the metaphysics immanent in Courbet's most characteristic paintings, and what the Freudian scenario suggests is that the representation of that metaphysics in and by the theme of hunting made such a breakdown likely sooner or later.

# 6    Courbet's "Femininity": Chiefly Paintings of Women along with Certain Landscapes and Related Subjects

*"Power is at the tip of the phallus."*[1]

RECENT FEMINIST writing about the gender coding of visual images in the Western tradition, much of it centered on film and almost all of it informed by psychoanalysis, has stressed the extent to which the representation of women has been governed by a series of systematic oppositions: between man as the *bearer* and woman as the *object* of the look or gaze; between *having* the image (at a commanding distance from it, so to speak) and *being* the image (or at least lacking such distance); between *activity,* including the activity of looking, and *passivity,* as exemplified in merely being seen; and, perhaps most important, between man as *possessing* and woman as *lacking* (or in Lacanian terms, *being*) the phallus.[2] In all these pairings, and they are by no means exhaustive, the first term historically has been privileged, the second subordinate. My basic claim in this chapter is that although Courbet in ordinary life was a representative male of his time,[3] the measures he was forced to take in his efforts to defeat the theatrical meant that the art he produced is often structurally feminine, or at any rate is often more closely aligned with the feminine than with the masculine side of the above oppositions.

Often, not always: Courbet after all is notoriously the painter of overtly erotic or quasi-erotic nudes, the nature of whose appeal is undeniably masculist (to say the least). And yet I shall try to show that even paintings such as the *Woman with a Parrot, Sleep,* and *The Origin of the World* reveal the workings of an antitheatrical impulse if not fundamentally in tension with at least not perfectly in harmony with the dominant masculist one, which however doesn't mean that the paintings in question are any less erotic on that count. A related caveat concerns the implicit sexual politics of Courbet's antitheatrical project. To what extent, we may ask, did Courbet's project even at its most unimpeded call into question the gender oppositions I have just enumerated, and to what extent did it involve merely occupying, some would say colonizing, the

feminine position? Put more strongly, is Courbet's "femininity" a masculist ploy, not so much because he himself was undoubtedly a chauvinist as because the oppositions in question, indeed the representation of sexual difference in oppositional terms, are inescapably ideological no matter which side it is claimed the artist is on? Or does the sheer mobility of those oppositions in Courbet's art, as well as the fact that his paintings will often be seen unsettlingly to combine masculine and feminine aspects, imply a more complex politics than the absence of a specifically critical stance toward gender oppositions as such would appear to suggest? (The same questions might be asked of the metaphorics of phallicism, menstrual bleeding, pregnancy, and flowers that I shall also be bringing to bear on Courbet's paintings.) I have no final answers to these questions, though I incline to the view that Courbet's art at its most disconcerting does more than simply confirm a representational regime in which femininity is exploited to the greater glory of its antithesis.[4] What chiefly interests me, in any case, are the precise dynamics by which Courbet's antitheatrical project issued in paintings of women and related subjects that in certain fundamental respects depart from traditional gender thematizations, whatever the ultimate political meaning of that departure may turn out to be.

For example, there is in Courbet's Realism as it has emerged in the previous chapters an emphasis on nearness to the image, even on a relation of something like identity with it, that feminist film theorists have frequently associated with the position of the female spectator in the Western regime of representation.[5] More radically, the overriding aim of Courbet's enterprise in my account—to undo or at least suspend his own spectatorhood—led to repeated attempts by him as painter-beholder to merge as if corporeally with various figures in his paintings, and, as my readings of the *Wheat Sifters,* the *Source,* and, from a different angle, the *Studio* have made clear, the personages in question could as well be female as male. Paintings such as these go at least part of the way toward eliminating the basis of the distinction between seeing and being seen on which the opposition between man as bearer and woman as object of the gaze depends. (In the *Bathers* [fig. 63], an uncharacteristic work, all possibility of merger has been forestalled, but that painting not only thematizes beholding, it also makes the beholder within the painting a woman—not that this alone, or even in conjunction with the strategy of frontally revealing the standing bather only to her seated companion,

suffices to call into question the gendered opposition between looking and being looked at.)

Another traditional, ideologically charged opposition that Courbet's paintings revise is that between active and passive, the first term coded as masculine and the second as feminine.[6] For not only does a work like the *Wheat Sifters* represent in diverse ways what might be called the passivity of activity (a phrase of Merleau-Ponty's);[7] it also recasts the distinction between active and passive as one between the painter-beholder's relatively active right (or brush) hand—figured by the kneeling sifter—and his relatively passive left (or palette) hand—figured by the seated sifter—as both of these take part in the act of painting, a recasting that preserves the masculine-versus-feminine connotations of the original distinction only to the extent that it declares the painter-beholder to be figuratively both the one and the other.[8] The same point can be made with equal force about the *Source* (fig. 67), in which an even more obviously relativized distinction between active and passive is expressed through the superior elevation and lightly grasping gesture of the woman's right hand versus the lower placement and receptive posture of her left hand.[9] In fact a kind of doubleness of gender is also implicit in the position of the painter-beholder relative to the *Wheat Sifters,* the *Source,* and other canvases in which he seems to have identified strongly if unconsciously with female personages: for to the extent that the painter-beholder falls short of *literally* transporting himself into the painting before him—and of course he always does fall short of this—he is both the subject (masculine) and the object (feminine) of beholding, a condition perhaps expressed by the emphatic muscularity of the kneeling farm-girl in the *Wheat Sifters.* (In the pages that follow I shall use the term "bigendered" to describe the outcome of these and similar identifications; the more familiar term "bisexual" commonly implies a doubleness of object choice that, as I read Courbet's art, including his lesbian pictures of the mid-1860s, remains foreign to it from beginning to end. I shall return to this point in my discussion of the greatest of the lesbian pictures, *Sleep,* further on in this chapter.)

Or consider the representation of sexual difference in the central group of the *Studio* (pl. 7), which both is and is not culturally stereotypical. On the one hand, by associating the act of painting with the male artist and that of beholding with the female model, the central group confirms a conventional privileging of masculinity as active and productive over

against femininity as passive and supportive. On the other hand, by depicting the model as the bearer rather than merely the object of the look (standing behind the seated painter she is unavailable to his gaze even while she is exposed to ours), the central group characterizes femininity as implicitly active after all, while the rhyming at vital junctures of painter and model, and *a fortiori* the merging of painter, model, and painting in a single pictorial-ontological entity coextensive with the central group as a whole, work against the privileging of any one of those elements above the others. Also contributing to a destabilizing of gender identities in the central group is the pairing just the other side of the easel of the Irishwoman nursing an infant and the partly draped male manikin standing behind her, a pairing I have already suggested may be seen as chiasmically equivalent to that of the painter-beholder and model.[10]

It might seem that the role of the phallus/paintbrush in Courbet's paintings would necessarily prove an exception to my insistence on the feminine, or at least the other than unambiguously masculine, character of his art.[11] But it can be shown how, in some of his most important representations of women, Courbet's metaphorizations of the painter's tools are themselves feminized in ways that make problematic, if not the distinction between having and lacking the phallus, at any rate the unequivocal sexual difference that the distinction traditionally signals. For example, in *The Sleeping Spinner* (1853; pl. 9), a work that precedes the *Wheat Sifters* by roughly a year, our attention is instantly caught by the large distaff wound with wool (and bound with a bright red ribbon!) that has fallen from the spinner's grasp and now lies obliquely across her thighs. Both the form and the general orientation of the distaff proffer an analogy with the painter-beholder's brush, while the rendering of the partly unbound wool is at once vivid testimony to the actual work of that brush and a marvelously hyperbolic image of the brush's hairs. Furthermore, a distaff is phallic by virtue of both its shape and its traditional iconography,[12] and this particular specimen, owing to its coloristic brilliance, impressive dimensions, and vigorous diagonal thrust into the picture space, invites being seen as embodying the aggressive maleness of the painting's maker and in that sense as equating the act of painting with the sexual possession of the young woman. The fact remains, however, that the French word for distaff, *quenouille,* like its English equivalent, connotes femaleness as such;[13] and this suggests that what we find in the treatment of the distaff in the *Sleeping Spinner* is a fantasmatic conflation

of masculine and feminine, a conflation that comes close to thematizing the activity of painting as simultaneously man's and woman's work.[14]

Something analogous though more intricate takes place in the *Wheat Sifters* (pl. 6), in which the fall of sifted wheat onto the ground cloth in front of the kneeling sifter has already been likened to a rain of pigment and hence to the actual making of the painting. Now I want to suggest that the fall of grain and pigment—pigment representing grain representing pigment—can also be seen as a downpour of menstrual blood— not red but warm-hued and sticky-seeming, flooding outward from the sifter's rose-draped thighs—and thus as expressing an even more extreme fantasy of pictorial productivity, one that imagines painting to be a wholly natural activity, to be unmediated by anything beyond the painter's body itself. (This would amount to a gendered version of Buchon's comparison of Courbet producing paintings to an apple tree producing apples.)[15] Here it might be objected that menstruation is an equivocal index of *biological* productivity, representing as we now know it does not only a woman's ability to bear a child but also the fact that she isn't actually pregnant. But, in the first place, advanced scientific thinking then held that "menstruation in women [was] the precise equivalent of the heat in animals, marking the only period during which women are normally fertile."[16] And in the second, the *Wheat Sifters* also offers several metaphors of pregnancy, most notably the ovenlike *tarare* with its mysterious interior being peered into by the peasant boy (the model for whom may have been Courbet's son) but also the seated sifter holding a round dish on her spreading lap and the bursting sacks of grain against the wall behind her, which is to say that it figuratively juxtaposes menstruation and pregnancy under the sign of productivity or indeed of productive *work,* the French word *travail* having the same connotations of the effort of giving birth as the English "labor" and "travail."[17] I find support for my reading in the recognition that the verb *cribler* (the French title of the painting is *Les Cribleuses de blé*) means not only to pass something through a sieve but also to pierce someone all over, to riddle with wounds as with a sword (figuratively, to make a sieve of him),[18] an action or series of actions involving the use of a tool not dissimilar in form to both a distaff and a paintbrush and equally phallic in its connotations. (This is roughly the moment of the completion of the *Wounded Man,* in which a sword and blood have been seen as representing a brush and pigment respectively.) There thus turns out to be an aggressively

masculine dimension to the *Wheat Sifters*—and here we may note that the angled thrust into the picture of the kneeling sifter's powerful body is exactly that of phallus/paintbrush in the *Sleeping Spinner*—though having said this it should be added that the phallic resonances of the word *cribler* are visually drowned in the painting's imagery of menstruation. But they are perhaps indirectly recuperated in its imagery, including its verbal imagery, of pregnancy.[19] (Once again the central group of the *Studio* can be seen as going farther than the *Wheat Sifters* in the direction of perspicuous allegoricalness: the painter, model, and peasant boy constituting an image of a nuclear family while the virtual merger of painter, model, and landscape in a single bigendered "figure" suggests a conflation of the values of [feminine] natural productivity and [masculine] cultural work.)*

Another major canvas of the mid-1850s, the *Young Women on the Banks of the Seine (Summer)* (1856–57; pl. 10), depicts two young Parisiennes (the French title calls them *demoiselles*) relaxing in a secluded spot on a summer day. It has never been doubted that the women are prostitutes, though exactly what niche they occupy in the mid-century demimonde remains an open question;[20] in any case, their sexual availability and *a fortiori* their status as objects of masculine beholding are underscored by the man's hat in the rowboat moored to the bank in the middle distance. Accordingly, some commentators have found a morally motivated contrast between the overdressed women, the nearer of whom is in *déshabille,*

---

*Some remarks by Walter Benjamin apropos Baudelaire's attraction to the figure of the lesbian seem relevant here. "The nineteenth century began to use women without reservation in the production process outside the home," Benjamin writes.

> It did so primarily in a primitive fashion by putting them into factories. Consequently, in the course of time masculine traits were bound to manifest themselves in these women. These were caused particularly by disfiguring factory work. Higher forms of production as well as the political struggle as such were able to promote masculine features of a more refined nature. . . . Such a change of the feminine habitus brought out tendencies which were capable of engaging Baudelaire's imagination. It would not be surprising if his profound antipathy to pregnancy had been involved. The masculinization of woman was in keeping with it, so Baudelaire approved of the process. At the same time, however, he sought to free it from economic bondage. Thus he reached the point where he gave a purely sexual accent to this development. What he could not forgive George Sand was perhaps that she had desecrated the features of a lesbian by her affair with Musset ("The Paris of the Second Empire in Baudelaire," in *Charles Baudelaire: A Lyric Poet in the Era of High Capitalism* [London: New Left Books, 1973], pp. 93–94).

My reading of the *Wheat Sifters* and the *Studio* suggests that Courbet felt no such antipathy to pregnancy (elsewhere Benjamin speculates that "Baudelaire must have experienced pregnancy to a certain extent as unfair competition" ["Central Park," trans. Lloyd Spencer with Mark Harrington, *New German Critique,* no. 34 (Winter 1985):41]), but

and their natural surroundings, but I believe the truth of the painting, whatever may have been the painter's original intentions, is much more complex.

For one thing, the blonde woman holds in her lap a bouquet of wild flowers while the supine dark-haired woman has gathered a smaller bouquet in her bonnet, which hangs from a branch near the right-hand edge of the painting. For another, the dark-haired woman has vines of ivy twined around her hair, a detail open to various interpretations but which in any case binds the two women all the more closely to the floral imagery surrounding them. Indeed on closer view one becomes aware that their garments are permeated with floral motifs, with the result that the women seem rather to merge with their surroundings than to contrast with them.[21] Finally, I want to call attention to the seemingly broken branch that enters the painting immediately below the dark-haired woman's hanging bonnet at the right, almost but doesn't quite touch the back of her left hand, then sweeps in an arc toward her right hand, just short of which it divides into an abbreviated twig and a second, thinner twig that skirts her extended right forefinger before bursting profusely into leaf. I take this interplay as implying that the branch is in the process of animating the woman through near-contact with her hands, or at any rate that between the branch with its sudden outpouring of leaves and the woman, who not only is suffused with embroidered flowers but can herself be read as an elaborate bloom, there exists a more pointed rela-

---

Benjamin's reference to the increasing masculinization of women in factories is surely to the point, as is the complementary feminization of male workers whose jobs no longer required the exercise of physical force. See in this connection the important essay by Joan Wallach Scott, "'L'ouvrière! Mot impie, sordide . . .' Women Workers in the Discourse of French Political Economy, 1840–1860," in *Gender and the Politics of History* (New York: Columbia University Press, 1988), pp. 139–63, especially pp. 148–52. Scott writes:

With the introduction of machinery, jobs had acquired a certain homogeneity. . . . This resulted in a more productive use of socially available labor power. But it also had ambiguous implications. Since differences of "muscular strength" were no longer required, and since such strength had been a factor in male and female wage differentials, a certain equality between the sexes might be achieved. The labor market might as a result be more open, demonstrating the virtue of "liberté du travail." More ominously, of course, machines could feminize all work by dissociating production from human physical effort, from the value-creating activity recognized by the wage and associated in political economy with masculinity (pp. 148–49).

We might say that something of the masculinization of the feminine and feminization of the masculine Scott describes is represented in paintings like the *Wheat Sifters* and the *Studio* (and others to be considered) without any discernible signs of anxiety.

tionship than those between other manifestly or metaphorically floral elements within the painting. (The dark-haired woman's transparent yellow gloves are in this account less a barrier to that relationship than a heightening of it—certainly they draw attention to her right hand with its extended forefinger.) An art-historical analog for such a feat of animation is the *Creation of Adam* on the Sistine ceiling, but the particular affinity I want to emphasize is between the blossoming branch in the *Young Women* and the distaff/brush in the *Sleeping Spinner* as well as, by extension, other metaphorical representations of the painter-beholder's primary tool, his paintbrush, in Courbet's art. (In the *Source,* as we have seen, the paintbrush will again be represented by a branch. Note too that Buchon's comparison of Courbet's productivity to that of an apple tree becomes even more arresting in this connection.) What's unusual about the *Young Women*'s representation of that tool, however, is that it is marginal, inconspicuous, one might almost say nonphallic by virtue of both its formal

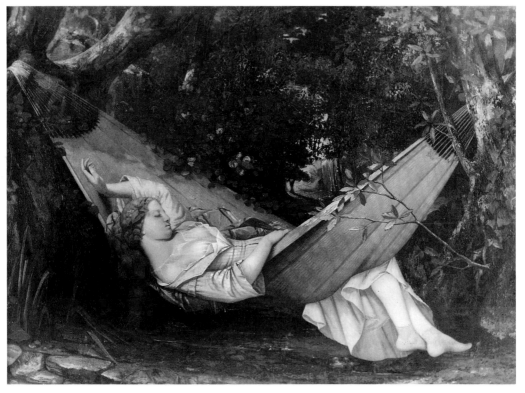

Figure 71. Gustave Courbet, *The Hammock,* 1844.

character (broken, curving, loosely painted, improbably slender, etc.) and its manifest attributes (leafy, in that sense floral, which is to say feminine), or to put this slightly differently, what is striking about it is that it is so *unstriking*, being barely distinguishable from the strongly gendered floral imagery pervading the painting as a whole.[22]

The question that now arises is whether the floral imagery of the *Young Women* can be associated with the act of painting, and I want to suggest that it can. Briefly, I find a close enough analogy between the bouquet of flowers that occupies almost the exact center of the composition and the painter-beholder's *secondary* tool, his palette covered with daubs and patches of raw pigment—as represented, for example, in the *Painter's Studio* of the previous year—to lead me to suggest that such a palette may have been the ultimate source of or sanction for the floral metaphor in the *Young Women* and other paintings and drawings by Courbet, including the *Sleeping Spinner* and going back as early as the precocious *Hammock* (1844; fig. 71). (In the *Hammock,* a canvas that anticipates the *Young Women* in many respects, a blossoming rosebush bends amorously over a sleeping garlanded woman as if to embrace her; I see the rosebush as a figure for the painter's [heterosexual] desire, which thus is given feminine expression.[23] A work that specifically suggests an association between flowers and palette is the lyrical drawing, *Women in a Wheatfield* [1855; fig. 72], in which the nearer of the two sleeping women embraces with her left hand a bunch of freshly gathered flowers, and a hat has been depicted upside-down with its wide brim almost parallel to the bottom of the sheet much as if it were itself a palette.)[24] Returning to the *Young Women,* it may be significant that the dark-haired woman's hanging bonnet filled with flowers—a second, conspicuously supported bouquet—is almost contiguous with the phallus/paintbrush/branch where it enters the picture, as if to imply that bouquet and branch, or the tools they represent, belong together. My argument can be summed up by saying that in the *Young Women* what appears at first to be simply or exclusively a strongly oppositional thematics of sexual difference (the women as objects of masculine sexual possession) gives way to or at the very least coexists with a more embracing metaphorics of gender (a pervasive feminization of the pictorial field through an imagery of flowers), which in turn demands to be interpreted in the light of a specifically pictorial problematic (Courbet's antitheatrical project). And when it is so interpreted the basis of that metaphorics—the association of flowers with the painter-beholder's palette—resituates sexual difference "within" the

painter-beholder rather than between him and the object of his representations.*

The same structure emerges when we consider the role of another traditional signifier of femininity, women's hair, in works as separated in time as the *Hammock,* the *Seated Model,* and the marvelous *Portrait of Jo,* also known as the *Beautiful Irish Girl,* (1866; pl. 11), the last a depiction of a young Irishwoman, Joanna Heffernan, looking absorbedly into a mirror she holds in her left hand while running her right hand through her Magdalen-like hair as if to display it to her own reflected gaze.[25] For just as Courbet's floral imagery can be associated with his palette, so his imagery of hair can be connected with the painter-beholder's primary tool, the phallus/paintbrush, which being tipped with hair is revealed as figuratively feminine as well as masculine. (Not only the painter-beholder but his phallus-brush itself may be thought of as bigendered.) At any rate, I see Jo Heffernan's lustrous serpentine red-gold tresses as what I

---

*Baudelaire's prose poem, "The Thyrsus (*Le Thyrse*)," dedicated to Franz Liszt, makes an interesting comparison. "What is a thyrsus?" the poem begins by asking and then continues:

In its religious and poetic sense it is the sacerdotal emblem of priests and priestesses when celebrating the deity whose interpreters they are. But physically it is just a stick, a simple stick, a staff to hold up hops, a prop for training vines, straight, hard and dry. Around this stick in capricious convolutions, stems and flowers play and gambol, some sinuous and wayward, others hanging like bells, or like goblets upside-down. And an amazing resplendence surges from this complexity of lines and of delicate or brilliant colors. Does it not seem as though all those delicate corollas, all those calyxes, in an explosion of scents and colors, were executing a mysterious fandango around the hieratic rod? But what imprudent mortal would dare to say whether the flowers and the vines have been made for the stick, or whether the stick is not a pretext for displaying the beauty of the vines and the flowers? The thyrsus is an image of your astonishing quality, great and venerated Master, dear Bacchante of mysterious and passionate Beauty. Never did a Nymph, driven to frenzy by the invincible Bacchus, shake her thyrsus over the heads of her maddened companions with such energy and wantonness as you your genius over the hearts of your brothers. The rod is your will, steady, straight, and firm, and the flowers, the wanderings of your fancy around your will, the feminine element executing its bewitching pirouettes around the male. Straight line and arabesque, intention and expression, inflexibility of the will, sinuosity of the word, unity of the goal, variety of the means, all-powerful and indivisible amalgam of genius, what analyst would have the detestable courage to divide and separate you? (*Paris Spleen,* trans. Louise Varese [New York: New Directions, 1970], pp. 72–73).

On the one hand, Baudelaire's characterization of Liszt as embodying both a masculine and a feminine principle suggests that this was a topos of (masculist) encomiastic discourse in the arts. On the other, the rigorously oppositional language of Baudelaire's text, with its elaborate contrast between a phallic stick or rod and a feminine imagery of flowers, points up the far more radical amalgam of masculine and feminine qualities in the *Young Women.* (For the original text of *Le Thyrse* see Charles Baudelaire, *Oeuvres complètes,* ed. Y. G. Le Dantec, rev. Claude Pichois [Paris: Gallimard, Bibliothèque de la Pléiade, 1961], pp. 284–85.)

have called a hyperbolic image of the business- (but also the pleasure-) end of the painter-beholder's brush—the brush representing hair representing the brush—and I find particular support for this reading in the way in which Jo's extended little finger, itself perhaps an expression of the mirror's hidden, phallic handle, comes close to touching the exquisitely painted pair of locks that seem almost independently to wind or flow toward the viewer at the lower left.[26] The rest of the mirror, the face of which we don't quite see, invites being understood (provisionally) as an image of a palette and (more profoundly) as a figure for a painting capable of all but physically absorbing the painter-beholder into itself. In short we find in the *Portrait of Jo,* as in the *Source* of two years later, a brilliantly condensed and manifestly feminine variation on themes, fig-

Figure 72.  Gustave Courbet, *Women in a Wheatfield,* 1855.

ures, and structures that made their first appearance in the self-portraits of the 1840s—I'm reminded especially of the *Desperate Man*—and received their decisive articulation in Courbet's "real allegories" of the mid-1850s. (A phallic element is also suggested by the illusionistic erectness of Courbet's signature immediately below the nearer of the two tresses. Note too that the tresses themselves can be seen as describing Courbet's initials, albeit with flourishes, especially beneath the "C.")

Two larger and more obviously ambitious works of the same year, the *Woman with a Parrot* and *Sleep* (both 1866; fig. 75 and pl. 12), introduce further complexities. In particular they force us to take account of the relation of Courbet's art at this stage of his career to the early work of the foremost realist painter of the younger generation, Edouard Manet (1832–83).[27] As I see them, Manet's masterpieces of the first half of the 1860s would have been inconceivable without Courbet's pathbreaking example; but the two men could hardly have been more different in origins and manner, and there is an acute sense in which Manet's version of the pictorial enterprise was antithetical to Courbet's as concerns the crucial issue of beholding. It is as though Manet intuitively recognized what we saw emerge in chapter one as the ever greater difficulty, verging by the 1850s on impossibility, of effectively negating or neutralizing the primordial convention that paintings are made to be beheld (more on Courbet in this regard in chapter seven); and as though he recognized too that it was therefore necessary to establish the beholder's presence abstractly—to build into the painting the separateness, distancedness, and mutual facing that had always characterized the painting-beholder relationship in its traditional, unreconstructed form—in order that the worst consequences of the theatricalizing of that relationship be averted. Such a reading identifies Manet's enterprise as simultaneously antitheatrical and theatrical (and vice-versa), which also means as not exactly one or the other as we have been using the terms until now. Thus Manet's paintings of the first half of the 1860s repudiate the anecdotally theatrical pictures, often costume pieces set in earlier centuries, that enjoyed great popularity at the Salons of the 1850s and 1860s. But they do so by exploiting a strictly presentational—as opposed to "actional"—mode of theatricality, the chief historical source and sanction for which was Watteau, and the principal function of which in Manet's art was to make newly perspicuous, in effect to force on the beholder's attention, certain truths about the

painting-beholder relationship it was no longer feasible to deny. It's also at least arguable that one effect of Manet's strategy, and doubtless also a principal cause of the extreme provocation that his paintings typically offered to contemporary audiences, is that the beholder sensed that he had been made supererogatory to a situation that ostensibly demanded his presence, as if his place before the painting were *already occupied* by virtue of the extreme measures that had been taken to stake it out.[28]

The aggrandizingly presentational force of Manet's art is nowhere more evident than in two major canvases of the first half of the 1860s that crucially involve the figure of a naked woman gazing enigmatically out at the beholder (or at least out of the painting), the *Déjeuner sur l'herbe* (1862–63; fig. 73) and the *Olympia* (1863; fig. 74). And what I want to emphasize at this juncture is, first, that between these two revolutionary productions and Courbet's ambitious nudes of 1866 there appears to have taken place a competition that had the two men responding to one another's art across the immitigable difference in their temperaments and the seemingly much slighter but in fact fundamental disparity in their historical positions. And second, that the traditional erotic nude as a pictorial genre was especially suited to Manet's enterprise because it involved a type of subject matter that more emphatically than any other offered itself to a masculist public as an object of beholding and therefore provided maximum purchase for his far-reaching attempt to reverse traditional power relations by implying that the beholder was now under the painting's controlling gaze rather than the other way around. (The sexual politics of this attempt too remains an open question.)[29] These considerations, however, were at odds with Courbet's altogether different project, and in fact made it likely that his pictures in this vein would be more than usually marked by signs of compromise.[30]

This is especially true of the *Woman with a Parrot* (fig. 75), which depicts a naked female figure sprawling on her back across a four-poster bed and holding aloft on her left hand a brightly colored parrot with outspread wings. The woman's discarded dark brown gown occupies much of the immediate foreground, while she herself lies directly on a rumpled sheet of brilliant white, part of which somewhat improbably covers the upper portion of her right thigh and in doing so just manages to conceal her sex. Her breasts are full, her hands and feet (as always in Courbet) are delicate, her upside-down mouth opens in a smile that reveals a row of perfect white teeth, and her great shock of tawny hair spreads outward from her head in burnished snakelike waves. Beyond one twisted bedpost

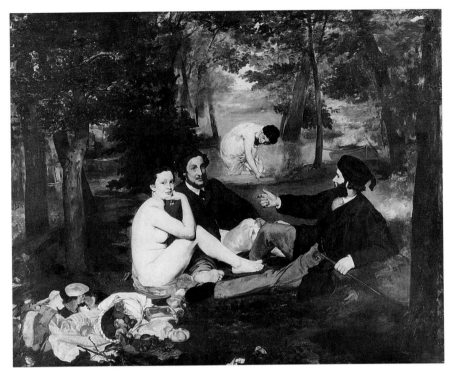

Figure 73. Edouard Manet, *Le Déjeuner sur l'herbe*, 1862–63.

Figure 74. Edouard Manet, *Olympia*, 1863.

toward the left we glimpse, as if through a large window, a wooded land-
scape at dusk; toward the right our view is screened by a dark green tap-
estry that presumably hangs along the window wall (all but the nearest
spatial relations in the picture are unresolvably ambiguous); and at the
foot of the bed Courbet has provided a wooden stand for the parrot with
multiple perches and, at its top, a metal bowl.

I think it's fair to say that although the *Woman with a Parrot* contains
much that is superb, it palpably conveys an impression of difficulties only
partly overcome. The composition, for example, is strongly weighted to-
ward the left, so much so that the right-hand half of the picture feels
strangely empty (this almost never happens in Courbet), while the parrot
stand in its bareness and isolation seems an intrusion from another, alien
representational system. (A more Manet-like one? In any event, Manet
soon will make use of a stand such as this in his *Woman with a Parrot*
[1866].) Then too there is an unusually stark contrast between, on the
one hand, the brightness of the woman's naked body and the white sheet
on which she lies and, on the other, the generally dark tonality of her

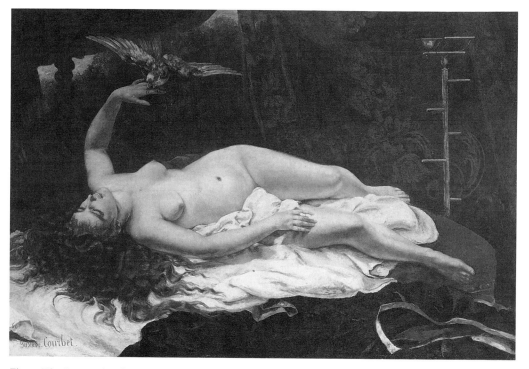

Figure 75.  Gustave Courbet, *Woman with a Parrot,* 1866.

surroundings, with the result that the subtle play of reflected lights within the shadows along her legs and right arm scarcely makes itself felt. Also unlike Courbet is the sleekness verging on abstraction of the woman's body below her breasts, which contributes to our sense of the painting's vacancy toward the right and is oddly reminiscent of the smoothness and unreality of the highly popular nudes of lesser artists such as Cabanel and Baudry. And yet the *Woman with a Parrot* isn't simply another more or less standard, albeit magnificently painted, erotic nude; instead it struggles ingeniously if almost surreptitiously against the basic conventions of the genre, in particular against the convention that would have the woman display herself for the delectation of a male viewer located unproblematically at a distance from the painting that allows him easy command of the pictorial field.

Consider, for example, the significance of the figure's orientation, by which I refer not only to her position on her back but, more important, to the fact that her head and upper body must be understood, in view of the axis of her face, the location of her left leg, and the angle of the bed as we are shown it toward the right, as nearer to us than her feet.[31] Such an orientation corresponds, in a certain sense, to that of the painter-beholder seated before the canvas (i.e., his upper body was further from the canvas than his lower body), though we could hardly be further from the virtual matching of figure and painter-beholder we have noted in other paintings by Courbet. A more restricted (and partly for that reason more salient) locus of struggle is the woman's upside-down head and face, whose smiling but also potentially disquieting expression remains unconstruable unless one approaches the left-hand portion of the painting and perhaps also tilts one's head sharply to the left as if in an attempt to look directly down into the woman's upturned features.[32] (It's hard to imagine how Courbet could have painted her face without achieving that impossible position.)[33] Moreover, the woman's waves of tawny hair stream toward the picture surface as if in reciprocation of an implied movement into or at least toward that sector of the painting; obvious analogues are the outward rush of water and waterlike representations from the canvas on the easel in the *Studio,* though perhaps even more apposite is the early *Hammock,* in which the shining waterfall of the woman's hair in the left foreground is juxtaposed with the windings toward the bottom of the picture of a ribbony creek that we intuitively perceive as flowing in our direction, no doubt in contrast to the distant sunlit clearing that draws our attention toward the depths of the picture. (No-

tice, by the way, how in the *Hammock* the disposition of the woman's body leaves no doubt that her head and torso are nearer the beholder than are her legs and feet.)[34]

In a slightly different key, already familiar to us from the *Portrait of Jo,* there is also an analogy between the consummate paint-handling of the woman with a parrot's hair and the treatment of the phallic distaff/paintbrush in the *Sleeping Spinner* of the previous decade, the wavy spreading tresses in the later work serving as one more hyperbolic image both of the painter-beholder's primary implement (i.e., of its long-haired working tip) and of the activity of that implement at its most inspired. And that analogy is strengthened both by the obvious painterliness and strident colorism of the vivid-hued parrot, a "phallic" creature whose outspread wings and tail in effect mirror the woman's outward-streaming hair, and by something else as well: the twisted bedpost that rises vertically just to the left of and beyond the woman's upraised arm. My point isn't simply that the bedpost and the woman's hair together form an image of a giant brush; I am struck too by the coincidence that the French word for bedpost, *quenouille,* is the same as that for distaff,[35] a doubleness of meaning I read as supporting the notion that, for all the differences between them, the *Woman with a Parrot* and the *Sleeping Spinner* share a common pre-occupation.

Courbet's other ambitious erotic canvas of 1866, the astonishing *Sleep* (pl.12), was painted for Khalil Bey, formerly Ottoman ambassador to Athens and St. Petersburg and at that time a wealthy collector living in Paris. It represents, roughly life-size, two naked women, one with dark brown hair and the other—Jo Heffernan—with red hair, asleep with bodies entwined on a large bed. In the left foreground there appears as if floating the decorated top of a squarish table on which stand two decanters and a crystal goblet, while on the far side of the bed and toward the right a narrow shelf (or table?) bears a yellow vase overflowing with multihued flowers. The wall of the room is a dark Prussian blue and almost indiscernibly carries a floral imprint; beyond the women at the head of the bed a blue curtain, also bearing a floral pattern, has been gathered by a velvet rope; and in the near foreground, to the right of the table, the brunette sleeper's hand (perhaps the most exquisitely sensuous in all of Courbet, which is saying a lot) rests lightly atop the edge of a rose-pink coverlet the bulk of which must be imagined to have fallen to the floor. The juxtaposition of the snowy white of the bedsheets with the light pink

of what seems to be the exposed underside of the coverlet, and of both of these with the stronger rose-pink of the latter's largely hidden upper surface, could hardly be more suggestive. Another coloristic touch that enhances the picture's sensuous impact is the slight but telling difference between the darker and lighter skin tones of the brunette and redhead respectively.

Not surprisingly, discussions of *Sleep* have tended to dwell on its lesbian theme, which from the perspective of that painting has been seen to have had several mostly less explicit antecedents in his art.[36] In this connection too various nineteenth-century literary representations of lesbian love have been adduced, Baudelaire's "Femmes damnées" from *Les Fleurs du mal* being probably the most often cited.[37] What remains unclear, however, is the nature of Courbet's interest in the subject. Two of Courbet's early critical advocates, Jules Castagnary and Pierre-Joseph Proudhon, interpreted his depictions of lesbianism as political commentaries on the Parisian society of his time ("You who tolerate the Empire, take care," Castagnary reads the painter of *Venus and Psyche* [1864] as saying to the bourgeoisie, "here are the women that the Empire is in the process of forming"),[38] but neither man is a reliable guide to Courbet's artistic intentions, and in any case the sheer persistence of the motif of women reclining together in Courbet's art can't be understood in those terms. Moreover, as so often in Courbet, *Sleep* invites comparison with works that on narrowly thematic grounds might seem beside the point: the early drawing *Country Siesta,* for example, which depicts Courbet and a female companion asleep against the base of a tree, or, again, the *Hammock,* with its sleeping woman and amorous rosebush, the latter associable, I have proposed, with the painter-beholder. As the last comparison recalls, the painter-beholder—or his desire—is frequently thematized in Courbet's art as metaphorically feminine (or at least as bigendered), which suggests that the lesbianism of *Sleep* may perhaps be seen as a transposition into an entirely feminine and manifestly erotic register of the aspiration toward merger that I have claimed was basic to Courbet's enterprise throughout his career. That the nearer woman has been depicted partly from the rear reinforces the suggestion, as does the fact that her dark hair and tannish skin function in this context as secondarily masculine traits that in turn link her with the painter-beholder (recall my earlier remarks about the consistently feminine character of the object of desire in Courbet's art).

Alternatively, or in addition, it is as though in *Sleep,* enjoying the se-

curity of working for a collector he knew wouldn't be shocked, Courbet gave free rein to a fantasy of total corporeal presence that had never before been allowed to erupt so dazzlingly in his art—the fantasy that a sufficiently sensuous, which for him meant a spectacularly feminine, object could draw the beholder literally out of himself, or at the very least could eliminate all sense of difference between himself as painter-beholder and what lay before his eyes, thereby resolving at a stroke the issue of theatricality framing Courbet's endeavors from the first. As is also true of the *Young Women on the Banks of the Seine,* the (male or female) viewer's experience before *Sleep* approaches sensory overload, but the later painting differs sharply from the earlier one in its stunning assertion of the two women's nakedness: between them we are shown not only a seemingly endless expanse of flesh but also complementary aspects (front and rear, from below and from above) of what we come to realize may be seen as virtually a single (bigendered) female body, embraced by a single pair of arms.[39] (The darker pink of the coverlet contributes its intimation of an *interior* aspect, as of the inside of a mouth or vagina.) And no more than in the *Woman with a Parrot* are we offered a full revelation of either woman's sex, but instead of the abrupt displacement of interest to the woman with a parrot's inverted face and hair and consequent devaluation of the rest of her body, our attention finds itself divided and dispersed among multiple competing foci, each of which appears to have been rendered with equal relish for the pleasures of representation. In short the viewer's experience before *Sleep* is simultaneously that of a comprehensive quasi-corporeal unity and of a highly mobile perceptual multiplicity, a combination not untypical of Courbet's art but here given its extreme expression involving the human figure.*

---

*An earlier work that anticipates *Sleep* in this regard is the Rembrandtesque *Sleeping Blonde Girl* (ca. 1849; fig. 76), in which a mostly naked woman has been depicted asleep on a bed or divan with her upper body raised by pillows in a darkish interior that includes a vase of flowers on a side table. Note for example how the tapestry-like rug that partly covers the woman's lower half disconnects her left foot and lower right leg from the rest of her body and how the part-by-part description of her head (in profile), upper body (viewed erect and from the front), stomach (facing upward and turned slightly toward the woman's left), and right hip and thigh conveys an impression of separate, physically intimate acts of sustained attention. And yet the overall effect isn't one of simple disjunction, any more than in the *Man with the Leather Belt* the active hands and dreaming head are felt to belong to different subjects. Rather, as in that and other self-portraits, the body's integrity of outward form is sacrificed to an evocation of its sensuous presence to itself, which in this instance (the woman being asleep) is expressly not a matter of conscious awareness.

A further index of the uniqueness of *Sleep* as a projection of painterly desire might appear to be the absence from it of any metaphorical sign of its making of the sort I have been claiming to detect elsewhere in Courbet's oeuvre, including the *Woman with a Parrot,* on the face of it an unlikely candidate for such an understanding. But once again the rendering of both women's hair invites being seen in connection with a thematics of the brush, in addition to which the "floating" table in the left fore-

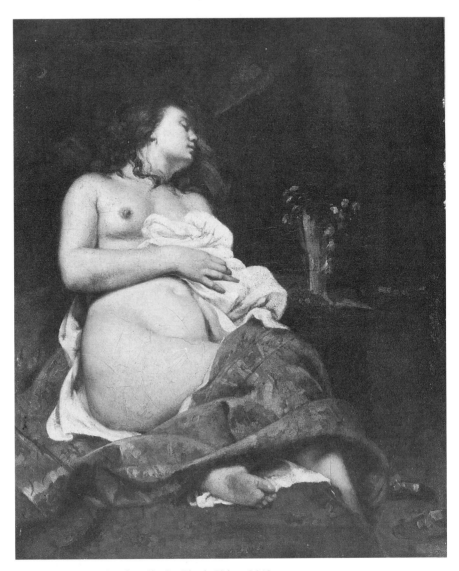

Figure 76.  Gustave Courbet, *Sleeping Blonde Girl,* ca. 1849.

ground and the vase of flowers against the wall at the right may be understood as expressions of the painter-beholder's palette and brush respectively, the flowers here vividly embodying the work of the brush (cf. the blossoming phallus/brush in the *Young Women on the Banks of the Seine*) and the vase itself being blazoned with a highly colored image, hence perhaps figuring the painting as well. I suggest too that the spatial elision by which the string of pearls alongside the sleeping brunette appears to emerge from the goblet on the table allows one to imagine the entire scene, in fact the painting as a whole, as issuing magically from the goblet, thus figuratively from the palette.[40] So even in *Sleep* a rather rich thematics of pictorial production can be brought to light.

All this, however, isn't to claim that once alerted to the various means by which the *Woman with a Parrot* and, especially, *Sleep* struggle with the norms of the traditional erotic nude we are likely to find the overall effect of those paintings significantly different from that of comparable works by Courbet's contemporaries in which no such struggle takes place. Indeed it's entirely possible that the pursuit of antitheatricality functions in *Sleep* (the more impressive of the two pictures) as a new and powerful technology for the production of erotic, even semipornographic effects, as if the painter-beholder's efforts to merge quasi-corporeally with that painting only enhanced its appeal to the collector who commissioned it and by extension to the masculist public at large. More ravishingly than any other painting in his oeuvre, *Sleep* represents the limits of Courbet's "femininity."

ONE LAST subgroup of Courbet's paintings of women must be considered here, both because it bears directly on the argument of this chapter and because traditionally it has been connected with his work in another genre: landscape. Briefly, scholars have often noted an analogy between Courbet's depictions of caves and grottos and certain overtly erotic paintings of female nudes centered on the vagina, most notoriously the *Nude with White Stockings* (ca. 1861; fig. 77) and the recently rediscovered canvas, very likely the most brilliant rendering of flesh in all Courbet's art, *The Origin of the World* (1866; fig. 78).[41] Lindsay, for example, has remarked of the *Nude with White Stockings*:

[I]f we look at its structure and make a sketch, keeping the essential layout but transforming the human sections into rocks, tree clumps and the like, we arrive

at a typical landscape of the kind that deeply stirred Courbet—the vagina form-
ing the cave entry, the water grotto, which recurs in his scenes. The point is
worth making because it helps us to see how he created the wonderfully com-
pact pattern of the body here, and how a certain symbolism was present in
many of the landscapes: for instance, the one in the easel painting of the *Stu-
dio*.[42]

Similarly, Werner Hofmann has associated *The Origin of the World* with a
drawing of a cave called the "Dame verte" (fig. 79) from an early sketch-
book:

What again and again draws Courbet's eye into caves, crevices, and grottoes
is the fascination that emanates from the hidden, the impenetrable, but also the
longing for security [*Geborgenheit*]. What is behind this is a panerotic mode of
experience that perceives in nature a female creature and consequently projects
the experience of cave and grotto into the female body. At this point "realism"

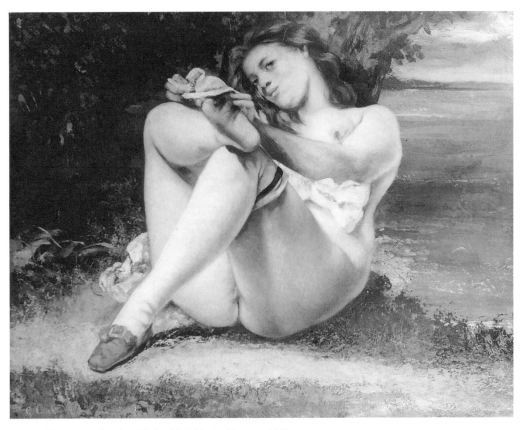

Figure 77.  Gustave Courbet, *Nude with White Stockings*, ca. 1861.

Fig

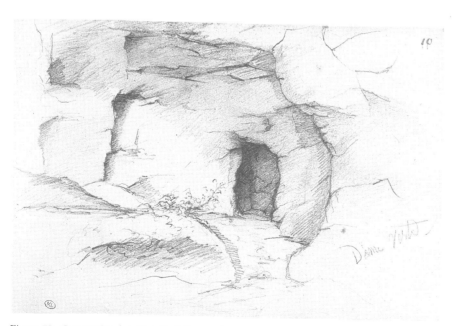

Figure 79. Gustave Courbet, *Sketchbook Page*, early 1840s.

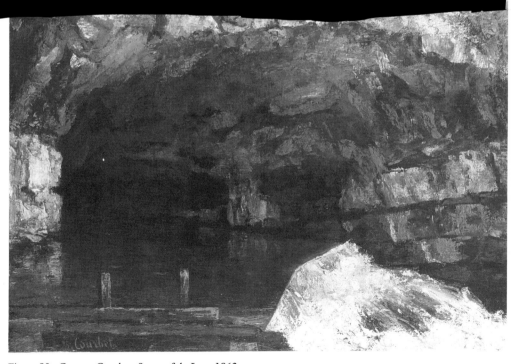

Figure 80.  Gustave Courbet, *Source of the Loue,* 1863.

rectly representing that movement. The landscape on the easel at the center of the *Studio,* alluded to by Lindsay, is indeed to the point, though Lindsay's account of the central group fails to recognize the metaphorical flow of water out from the picture on the easel, and *a fortiori* the implied merger of painter-beholder and model with the picture itself.[44] Equally pertinent are Courbet's paintings of the Source of the Loue, a famous site in the Franche-Comté, such as those in Zurich (1863; fig. 80) and Buffalo (1864; fig. 81), as well as the many versions of a covered stream near Ornans known as Le Puits noir (the Black Well), including the picture in the Musée d'Orsay (1865?; fig. 82) and the smaller, beautifully preserved canvas in Baltimore (1860–65; pl. 13), that depict at or near their center what appears to be a smallish cave. (The Baltimore picture is a closer view of the left-hand half of the scene represented in the Paris picture.) But once we recognize that what finally is at stake in all these works isn't

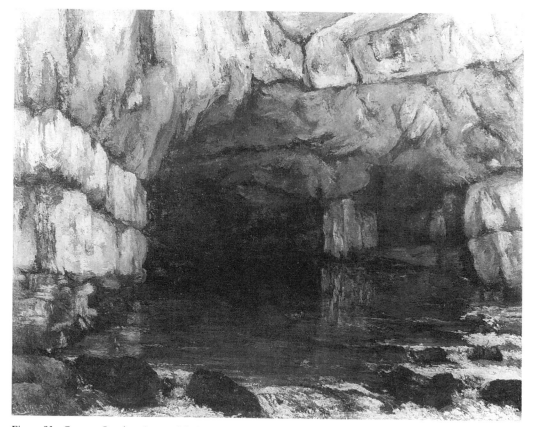

Figure 81.  Gustave Courbet, *Source of the Loue,* 1864.

simply a fascination with a central dark vaginal-like opening or womblike enclosure but rather a double movement into and out from the painting, the strictly morphological resemblance between, for example, the Zurich and Buffalo versions of the *Source of the Loue* on the one hand and the *Nude with White Stockings* or *The Origin of the World* on the other comes to seem, while not exactly irrelevant, at any rate not quite the key to the meaning of either.[45]

The point can be underscored by introducing another group of works that involves the representation of water moving toward the viewer: the series of paintings of breaking waves painted by Courbet in the late 1860s and early 1870s, the most impressive of which are *The Stormy Sea* in the Orsay (1869; fig. 83) and *The Wave* in Berlin (1870; fig. 84). In each of these a marvelously subtle and varied handling of paint yields a massively tactile illusion of a large, dark, greenish-blue wave crowned with white froth in the act of breaking on a stony shore, which is to say

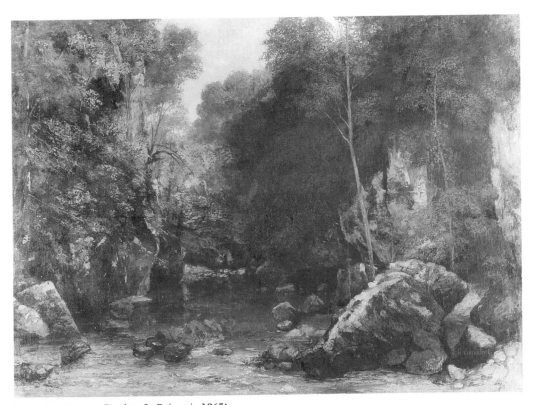

Figure 82.  Gustave Courbet, *Le Puits noir,* 1865?

that each evokes a powerful movement—of water, of pigment—from within the painting out toward the beholder. What may not be evident in reproduction, however, is the magnetism with which in both works, as in the wave paintings generally, a strongly marked horizon exerts a counterattraction into the far distance, an effect compounded in the Berlin picture both by the dramatically lowering clouds and by the more than a half dozen tiny sailboats that carry the viewer's attention back toward the limits of representational space. ("One feels physically drawn to [*The Stormy Sea*], as by an undertow," the Spanish painter Joan Miró remarked on a visit to the Louvre. "It is fatal. Even if this painting had been behind our backs, we would have felt it.")[46] In the Berlin picture too a pair of smallish rocks on the verge of inundation in the left foreground invite being read almost anthropomorphically as expressing the desired relation of the painter-beholder to the oncoming wave and by implication to the painting itself, while the fact that there are *two* such

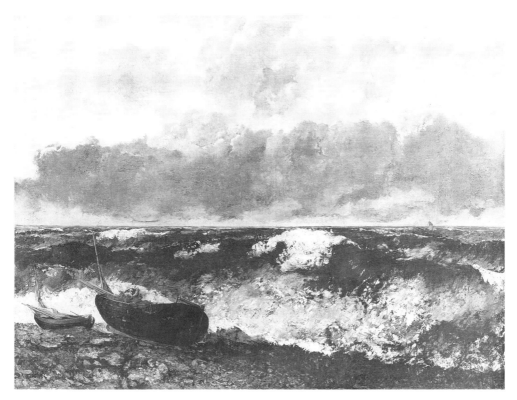

Figure 83. Gustave Courbet, *The Stormy Sea,* 1869.

rocks, one larger than the other, suggests a certain "inner" dividedness—between painter-beholder and beholder *tout court,* or between painting and beholding functions "in" the painter-beholder, or between will and automatism, or between the painter-beholder's left and right hands . . . A similar division is also suggested by the larger and smaller beached sailboats in the Orsay canvas, though their greater apparent distance from both the picture plane and the sea allows a more conventional response to them as *staffage.* A broader point about Courbet's paintings of breaking waves, the Source of the Loue, Le Puits noir, and related subjects is that he seems to have found in the natural motifs on which those series were based not only a perfect vehicle for his art but also a literal anticipation of the quasi-corporeal merger of painting and painter-beholder he continually sought to achieve (cf. my earlier remarks about the conditions under which he painted the *Burial at Ornans*).[47]

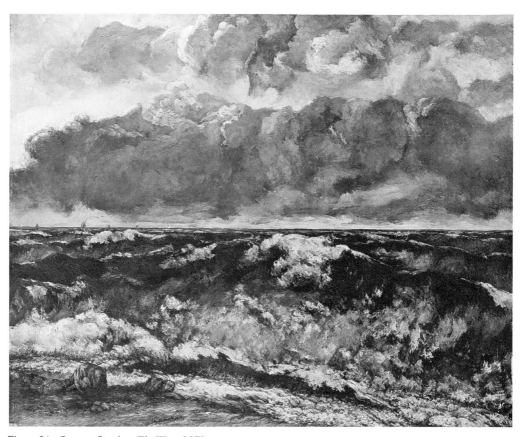

Figure 84.  Gustave Courbet, *The Wave,* 1870.

In a slightly different register, I think of the cave motif in the *Source of the Loue* series and some of the *Le Puits noir* pictures (the Baltimore canvas, for example) as analogous to the large "blind spot" hovering above the open grave in the *Burial,* to the black interior of the *tarare* into which the farm-boy peers in the *Wheat Sifters,* and, more broadly, to the devaluation of seeing that takes place in Courbet's art as early as the self-portraits of the 1840s, which is to say that I associate it with the eclipse of visuality—the undoing of spectatorhood—that would be concomitant with the bodily absorption of the painter-beholder into the painting on which he was working. And I think of the reflections in the surface of the water in the *Source of the Loue* and *Le Puits noir* paintings as comparable to the patch of sunlight high on the left-hand wall in the *Wheat Sifters* or to the reflection of the seated figure's lower legs in the stream that floods the near foreground of the *Source,* by which I mean that I see in them an image of a mode of representation that at first appears to have nothing to do with human agency or artifice precisely because it is the work of the automatic processes of nature. However, my account of the *Quarry* in chapter five suggested that in Courbet's paintings automatism and will (including the will to represent in paint) cannot simply be contrasted with one another. Similarly, the patch of sunlight in the *Wheat Sifters* was observed to bear the stamp of artifice in its shadowy rectilinear latticework, a feature I went on to associate with the rectilinear support over which the painter had stretched his canvas; just as the nude woman in the *Source* emerged, through a comparison with the central group in the *Studio,* as a figure for the painter-beholder at work on the painting, a reading I take as compromising the seeming naturalness of the scene as a whole and of the reflections in the stream in particular. (This was already implied by my suggestion that we regard those reflections as analogous to the picture on the easel in the central group.) The absence from almost all Courbet's pictures of caves or grottos of human figures and hence of the possibility of finding relatively specific images of the activity of painting may seem to distinguish those pictures sharply from the *Wheat Sifters* and the *Source,* not to mention the *Studio,* but the interpretation of the cave-plus-water motif I have just proposed connects that motif to Courbet's antitheatrical project, while the reflection in the surface of the stream suggests that the cave is ontologically "prior" to its reflection (it is what the latter represents), from which I conclude that representation in the *Source of the Loue* and *Le Puits noir* pictures is thematized as the product, perhaps by-product, of an enterprise that has for its primary aim

the accomplishment of quasi-physical merger between painter-beholder and painting. (Note too how the wooden platform in the left foreground of the Zurich version of the *Source of the Loue* [fig. 80] may be seen as a figure for the painter-beholder's palette along the lines of the "floating" tabletop in *Sleep*.)[48] This emphasis on something like the indirect production of representation is consistent with the obliviousness of the painter-surrogates in the *Wheat Sifters* and the *Source* to the sunlight on the wall and the reflection in the stream, an obliviousness I have read as a further index of antitheatricality.

Once again a page from the same early sketchbook to which we have gone before helps elucidate the mature paintings. On the page following the one bearing portraits of the sleeping Courbet and of his own upturned left hand, the artist has juxtaposed pencil drawings of a young man in a peaked cap reading a book and, at right angles, of a bridge near Ornans reflected in the river flowing beneath it (fig. 85).[49] It's as though

Figure 85.  Gustave Courbet, *Sketchbook Page*, early 1840s.

the page taken as a whole equates absorption in reading with reflection in water while leaving open the question of exactly how the equation is to be fleshed out. But the greater definiteness of the drawing of the reader confers a certain primacy on absorption even as the analogy between the two images calls into question, in a way familiar to us from our reading of the *Quarry*, all distinction between the realms of human activity and material nature. In any case, I want to associate the drawing of the man engrossed in his book not only with other manifestly absorbed personages in Courbet's oeuvre (including the hunter-painter in the *Quarry*) but also with the "absorptive" caves and grottos that we have seen play a central role in paintings in which reflection in water also figures prominently. In this connection too I'm struck by the silhouette-like shadow cast by the reader on the wall behind him, a classical trope for the invention of painting,[50] which in this instance carries the added connotation of unseenness and hence of antitheatricality (the reader appears oblivious

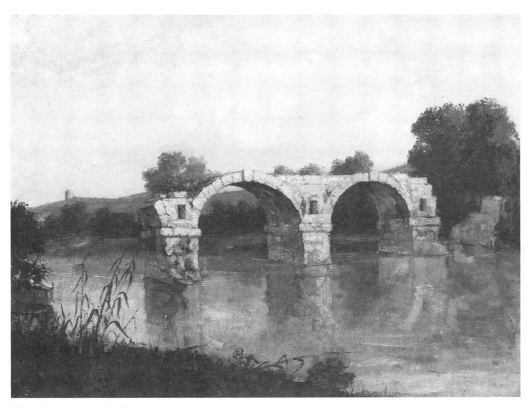

Figure 86.  Gustave Courbet, *Bridge at Ambrussum,* 1854 or 1857.

to the shadow to his right). There is even a sense in which the reader's engrossment in his book, by immobilizing him before a flood of light of which he is unaware, may be understood as a precondition of the casting of his shadow-image on the wall, as if in this respect too representation is thematized as a by-product of absorption.[51] The *Bridge at Ambrussum* (1854 or 1857; fig. 86) shows what the mature Courbet made of a scene not unlike the one rapidly sketched on the right-hand half of the sketch-book page; the *Seated Model* (fig. 64) and the *Portrait of Baudelaire* (fig. 65) are two of several drawings and paintings of figures absorbed in reading that have their prototype in the drawing of the reader on that page (and note the poet's obliviousness to the soaring plume in his inkwell, a figure for his mounting inner excitement and perhaps also for the act of representation itself);[52] while the *Portrait of Jo* discussed earlier in this chapter brings together motifs of absorption and reflection, both equally closed to our view, in a single "narcissistic" image that thus emerges all the more comprehensively as emblematic of Courbet's enterprise.

If we now turn again to Courbet's *Nude with White Stockings* (fig. 77) and *The Origin of the World* (fig. 78), their relation to that enterprise can be specified with some precision. For one thing, both paintings evoke the notion of an act of sexual possession of the woman, and implicitly the painting, by the painter-beholder. A more corporeal relation between painting and painter-beholder could hardly by imagined, and in fact it's striking that the metaphor of the sexual act makes an early appearance in Courbet's oeuvre—I'm thinking especially of the fine, insufficiently known *Bacchante* (1844–45; fig. 87)—before going underground for a decade or more. It's worth noting too that, with respect to the painter-beholder, one concomitant of such an act would be a complete undoing of distance and hence of spectatorship, which is what Leo Steinberg means when he remarks apropos certain works by Picasso that the sexual embrace is "blind."[53] This for me is the gist of any analogy between the overtly erotic paintings and Courbet's pictures of caves and grottos, though I would add that there is also in the erotic works a phantom image of reflection, if we imagine a male body exactly covering the female one (cf. the phallic bird in the *Woman with a Parrot*). Indeed the *Bacchante*'s unmistakable aura of sexual aftermath suggests that it represents not just a moment following the unrepresentable one of physical union but specifically the mutual falling back of both partners—of the painter-beholder and the painting—into separate realms. Seen in this light, the

foreshortening of the trunk and upper body that makes the bacchante so tangible-seeming a presence is less a provocation to possession than the form of a memory, while representability is thematized as deriving from the inevitable failure of a project of merger. But of course the failure (or say impossibility) of such a project is also intrinsic to the *Nude with White Stockings* and *The Origin of the World,* both of which go farther in the direction of outright pornography than any other works in Courbet's oeuvre. Finally, to the extent that a metaphor of sexual possession has been implicit in my account of the painter-beholder seeking to translate himself quasi-corporeally into paintings such as the *Wheat Sifters* and the *Source* via figures of women, his effort to do so emerges as figuratively masculine, a point already acknowledged by my discussion of phallic

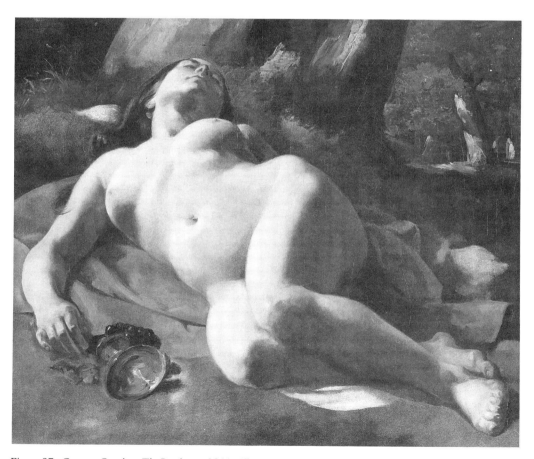

Figure 87.  Gustave Courbet, *The Bacchante,* 1844–45.

metaphors for the artist's paintbrush. But just as the phallus/paintbrush in those paintings is characterized by feminine attributes and thus is other than the unitary masculine entity phallic objects have classically been theorized to be, so possession turns out to have unexpected consequences as the painter-beholder all but becomes his female surrogates. Here as elsewhere in Courbet's art, the difficult question—in this context inescapably a political one—is how exactly to assess the force of that *all but*.

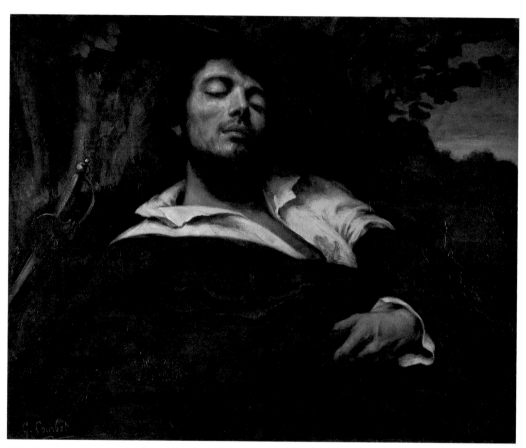

Plate 1. Gustave Courbet, *The Wounded Man*, ca. 1844–54.

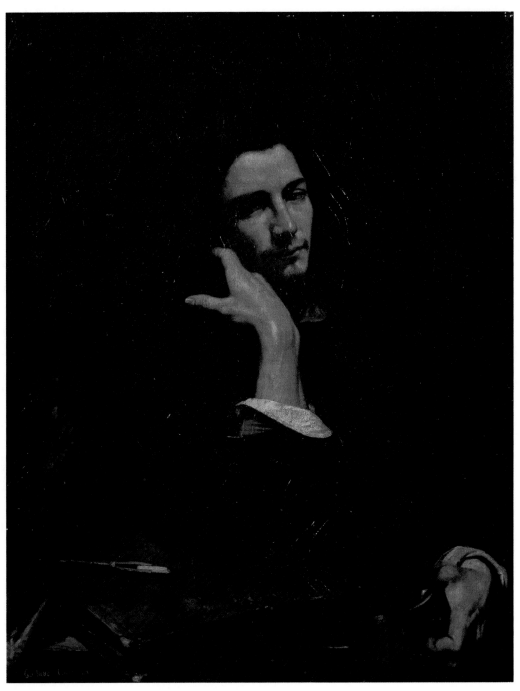

Plate 2. Gustave Courbet, *Man with the Leather Belt*, 1845–46?

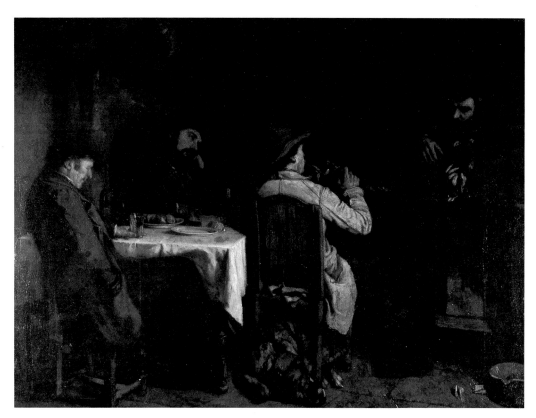

Plate 3. Gustave Courbet, *An After Dinner at Ornans*, 1848–49.

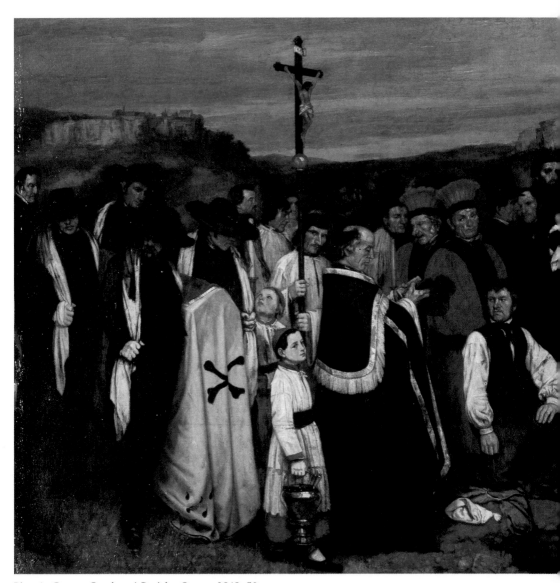

Plate 4. Gustave Courbet, *A Burial at Ornans*, 1849–50.

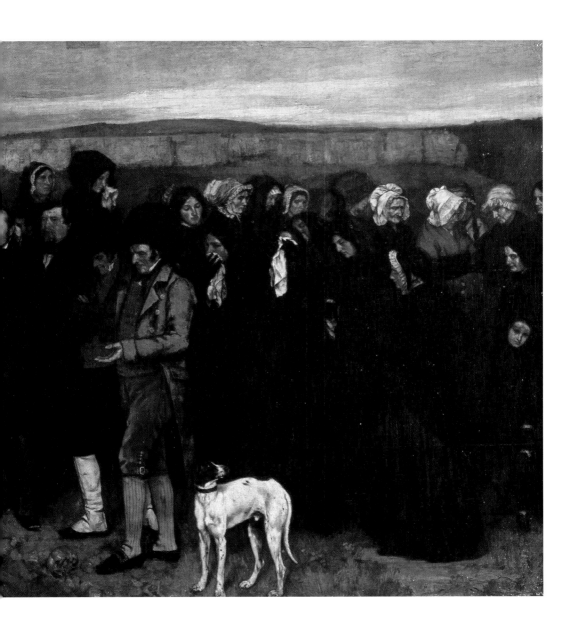

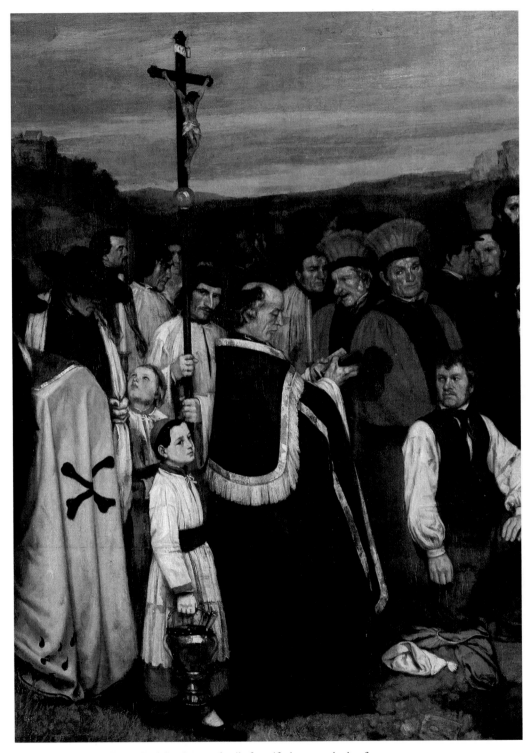

Plate 5. Gustave Courbet, *A Burial at Ornans,* detail of crucifix-bearer and other figures.

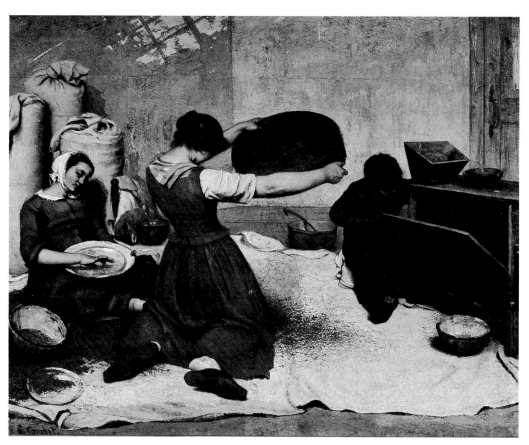

Plate 6. Gustave Courbet, *The Wheat Sifters*, 1853–54.

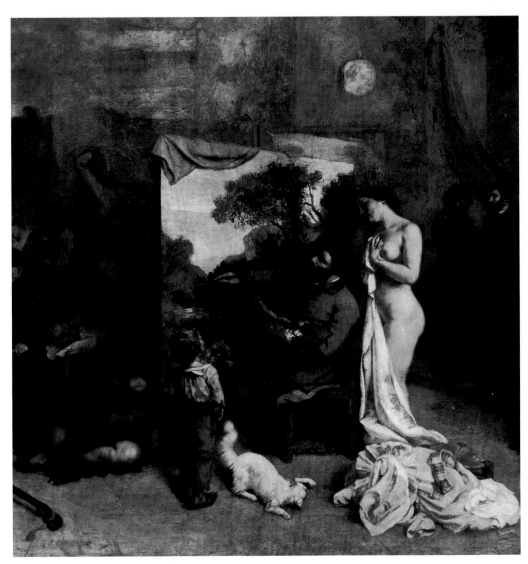

Plate 7. Gustave Courbet, *The Painter's Studio,* detail of central group, 1854–55.

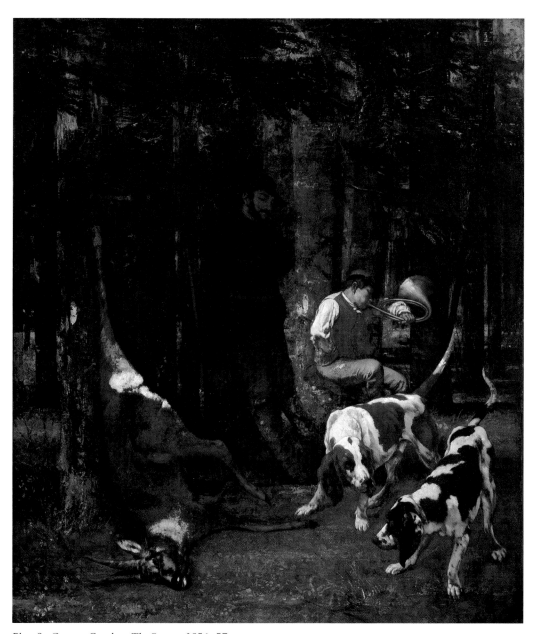

Plate 8. Gustave Courbet, *The Quarry*, 1856–57.

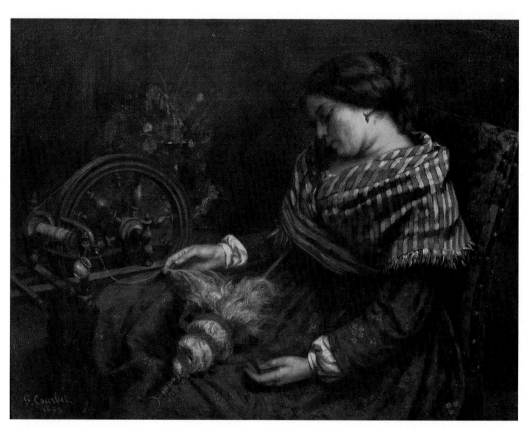

Plate 9. Gustave Courbet, *The Sleeping Spinner*, 1853.

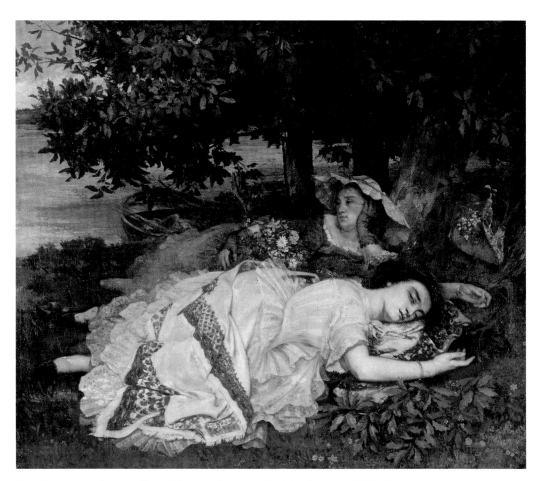

Plate 10. Gustave Courbet, *Young Women on the Banks of the Seine (Summer)*, 1856–57.

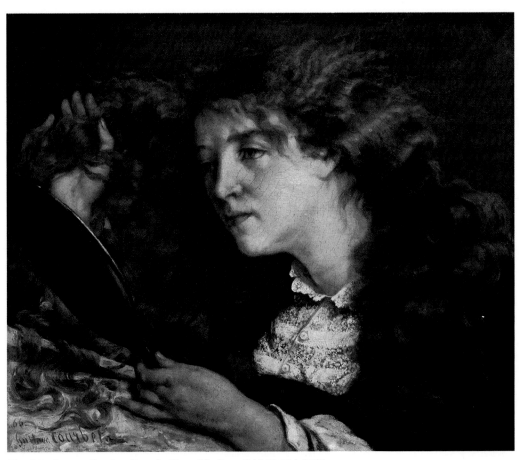

Plate 11. Gustave Courbet, *Portrait of Jo,* or *The Beautiful Irish Girl,* 1866.

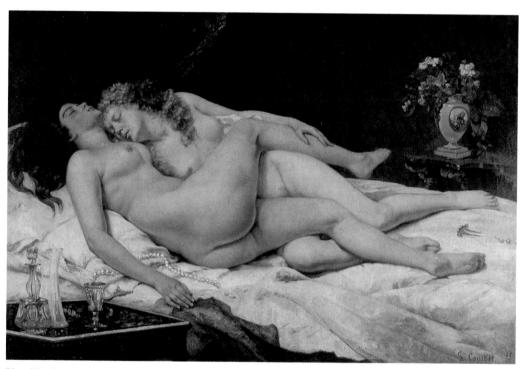

Plate 12. Gustave Courbet, *Sleep,* 1866.

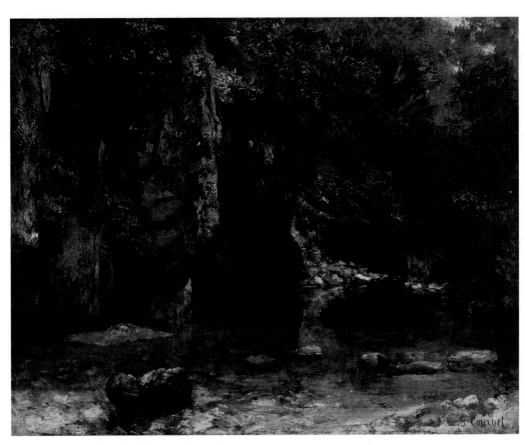

Plate 13. Gustave Courbet, *Le Puits noir,* 1860–65.

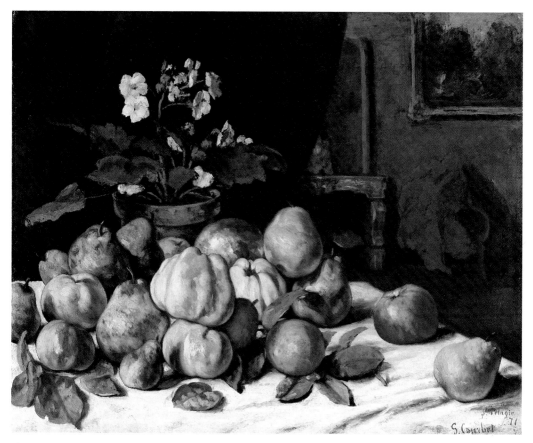

Plate 14. Gustave Courbet, *Apples, Pears, and Primroses on a Table*, 1871–72.

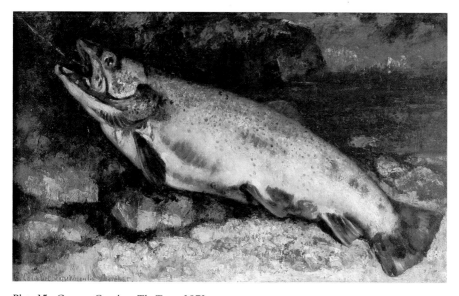

Plate 15. Gustave Courbet, *The Trout*, 1872.

Plate 16. Gustave Courbet, *Hunter on Horseback, Recovering the Trail*, 1864?

# 7    Courbet's Realism

I NOW WANT to start to bring this book to a conclusion by considering under separate heads a number of topics that either haven't yet arisen or require further discussion. Naturally the topics themselves aren't unrelated to one another. But I shall be less concerned to give the chapter as a whole a satisfying shape than to amplify and deepen my interpretation of Courbet's Realism both historically and philosophically.

## Courbet and Pictorial Drama

In the first chapter of this book, after summarizing the division among nineteenth-century critics over Millet's art, I said that I would go on to claim that Courbet (unlike Millet) broke fundamentally with the dramatic norms of the antitheatrical tradition within French painting I had just traced. The chapters that followed have, I hope, done much to clarify that statement, but the claim itself stands in need of elaboration. This is all the more the case in that Courbet's major paintings are consistent with previous works in that tradition in certain important respects: most notably in their predilection for subjects involving two or more personages engaged in something like significant human action, but also in their commitment to a seeming naturalness of scale (the chief precedent for which was David) that often meant that the pictures were of considerable size.[1] And of course it has been the aim of this book to show how Courbet's paintings sought new means by which to overcome the theatrical, a task that had been crucial to the Diderotian tradition from the outset. I suggest, however, that the means in question were at odds with Diderot's very conception of painting as drama, and moreover that what gave Courbet's repudiation of drama its momentousness—what made it a repudiation rather than a sublimation of dramatic values and effects—was

his refusal to retreat from human subject matter into landscape, as in principle he might have done. (I'm claiming, in other words, that although Courbet was a masterly painter of landscapes he wasn't essentially a landscapist but a figure painter—indeed that the meaning of his landscapes only becomes clear when they are seen in relation to his figure paintings, as in chapters four and six. This is the main reason why his landscapes play a subordinate role in this book.)

## TWO COMPARISONS

Two comparisons with earlier moments in the antitheatrical tradition may be helpful here. Toward the end of my summary of Diderot's views in chapter one I remarked that alongside the principal, dramatic conception of painting in his *Salons* there exists a seemingly opposite but in fact complementary conception that I called pastoral, according to which the beholder was to be negated not by denying his presence—by walling him out—but on the contrary by making him imagine that he had entered the depicted scene and so was no longer standing before the painting looking on. Now there is an important sense in which Courbet's art can be seen as a delayed fulfillment of Diderot's pastoral conception, as if with the progressive theatricalization of dramatic means and effects a strategy that in Diderot's criticism had been merely secondary emerged in the paintings we have been examining as the only vehicle for an effort that otherwise couldn't have got under way. At the same time, Courbet's version of that strategy departs from Diderot's in two respects. First, Courbet's attempts to transport himself into the paintings on which he was working were in no way limited to the landscapes, paintings of ruins, and other works in lesser genres that elicited Diderot's fictions of inclusion; instead they found their most characteristic purchase in representations of human beings engaged in actions that in turn lent themselves to a thematization of the act of painting. And second, Courbet's ultimate aim was not the imaginary enticement of some other beholder (some other Diderot) into a depicted scene but rather the all but literal merger of himself as painter-beholder with the painting on which he was working. Despite these basic differences, the affinity between Diderot's criticism and theory and Courbet's practice testifies to the historical coherence of the antitheatrical tradition to which both belong.

Another aspect of Courbet's repudiation of the dramatic (i.e., of the dramatic become theatrical) that invites comparison with the opening phase of that tradition is his predilection for depicting manifestly absorp-

tive states and activities, from sleep (even, in the *Quarry*, death) and rev-
erie to certain forms of cultural work (reading, playing a violin, painting
a picture) to repetitive, quasi-automatistic labor (breaking stones, win-
nowing grain) and, much more rarely, sustained physical effort (blowing
a hunting horn). It's possible to see in this a return to a moment imme-
diately preceding Diderot's formulation of the dramatic conception,
when, in Chardin's genre paintings of the 1730s and 1740s, the primacy
of absorption on the thematic level was accompanied by an acknowledg-
ment of the beholder's presence before the canvas that didn't yet pose
fundamental problems for the representation of absorption itself. (Re-
member that the function of Diderot's dramatic conception was to secure
the representation of absorption against the emerging threat associated
with the beholder.) But the differences between Chardin and Courbet are
at least as important as the resemblances. Thus for all Chardin's perfect
mastery of the body's moods and graces, we don't find in his pictures the
evocation of absorption *in embodiedness* that forms the ground bass of
Courbet's art throughout his career. Moreover, whereas Chardin's repre-
sentations of absorption characteristically suggest the isolation of indi-
vidual personages in their respective "worlds" (an effect sometimes
underscored by their occupying different rooms), in Courbet's multi-
figure compositions the emphasis is rather on what I have called an ab-
sorptive continuum that comes close to effacing individual differences
not only among the figures themselves but also, in a manner of speaking,
between them and the painter-beholder.[2] By the same token, nothing
could be more alien to Courbet's art than Chardin's separation in paint-
ings like the *Card Castle* of the axis of absorption from the axis of behold-
ing. Rather, Courbet's art conflates the two either by depicting one or
more figures largely from the rear or by the process referred to earlier as
lateralization by which the painter-beholder's not quite rigorously fron-
tal position before the canvas is transposed into implied or depicted
movement back and forth across the representational field.

  Indeed the differences between Chardin and Courbet remain funda-
mental even when the two artists seem to have been working in identical
modes. For example, the protagonist of Chardin's *Draughtsman* (fig. 3)
and the principal figure in Courbet's *Wheat Sifters* (fig. 88) have much in
common with respect to bodily position, absorption in their respective
actions, and orientation relative to that of the beholder (even granting
that the engraving reverses the direction of Chardin's lost painting)—
similarities compounded by my reading of the action of sifting grain as a

metaphor for the act of painting. But it's typical of the differences I have been stressing that Courbet's sifter strikes us as engaged in a far more physical operation than does Chardin's draughtsman, whose hands are obscured from view and whose bodily posture expresses none of the competing pressures—between the demands of sifting grain and of representing the act of painting—that make Courbet's figure so strange and yet so memorable. Moreover, the almost identical orientation of the two figures doesn't imply sameness of meaning with respect to the issues we have been tracing. Thus the fact that the seated draughtsman has been depicted from the rear serves mainly to suggest that he is oblivious to our presence, a state of mind I take to be underscored by the small tear in his jacket near the right shoulder (in the original picture the tear almost certainly would have been painted a contrasting color and so made more conspicuous).[3] That is, the tear simultaneously functions as an objective sign of the draughtsman's absorption (he is too engrossed in his art to

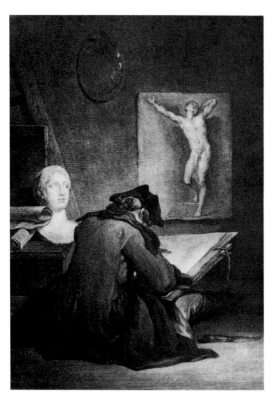

Figure 3. After Chardin, *The Draughtsman*.

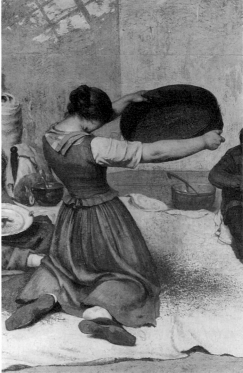

Figure 88. Gustave Courbet, *The Wheat Sifters,* detail of kneeling sifter.

care about his appearance) and, by virtue of its exposure to our gaze but unavailability to his, effects a radical separation between the axes of absorption and beholding, which in this instance face in almost exactly opposite directions. In the *Wheat Sifters,* on the other hand, the treatment of the kneeling woman's back has a different import: not only are there no details that attract and hold one's gaze, the forward thrust of her hips evokes a movement into the painting, while the folds of her skirt descending to the floor and breaking behind her knees hint at a metaphorical fall and outward flow of water that will soon reappear greatly strengthened in the standing model's white sheet and discarded dress in the *Studio*'s central group. More broadly, the kneeling sifter's orientation isn't meant to convey a sense of her obliviousness to being beheld so much as it establishes her positional and "actional" congruence with a specific beholder, the painter-beholder, whose aim I have repeatedly described as one of quasi-corporeal merger with the painting as a whole.

Finally, even the motifs of something like blindness that appear in both paintings have different implications. In the Chardin the blank, unseeing stare of the plaster head to the draughtsman's left suggests the painting's figurative blindness to the beholder standing before it. In contrast, I have described the kneeling sifter as unaware of, in that sense blind to, the sunlight on the wall above her, while the boy peering into the black interior of the *tarare* has been read by me as a metaphor for the eclipse of visuality—figuratively, the blindness not of the painting but of the painter-beholder—that the accomplishment of Courbet's antitheatrical project would necessarily entail. Once again, however, the undeniable similarities between the *Draughtsman* and the *Wheat Sifters* draw attention to the coherence of the antitheatrical tradition that Chardin either immediately preceded or inaugurated (both characterizations are tenable) and Courbet and his successor Manet brought to a climax (though not to a close).

## THE REJECTION OF CONFLICT, OPPOSITION, AND CONTRAST; SOME EXCEPTIONS

Courbet's repudiation of drama involved an almost total rejection of conflict, opposition, and contrast both thematically and structurally. Thus for example none of the breakthrough paintings depicts a scene of competing wills, desires, or bodies, while compositionally all are based on an implied processional movement either in a single direction or back and forth across the pictorial field, as if the latter were not a stage on which

events take place so much as a ground to be occupied and in effect possessed, in the first instance by the personages within the painting and ultimately by the painter-beholder (and in the *Burial* the beholder *tout court*). A similar absence of conflict and opposition marks the *Wheat Sifters* and the *Quarry,* though in the case of the latter it required a certain work of interpretation to establish that elements that at first appear contrasting in fact belong to a single absorptive continuum that ideally is itself continuous with the absorptive act of painting. Finally, I have tried to show how some of Courbet's most important representations of women, including the *Wheat Sifters,* the *Young Women on the Banks of the Seine,* and the *Portrait of Jo,* radically reinterpret the "natural" opposition between male and female that had been present in the dramatic tradition from the beginning and is especially evident, as has often been remarked, in David's history paintings of the 1780s.[4]

Just how alien a thematics of conflict was to Courbet may be gauged from a painting in which, altogether uncharacteristically, he set out to represent two figures struggling with one another—*The Wrestlers* (1853; fig. 89).[5] In that canvas two almost naked life-size male figures have been depicted grappling violently in the extreme foreground of a large open space, said to be the Hippodrome on the Champs-Elysées, at the far end of which, improbably remote from the principals and painted in a deliberately "naive" manner, are grandstands filled with spectators. The two wrestlers, veins bulging and muscles straining, are plainly meant to strike the viewer as entirely engaged in intense physical effort: thus despite the fact that both figures have been depicted from the front, Courbet has managed, as in the *Stonebreakers,* to obscure their faces, denying us any view at all of the one on the left and inclining the other so as to reveal mainly a furrowed brow and a nose but not the eyes, which are lost in shadow and might almost be shut. I suggest that the two antagonists may be seen as embodying to the point of hypostatizing the painter-beholder's sense of the willed physical effort involved in the act of painting, much as if they were personifications of his hands—in this instance, as in the *Man with the Leather Belt,* not distinguished from one another as relatively active and passive (though perhaps significantly the wrestler on the right appears dominant).[6] This would help explain why the two antagonists have been fused together in a single compound entity, the four legs seeming to compose a single system of support and the two upper bodies all but merging in a darkish expanse of striving limbs and sculpted flesh. Understood in these terms, the wholly tactile connection

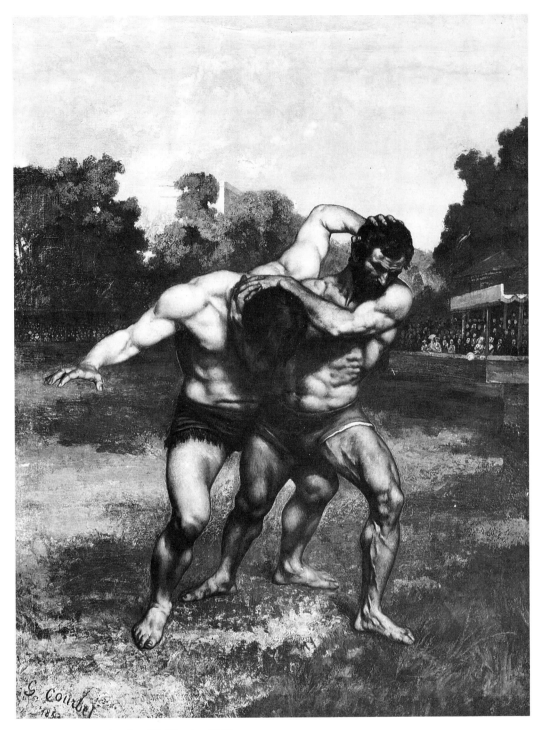

Figure 89. Gustave Courbet, *The Wrestlers,* 1853.

between the figures suggests an eclipse of vision, as if here too the act of painting were imagined as blind, at the same time as the distant grand-stands filled with spectators imply a displacement of spectatorship to within the painting—a first, crude deployment of a strategy that was to undergo progressive refinement in the next several years.

In the end, however, the *Wrestlers* remains anomalous. For one thing, because neither of the men has been depicted even slightly from the rear, nothing mitigates their character as looming, alien, material presences in the absolute forefront of the picture's space, the obscuring of their faces only adding to the effect of near-monstrosity. (The contrast with the *Stonebreakers* in this regard is instructive.) For another, the evocation of muscular strain and the welding of the two combatants into a strongly modeled, sharply contoured, peculiarly configured unit—altogether different in feeling from the virtual merger of bodies noted in *Sleep*—make especially salient the painting's most discordant feature, the collagelike discontinuity between the wrestlers and their surroundings. Also contributing to this effect is the apparent temporal freezing of the action, a function both of the convulsive character of the gestures and of the abruptness of the modeling and contouring. In short the attempt to produce a dramatic, or at any rate conflictive, image of the effort of painting proved pictorially disruptive, and it isn't surprising that the major paintings of the next phase mark a return to the less overtly effortful absorptive thematics of his greatest work.

Not quite a decade later Courbet again took up the theme of conflict, in terms that illustrate both an attraction despite everything to the dramatic tradition that preceded him and a counterimpulse, implicitly anti-theatrical, to challenge that tradition's basis in human action. *Fighting Stags, Rutting in Spring* (1861; fig. 90) is a monumental canvas in the left foreground of which two stags battle one another while to the right and further away a third stag, mouth open and head twisted upward, bellows soundlessly. On the one hand, the composition recalls that of David's *Oath of the Horatii* (fig. 4), the Roman father and his sons swearing their mortal oath having been replaced by the violently clashing stags and the subsidiary group of swooning women having found an equivalent in the solitary belling animal. In fact the analogy with the *Oath* seems so close—or rather the contast between the fighting stags and the third, emotionally expressive one feels so stark—that it takes a moment to realize that the third stag too is male, as its antlers plainly attest. On the other hand, that the *Fighting Stags' dramatis personae* are not men and women

but rather these particular beasts seems to have mattered to the artist, who wrote to Francis Wey: "In these animals no muscle stands out; the combat is cold, the rage profound, the blows are terrible though it looks as if they barely touch each other."[7] The absence of conspicuous muscu-lature and more broadly of signs of extreme physical effort is a crucial difference between the *Fighting Stags* and the *Wrestlers,* but it also distin-guishes the former from the *Oath of the Horatii,* which I argued in chapter one came to strike David himself as theatrical partly because of its com-bination of muscular strain and expressive intensity. (As though Courbet, like Géricault but far less sweepingly, found in the representation of ani-mals a way around theatricality.) Interestingly, Courbet began his ac-count of the *Fighting Stags* in his letter to Wey by saying that it "ought to have, in a different sense, the importance of the *Burial,*"[8] a statement that suggests he may have been aware, if not of the resemblance between his composition and that of the *Oath,* at least of the extent to which the later

Figure 90.  Gustave Courbet, *Fighting Stags, Rutting in Spring,* 1861.

painting represented something new in his art.\* And in fact Courbet soon went on to paint *The Stag Taking to the Water* (1862; fig. 91) in which the pathos-charged expressiveness of the belling animal in the *Fighting Stags* has been brought front and center to remarkable though not entirely comfortable effect,[9] and later that decade he produced the enormous *Death of the Stag* (fig. 69), a far more problematic canvas that we have already examined. But the recuperation of drama and expression

\*For his part, Wey in his review of the Salon of 1861 praised the *Fighting Stags* for its evocation of what in chapter one, summarizing the aims of Diderot's dramatic conception, I called aloneness. "Everything expresses solitude and silence," Wey writes, "and one feels that this ten-point [the third stag], who bellows under these vaults of greenery, wakens echoes *without attracting anyone*" ("Salon de 1861," *Le Pays,* 15 May 1861, emphasis added). (Tout respire la solitude, le silence, et l'on sent que ce dix-cors, qui brame sous ces voûtes de verdure, en réveillera les échos sans attirer personne.)

Figure 91.  Gustave Courbet, *The Stag Taking to the Water,* 1862.

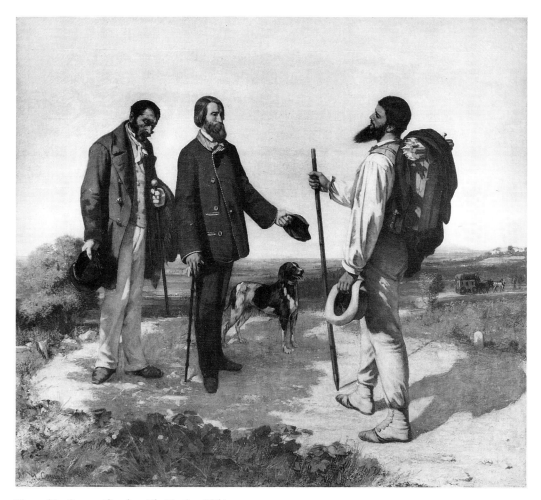

Figure 92. Gustave Courbet, *The Meeting*, 1854.

through scenes of animal conflict or conflict between men and animals never became a large part of Courbet's pictorial project, perhaps because he sensed that even so mediated a relation to the dramatic threatened the internal equilibrium of his art.

Two additional paintings should be mentioned in this connection. In *The Meeting* (1854; fig. 92), a scene of Courbet being greeted near Montpellier by Alfred Bruyas, his foremost patron, and Bruyas's servant, there is to my eye more than a hint of Davidian structure in the encounter (not quite a confrontation) between the artist and the others.[10] If this seems doubtful, and by itself I imagine it does, consider the related oil sketch known as *The Homecoming* (ca. 1854; fig. 93), in which Courbet's portrayal of himself from behind doffing his hat with extended arm in what

seems a gesture of exultation comes uncannily close in pose and feeling to the figure of the elder Horatius in the *Oath of the Horatii,* or perhaps to a combination of that figure and the nearest of the three sons. The unfinished state of Courbet's face in the *Homecoming* recalls the too-abrupt lost profile of the kneeling woman in the *Wheat Sifters,* but the picture as a whole can be seen as an attempt almost literally to take over David's masterpiece for his own purposes.

(Before leaving the *Fighting Stags* I want to note that the nearest of the two combatants—the one we see largely from the rear—has his head deeply bowed so as to bring his antlers more effectively into play. Recalling the discussion in chapter three of signature effects in the *Stonebreakers,* it seems possible that Courbet found in the subject of fighting stags a means of recharacterizing as aggressive, even as triumphant, that ordinarily subservient posture, and thereby of redeeming more triumphantly than in any previous work the demeaning connotations of his name [i.e., of its homonym *courbé*]. This would be another, unconscious reason why he regarded the *Fighting Stags* as a decisive work.)[11]

## COURBET AND PICTORIAL UNITY

Closely linked with Courbet's overall rejection of pictorial drama was his implicit refusal of the effects of unity and closure that had been fundamental to the dramatic conception of painting from the first. Not that Courbet wished his paintings to be seen as positively disunified, nor was he indifferent to compositional concerns. On the contrary, as I have tried to show, Courbet was often both highly original and consummately artful in his handling of pictorial structure, and it's one of the ironies of his reception (continuing to the present day) that his mastery in this regard has so consistently been slighted.

Indeed it was above all Courbet's pursuit of a hitherto unexampled mode of *unification* through rhythmic repetitions, thematic continuities, and metaphorical equivalences across the pictorial field that seems to have given rise to a universal impression of lack of *unity,* as if there could be no unity worth the name that wasn't based exclusively on conflict, opposition, and contrast. (The art-historical notion of additive composition perpetuates this idea.) Or perhaps it was the conjunction of the pursuit of unification with the determination to minimize all sense of distance between painting and painter-beholder that from the first has led critics to describe his most ambitious compositions as nothing more than segments of an implicitly still larger entity. Thus Claude Vignon in 1851

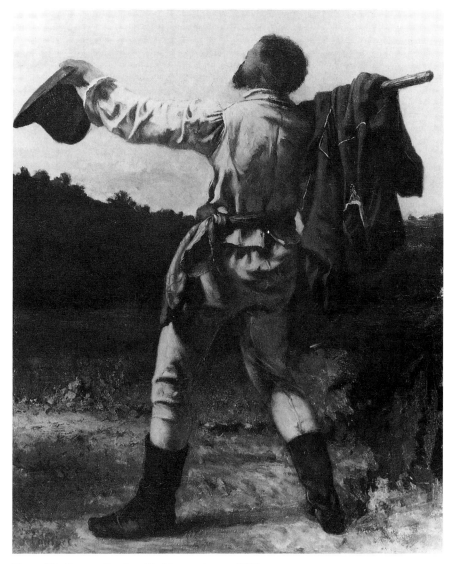

Figure 93. Gustave Courbet, *The Homecoming,* ca. 1854.

characterized the *Burial* as "a canvas of eight or ten meters [in width] which seems to have been cut from one of fifty meters," in part because "all its personages, arranged in a line across the foreground of the painting, are in the same plane and appear to form a single episode of immense size." [12] Similarly, Edmond About complained in 1857 that the folly of Realism consisted "in taking the part for the whole and the accessory for the principal; in groping at nature instead of looking at it; . . . and in believing that the world is six feet deep because one is myopic." [13]

Often the accusation that Courbet failed to produce satisfying wholes—technically speaking, that he was a painter of *morceaux,* fragments, not *tableaux,* fully realized paintings—went hand in hand with the recognition that he was masterly in his treatment of details and even entire figures.[14] An early instance of that divided response is Delécluze's commentary on the *Burial* and related works in his review of the Salon of 1850–51. Far from simply deprecating Courbet's achievement, as one might have expected of the septagenarian champion of the classical school, Delécluze remarked that "after having accustomed one's eye to the repulsive aspect of [the *Burial*], one discovers in certain details of that canvas some very well-painted parts and even some entire figures that reveal an uncommon competence." Nevertheless, the *Burial* was "a very bad *tableau,*" as opposed to the *Man with the Pipe* which Delécluze considered "the best-painted *morceau*" (by which he meant a work that didn't quite aspire to the status of a true *tableau*) in the entire Salon.[15] Two years later, the same Gustave Planche who in the 1830s had been Delaroche's chief antagonist praised Courbet's powers of visual description but complained that "he has retained, at the same time, all his incapacity for composition, and that incapacity is so evident that his paintings are nothing more than *morceaux copiés* and have no resemblance to *tableaux.*"[16] (The work that immediately elicited this critique, the *Young Women of the Village* [fig. 114], is in fact marred by an apparent inconsistency of scale in the rendering of a pair of cows,[17] but Planche intended his remarks to apply to the *Stonebreakers* and the *Burial* as well.) Even more ambivalently, the painter Alexandre-Gabriel Decamps is reported to have said to Millet, "I like to see robust, healthy, young painting; Courbet often produces astonishing work of this sort; but the man lacks common sense. He will never know how to make a *tableau.*"[18] Or as Zacharie Astruc, a young critic who was a friend of Manet and who regarded Courbet as the foremost painter of his time, wrote in 1860: "M. Courbet doesn't bring to the composing of his works as much care as is desirable. . . . Oppositely to Delacroix, who sees only an ensemble resonant with his idea, he takes pleasure in the *morceau spécial* from which it is distant. From the *morceau* he moves to the ensemble, the *tableau:* whence the errors and inconsistencies [that mark his pictures]."[19] Astruc was thinking particularly of the *Quarry,* which was indeed assembled out of pieces, but the criticism had by then become standard.

It's worth emphasizing the contrast in this regard between Courbet and Millet, who as was noted in chapter one can also be seen as returning

to absorptive themes and motifs. Thus Millet in a letter to the critic Théo-
phile Thoré explained that he wanted to make paintings in which "things
don't at all have the air of being brought together by chance and for the
occasion, but rather have between them an indispensable and forcible
connection [*une liaison indispensable et forcée*]. I would like the beings I
represent to have the air appropriate to their position, and for it to be
impossible to imagine that they could be anything else. In sum, men and
things must always be there for a purpose. I want to put in place fully and
finally that which is necessary . . ."[20] Millet's ideal of unity as a causal
system in which every element in the composition visibly exerts a con-
trolling influence on every other amounts to an updated version of Di-
derot's statement in his *Pensées détachées sur la peinture:* "A composition
must be organized so as to persuade me that it could not be organized
otherwise; a figure must act or rest so as to persuade me that it could not
do otherwise."[21] Nothing could be clearer than that Courbet wanted no
part of such an ideal, perhaps because he intuitively recognized that the
pursuit of a compelling illusion of internal causal necessity was bound to
go too far (Millet's claim that he wanted to evoke "the indispensable *and
forcible* connection" between things verbally expresses such a tendency
toward excess). In any case, Millet's preoccupation with unity is evident
throughout his paintings and drawings of peasant subjects, sharing both
the credit for their success among those commentators who found them
paragons of antitheatricality and the blame for their failure among the
growing number of critics who detected in his work an evident intention
*to be seen as* antitheatrical that spoiled everything. Conversely, what takes
the place of the Diderotian ideal of unity in Courbet's art is a composi-
tional strategy that, for reasons that will soon become plain, *could not be
made* perspicuous, a limitation that was inseparable from its strengths.

    We should note too that Millet's statement to Thoré has connotations
that may fairly be termed political. That is, his account of his composi-
tional aims conflates notions of pictorial and social necessity, largely
through a metaphorics of positionality, in a way that suggests that his
version of the Diderotian ideal implied an acceptance, if not in everyday
life at least within painting, of the social, economic, and political status
quo. (As though even the possibility of social protest were tantamount
to contesting the laws of pictorial composition.) Something very similar
is also indicated by the report Millet gave Sensier of his attraction to the
art of the so-called primitives, "to those subjects as simple as childhood,
to those unconscious expressions, to those beings who say nothing but

seem charged with life, or who suffer patiently without crying out, without complaining, who submit to the human law and haven't even the idea of asking for reasons why things are as they are. Those artists didn't practice an art of social revolt as in our time."[22] It doesn't follow, of course, that Courbet's art should be seen as politically radical on the level of pictorial structure. But the example of Millet suggests how pictorial and political issues could be mutually entangled,[23] and it further sharpens my insistence that, despite the two painters' shared hostility to the theatrical and common preoccupation with the life of the body, there exists a gulf between their respective achievements.[24]

## Courbet and Anthropomorphism

In my discussion in chapter six of the Baltimore version of *Le Puits noir* I held off mentioning a significant feature of that picture—the suggestion of the lower half of a human face (a nose, mouth, and chin) in the large rock formation immediately to the left of and rising considerably above the central cave (pl. 13; fig. 94). The first scholar to propose that some of Courbet's landscapes contain hidden anthropomorphic or zoomorphic images was Toussaint, who in her catalog to the great exhibition of 1977–78 states that the painter "sometimes yielded to the temptation . . . of unobtrusively turning rocks and vegetation into humorous likenesses of animal or human faces."[25] The superb *Le Gour de Conches* (1864; fig. 95), for example, "resembles puzzle-drawings for children in which human figures are concealed under the semblance of objects. Can we not distinguish a policeman in a kepi at either side of the bridge? The rocks are carefully arranged to suggest the appropriate outline, and other human heads can be found here and there throughout the composition."[26] (Note especially the upward-tilted profile composed of a rock and rushing water toward the bottom right of the canvas.) Another instance of such playfulness, Toussaint suggests, can be found in the *Studio,* the model's clothes heaped on the floor seeming to her to have been given the shape of "a crouching animal of some odd species, with its head between its paws, teasing the cat and thus focusing attention on it."[27] In addition she attributes to Courbet a previously unpublished canvas she calls *Fantastic Landscape with Anthropomorphic Rocks* about which she writes: "In this painting all concealment is abandoned: two undisguised heads are seen, as well as about a dozen human and animal shapes."[28]

More recently, the attribution to Courbet by Klaus Herding of more than 200 previously unknown drawings and watercolors, many of which contain unmistakable images of human and animal faces in foliage, rocks, and clouds, has underscored the importance of the issue of anthropomorphism (I shall use the single term to include zoomorphic imagery as well), while at the same time widespread doubt about the authorship of the works in question has made the issue all the harder to resolve.[29] (The *Fantastic Landscape* too has been disputed.)[30]

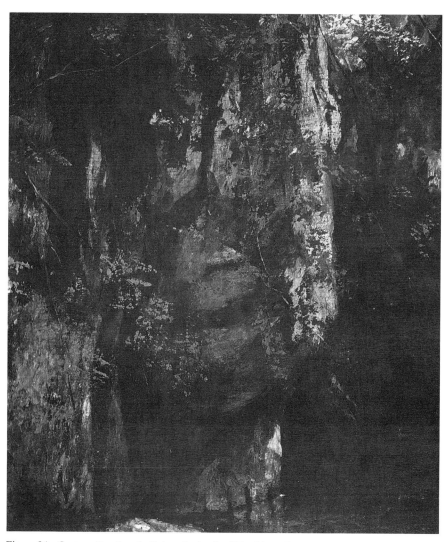

Figure 94. Gustave Courbet, *Le Puits noir,* detail of "face" in rock.

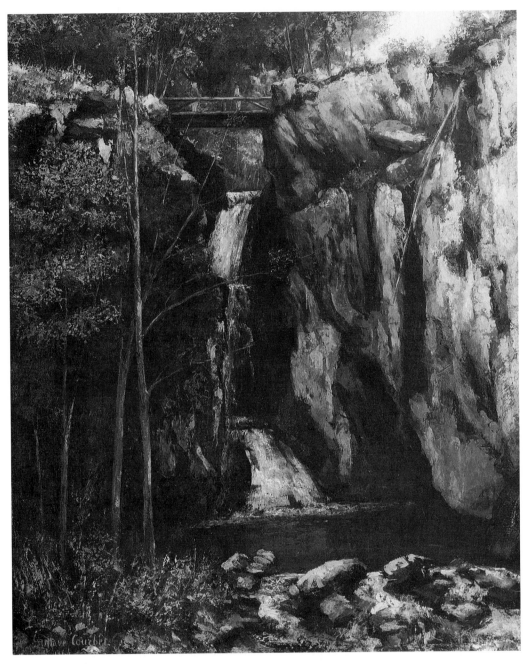

Figure 95. Gustave Courbet, *Le Gour de Conches,* 1864.

My stake in all this is considerable because in obvious respects my reading of Courbet's enterprise not only would be able to accommodate a quotient of anthropomorphism but would positively discover in the latter further confirmation of its claims. Specifically, the claim that Courbet as painter-beholder continually sought to transport himself into the painting on which he was working could be taken as explaining the irruption of anthropomorphic imagery in his art, not so much on the grounds that such imagery indicates the painter-beholder's "presence" inside the painting as because a possible consequence of Courbet's antitheatrical project as I have described it would be a "corporealizing" of the representational field—a projection of bodily feeling into various elements within it—that might well find displaced expression in imagery of that sort. In any case, I agree with Toussaint that anthropomorphic imagery can sometimes be found in Courbet's pictures, but in contrast to her emphasis on the artist's deliberate playfulness I want to argue that by and large the features of those pictures I associate with the notion of anthropomorphism aren't the product of conscious intention—in fact I'm inclined to doubt alleged instances of anthropomorphism in Courbet that go too far. Thus I too question the attribution of the *Fantastic Landscape* and regard it as impossible that Herding's drawings have anything to do with Courbet. And I suggest that a more productive approach to the issue would begin by resisting any too precise or limited definition of anthropomorphism in the interests of registering both the range and the variety of imagery in Courbet's work that may, however loosely, be understood in these terms. It might be objected that so free a way of proceeding risks diluting the concept beyond recognition. But the concept is far less important than the phenomena it can help bring into focus, and in any event it would be surprising if here as elsewhere in Courbet's art we were not dealing with a range of cases from the relatively unmistakable (*Le Gour de Conches*) to the somewhat speculative (the Baltimore *Le Puits noir*) as well as to instances in which the meaning of anthropomorphism seems to hang in the balance.

Probably the best way of approaching the problem is by looking briefly at several paintings already discussed in detail. In the *Sleeping Spinner* (pl. 9), for example, the tiny red blossoms drooping on their stems just the other side of the spinning wheel may be seen as sympathizing with the sleeping woman, or at least as miming or repeating (or indeed anticipating) the forward slump of her head and perhaps also the slackness of her partly open hands. This may seem too minor an accord to

bear interpretive weight, but if we turn to the slightly later *Wheat Sifters* (pl. 6) we encounter a more elaborate instance of the same kind, namely the three sacks of grain standing against the wall at the far left each of whose lolling, drooping tops evokes a mood of somnolence keyed to that of the seated sifter and more broadly to the absorptive tenor of the scene as a whole. The expressiveness of the sacks in this regard is heightened by their fullness, or rather by the way in which the pressure of the grain against the inside of their cloth envelopes suggests bodily sensation. There is also a rough parallel between the relative sizes of the three sacks, the tallest of which is in the middle and the next tallest at the left, and of the human figures, which are similarly deployed. Finally, our sense of the participation of the sacks in what I have been calling an absorptive continuum is enhanced by the presence in the space between the two sifters of a sleeping cat, which metaphysically is intermediate between the literally inanimate but anthropomorphic-seeming sacks of grain and the absorbed, in one instance distinctly drowsy, personages. (Note too how my characterization in chapter six of the sacks as well as the *tarare* as figures of pregnancy was already anthropomorphizing.)

In Courbet's next ambitious work, the *Painter's Studio* (pl. 7), anthropomorphism is virtually thematized—it is as it were represented in the process of happening—although partly by virtue of being so it is also made subject to an expanded definition of its effects that threatens its integrity as a concept. For example, the remarkably exact rhyming of the standing model's neck and hair with the trees emerging from the hillside in the landscape on the easel may be read as allegorizing, even as directing attention to, the trees' anthropomorphic character. Yet the trees alone—in the absence of the model—would not *appear* anthropomorphic, and it may be that this more than anything else is the allegorical point: that anthropomorphism in Courbet is often not only unperspicuous but indiscernible, which is to say that it can only be brought to light, posited as there, by acts of interpretation—of analogizing some feature or features of a painting to an absent second term—that can point to no more than the barest sort of evidence in those features themselves. Thus Nochlin has suggested that a painting of a famous tree, *The Oak at Flagey* (1864; fig. 96), should be seen as a symbolic self-portrait, and there are plausible external reasons for thinking that this makes sense.[31] But I have always found a strong evocation of the painter-beholder's corporeality in the nearly identical massive stone bluffs that dominate two splendid large landscapes (the second a variation on the first)—*Rocks at Mouthier* (ca.

1855; fig. 97) and *Rock of Hautepierre* (ca. 1869; fig. 98)—and in neither instance are there external considerations that bear directly on the question or internal characteristics (e.g., the profile of the bluffs) that possess the sort of resemblance to a person that would seem to be required to justify the claim of anthropomorphism. On the other hand, there exists a similarly bare analogy between the hillside and cliffs at the right of the picture on the easel in the central group in the *Painter's Studio* and the artist who sits painting that picture, a figure I earlier described as appearing to be leaning back against that hillside as if he were already in the landscape. (In fact the river in the immediate foreground of the *Rocks at Mouthier* brings the latter quite close to the canvas on the easel in the central group.) Moreover, landscapes such as these that feature an imposing central mass are complementary to others—pictures of the valley of

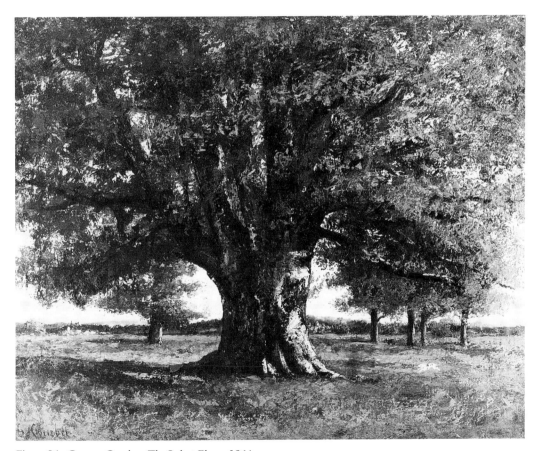

Figure 96.  Gustave Courbet, *The Oak at Flagey,* 1864.

the Loue, the Source of the Loue, etc.—that have at their center serpentine or cavelike motifs whose function, I have suggested, is virtually to draw the painter-beholder into the painting.

Or consider the metaphorical flow of waterlike representations out from the picture on the easel in the *Studio*'s central group—is this an instance of anthropomorphism? Not in the accepted sense of the term (I'm deliberately putting Toussaint's reading of the face in the dress to one side).[32] Yet the relation of the river in the picture to the waterlike imagery outside it scarcely differs in principle from that between the model and the trees, or indeed from that between the model and the painter, whose bodies, as was noted earlier, have also been rhymed with one another at crucial junctures. There is even a sense in which seeing the cat playing at the artist's feet as still another image of flowing water im-

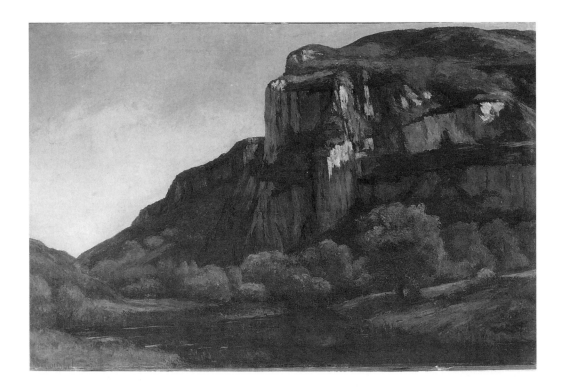

Figure 97.  Gustave Courbet, *Rocks at Mouthier,* ca. 1855.

plicitly anthropomorphizes (i.e., zoomorphizes) the river, though once again the river alone would give no hint of such a possibility. And if we add to these relations the chiasmic mirroring of the seated painter and standing model in the figures of the seated Irishwoman and the standing male manikin, we begin to grasp the extent to which the *Studio* allegorically situates anthropomorphism in the context of a larger transformational system—a field of force that goes far beyond the limits of the central group—in which persons, animals, objects, and representations are continually sharing attributes, suggesting analogies, exchanging places. (A mysterious drawing in Budapest [1860s?; fig. 99] of a woman seated on the ground before a large wrinkled overhanging rock from which a fall of water inexplicably issues, amounts to a commentary on this aspect of the *Studio*.[33] The woman, seen from behind, is herself rocklike, while

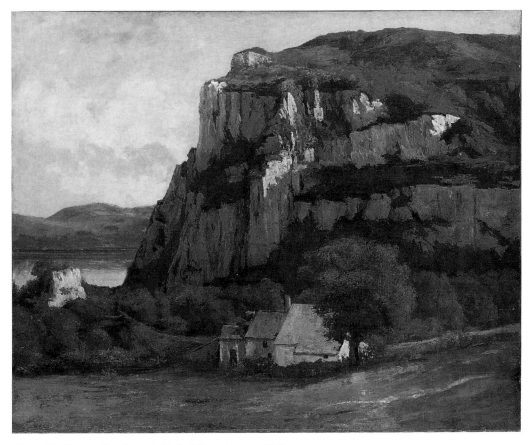

Figure 98.  Gustave Courbet, *The Rock of Hautepierre*, ca. 1869.

Figure 99. Gustave Courbet, *Woman at a Waterfall*, drawing, 1860s?

the whalelike rock both in form and texture has the character of a giant body or perhaps body-part, with the result that we seem to be watching the metamorphosis of each into the other. And of course the seated woman is one more figure for the painter-beholder, whose own projected metamorphoses into male and female personages, depicted objects of all sorts, and ultimately entire paintings we have been tracing throughout this book.)[34]

Just how far-reaching, and how hard to specify, the effects of that larger system or field of force can be is suggested by several of the still lifes of fruit painted by Courbet during and after his imprisonment following the fall of the Commune. For example, in one of the earliest of the still lifes, *Apples, Pear, and Pomegranate* (1871; fig. 100), the various pieces of fruit seem almost artlessly to refer to portions of the human anatomy while their relative positioning suggests the form of a female nude. The pear in particular evokes the image of a female breast; the apple to its right suggests an abdomen and navel; while the apple to its left, propped on its side, appears to gaze at us with an unblinking eye (a shockingly theatrical motif, made even more disturbing by the violation of bodily coherence it implies). In other, later still lifes the specifically anthropomorphic connotations of individual pieces of fruit are relatively diminished while the overall character of the image approaches that of the ambitious nudes of the 1860s. Thus for example the large, proto-Cézannesque *Apples, Pears, and Primroses on a Table* in the Norton Simon

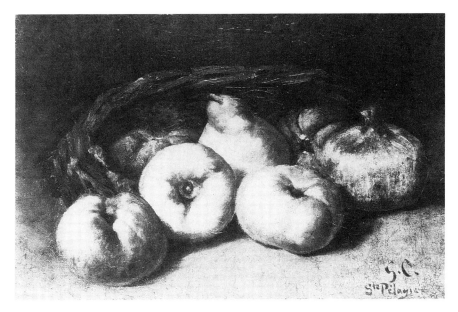

Figure 100. Gustave Courbet, *Apples, Pear, and Pomegranate,* 1871.

Museum (1871–72; pl. 14) invites comparison with both the *Woman with a Parrot* and *Sleep,* the vase of primroses in the still life recalling the outspread wings of the parrot in the first of the nudes while the proliferation of richly hued, strongly modeled, sensuously rounded forms on a white tablecloth seems particularly close in feeling to the profusion of competing centers of interest in the second. Another, much more modest still life, *Apple, Pear, and Orange* (1872; fig. 101), might similarly be compared to the *Nude with White Stockings* (fig. 77), while an entire series of still lifes centered on a pomegranate split in two in the near foreground—illustrated by the example in the Lefevre Gallery in London (1871–72; fig. 102)—may be taken as going even further than *The Origin of the World* in the direction of the modern centerfold (not that Courbet would have viewed them in this light, or probably have been aware of any of the analogies I am proposing).

Two implications follow. First, seeing a small or large assemblage of pieces of fruit (subliminally, fantasmatically) as evoking the figure of a naked woman not only brings out the erotic metaphor latent in the shapes, colors, and texture of apples, pears, and pomegranates,[35] but also underscores what, following Ravaisson, I have called the continuity of nature, an aspect of reality which in his metaphysics—and, I have argued, in Courbet's painting—overrides the separateness of objects. And second, the figure of a woman thus evoked is rendered all the more proximate, possessable, even consumable, as if painting and painter-beholder

might equally plausibly be described as incorporating—almost literally absorbing—the other. A tension between these alternative descriptions can, I think, be detected in the Norton Simon painting (pl. 14), in which the red shawl or wrap thrown across the chair to the right of the fireplace suggests the profile of a potential consumer of the fruit on the table, while the landscape painting with waterfall on the wall above the chair, and perhaps also the cavelike opening of the fireplace, are associable with the general project of drawing the painter-beholder into the picture. (The latter project, of course, is itself in tension with certain limitations of still life as a genre—in what sense can a viewer be invited to enter a representation of smallish objects, traditionally arranged in a shallow space?—which in turn suggests that a primary function of Courbet's fantasmatic imagery of recumbent female nudes may be to overcome those limitations by introducing the possibility of a different relation to the picture. This would also help explain those still lifes, such as the example in the Hague [1871–72; fig. 103], in which pieces of fruit of indeterminate size have been depicted in landscape settings recalling those of the *Bacchante* and *Wounded Man*.)[36]

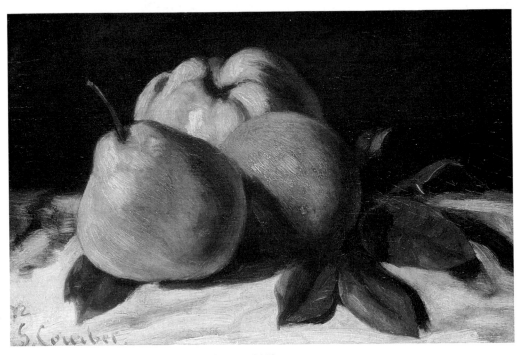

Figure 101. Gustave Courbet, *Apple, Pear, and Orange*, 1872.

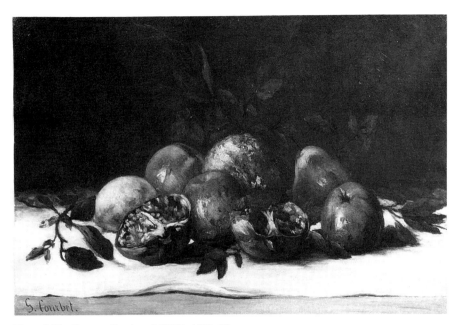

Figure 102. Gustave Courbet, *Still Life*, 1871–72.

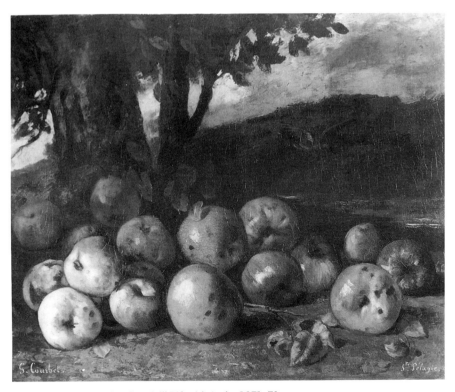

Figure 103. Gustave Courbet, *Still Life with Apples*, 1871–72.

Anthropomorphizing in a different mode takes place in paintings like the Zurich and Orsay *Trout* (1872 and 1873; pl. 15, fig. 104), the second of which is a reversed version, with slight changes, of the first. The difference I refer to concerns not only the undeniable pathos of the basic image but also the fact that both paintings have been viewed as expressing Courbet's feelings of persecution and the collapse of his health during and after his imprisonment in 1871–72.[37] Indeed there is in both pictures an excruciating sense of a not wholly alien physicality, as if across what would seem must be an insuperable gap of genera Courbet—lover of swimming—identified bodily with his gasping, strangulating subjects, an identification I see echoed or displaced in the prominent rock toward the lower right of the Orsay canvas that mimes the shape, tilt, and open mouth of the trout immediately above it.[38] I'm struck too by the way in which in both paintings the dying trout's glistening, silvery skin has been made the ground for some of the freest, most abstract application of paint in all Courbet's art, as if at least in this regard the painter-beholder's identification with the trout were tantamount to an identification with

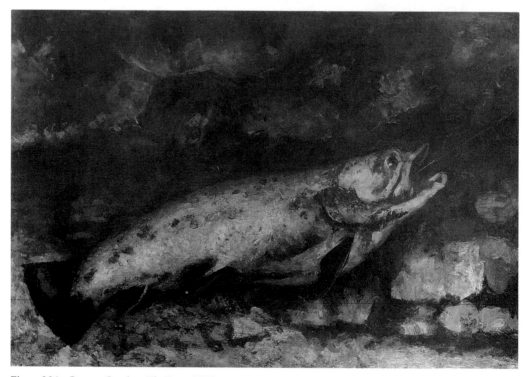

Figure 104. Gustave Courbet, *The Trout,* 1873.

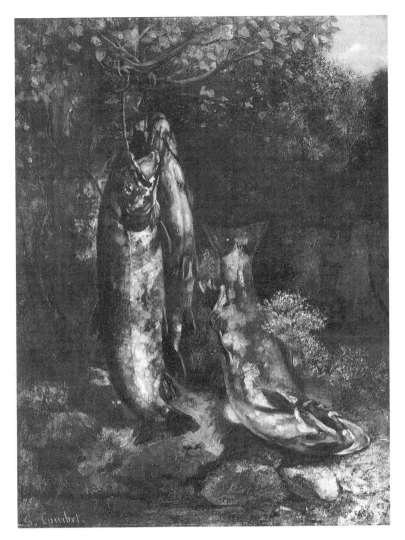

Figure 105. Gustave Courbet, *Trout of the Loue,* 1873.

the painting, or to put this slightly differently, as if the *Trout* pictures imagine an act of painting done not so much with the body as *upon* it, or simultaneously with and upon it. (Something not dissimilar perhaps takes place in the *Stag Taking to the Water,* in which the highly tactile rendering of the stag's long-haired fur evokes by direct equivalence the paint-soaked bristles of the painter-beholder's brush.) Ominously, nothing of the sort occurs in another canvas of these years, *Trout of the Loue* (1873; fig. 105), in which three giant dead trout in an outdoor setting are displayed in a configuration that inadvertently parodies the relations between hunter and roe deer in the *Quarry.* Even more disturbing than

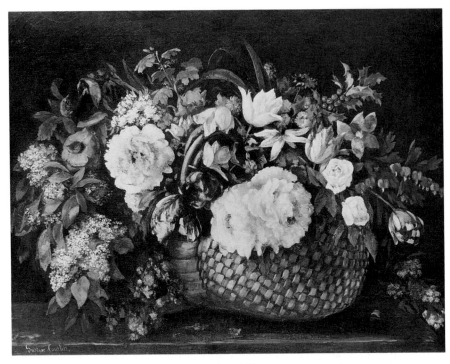

Figure 106. Gustave Courbet, *Flowers in a Basket,* 1863.

the presentation of the trout, however, is their implied scale, which comes across less as monumental than as bloated and so invites being read as an early sign of the illness that was to kill Courbet within several years.[39]

One further intuition: in Courbet's gorgeous flower pieces of 1862–63—for example, the Glasgow *Flowers in a Basket* (1863; fig. 106)—I find at once a dazzlingly direct expression of the work of his brush and a vivid evocation of his sense not simply of his embodiedness but specifically of his body's *interior,* his organs and viscera, blossoming before our eyes in the most radical exteriorization of bodily feeling in all his art.[40] (Mediating this doubleness, this simultaneous reference to external and internal experience, would be the actual odor of the flowers as Courbet painted them.)[41] The mood of these pictures seems frankly joyous. But a strange canvas of the Sainte-Pélagie period, *Head of a Woman with Flowers* (1871; fig. 107), in which a densely painted bouquet of flowers dominates the shadowy head of a woman gazing at a sheet of paper, strongly suggests that the flowers express a state or activity taking place within the woman (cf. the soaring plume of the quill pen in the *Portrait of Baudelaire*), but also that there isn't sufficient vitality available for both the woman and the flowers to be rendered as vivid, tangible presences. This

would be to link that painting to the impaired health of Courbet's later years, and it would also support a reading of his earlier flower pictures as exteriorizations of an inner condition or milieu.

Finally, I want to call attention to an unexpected affinity between the general phenomenon of anthropomorphism in Courbet's work and a central concern of one of Baudelaire's major essays in esthetics, "On the Essence of Laughter, and Generally on the Comic in Art" (ca. 1855).[42]

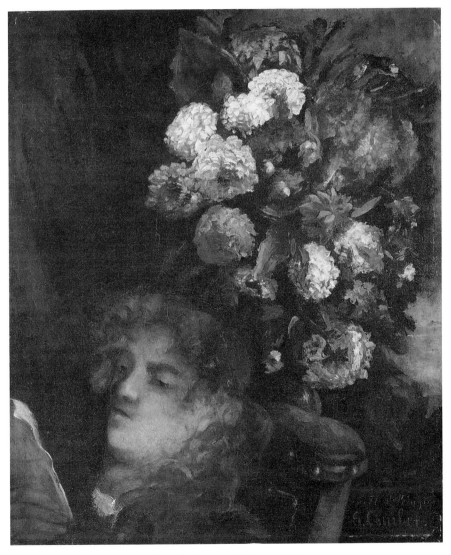

Figure 107. Gustave Courbet, *Head of a Woman with Flowers,* 1871.

In that essay, which makes no reference to Courbet, Baudelaire draws the following distinction between "the comic" and "the grotesque" (he goes on to recast it as one between the "signifying comic" [*comique significatif*] and the "absolute comic" [*comique absolu*]):

The comic is, from an artistic point of view, an imitation; the grotesque, a creation. The comic is an imitation mixed with a certain creative faculty, that is, with an artistic ideality. Now, human pride, which always takes the upper ground, and which is the natural cause of laughter in the case of the comic, also becomes the natural cause of laughter in the case of the grotesque, which is a creation mixed with a certain imitative faculty, imitative of elements preexisting in nature [as the rock in the Baltimore *Le Puits noir* may be seen as imitating a partial human face]. I mean that in the latter case, laughter is the expression of superiority, no longer [as in the case of the comic] of man over man, but of man over nature. . . . If this explanation seems far-fetched and somewhat difficult to grant, it's because the laughter caused by the grotesque has in it something profound, axiomatic, and primitive that comes much closer to innocence and absolute joy than the laughter caused by the comic of *moeurs*. Between these two laughters . . . there is the same difference as between the literary school of social engagement [*l'école littéraire intéressée*] and the school of art for art's sake [*l'école de l'art pour l'art*]. The grotesque dominates the comic from a proportional height.[43]

Further on Baudelaire adds that "the essence of [the absolute comic] is to appear to be unaware of itself"—much as the partial face in the rock in the Baltimore picture cannot be thought to have been intended as such by the natural forces that ostensibly put it there—"and to produce in the beholder . . . the joy of his own superiority and the joy of the superiority of man over nature."[44] Unawareness of self is, I need hardly add, the antitheatrical condition *par excellence,* which suggests that for Baudelaire in 1855 it was the absolute comic, which in the case of painting meant anthropomorphism as I have broadly defined it, that rescued the representation of nature from theatricality, or at any rate that made possible the accomplishment of an antitheatrical relation to nature in art. In this respect as in others, Baudelaire never imagined the extent to which Courbet's paintings may be seen as harmonizing with his own furthest-ranging speculations.

## Courbet and Politics

The relation of Courbet's art to the politics of his time has always been a vexed topic. There is no doubt that Courbet's political sympathies were

republican and anti-Bonapartist, and of course his participation in the Commune, culminating in his alleged responsibility for the destruction of the Vendôme Column, gave his enemies the chance to make him pay dearly for his views.[45] It seems clear as well that much of the negative criticism Courbet received during his lifetime was loosely political—reviewers of his breakthrough pictures resented the depiction of ordinary rural townspeople on a monumental scale, and critics throughout his career reacted predictably to his work's affront to the cultural norms of Second Empire society—while a handful of other writers, most importantly the leading French political philosopher of the period, Pierre-Joseph Proudhon, championed his art on the grounds of what they took to be its politically progressive content.[46] Still other writers, including Champfleury and Zola, minimized issues of politics in favor of an emphasis on the painter's technical mastery and commitment to the truth of his vision.[47] Meanwhile Courbet found support among wealthy collectors whose politics were often conservative (his chief early patron, Alfred Bruyas, was an ardent if unorthodox Bonapartist) and on more than one occasion negotiated with the administration he professed to despise.[48] Following Courbet's death, as Nochlin has shown, the possible political significance of his work was largely suppressed and even his participation in the Commune was minimized as part of his rehabilitation as a major French artist.[49] Schapiro's famous article of almost fifty years ago brought politics into play once more, and in recent decades Nochlin, Clark, Lindsay, Herding, Rubin, and others have sought to redress the balance and in fact have been so successful that the account of Courbet's painting put forward in this book, with its central focus on issues of beholding, runs the risk of appearing determinedly *anti*political in its approach. I want therefore to make clear where I stand, if only to prevent my work from being enlisted in a cause—the repudiation of the political in the name of the esthetic—of which I want no part.

In the first place, I'm unimpressed by attempts to extract political connotations from hackneyed formalist readings of Courbet's pictures, as for example when it's claimed that because his additive compositions (a notion I have repeatedly disputed) accord equal importance to their constituent elements they are inherently democratic.[50] Suggestions of this sort are too simplistic to be intellectually or for that matter visually persuasive, and it's one of the many virtues of Clark's deeply researched attempt to situate Courbet's early Realist paintings in the social and political context of the late 1840s and early 1850s that it explicitly disclaims such formu-

lations in favor of "a history of mediations."[51] "I want to discover what concrete transactions are hidden behind the mechanical image of 'reflection,'" Clark writes, "to know *how* 'background' becomes foreground; instead of analogy between form and content, to discover the network of real, complex relations between the two."[52] Accordingly, Clark draws attention to the youthful Courbet's movements between two different environments, his native Ornans and Parisian Bohemia; insists on the importance of the political struggle for control of the countryside as a primary context for the *Burial at Ornans* and other works of 1849–50; argues that certain ambiguities in the social position of Courbet's family (peasant in origin, bourgeois in wealth and standing) found expression in the *Burial* and the *Peasants of Flagey;* and, in the most original but also most speculative section of his book, attempts to explain the widely disparate receptions given those canvases and the *Stonebreakers* in successive exhibitions in Besançon, Dijon, and Paris in 1850–51 by proposing that Courbet's revelation of the existence of a *rural* bourgeoisie threatened the fragile social identities of large numbers of Parisians who considered themselves bourgeois but had only recently arrived in the city from the countryside, where they now found it imperative to imagine no bourgeoisie existed.[53] I find this last explanation more ingenious than persuasive and have reservations about some of Clark's other points as well,[54] but it should be clear even from my brief summary of his views here and in chapter four that his book raised the discussion of the political significance of Courbet's art to a new level of intelligence, complexity, and sophistication. Another important recent contribution to the subject is the Toussaint-Herding interpretation of the *Studio,* in particular Herding's reading of it as an exhortation to Napoleon III to reconcile opposing factions, classes, and nations by taking as his model the redemptive and harmonizing activity of the artist at the center of the canvas.[55] And in the wake of Clark's pathbreaking example, a number of scholars have put forward political interpretations of specific pictures, with varying results.[56]

My aim in these pages, however, isn't to assess what others have written but rather to say where the present book stands with respect to the political. Briefly, I suggest that my account of Courbet's art has been dealing all along with issues that in one sense or another can be understood as political, though I also hasten to add that the result of such acts of understanding will not be the attribution to Courbet of a single, univocal political position. The whole of chapter six, which everywhere raises the

perhaps unanswerable question of the sexual politics of Courbet's feminine identifications, is a case in point, as is the distinction touched on earlier in this chapter between Millet's politically conservative ideal of pictorial unity and Courbet's fundamentally different but not therefore necessarily politically progressive mode of pictorial unification.

It's also possible to go further than I did in a footnote on Napoleonic painting in chapter one (p. 22) in relating my problematic of beholding to Michel Foucault's problematic of surveillance, "incorporation" of power, and increasingly fine-grained exercise of social control.[57] For example, the entire effort to defeat the theatrical that I have ascribed to the Diderotian tradition might be understood simultaneously as an attempt to imagine an escape from the coercive visuality of the disciplinary mechanisms whose origin Foucault traces back to the middle of the eighteenth century (the figures in the painting must appear to be acting freely, as if in the absence of any beholder) and as a product of those mechanisms and thus a source of coercion in its own right (the demand that the figures be seen in these terms virtually dictating the limits of representability, besides being finally impossible to satisfy). Similarly, although I have claimed that what made the body central to Courbet's project was his place in a specific historical development (the Diderotian tradition and its crisis), the body in question had been shaped and trained and coded by forces at work in nineteenth-century French society, including what Foucault describes as the ever more thorough investment of the natural body by techniques of power, a process that appears to have reached a new level of intensity in the 1840s.[58] In fact it might be argued that Courbet's ability to enlist his own corporeality in the service of his painting is a prime example of the phenomenon Foucault calls *resistance,* by which power gives rise (locally, to begin with) to countermovements that oppose its dominant strategic mobilization.[59]

An obvious index of the resistant character of Courbet's Realism was the hostility with which it was greeted by politically conservative critics, but Foucault stresses that effects of resistance—like those of power, which however are far more massive—are inherently unstable, and indeed Courbet's Realist paintings may be considered complicit with the disciplinary mechanisms alluded to above to the extent that they invited being seen as epitomizing an ontologically "neutral" representation of reality that increasingly became one of the main instruments of disciplinary control.[60] (Baudelaire's criticisms of Courbet cited in chapter one concern this aspect of his art, but Baudelaire's advocacy of the imagina-

tion, or rather his insistence that only Delacroix among his contemporaries was a true *imaginatif,* had the effect of discounting reality entirely.) Finally, however, that Courbet's Realism was, as I have tried to show, based on acts of quasi-corporeal identification, displacement, and transformation made his paintings potentially a privileged site for rethinking, even so to speak for seeing through, the dominant mid-nineteenth-century discourses of nature and the real as well as the later, in fact still current, disciplinary discourse of art history itself.

Another way of putting my central claim about the nature of the enterprise by which Courbet's Realist paintings came into being might be to say that ideally the production and the consumption of those paintings exactly coincided, at least as far as their initial or *primary* consumption by the painter-beholder was concerned. This in turn would be to see in Courbet's desired relation to his paintings an archetype of the perfect reciprocity between production and consumption that Karl Marx in the "General Introduction" to the *Grundrisse* posited simultaneously as a theoretical basis for all his arguments to come and as an implicit ideal fated to be distorted in society by the laws of distribution, which with the rise of capitalism would increasingly alienate the individual laborer from the products of his labor. As Marx puts it in a typical passage:

> Now only is production immediately consumption and consumption immediately production, not only is production a means for consumption and consumption the aim of production, i.e., each supplies the other with its object (production supplying the external object of consumption, consumption the conceived object of production); but also, each of them, apart from being immediately the other, and apart from mediating the other, in addition to this creates the other in completing itself, and creates itself as the other. Consumption accomplishes the act of production only in completing the product as product by dissolving it, by devouring its autonomous thinglike form, by raising the disposition developed in the first act of production, through the need for repetition, to a state of skillfulness; it is thus not only the concluding act in which the product becomes product, but also that in which the producer becomes producer. On the other side, production produces consumption by creating the specific manner of consumption, the ability to consume, as a need.[61]

Think of this, with its continual upping the ante of reciprocity, its tacit insistence that we have still not sufficiently appreciated the intimate dynamic linking the two processes, as a gloss on Courbet's greatest image of artistic production, the central group from the *Studio* (painted just over two years before Marx drafted the *Grundrisse*), in which the painter-beholder's consumption of the painting on his easel—I mean his quasi-

corporeal projection of himself into that painting even as the latter subsumes him in an expanded definition of itself—is precisely what "accomplishes the act of production only in completing the product as product by dissolving it, by devouring its autonomous thinglike form," and ultimately by producing the producer, the painter-beholder, himself.[62] At the same time, it's the act of producing the painting on the easel that not only determines the specific manner of the painter-beholder's identification with that painting but also, in Marx's phrasing, "[creates] the specific manner of consumption, the ability to consume, as a need"—in this instance the need to overcome the theatricalization of the painting-beholder relationship by escaping beholding altogether. (The presence of the standing model underscores the analogy by *seeming* to effect a separation between making and beholding that is all the more forcefully undone when the central group is read as an allegory of its own production/consumption.)

It might be objected that my association of Marx's notion of the perfect reciprocity of production and consumption with Courbet's antitheatrical project rests on a distinction between artistic and inartistic labor, and in the sense that Courbet's project was plainly an artistic one there is a certain plausibility to the charge. But I expressly do not privilege the artistic (or, unlike many Marxists, the realistic) as such, but instead base my comparison on what I have been calling ontological aspects of Courbet's enterprise. Alternatively, it might be held that reciprocity of the sort Marx refers to is the hallmark of all truly artistic production. But the equivalent to that reciprocity I have claimed to discover in Courbet's pictures goes far beyond some abstract, universalizing notion of painters, writers, and composers working to please themselves and thereby creating publics capable of appreciating their art.[63] Still another objection might be that Marx's notion of consumption ultimately involves the literal feeding of the laborer, his preservation as a species being,[64] which in Courbet's case would seem to have nothing to do with his desired relation to his paintings and indeed would seem to come into play only when he sold his paintings to others. But in the first place the "General Introduction" expressly stipulates that "every kind of consumption . . . in one way or another produces human beings in some particular aspect."[65] And in the second what finally secures the analogy between Marx's theorizing and Courbet's practice is the common reference in both to the central metaphor of the human body or say *to a vision of material making that crucially entails the projection of the maker's living body into the created arti-*

*fact*.[66] The alienation of the worker under capitalism consists in nothing other than what Elaine Scarry calls "the severing of projection and reciprocation," by which she means the breakdown of the dialectic between the externalization of physical sentience in the created artifact and the consequent production of the human maker "in some particular aspect" by the artifact itself.[67] (Scarry doesn't relate her reading of Marx to Foucault's speculations on the body and power, but it wouldn't be difficult to do so, and in any case Foucault refers often to Marx in his own work.)[68] Conversely, the special aptness of the analogy I have been pursuing resides in the unexampled comprehensiveness with which, in my reading of them, Courbet's paintings recreate and thus transfigure the terms of his embodiedness—a comprehensiveness that far outstrips the more limited or sense-specific reference to the body implied by other

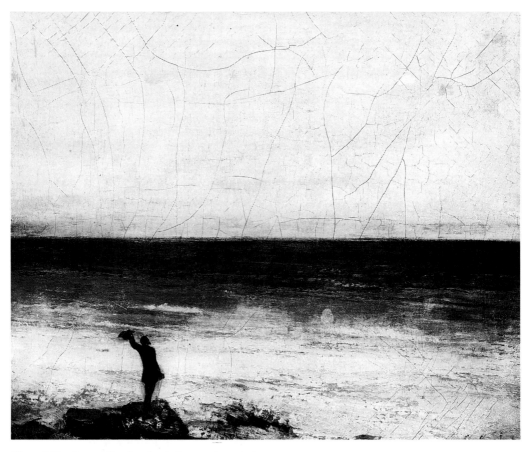

Figure 108. Gustave Courbet, *By the Sea at Palavas*, 1854.

sorts of made objects, however large or complex.[69] (The experience of such transfiguration is perhaps the true subject of the radiant *By the Sea at Palavas* [1854; fig. 108], in which the painter-beholder has portrayed himself saluting the Mediterranean as if in an exalted exchange between physical equals, an exchange I see as a figure for the quasi-corporeal relation to the painting Courbet habitually sought.)\* It's noteworthy, too, that Marx in the "General Introduction" resorts more than once to the painterly trope of the "finishing stroke" to evoke the completion-through-dissolution of the product in consumption,[70] as if to suggest that the specific action whereby a painter concludes his work on a picture epitomizes that operation. My countersuggestion, of course, is that Courbet's paintings more than any others lend that trope its aptness.

The analogy between Marx's thought and Courbet's project becomes both more interesting and more problematic when we turn to a painting that has always been viewed as *the* image of alienated labor in all Courbet's art, the *Stonebreakers* (fig. 47). So for example Clark, in the most sensitive and probing description of the latter it has yet received, sees in it "an image of balked and frozen movement rather than simple exertion: poses which are active and yet constricted; effort which is somehow insubstantial in this world of substances."[71] He continues:

What Courbet painted was assertion turned away from the spectator, not moving towards him: it is this simple contradiction which animates the picture as a whole. Courbet swivelled the boy and his basket of stones into the picture; he

---

\*Cf. Jules Troubat, who knew Courbet during his second visit to Montpellier in 1857 and was later to write: "M. Courbet was already known there because of the long visit that he had made several years before and from which he had brought back those marvelous views of the sea in which it seems that the painter is so identified with nature that one would say that he himself was part of the elements surrounding him before taking human form" (*Plume et pinceau* [1878], quoted in Philippe Bordes, "Montpellier, Bruyas et Courbet," in *Courbet à Montpellier*, p. 33). (M. Courbet y était déjà connu par le long séjour qu'il y avait fait quelques années auparavant, et dont il avait rapporté ces merveilleuses vues de mer dans lesquelles il semble que le peintre se soit tellement identifié avec la nature, qu'on dirait qu'il a fait partie lui-même des éléments qui l'entourent avant d'avoir forme humaine.)

Moreover, Courbet's letter of 1854 to Jules Vallés, with its seemingly jejune assertion that the formidable voice of the sea "will never drown out the voice of Fame, shouting my name to the entire world" (*Courbet à Montpellier*, cat. no. 16, p. 55), suggests not only an anxiety that he might be overmatched but also a reference to the sense of *hearing,* the importance of which to Courbet's Realism I first emphasized toward the end of chapter three. (O mer! ta voix est formidable, mais elle ne parviendra pas à couvrir celle de la Renommée criant mon nom au monde entier.)

drew the old man with averted gaze and a kind of hieratic (but also senile) stiff-
ness. The force of their actions is implied in the pose, but also half concealed by
it. . . . Clearly enough Courbet wanted to show an image of labour gone to
waste, and men turned stiff and wooden by routine. In . . . explanatory letters at
the time he stated the scene's simple moral: "in this occupation, you begin like
the one and end like the other [*dans cet état, c'est ainsi qu'on commence, c'est ainsi
qu'on finit*]." . . . But the achievement here is that Courbet gets the moral down
in paint, and does not lean on anecdote or pathos: he dissipates the weight his
brushstrokes register, he turns the painting against itself. He concentrates on
the task in hand: the action of labour, not the feelings of the individuals who
perform it.[72]

And in a footnote Clark refines his point by emphasizing the way in
which the *Stonebreakers* conveys a sense of the bourgeois painter's "radical
incomprehension of the psychology" of the two laborers, apparently by
its refusal to portray the latter's faces and so allow us to draw conclusions
about their states of mind from their expressions.[73]

Now in chapter three I put forward an altogether different reading of
the *Stonebreakers* according to which the actions of the old and young
laborers are metaphors for those of the painter-beholder's right and left
hands at work on the painting. I won't rehearse that reading here other
than to say that it was mainly based on similarities between the *Stone-
breakers* and both the *After Dinner at Ornans* and the self-portraits of the
1840s, involving features such as the obscuring of the two stonebreakers'
faces, the depiction of the young stonebreaker largely from the rear, and
the automaticity of both figures' actions—the same features, in short,
that seem to Clark to set the *Stonebreakers* apart and to which he gives an
explicitly political interpretation. But I don't want merely to take issue
with Clark's observations, which in any case aren't simply mistaken.
Whatever else it turns out to be, the *Stonebreakers* is undeniably also an
image of what Clark calls "labor gone to waste" and Marx would have
called alienated labor. The question I now want to ask is what it means
*politically* that it can be seen *both* as such an image and as a densely cor-
poreal metaphor for an act of painting that involved an equivalent to the
perfect reciprocity between production and consumption that in Marx's
economic theory defined nonalienated labor. Simply put, how are we to
understand the relation between the alienated labor of stonebreaking and
the nonalienated labor of painting as these (and that relation) are repre-
sented in the *Stonebreakers*?

One possible answer is that the second is imagined or fantasized as
somehow redeeming the first, as undoing its barrenness and alienation,

as though in this instance Courbet's antitheatrical project also called for recuperating the miserable, life-destroying, endlessly repetitive labor of breaking stones in (or *as*) the nonalienated, independent, and (I am suggesting) liberatory labor of painting the *Stonebreakers*. Such an account of the implicit politics of Courbet's project recalls the brief dismissive comment, *"Courbet saving the world,"* that ends Baudelaire's notes to his never-written article on Realism,[74] and it is consistent with Herding's reading of the *Studio,* which it amplifies by giving substance to the idea that Courbet is there portrayed as "redeeming" contemporary society, an idea that otherwise remains imprecise.[75] At the same time, it must be acknowledged that such a notion of redemption is nothing if not Utopian, or at any rate that the political effects I am suggesting the *Stonebreakers* and for that matter the *Studio* perhaps envision could only have taken place in the paintings themselves rather than in the world outside the paintings. (Herding says much the same about his reading of the *Studio.*) But it should be stressed in turn that Courbet's enterprise as I have explained it aspired to *leave no world* outside the painting, not because he hoped to cram the entire material universe into the representation but rather by striving to transport himself into the painting on which he was working the painter-beholder sought to annihilate or at least to consign to oblivion everything that was not either the painting at hand or the immediate physical context of its making. Which is to say that the Utopian character of the redemptive politics I have tentatively imputed to the *Stonebreakers* and the *Studio* would have been the expression in another register of what I am about to argue was the constitutive impossibility that that feat of transport could literally be achieved.

It's also conceivable, of course, that no project of redemption of the sort I have just invoked is implied by my reading of the *Stonebreakers* as a metaphor of its own production. In that event its political meaning might be thought to reside in the complex and multiple but also partial and limited affinities between painting and breaking stones on which the metaphor depends, but whether those affinities express a politics of solidarity or estheticization or indeed exploitation remains an open question.

## The Beholder in Courbet

Throughout this book I have been at pains to state that the structures of beholding (to broaden a notion introduced in chapter four) I have dis-

cerned in Courbet's work involve a particular relationship between paint-ing and painter-beholder. Can we now say that Courbet's paintings, by virtue of that relationship, *also* relate to the beholder in general (not the beholder *tout court,* to whom I shall return) in some determined way? Or is the nature of the case such that there is no specifiable connection be-tween the *first* beholder's project of merger and the experience of *subse-quent* beholders, for whom after all that project historically has been any-thing but self-evident?

I think the second alternative is correct, for the simple reason that the aspects of Courbet's paintings that I have read as expressive of an unprec-edented endeavor are no more univocal in their effects than the various means and devices by which the Diderotian tradition attempted to en-force an absolute distinction between the dramatic and the theatrical and by so doing to establish the fiction that the beholder didn't exist.

Take for example one of the basic structural devices of Courbet's art, his reliance on figures depicted from the rear. On the one hand, I have interpreted such figures as representing his own situation as painter-beholder seated before the canvas and thus as facilitating his project of quasi-corporeal merger. On the other hand, viewed separately from all the other features of his work I have analyzed in this book—insofar as such an act of isolated viewing can be imagined—the orientation in ques-tion would lend itself equally well to being seen as a gesture of closure or even of rejection.

Or consider what can appear to be a certain theatricality in Courbet's mode of self-representation, starting with various self-portraits of the 1840s (most obviously the ones in medieval costume but not only those) and reaching a climax in the *Studio,* a work intended not merely as the centerpiece of a one-man exhibition Courbet hoped would outshine the Exposition Universelle but also as a public demonstration of the powers of his art. Here too my readings of the self-portraits and the central group have emphasized their antagonism to the theatrical in the Diderotian sense of the term. But I also want to acknowledge that nothing in those readings can or indeed is meant to altogether dissolve one's initial im-pression that the protagonist of the *Sculptor* holds an extremely awkward pose; or that the protagonist of *Courbet with a Black Dog* is vaunting his good looks; or that there is something traditional, even incipiently the-atrical, about the *Studio*'s overall mise-en-scène, the shadowy interior of the large atelier being far more stagelike in feeling than any of the settings

of the great paintings of the previous seven years (the *Studio*'s temporal frame of reference).

But the feature of Courbet's paintings that most conspicuously resists, if not his antitheatrical project itself, at any rate the extension of that project to include beholders other than the painter-beholder, is the way in which they have been painted and in particular the sheer materiality of their surfaces. In chapter four I quoted Charles Rosen and Henri Zerner as stating of the *Burial* that "[t]he spectator is entirely occupied by the aggressive presence of the personages—paralleled, mediated, and guaranteed by the aggressive presence of the paint."[76] This is said in connection with a larger claim that the essence of Courbet's Realism (indeed of Realism generally, by which they mean the art of Courbet, Manet, and the Impressionists) resided above all in the "extraordinary *facture,* or working of the paint, in which both the material of the paint and the painter's physical action are powerfully displayed."[77] "[T]he strategy of 'official' painters like [Ernest] Meissonier and, a little later, [Jean-Léon] Gérôme," they write, "[was to insist] on the painting as an open window or an illusion. Since a painting is quite clearly not a real window, this insistence makes it simply an illusion. The eye goes right through the surface of a Meissonier painting into a world of fantasy. Such pictures are both realistic and unreal; they have nothing to do with Realism. We are first aware of the scene; the means of representation take second place." They continue:

> Courbet's procedure is precisely the opposite. By the time he painted his mature work, especially *A Burial at Ornans,* he insisted on the painted surface as no one had ever done before. Only the late Rembrandt had come close to it, but never on this scale. The thick impasto is extremely apparent; the paint is often laid down with a palette knife rather than a brush, so that it becomes a tangible, built-up crust that arrests the eye. Not for a moment are we allowed to believe that we dream, that we have in front of us a vivid but unreal world—an effect that Delacroix could still brilliantly exploit in *The Death of Sardanapalus.* On the contrary, with Courbet, we are forced to remember that we are in front of a solid work of art, a painted object, a representation. Imagination has become the power of visualizing the real world, while fantasy is banished. The insistence is entirely on representation, on painting as a transcription of the experience of things.[78]

There's a lot I would criticize in Rosen and Zerner's observations, starting with their claim that whereas Gérôme and Meissonier intended the

viewer to be aware of the scene (i.e., the illusion) first and the means of representation second, Courbet intended the reverse. Is so bald an opposition tenable? The entire argument of this book suggests that it isn't.[79] And yet the fact remains that the crusted surface of the *Burial is* extremely conspicuous, that the paint has in fact been laid down in a manner that attracts attention both to its materiality and to its application, and moreover that Courbet's contemporaries often remarked on this aspect of his work (usually in disapproval).

What must be recognized is that there is no contradiction, as distinct from conflict, between Courbet's paint handling and his antitheatrical project. That is, I take the extraordinary facture of a painting like the *Burial* to have been motivated by a desire to evoke not simply the activity of a seeing that was also a virtual embracing but also an experience of corporeality, mobilized around the act of painting, that sought to undo the very distinction between embodied subject and "objective" world, including, in the first instance, the *Burial* itself. (As though ideally the densely material surface of the *Burial* would wall the painter-beholder not out but *in*.) But the point is that such a reading of Courbet's facture could not be "insisted on" by that facture: rather, the materiality of his paintings inevitably has elicited a contrary reading of them as first and foremost physical objects that confront the beholder as obdurate facing presences. (As though by virtue of the frankness with which they have been painted they appear to wall their beholders only out.) Indeed even if the actual manipulation of the paint is seen as referring both to acts of perception and to the physical making of the painting, there is every likelihood that this itself will be perceived and described in terms of a metaphorics of performance and exhibition. Thus Rosen and Zerner speak of Courbet's facture as "displaying" both the material of the paint and the painter's physical action, while in a recent essay Kermit Champa, who nicely observes that "Courbet's paint construction is what he feels with; it is what enacts in the painting object the passion of touched seeing," also asserts that "it is very obtrusive in an expressively unique way" and goes so far as to claim that it "theatricalized seeing as touching and vice versa."[80] Obviously, I think so unqualified an appeal to theatrical metaphors to characterize Courbet's paint handling lacks historical nuance. Here too, however, my objection to those metaphors can't be made good on the basis of his paint handling alone, which is why I couldn't have begun my reading of his work with an analysis of facture, indeed why it

was necessary to defer consideration of the unprecedented materiality of his art until near the end.*

In their extended discussion of Realism in painting and literature Rosen and Zerner often allude to Gustave Flaubert, in particular to various passages from his letters of the 1850s in which he appears to hold that (in their paraphrase) "the subject of a work [of poetry or fiction or painting] is aesthetically indifferent," and that therefore "aesthetic significance [rests] entirely on the style, which must attain an abstract beauty of its

---

*Two related points. First, the unconventional frames that Courbet originally placed around the *Burial* and other paintings exhibited in 1850–51—pieces of fir that he described in a letter to Buchon as "enlarg[ing] them considerably" and "mak[ing] them perfectly comprehensible" (quoted by Riat, p. 82)—could only have compounded the problem. (. . . un énorme cadre en planche de sapin, qui les réhausse considérablement et les fait parfaitement comprendre.) That is, the initial effect of such a frame appears to have been to enhance the paintings' representational "presence," but the rustic simplicity and perhaps too the sheer size of the pieces of fir would inevitably have called attention as well to their character as material artifacts. Something of this double effect resonates in Champfleury's statement, part of which was quoted earlier, that "[f]rom a distance, on entering, the *Burial* appears to be framed by a doorway; everyone is surprised by this simple painting, as at the sight of those naive woodcuts, engraved by a clumsy knife, at the top of broadsheets describing murders printed on the rue Gît-le-Coeur. The effect is the same because the execution is equally simple. Sophisticated art finds the same *accent* as naive art" ("L'Enterrement d'Ornans," in *Grandes figures d'hier et d'aujourd'hui* [Paris: Poulet-Malassis et de Broise, 1861], p. 244). (De loin, en entrant, l'*Enterrement* apparaît comme encadré par une porte; chacun est surpris par cette peinture simple, comme à la vue de ces naïves images sur bois, taillées par un couteau maladroit, en tête des assassinats imprimés rue Gît-le-Coeur. L'effet est le même, parce que l'exécution est aussi simple. L'art savant trouve le même *accent* que l'art naïf.)

Second, the enormous signature that the *Burial* originally bore in its lower left corner may well have been a further expression of a project of merger (cf. my discussion of the relation between figures and signature in the *Stonebreakers* in chapter three), but its unusual size, bright orange-red color, and separateness from the rest of the representation could only have been disruptive in effect and in any case would surely have reinforced the viewer's sense of the materiality of the painting's surface (see the caricature by Bertall, reproduced in Toussaint, p. 103).

Both picture frames and signatures, *but also in a sense picture surfaces,* exemplify what Jacques Derrida has called "parergons," supplementary entities or structures that "come against, beside, and in addition to the *ergon,* the work done [*fait*], the fact [*le fait*], the work, but they do not fall to one side, they touch and cooperate within the operation, from a certain outside" ("Parergon," in *The Truth in Painting,* trans. Geoff Bennington and Ian McLeod [Chicago: University of Chicago Press, 1987], p. 54, with slight alterations; see also pp. 60–61). One might say that because Courbet's antitheatrical project called into question the relation between what lay "inside" and "outside" his paintings, it put exceptional pressure on the "parergonal" elements of his art.

own absolutely independent of the subject."[81] It's true that this is a recurrent motif in his correspondence, and it isn't hard to see why Rosen and Zerner are led to compare the foregrounding of style it evokes with what they take to be the "almost indecent flaunting of the material substance of the painting and the work of the brush" in a picture like the *Burial*.[82] But there is another strain in Flaubert's letters that bears far more intimately on Courbet's art, and that is what Dominick LaCapra has shrewdly identified as a fundamental tension in Flaubert's accounts of the ideal relation of the author (or any artist) to his productions. LaCapra characterizes that tension as one between antithetical extremes of "total, transcendental objectivity and of mystical immanence," and suggests that in Flaubert's theorizing both extremes *meet* in the sense that "the height of impersonality eliminated the particular forms of subjectivity, as did complete merger of the narrating self with the object of narration."[83] A well-known passage from a letter to Louise Colet exemplifies the elusiveness of Flaubert's authorial ideal:

The author in his work should be like God in the universe, present everywhere and visible nowhere. Art being a second nature, the creator of this nature should act by analogous procedures. One should feel in all the atoms, in all the aspects, a hidden and infinite impersonality [*impassibilité*]. The effect for the spectator should be a sort of astonishment.[84]

And in another passage, from a somewhat later letter to George Sand, he writes: "I expressed myself badly when I told you that 'one should not write with one's heart.' I wanted to say: one should not put one's personality on stage. I believe that great art is scientific and impersonal. One should, by an effort of the spirit, transport oneself into the characters, not draw them to oneself. That, at any rate, is the method."[85] As LaCapra observes, the latter passage in particular "seems to vacillate between objective impersonality and subjective identification in attempting to describe a mode of narration whose very criterion would seem to be the ability to undercut or problematize the opposition between the objective and the subjective (or the ironic-impersonal and the empathetic-pantheistic)."[86] Indeed LaCapra sees such vacillation as typifying not just Flaubert's reflections on impersonality but the actual effect of his free indirect style (*style indirect libre*), which in LaCapra's view "involves a dialogue between narrator and character that assumes changing positions on the threshold between 'self' and 'other.'"[87]

What interests me in the above isn't so much the exact terms of La-

Capra's commentary as the close analogy (or series of analogies) that can be drawn between Flaubert's authorial ideal and Courbet's antitheatrical project. Thus Flaubert's insistence that the author should be everywhere in his work (or as he also says, "disseminated in all")[88] might be taken as a gloss on the multiplicity and diversity of self-representations in Courbet's Realist paintings, an aspect of them that I have argued is crucial to their characteristic effect. Similarly, Flaubert's distinction between "transport[ing] oneself into the characters" (the tactic he advocates) and "draw[ing] them to oneself" (the one he opposes)—a distinction that, considered simply by itself, is at best imprecise—has a parallel of sorts not only in Courbet's ability to identify with an extraordinary range of figures and objects that don't obviously resemble him ("I even make stones think") but also in his paintings' tendency to seek to absorb the painter-beholder into themselves rather than to project illusionistically toward him (recall my discussion of Caravaggio in chapter four).

But perhaps most striking of all is the analogy between Flaubert's failure in his letters to locate himself definitively either wholly outside or immanently within his productions and an inherent or structural instability in Courbet's antitheatrical project. As has just been noted, Courbet's efforts to undo his own spectatorhood by transporting himself into his paintings in the act of making them have much in common with Flaubert's ideal of immanence. But it can't be emphasized too strongly that all such efforts were doomed to failure—that no matter what steps Courbet took to realize what I have been claiming was his central aim, he couldn't literally or corporeally merge with the canvas before him but instead was compelled to remain outside it, a beholder (albeit a privileged one) to the end. In fact the linkage between immanence and outsideness in Courbet's art is even closer than this suggests. For it isn't merely a contingent fact about Courbet's project that it was bound to fail: on the contrary, *it was precisely the impossibility of literal or corporeal merger that made that project conceivable, or rather pursuable, in the first place.* (The impossibility of corporeal merger was the condition of possibility of the project of *quasi*-corporeal merger.) To put this another way, had transporting oneself into a painting been physically feasible, which is to say had paintings traditionally been altogether different sorts of objects from what they are, the issue of theatricality would have taken a wholly different form or indeed wouldn't have arisen. Understood in this light, the alternatives of immanence and outsideness between which Flaubert's authorial ideal vacillates mark in the case of Courbet's art a mutually consti-

tutive duality that standard accounts of the materiality of his paintings have been powerless to discern.[89]

Finally, however, there is the further, difficult question of the extent to which at different stages in his career Courbet's paintings attempt to establish or imply a relationship to a beholder other than the painter-beholder. It seems safe to say that nothing of the kind takes place in the self-portraits of the 1840s, in which the conventions of the genre—not only the identity of sitter and maker but the attendant fiction that the latter is alone with his image—allowed the painter-beholder to pursue his goal of quasi-corporeal merger without in any way taking a wider audience into account. (This is slightly misleading: as I stated earlier, the self-portraits—like all Courbet's paintings—are so many compromises between his most radical impulses and the need to come to terms with a complex structure of generic and other sorts of public expectations, in this instance specifically including the expectation that a self-portrait will represent a sitter who at the very least doesn't face away from the beholder.) Nor do the first breakthrough pictures, the *After Dinner at Ornans* and the *Stonebreakers,* appear concerned with representing a beholder other than the painter-beholder; on the contrary, I have suggested that the distinctive mood and rhythmic organization of those works stemmed from the discovery, which I take to be foundational for Courbet's Realism, that a metaphorics based on the uncontested primacy of the painter-beholder could provide the matrix for an art that broke decisively with the restricted dimensions and narrowly personal focus of the self-portraits. Note by the way how in both the *After Dinner* and the *Stonebreakers* going beyond the self-portrait format allowed Courbet to depict at least one figure largely from the rear, which is to say to be more faithful than the self-portraits allowed to the facts of his own bodily orientation as he sat before the canvas. (As though Realism made possible a closer relation to the painter-beholder than ever before, or as though the increased scale and expanded subject matter of the *After Dinner* and *Stonebreakers* enhanced even as they disguised both paintings' absorptive appetite for the painter-beholder.)

In the *Burial at Ornans,* however, something different happens. In part because its physical dimensions are so much vaster than those of the first two breakthrough pictures, in part because the number of life-size figures in the scene has been commensurately increased, the relatively simple identificatory strategies of the earlier paintings no longer apply. Instead

we discover a highly complex compositional structure that I have read as yielding a distinction between two physically separate points of view: the first directly in front of the open grave (and implicitly merging with the painting in the general area of the blackness above that grave, hence not properly speaking a point of view at all); and the second five or six feet to its left, at a spot designated by the skewed orientation of the grave and directly in front of the sector of the painting that includes the crucifix-bearer, the near collision between the choirboy and the pallbearer, and the figure of Max Buchon. I went on to associate the second point of view with the painter-beholder and the first point of view with what I termed the beholder *tout court,* by which I meant (or began by meaning) the condition of spectatorhood as such. But by the end of my analysis I was led to conclude that the distinction between the points of view or at least between the terms with which I had sought to characterize them was progressively undone by the structure of beholding I had brought to light—in other words, that Courbet's attempt in the *Burial* to enforce a clear separation between himself as painter-beholder and some other, more abstract or universal beholding agency or function was crucially at odds with the internal dynamics of his Realism, which even in that most ambitious of all his pictures up to that time left little scope for references to a wider viewership.[90] The far simpler composition of the *Peasants of Flagey Returning from the Fair* perhaps expresses a reaction to this state of affairs, while in a subsequent canvas, the *Firemen Rushing to a Fire,* the abrupt expulsion as if from the painting itself of the figure of a passerby suggests not just an unrealizable but a hyperbolic desire to abolish beholding altogether, which in turn would help explain why the *Firemen* was never finished.

The next major group of paintings considered in this book, the *Wheat Sifters,* the *Painter's Studio,* and the *Quarry,* mark a return to the self-portrait as the tacit or (in the latter two works) explicit basis of their operations at the same time as they metaphorically or allegorically represent the nature of those operations in much thicker detail than ever before. Thus the *Wheat Sifters* goes far beyond the *After Dinner* and the *Stonebreakers* in its specification of different aspects of the physical medium of painting (pigment, canvas, support), its thematization of a mode of visuality that isn't quite beholding (the boy peering into the *tarare*), and its depiction of something like a representation that with respect to the personages within the picture escapes being beheld (the sunlight on the wall); the *Quarry* unfolds a relationship to violence and to death that

I have suggested was implicit in Courbet's Realism from the first, and in the course of doing so also investigates the interpenetration of activity and passivity (or will and automatism) not just in the act of painting but throughout all nature (cf. Ravaisson's *De l'Habitude*); while the central group of the *Studio,* a work whose full title announces its allegorical intentions, allows us virtually to follow the process by which the seated artist's project of merger with the picture on which he is working not only determines the character of that picture but generates the central group as a whole.

Throughout the early and mid-1850s Courbet was clearly interested in women as subject matter, but it wasn't until the mid-1860s, largely in response to Manet, that depictions of the female nude came to play a central role in his art. In the later 1850s and 1860s he also began to paint hunting scenes and pictures of animals, and it may be that the two developments were related in that both involved a necessarily highly ambivalent act of identification with creatures (fundamentally? or merely profoundly?) different from himself, and perhaps also in that both had as settings scenes of privacy (the intimacy of a bedroom, the solitude of the forest). I understand the turn toward privacy as motivated by a desire to escape the eyes of others, as if the issue of theatricality could be if not resolved at least ameliorated by the proper choice of milieu, though in the *Quarry* itself the blowing of the hunting horn may be read as a summoning of beholders, while even the most identificatory of Courbet's nudes—*Sleep,* for example—can't be said to escape the fundamental implication of the genre in a masculist regime of specularity and control. (The two genres nearly come together in the startling *German Huntsman* [1859; fig. 109], in which an armed hunter restraining a dog gazes transfixed at a wounded, perhaps dying, stag sprawling on its back and contorting its body to drink from a stream. The stag's expression could hardly be more intense, while the hunter's stance, rifle, and leather straps crossed over his jacket suggest a phallic stiffening that I take to be both cause and effect of the act of wounding.)[91] In another group of paintings of women of the mid-1860s, the four versions of the *Portrait of Jo,* specularity is thematized in the double motif of Jo's intense searching gaze into her mirror and her gesture of displaying her hair as if to reflect back into the mirror the image she alone sees. I have also read the *Portrait of Jo* as allegorizing the act of painting, and although the terms in which it does so aren't exactly those of the major allegories of the mid-1850s, we have only to compare it with the depiction of the seated painter and the

standing model in the central group from the *Studio* to appreciate yet again the consistency of Courbet's pictorial concerns, a consistency even more striking in the *Source* of two years later. At the same time, the shift in both the *Portrait of Jo* and the *Source* to a sensuously appealing female surrogate for the painter-beholder seems to have been correlated with a suppression of all sense of the physical effort of picture making and more broadly with a transposition of the problematic of beholding I have been tracing into an imaginary register in which a beautiful woman's self-absorption emerges as the prototype of an antitheatrical relation to the painting.

The finest of the landscapes and seascapes of the 1850s and 1860s can also be understood as essentially private in their reference to the painter-beholder, as can the still lifes of 1871–73 whose genesis in Courbet's imprisonment in Sainte-Pélagie marks them as highly personal documents and whose fantasmatic relation to his paintings of nudes further situates them in an imaginary space that only partly coincides with their

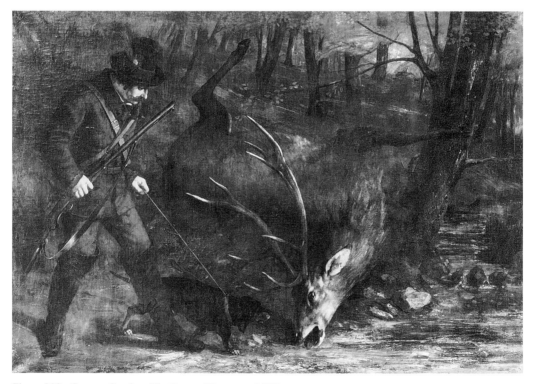

Figure 109.  Gustave Courbet, *The German Huntsman,* 1859.

ostensible settings. It's possible too that the unnaturally large scale of the fruit in some of the still lifes represents a defense against or compensation for the insult inflicted by imprisonment and sickness on Courbet's sense of corporeal identity. (I have proposed a not dissimilar reading of the *Trout of the Loue*.) But in Courbet's last years something altogether different takes place that provides an unexpected—at once a tragic and a comic—finale to his lifelong enterprise. I'm referring to the systematic manufacture of false Courbets, mostly landscapes painted by his assistants Cherubino Pata and Marcel Ordinaire and signed by Courbet himself, throughout the period of his exile in La Tour-de-Peilz. (Actually this seems to have begun shortly before his flight to Switzerland, while he was still in Ornans.) In place of the desire for quasi-corporeal merger on which I have put such stress, Courbet in these works remained aloof from the process of production, as if to ensure that he gave nothing of himself to the public that had approved the defeat of the Commune and his persecution for the Vendôme Column affair and yet at the same time clamored for his paintings, not because it truly admired or comprehended them but simply because of his political notoriety. With these expensive nonpaintings, which lifelessly reproduce his familiar motifs and grotesquely parody his inspired touch, he paid that public back in its own currency. We might think of this, in more ways than one, as a theatrical gesture.[92]

## Narcissism, Photography
### THE QUESTION OF NARCISSISM

One construction that has been placed on earlier versions of some of the chapters in this book by sympathetic readers is that I seem to be describing a dynamic of picture making that ought properly to be termed narcissistic. The suggestion can appear all the more compelling because of the prevalence of images of reflection in Courbet's art, and also because he personally was notoriously proud and self-admiring, traits that led Théophile Silvestre to write in 1856 that "the soul of Narcissus has stopped in [Courbet] in its latest migration. He always paints himself in his pictures with voluptuousness, and swoons with admiration for his work."[93] Moreover, as Silvestre's remarks suggest, the myth of Narcissus was current in nineteenth-century France, especially during its closing decades.[94] And of course recent psychoanalytic theory has largely shifted the focus of its attention from oedipal to narcissistic psychological structures, that

is, "from the father-mother-child triangle to the dyad of child and first love-object (usually but not necessarily the mother)."[95] But I want to resist narcissism as an explanatory category; saying why I do will help bring my account of Courbet's Realism to a close.

Put as simply as possible, a reading of Courbet's art as narcissistic would claim that the proliferation of explicit and (especially) metaphorical self-representations in his paintings came about because the painter saw himself wherever he looked, loved what he saw, and painted what he loved.[96] The trouble with this claim, however, is that it places far too much emphasis on the act of seeing and not nearly enough on the act of painting. In fact I suggest that the narcissistic account of the psychogenesis of Courbet's oeuvre amounts to little more than a subjective version of the standard realist account that I have been controverting throughout this book. Both accounts hold that Courbet's paintings are the way they are because the artist faithfully recorded what he saw; the difference between them is that one assumes that Courbet saw the world objectively, i.e., as it truly is, while the other maintains that when Courbet looked at the world what he saw were images of himself or at any rate, as in the nudes, landscapes, and still lifes, of his desire. In both accounts the act of painting is taken to be secondary to an act of seeing, even to an object of seeing, that for all intents and purposes determines the character of the representation. Another way of putting this is to say that the standard realist and narcissistic accounts agree in characterizing the painter as largely passive with respect to the "content" of his work—an eye rather than a hand, though in the narcissistic account admittedly a desiring eye. Whereas from the first I have minimized the role of seeing in the genesis of Courbet's art and instead have insisted that it was above all the painter-beholder's attempt to transport himself as if bodily into the painting on which he was working that explains both the idiosyncratic nature of the self-portraits of the 1840s and more generally the dissemination of partial and plural self-representations throughout individual pictures at all stages of his career except the very last. I have also tried to show how images of reflection in his paintings must be understood in terms of that attempt: thus in my reading of the *Source* I analogized the reflection of the woman's legs in the forest stream to the river landscape on the easel in the central group from the *Studio* not to equate the act of painting as portrayed in the latter with a natural mode of representation but on the contrary to show how reflection in Courbet's art is figuratively a product of the act of painting. (Cf. the patch of sunlight on the wall in the *Wheat*

*Sifters.*) In short my objection to a narcissistic rewriting of my account of Courbet's enterprise is that it grossly simplifies, in fact it elides, the complex dynamic at the heart of his work.

Fascinatingly, the issue of narcissism is at stake in a central passage in the "Introduction" to Georg Wilhelm Friedrich Hegel's *Aesthetics,* a work not customarily thought of in relation to Courbet. The passage reads:

> The universal and absolute need from which art . . . springs has its origin in the fact that man is a *thinking* consciousness, i.e., that man draws out of himself and puts *before himself* what he is and whatever else is. . . . This consciousness of himself man acquires in a two-fold way: *first, theoretically,* in so far as inwardly he must bring himself into his own consciousness, along with whatever moves, stirs, and presses in the human breast; and in general he must see himself, represent himself to himself, fix before himself what thinking finds as his essence, and recognize himself alone alike in what is summoned out of himself and in what is accepted from without. *Secondly,* man brings himself before himself by *practical* activity, since he has the impulse, in whatever is directly given to him, in what is present to him externally, to produce himself and therein equally to recognize himself. This aim he achieves by altering external things whereon he impresses the seal of his inner being and in which he now finds again his own characteristics. Man does this in order, as a free subject, to strip the external world of its inflexible foreignness and to enjoy in the shape of things only an external realization of himself. Even a child's first impulse involves this practical alteration of external things; a boy throws stones into the river and now marvels at the circles drawn in the water as an effect in which he gains an intuition of something that is his own doing. This need runs through the most diversiform phenomena up to that mode of self-production in external things which is present in the work of art.[97]

According to Hegel, artistic production is at bottom a form of self-representation (or self-production, a notion that looks forward to Marx), but self-representation here involves something other than a simple mirroring of the self. This is spelled out by the example he gives of the boy throwing stones into a river. The scene in question inevitably recalls (and no doubt was devised to recall) that of the Narcissus myth; but rather than have the boy fall in love with his own features in the placid surface of the water, Hegel has him disrupt that surface (i.e., destroy its character as a mirror), which is to say that he replaces passive desiring seeing—in Ovid's narrative inherently sterile and self-annihilating—with action on the world that produces "an effect in which [the boy] gains an intuition of something that is his own doing." Indeed the primacy of action over seeing is anticipated in the substitution of a river, implying flow and movement, for Ovid's secluded pool ("To which no shepherds came, no

goats, no cattle, / Whose glass no bird, no beast, no falling leaf / Had ever troubled"),[98] just as the continuity between ordinary action and the action of producing works of art is already implied by the image of the *drawing* of circles in the surface of the water.

My aim in citing Hegel's "Introduction" to his *Aesthetics* in the last chapter of a book on Courbet isn't to propose a historical connection between the philosopher and the painter. But Hegel's speculations relate to my argument on several counts. First, they provide a conceptual (also a mythological) model for understanding self-representation in nonmimetic, non-"realistic" terms, one moreover that implicitly revokes the Narcissus topos I have just rejected as a governing figure for Courbet's project. Second, because according to Hegel the effects of self-representation aren't determined by resemblance (the circles drawn in the water by the boy's stones don't look like the boy), what is required in order that they be recognized as such is a feat of interpretation—Hegel calls it intuition—or say of the connecting of effects with their causes, the grasping of powerful analogies, the reading of metaphors and allegories. Third, the effacement of the very conditions of resemblance (the breaking of the mirror-surface of the river) also means that the boy's relation to the spreading circles in the water might be described in Flaubertian language as one in which he is "present everywhere but visible nowhere." As we have noted, Flaubert imagines that effect of immanence as producing in the spectator "a sort of astonishment," an emotion I take to be close to the *marveling* that Hegel attributes to the boy faced for the first time with his own handiwork.

Finally, the primacy of action over seeing in Hegel's model recalls my insistence that self-representation in Courbet is always essentially a function of the painter-beholder's engagement in the act of painting. But what I want to stress is that this in turn directs attention to a deep continuity between Courbet's art and the Diderotian or dramatic tradition, in which (as I make clear in *Absorption and Theatricality*) the representation of significant human action played a fundamental role. As we have seen, the ever-increasing difficulty of dealing effectively with the issue of theatricality meant that action and expression became more and more disabled as vehicles of major pictorial ambition, until in Courbet's self-portraits and then his breakthrough pictures and later works a radically different strategy, directed toward merger rather than closure, was brought into play. But there is an important sense in which Courbet's art too was based on the representation of significant action, specifically the

action of making paintings—not because that action was inherently immune to the risk of theatricalization but rather because by the 1840s and 1850s the issue of theatricality had come to loom between the painter-beholder and his canvas, with the result that it now had to be resolved in and through the act of painting rather than strictly as a problem of representation (not, perhaps, that the distinction had ever been absolute; certainly it wasn't for Géricault). The effort this called forth might fairly be called heroic (as was also true for Géricault, in an age when heroism still tended toward tragedy instead of farce), which perhaps explains why, despite the repudiation of pictorial drama at the heart of his antitheatrical project, Courbet sometimes found himself drawn to the violent gestures and contrastive compositional format of David's *Horatii*. (I'm thinking especially of his exultant faceless self-portrait, the *Homecoming*.)

One last point. In early March 1872 Courbet's prison sentence came to an end but he remained for a while in a clinic in Neuilly. He was visited there by a journalist named Puissant, who in a subsequent article described Courbet's altered condition and reported that the painter's *idée fixe* was "to walk, run, take in big breaths, sprawl on the grass . . . He would like to seize the earth of the fields in his fists, to kiss it, smell it, bite it, thump the bellies of trees, to throw stones in water holes, flounder about in streams, to eat, to devour nature!"[99] The partial parallel with Hegel's imagery is fortuitous, but it underscores the fact that Courbet on the verge of regaining his freedom imagined not a passive contemplation of his own features and *a fortiori* not a passive return to the maternal element but rather a series of more or less violent actions by virtue of which the world would again be made to bear the imprint of his existence.[100]

### REALISM AND PHOTOGRAPHY

The case I have just made against a narcissistic reading of Courbet's painting also helps bring into focus certain fundamental differences between Courbet's Realism and the almost contemporary, in fact slightly previous, invention of photography, to which in its own time his work was frequently compared. What makes those differences particularly interesting is that a recent account of the ontology of photography and the movies, Stanley Cavell's *The World Viewed*, argues that photography overcame what he too calls theatricality "in a way undreamed of by painting, a way that could not satisfy painting, one which does not so much defeat the act of painting as escape it altogether: by *automatism*, by removing the

human agent from the task of reproduction."[101] Cavell adds a few pages later: "The depth of the automatism of photography is to be read not alone in its mechanical production of an image of reality, but in its mechanical defeat of our presence to that reality."[102] Cavell also suggests that the actual products of photography are sometimes theatrical in effect (because of problems associated with posing and temporality), as when he refers at one point to "the inherent theatricality of the (still) photograph."[103] But the invention of film, which is to say "the setting [of] pictures to motion," prodigiously enlarged the antitheatrical potential of the photographic medium.[104] "I have spoken of film as satisfying the wish for the magic reproduction of the world by enabling us to view it unseen," Cavell writes further on in his book. "I said also that what enables moving pictures to satisfy [that wish] is the automatism of photography. I have not claimed that film which is not used photographically, to reproduce the world, cannot be used for the purpose of art. I remark only that film which is not used photographically, in the sense intended, is not being used in its power of automatism. *Reproducing the world is the only thing film does automatically.*"[105] The power of film to achieve this effect—to reproduce the world by enabling us to view it unseen—is linked by Cavell to a necessary (i.e., transcendental) condition of the camera's existence, namely that it "is outside its subject."[106] Thus Cavell (writing in 1970) responds to what he takes to be a crisis in contemporary cinema with the suggestion that "the camera must now, in candor, acknowledge not its being present in the world but its being outside the world."[107] And in a long sequel to his original book, "More of The World Viewed," he goes on to associate that outsideness with "[t]he incompleteness . . . or contingency of the [camera's] angle of viewing, the fact that each is merely one among endless possibilities."[108]

The point of bringing in Cavell at this juncture isn't simply to contrast the automatism of photography and film as regards issues of beholding with the thematization and more broadly the primacy of the act of painting, hence of the will to paint, in Courbet's Realism. For on the one hand Courbet's pictures unmistakably and relentlessly thematize automatism as well; and on the other the automatisms of photography and film may be said to carry a whole array of intentions with respect to the characteristics of the images to be produced (i.e., those determined by lens size, focal length, shutter speed, type of negative, etc.), intentions that in effect have been built into the photographic apparatus by its designers. But Courbet's Realism also asserts that in the act of painting (as in all other

acts and states) will and automatism are interfused, whereas the intentionality of photographic automatisms is separated as if temporally from the *activation* of those automatisms in the taking of (still or moving) pictures, a process that at least in principle doesn't require the intervention of a human operator. And even when, as is almost always the case, the process is purposefully triggered by such an operator, there is an important sense in which the latter's intentions may be said to remain external to the actual, mechanical, production of the image.[109]

The difference between photography (to speak only of that) and Courbet's Realism in this regard can be most sharply brought out by recalling the *Quarry*, in particular its core image (fig. 68), the segment depicting Courbet as a hunter and the dead roe deer. As we noted earlier, the hunter-painter is shown in a state of seemingly complete passivity, arms crossed and hands out of sight, leaning back against a tree (it's not even clear that his eyes are open). And we noted too that the position and orientation of the dead roe deer suggest that it might almost be a reflection of the figure of the hunter-painter, as if the image of the roe deer came into being automatically, without the least effort on the part of the hunter-painter (and by implication the painter-beholder). The core image thus emerged as a fantasy of innocence and irresponsibility—in the present context we might think of it as a *photographic* fantasy, a fantasy of the act of painting as wholly automatistic and therefore very close to the taking (or shooting) of a photograph. But as we also saw, the fantasy couldn't be sustained. Instead Courbet found himself compelled to add the figure of the *piqueur* blowing a hunting horn, which I associated primarily with the effort of painting; and by virtue of that addition (not to mention the further addition of the hunting dogs) various affinities became discernible between the figures of the hunter-painter and the *piqueur* (and indeed the roe deer), affinities I saw as calling into question the absoluteness of the distinction between automatism and volition that the figures ostensibly embodied. In short, a painting that in its original form could be read as imagining a purely automatic mode of representation and in its expanded form as positing a strict separation of automatism and will turned out in the end to allegorize their necessary interpenetration. At the same time, the evident appeal to Courbet of what I have just described as a photographic fantasy and more broadly the centrality of automatism to his antitheatrical project bear witness to a deep connection between Realism and photography in the 1850s and after.[110]

Another basic difference between photography and film on the one

hand and Realism on the other concerns the contrast between the camera's position *outside* the world it reproduces and the painter-beholder's position *inside* the world he represents. Think of the seated painter-beholder in the *Painter's Studio* depicting his own immersion within the central group, or, again, of the figure of the hunter-painter in the *Quarry* who seems physically to be sinking into the pictorial field. Similarly, the fact that at any moment what the (still or motion picture) camera photographs is taken from a particular angle of viewing—that the camera even at its most mobile can always be described as occupying a particular point of view—is fundamentally opposed to the positional dynamics of Courbet's project, which in its pursuit of merger would undo the separation between beholder and beheld that is the precondition for there being points of view at all. (I was forced to speak of points of view in my analysis of the *Burial,* but that painting is unique in Courbet's oeuvre in its specification of a distinct viewing position, and in any case the latter proved to be both internally divided and radically unstable.)

Two incidents involving Courbet are illuminating here. The first took place during his exile in Switzerland; his assistant, Pata, had just called his attention to a choice point of view; Courbet responded: "You remind me of that poor Baudelaire, who, one evening in Normandy as the sun went down, led me to a rock overlooking the sea. He brought me before a gaping opening framed by jagged rocks. 'There is what I wanted to show you,' Baudelaire said to me, 'there is the point of view.' Wasn't he bourgeois! What are points of view? Do points of view exist?"[111] The second incident happened years before, during the summer of 1849 at Louveciennes; Courbet was staying with Francis Wey, and Corot too was visiting; one day after lunch the two painters went into the forest to paint. "Corot had a hard time finding his place," Courbet's biographer Georges Riat reports. "[H]e searched for his motif, squinted his eyes, tilted his head to the left and the right. . . . As for Courbet, he installed himself anywhere: 'Wherever I put myself,' he declared, 'is the same to me; it's always good, as long as one has nature under one's eyes.'"[112] The incidents are complementary in that Corot's search for a motif was inseparably a search for a point of view (what Riat calls "his place"), but what I want to stress is the clarity with which, taken together, they dramatize a contrast between a representational attitude keyed to the depiction of one or another of an infinite number of possible fragmentary *views* of the world and an attitude that aims on the contrary to represent the world or say nature *as a whole,* not by giving a complete inventory of its contents,

and certainly not by stepping ever further back to be able to embrace it all in a single glance, but rather by expressing its essential continuity with the embodied painter-beholder, a continuity, as Ravaisson claimed was true of that of nature itself, that can't actually be seen but can only be inferred. Put slightly differently, the wholeness of the world in Courbet's paintings is directly analogous to the sense in which the painter-beholder can be said to inhabit all of his body: anywhere is a good enough place for him to sit down to paint because he is wholly there and because wherever he finds himself nature is under his eyes, which I take to mean that it isn't fragmentarily and distantly present before him as a view. (Hence the special character of the bottom edges of Courbet's paintings.)

Still another way of putting this might be to say that in Courbet's Realism the world or nature possesses the quality of *omnipresence* that St. Anselm defined as "[existing] as a whole everywhere" and attributed only to God—that is, expressly not to the world—and that what takes the place of the *a priori* conception of God as the supreme being on which Anselm's ontological argument for God's existence relies is the phenomenological *a priori* of the lived body that I first invoked in discussing Courbet's self-portraits in chapter two.[113] (The most authoritative expression of the omnipresence of nature in mid-nineteenth-century literature is Thoreau's *Walden,* in which the notion of something like an *a priori* relation to the world is everywhere in play, as for example in the declaration of intent, "To anticipate, not sunrise and the dawn merely, but Nature herself!"[114] Notice, incidentally, how the idea of *anticipating* nature fits the action of the painter at the center of the *Studio,* who has often—understandably but perhaps too simply—been described as painting nature from memory.) In contrast to the densely figured mobilization of embodiedness in Courbet's painting, the photographic camera, in the words of a recent historian, "masqueraded as a transparent and incorporeal intermediary between observer and world," naturalizing or perhaps *re*naturalizing the convention of point of view and in general giving rise to the fundamental error that photography and Realism were synonymous.[115] Here too, however, the starkness of the opposition between Realism and photography points to their rootedness in the same historical conjuncture.*

---

*Another recent theorist (besides Cavell) who argues that photographs by their nature engage with the issue of theatricality is Roland Barthes. Thus for example Barthes claims that photographs that interest him involve the co-presence of two elements, the *studium,* which might roughly be equated with the photograph's ostensible subject and

which inevitably reflects the photographer's intentions, and the *punctum,* which Barthes defines as a detail that attracts him and that "is not, or at least is not strictly, intentional, and probably must not be so; it occurs in the field of the photographed thing like a supplement that is at once inevitable and delightful; it does not necessarily attest to the photographer's art; it says only that the photographer was there, or else, still more simply, that he could not *not* photograph the partial object at the same time as the total object . . ." (*Camera Lucida,* trans. Richard Howard [New York: Hill and Wang, 1981], pp. 23–47, especially p. 47). The passage concludes: "The Photographer's 'second sight' does not consist in 'seeing' but in being there. And above all, imitating Orpheus, he must not turn back to look at what he is leading—what he is giving to me!" (p. 47).

The *punctum,* in other words, must appear to have turned up in the photograph without the photographer having been aware of its presence, an antitheatrical criterion if there ever was one. Moreover, Barthes characterizes the *punctum* in terms that recall certain details in Chardin's paintings, for example the small tear in the seated draughtsman's jacket about which something has already been said. "The second element will break (or punctuate) the *studium.* This time it is not I who seek it out (as I invest the field of the *studium* with my sovereign consciousness), it is this element which rises from the scene, shoots out of it like an arrow, and pierces me. A Latin word exists to designate this wound, this prick, this mark made by a pointed instrument: the word suits me all the better in that it also refers to the notion of punctuation, and because the photographs I am speaking of are in effect punctuated, sometimes even speckled with these sensitive points . . . This second element which will disturb the *studium* I shall therefore call *punctum;* for *punctum* is also: sting, speck, cut, little hole—and also a cast of the dice. A photograph's *punctum* is that accident which pricks me (but also bruises me, is poignant to me)" (pp. 26–27). (The reference to a pointed instrument directs our attention also to the tip of Chardin's draughtsman's chalk, isolated by a daring elision against the sheet of paper on which he is drawing.) All this isn't to say that Chardin's paintings are photographic but rather to suggest how inextricably Barthes's speculations about photography are entangled with a problematic of theatricality that received its classic formulation around the middle of the eighteenth century and that he himself perhaps never fully understood. (Cf. his discussion of the *tableau* in "Diderot, Brecht, Eisenstein," in *Image-Music-Text,* trans. Stephen Heath [New York: Noonday Press, 1977], pp. 69–78.)

Further evidence of Barthes's concern with theatricality is his recognition that he cannot reproduce the "Winter Garden Photograph," a picture of his mother as a five-year-old child that is the center of his meditations in the second half of *Camera Lucida* and of which he remarks, "Something like an essence of the Photograph floated in this particular picture" (p. 73). Thus Barthes writes: "I cannot reproduce the Winter Garden Photograph. It exists only for me. For you, it would be nothing but an indifferent picture, one of the thousand manifestations of the 'ordinary'; . . . at most it would interest your *studium:* period, clothes, photogeny; but in it, for you, no wound" (ibid.). I read this structural nonreproducibility as in effect defining the Photograph as wholly private and in that sense antitheatrical: as though for Barthes the essence of the Photograph consists precisely in a denial of the "exhibition-value" that Walter Benjamin associated with the photographic as such (see "The Work of Art in the Age of Mechanical Reproduction," in *Illuminations,* ed. Hannah Arendt, trans. Harry Zohn [New York: Schocken Books, 1969], pp. 217–51). A parallel of sorts to Barthes's relation to the "Winter Garden Photograph" is the painter Frenhofer's relation to his portrait of Catherine Lescault in Honoré de Balzac's "Le Chef-d'oeuvre inconnu" (first version 1831, final version 1837), a text that could appropriately have been discussed in chapter one alongside the writings of antitheatrical critics of the 1820s and 1830s.

## Courbet and Modernism

One last question to be addressed concerns the relation of my account of
Courbet's paintings to traditional notions of modernism in the arts. The
question is this: does my reading of those paintings as representing the
circumstances and process of their making imply a version of the concept
of self-reference that in one form or another has been widely held to
characterize modernist artistic practice? I want to say no, primarily for
two reasons: first, because my insistence throughout this book that
Courbet's paintings stand in need of (metaphorical, allegorical, analogi-
cal) interpretation is in sharp contrast with the basic modernist trope of
explicitness according to which one or more material properties of a me-
dium, artistic conventions, or aspects of the actual making of a work of
art are taken to be forced on our attention in and by the work itself; and
second, a point made earlier in this chapter, because the vision of Cour-
bet's enterprise for which I have been arguing is at odds with the
formalist-modernist assumption that a fundamental opposition exists be-
tween painting as illusion or representation and painting as material ob-
ject.

To take an obvious example, Clement Greenberg's famous essay
"Modernist Painting" defines modernist practice as a kind of immanent
self-criticism, the aim of which has been to "exhibit and make explicit
that which is unique and irreducible not only in art in general but also in
each particular art."[116] A key passage reads:

> Realistic, illusionist art had dissembled the medium, using art to conceal art.
> Modernism used art to call attention to art. The limitations that constitute the
> medium of painting—the flat surface, the shape of the support, the properties
> of pigment—were treated by the Old Masters as negative factors that could be
> acknowledged only implicitly or indirectly. Modernist painting has come to re-
> gard these same limitations as positive factors that are to be acknowledged
> openly. Manet's paintings became the first Modernist ones by virtue of the
> frankness with which they declared the surfaces on which they were painted.
> The Impressionists, in Manet's wake, abjured underpainting and glazing, to
> leave the eye under no doubt as to the fact that the colors used were made of
> real paint that came from pots or tubes. Cézanne sacrificed verisimilitude, or
> correctness, in order to fit drawing and design more explicitly to the rectangular
> shape of the canvas. It was the stressing, however, of the ineluctable flatness of
> the support that remained most fundamental in the processes by which pictorial
> art criticized and defined itself under Modernism. . . . Flatness, two-
> dimensionality, was the only condition painting shared with no other art, and
> so Modernist painting oriented itself to flatness as it did to nothing else.[117]

Greenberg's association of modernism with the frank and explicit declaration of the materiality of the medium recalls Rosen and Zerner's description of the *Burial,* though presumably they would dispute Greenberg's implied relegation of Courbet's Realism to a pre-modernist moment.[118] But more important than any difference of opinion as to chronology is the common reliance of all three writers on a series of antitheses—implicit versus explicit, scene versus painting, illusion versus materiality, etc.—that I have tried to show yields far too simple and rigid an account of Courbet's art.[119]

An alternative theory of modernism in the arts, put forward by Cavell in *The World Viewed* and by me in various writings on abstract painting and sculpture of the 1960s and 1970s, crucially involves a particular use of the concept of *acknowledgment*. (Greenberg uses the word in the passage just quoted, but his stake is plainly in the modifers "implicitly," "indirectly," and "openly.") One virtue of the concept of acknowledgment for Cavell and me has always been its avoidance of the antithetical logic I have just criticized: thus we assume that it has never been sufficient merely to "exhibit" or "make explicit" (Greenberg's revealing conjunction) material properties of a particular medium; instead it is a historical question what in a given instance *counted* as acknowledging one or another property or condition of that medium, just as it is a historical question how most accurately to describe the property or condition that the acknowledgment was *of*. (The determining properties or conditions of a medium in a given instance might be virtually anything; at any rate, they can't simply be identified with materiality as such.) Thus Cavell distinguishes between the claim that the camera ought "merely [to] declare itself," which strikes him as empty, and his conviction that the movie camera must now acknowledge its outsideness to the world, an altogether different project;[120] while I have elsewhere explained how, in an attempt to make sculptures that would be not just literally but abstractly small, Anthony Caro found it necessary to build into those sculptures, in that sense to acknowledge, their placement on a table—the "natural" locus for objects of a not very large size—rather than on the ground—the locus of his abstract pieces up to that time.[121] (Caro did this by running at least one element in each sculpture below the level of the tabletop, thereby precluding the work's transposition to the ground both literally and, so to speak, imaginatively. One might wish to say that Caro thus made explicit the sculpture's placement on a table, but one would still have to explain why that placement matters as I claim it does: Caro's

essential discovery was not so much how to "table" his pieces as that "tabling" them opened up a new realm of abstract scale. Besides, there is nothing in the example that corresponds to a prior notion of *im*plicit-ness.)

Would it then be correct to summarize my account of Courbet's enter-prise by suggesting that he repeatedly found himself compelled to ac-knowledge in the painting on which he was working both his position before it and the actions by which he sought to bring it to completion? Obviously it would go too far to insist that one not say this; and yet there is in Cavell's and my use of the concept of acknowledgment the implica-tion of a response to a state of crisis in a given art that both does and doesn't apply to Courbet's paintings. "[W]hat has made the movie a can-didate for art is its natural relation to its traditions of automatism," Cavell writes. "The lapse of conviction in its traditional uses of its automatism forces it into modernism; its potentiality for acknowledging that lapse in ways that will redeem its power makes modernism an option for it."[122] Similarly, Caro's pursuit of abstract smallness was impelled by the recog-nition that, under the regime of abstraction that he himself had largely instituted, literal scale—simple difference of size—had more and more lost its power to convince.[123] Now I have painstakingly presented Cour-bet's Realism as a response to a historical crisis, namely the growing in-ability of the dramatic tradition to establish the illusion (to engender the conviction) that the beholder does not exist. But the terms in which I have characterized that response, in particular my insistence on the un-consciousness or, perhaps more accurately, the *unknowingness* of Cour-bet's repeated, obsessive attempts to transport himself as if corporeally into the canvas before him, militate against describing his enterprise as one of acknowledgment as Cavell and I have developed the concept. Not that self-awareness is precisely a *sine qua non* of acknowledgment. But the notions are sufficiently linked to have led me throughout this book not to speak of acknowledgment in my readings of Courbet's pictures.[124] Where I would wish to speak of it is apropos Manet's revolutionary mas-terpieces of the 1860s, in which (as was suggested in chapter six) I see a recognition, if not of the historical dimensions of the crisis of beholding itself, at any rate of the need to acknowledge by every means available—from choice of subject to sources in previous art to overall composition to the patterning of light and dark to each stroke of the brush—the pri-mordial convention that paintings are made to be beheld. Indeed I see in Manet's acknowledgment of beholding as the inescapable fate of painting

the true (i.e., historical) meaning of his pictures' alleged flatness: as though what has been taken as a declaration of flatness is rather the product of an attempt to make every portion of the picture surface *face* the beholder as never before. Considered in this light, the difference between Courbet's and Manet's paintings looms as fundamental, whereas in a formalist perspective, despite the evident stylistic disparity between the two oeuvres, it everywhere threatens to dissolve (*vide* the similarity between Rosen and Zerner on Courbet and Greenberg on Manet).[125] I will add that with the advent of Manet the problematic of theatricality analyzed in this book underwent a decisive change, by which I expressly don't mean to suggest that the impulse to overcome the theatrical simply disappeared. But from the early 1860s on, for Manet himself as for the younger painters who looked to him for guidance, the antitheatrical impulse was forced to coexist with a radical acceptance of the theatrical, and it is precisely the interplay between the two that we must now learn to disentangle in advanced painting of the succeeding decades.

## Courbet's *Hunter on Horseback*

Probably during the first half of 1864 Courbet painted a somewhat uncharacteristic but undeniably moving, even haunting, picture, *Hunter on Horseback, Recovering the Trail* (pl. 16).[126] The setting is an open space high in the forest of the Jura; the season is winter, the landscape covered with snow; and we look down and across woods and fields toward distant mountains that seem to rise and fall like waves in the sea. The hour is shortly before dusk: the sun, just above the far horizon, is hidden by the dark bulk of the hunter's body, but its position is made clear by the shadows of the horse's legs on the snow in the extreme foreground of the picture. As for the hunter himself, he may or may not be a self-portrait, but in any case he could hardly be closer in feeling to the protagonists of the *Wounded Man,* the *Studio,* and the *Quarry,* just as the blending of hunter and horse into a single darkish silhouette recalls the joining of sitter and dog in the early *Small Portrait of Courbet* and *Courbet with a Black Dog.* (The blending appears more complete than would have been the case when the painting was fresh. The darker portions of the image have suffered badly in comparison with the more thickly painted lighter areas, so that for example one has to look closely to make out the fox pelt wrapped around the rider's waist.) The title of the painting explains the

action: hunter and horse are shown at the moment of refinding the tracks of an animal (a deer?) they have been pursuing; the horse lowers its head as if sniffing the spoor; and there are telltale traces of red in the snow that suggest that the quarry has been wounded, presumably by the hunter. The hunter sits back in his saddle, holding the reins in his right hand and resting his left hand on the horse's rump; his gaze is downward, seemingly focused on the blood spots at the lower left; and partly owing to the greater frequency of such spots in what we take to be the direction of the quarry's flight, we sense that the hunt may be drawing to a close.

I want to end this book with a few comments on the *Hunter on Horseback* not because it sums up everything I have been saying about Courbet's art but rather because, while exemplifying my argument in various respects, it underscores the extent to which the persuasiveness of that argument finally depends not on any direct equivalence between the painted image on the one hand and the painter Gustave Courbet before his canvas on the other but rather on an entire network of connections within Courbet's oeuvre, a network that inevitably becomes more and more attenuated toward its limits. So for example I see a figure for the act of painting in both the tracks and the blood in the snow, but even more than is usual what gives this reading such plausibility as it has is the recall of other works, notably the *Wounded Man* and the *Wheat Sifters,* in which a not dissimilar imagery plays a comparable role, even though the *Hunter on Horseback* lacks the weapon/paintbrush of the first and the far denser and more specific metaphorics of painterly production of the second.

Or consider the depiction of the mounted hunter's hands, right and left again conforming to the distinction between relatively active and relatively passive that I have repeatedly associated with the actions of the painter-beholder's right and left hands as he worked on his paintings. Here, however, there is nothing either in the imagery of the reins or in the French words for "rein" or "bridle" to remotely suggest a brushlike instrument, so that if it weren't for the host of other works by Courbet in which the representation of hands yields a far stronger purchase for my argument, the suggestion that the differential treatment of the hunter's hands might be meaningful would lack all force. Even with those works in mind the suggestion may be felt to have no bearing on the *Hunter on Horseback,* which in this respect as in others stands very near the outer limit of the network of connections to which I have alluded.

But even in the vicinity of that limit further interpretive possibilities can arise: thus despite (though also because of) the absence of any imple-

ment that could be seen as figuring the painter-beholder's brush or pal-
ette knife—a feature also of the *Quarry* until the addition of the *piqueur*
blowing his horn—I'm struck by the sheer "brushness" of the horse's tail,
so different from, yet in this reading related to, the proliferating hair-
imagery in Courbet's paintings of women—the *Woman with a Parrot,*
*Sleep,* the *Portrait of Jo*—of just a few years later. How persuaded am I by
this interpretation? Not nearly so persuaded as, for example, by my read-
ing of the sword and wound in the *Wounded Man,* or the addition of the
*piqueur* to the core image of the *Quarry,* or virtually every detail of the
*Wheat Sifters.* And yet the (to me) undeniable fact that the *Hunter on*
*Horseback* resonates with these and other works by Courbet (for instance,
the *Seated Model* [fig. 64] discussed in chapters five and six) makes it per-
haps equally difficult to be certain that the interpretation I have just pro-
posed is wholly undeserving of belief. Note too how the *Hunter on Horse-*
*back* contains another significant absence, that of the painter's signature,
which ordinarily would be found in the lower left corner of the canvas.[127]
In a sense, though, the painting *is* signed there, by patches of blood of
exactly the color Courbet favored for his signatures. Does this lend sup-
port to my reading of the absent-weapon-plus-horse's-tail as a figure for
the painter's brush? And what of the parallel between the horse's tail and
the rider's scarf, which also happens to be the same shade of blood-red?
Does this have a bearing on the case, or are these merely detached obser-
vations without relevance to one another?

Then too there is the near-coincidence of the shadows of the horse's
legs with what would be their reflections if the horse were standing in
shallow water rather than in snow (and the fact that snow and water are
the same substance may not be beside the point). This represents perhaps
the most refined expression in all Courbet's oeuvre of the analogy be-
tween absorption and reflection adumbrated on the early sketchbook
page with drawings of a man reading and a bridge reflected in a river (fig.
85) and later carried further in his pictures of the Source of the Loue, Le
Puits noir, and other cave-plus-water motifs as well as in figure paintings
such as the *Quarry,* the *Portrait of Jo,* and the *Source.* Moreover, the ori-
entation of the horse-and-rider's shadow-body—legs extending into the
picture—evokes the painter-beholder's bodily orientation with respect to
the canvas on his easel, just as the shadows' skewing to the left rehearses
the familiar structural motif of an oblique thrust into the picture space, a
motif I have also associated with the painter-beholder's relation to his
canvas. In short, I take the shadows of the horse's legs, seemingly a minor

detail, to imply an entire thematics of embodiedness and picture-making, though once again what underwrites my doing so is a network of connections—of interpretations—it has required all of this book to set in place.

Finally, I see the theme of tracking a wounded animal and specifically the motif of the converging tracks in the snow as figuring the painter-beholder's project of seeking to undo both distance and difference between himself and his painting. (This would be a further instance of what I have been calling lateralization.) At the same time, the temporal and spatial disjunction that hasn't yet been closed, and perhaps also the evident threat of greater violence to come, suggest the necessary failure of that project, though not of course of the hunt itself. And what of the association between the drops of blood, Courbet's missing signature, and the hunter's red scarf, an association that hints at the corporeal identity of hunter-painter and quarry? This would seem to imply that the distance and difference that can't be overcome are also within the painter-beholder, a possibility that first emerged in my reading of the *Burial*. It may be that the poignant elegiac mood of the *Hunter on Horseback*, which as we stand before the painting comes to seem almost tangible, expresses, if not an awareness of that self-division, at any rate an intuition that death alone could bring it to an end.

# Notes

Abbreviations

EXHIBITION CATALOGS

*Autoportraits:*            Marie-Thérèse de Forges et al., *Autoportraits de Courbet,* Les
                            Dossiers du département des peintures 6 (Paris: Musée du
                            Louvre, 1973).

*Courbet à Montpellier*     Philippe Bordes, *Courbet à Montpellier* (Montpellier: Musée
                            Fabre, 5 Nov.–29 Dec. 1985).

*Courbet Reconsidered*      Linda Nochlin, Sarah Faunce, et al., *Courbet Reconsidered*
                            (Brooklyn, N.Y.: The Brooklyn Museum of Art, 4 Nov.
                            1988–16 Jan. 1989; Minneapolis: The Minneapolis Institute
                            of Arts, 18 Feb.–30 Apr. 1989) (New Haven: Yale University
                            Press, 1988).

*Courbet und Deutschland*   Werner Hofmann, Peter-Klaus Schuster, et al., *Courbet und
                            Deutschland* (Hamburg: Hamburger Kunsthalle, 19 Oct.–17
                            Dec. 1978; Frankfurt am Main: Städtische Galerie im Stä-
                            delschen Kunstinstitut, 17 Jan.–18 Mar. 1979).

Toussaint                   Hélène Toussaint et al., *Gustave Courbet (1819–1877)* (Paris:
                            Grand Palais, 30 Sept. 1977–2 Jan. 1978; London: Royal
                            Academy, 18 Jan.–19 Mar. 1978).

OTHER WORKS

Baudelaire, *Curiosités*    Charles Baudelaire, *Curiosités esthétiques; L'Art romantique,*
    *esthétiques*           ed. Henri Lemaître (Paris: Garnier Frères, 1961).

Clark                       T. J. Clark, *Image of the People: Gustave Courbet and the 1848
                            Revolution* (1973; reprint, Princeton: Princeton University
                            Press, 1982).

Courthion 1 and 2           Pierre Courthion, ed., *Courbet raconté par lui-même et par ses
                            amis,* 2 vols. (Geneva: Pierre Cailler, 1948 and 1950).

Fernier                     Robert Fernier, *La Vie et l'oeuvre de Gustave Courbet: Cata-
                            logue raisonné,* 2 vols. (Lausanne: Bibliothèque des Arts,
                            1977).

Léger                       Charles Léger, *Courbet* (Paris: G. Crès et Cie., 1929).

Lindsay                     Jack Lindsay, *Gustave Courbet: His Life and Art* (New York:
                            Harper & Row, 1973).

Mainzer            Claudette Roseline Mainzer, "Gustave Courbet, Franc-
                   Comtois: The Early Personal History Paintings, 1848–1850"
                   (Ph.D. diss., Ohio State University, 1982).
Nochlin            Linda Nochlin, *Gustave Courbet: A Study of Style and Society*
                   (New York: Garland, Outstanding Dissertations in the Fine
                   Arts, 1976).
Riat               Georges Riat, *Gustave Courbet, peintre* (Paris: H. Floury,
                   1906).

## Chapter One

1. The most comprehensive recent biography is Lindsay but there is much new in-
formation about Courbet's relation both to his family and to the townspeople of Ornans
in Mainzer. Important earlier biographies include Riat, Léger, and Gerstle Mack, *Gustave
Courbet* (New York: Knopf, 1951). See also Nochlin, Clark, and Toussaint. Courbet's
collected letters, edited by Petra ten-Doesschate Chu, will soon appear both in French
and in an English translation; meanwhile a selection of his letters to family and friends
can be found in the exhibition catalog *Courbet familier* (Ornans: Musée Départemental
Maison Natale Gustave Courbet, 28 June–2 Nov. 1980).

2. On Courbet's early years in Bohemia see, in addition to works cited in n. 1, Emile
Bouvier, *La Bataille Réaliste (1844–1857)* (Paris: Fontemoing et Cie., n.d. [1913]); and
Jerrold Seigel, *Bohemian Paris: Culture, Politics, and the Boundaries of Bourgeois Life, 1830–
1930* (New York: Viking, 1986), pp. 59–96.

3. Courbet said this to Francis Wey, a man of letters and fellow Franc-Comtois who
was to become a close friend, at their first meeting during the winter of 1848–49. See
Wey, "Notre maître peintre Gustave Courbet," in Courthion 2:184.

4. Roland Barthes, "L'Effet de réel," *Communications* 11 (Paris, 1968):84–89; En-
glish translation, "The Reality Effect," in *French Literary Theory Today: A Reader*, ed.
Tzvetan Todorov, trans. R. Carter (Cambridge: Cambridge University Press; Paris: Edi-
tions de la Maison des Sciences de l'Homme, 1982), pp. 11–17. See also Norman Bry-
son, *Vision and Painting: The Logic of the Gaze* (New Haven and London: Yale University
Press, 1983), especially chaps. 1–3.

5. See my comments on traditional accounts of Eakins's *The Gross Clinic* in Michael
Fried, *Realism, Writing, Disfiguration: On Thomas Eakins and Stephen Crane* (Chicago:
University of Chicago Press, 1987), pp. 10–11.

6. The relations between Baudelaire and Courbet are discussed in Yoshio Abe, "*Un
Enterrement à Ornans* et *l'habit noir* baudelairien," *Etudes de Langue et Littérature Fran-
çaises* (Bulletin de la Société Japonaise de Langue et Littérature Françaises) 1 (1962):29–
41; Alan Bowness, "Courbet and Baudelaire," *Gazette des Beaux-Arts*, ser. 6, vol. 90 (Dec.
1977):189–99; and Clark, pp. 52–76. See also T. J. Clark, *The Absolute Bourgeois: Artists
and Politics in France, 1848–1851* (1973; reprint, Princeton: Princeton University Press,
1982), pp. 141–77.

7. Baudelaire, "Exposition Universelle de 1855," in *Curiosités esthétiques*, p. 226.
(Mais la différence est que le sacrifice héroïque que M. Ingres fait en l'honneur de la
tradition et de l'idée du beau raphaélesque, M. Courbet l'accomplit au profit de la nature
extérieure, positive, immédiate.)

8. Ibid., pp. 329, 370. The crucial passage reads:

Il est évident que . . . l'immense classe des artistes . . . peut se diviser en deux camps bien distincts:
celui-ci, qui s'appelle lui-même *réaliste,* mot à double entente et dont le sens n'est pas bien déter-

miné, et que nous appellerons, pour mieux charactériser son erreur, un *positiviste,* dit: "Je veux représenter les choses telles qu'elles sont, ou bien qu'elles seraient, en supposant que je n'existe pas." L'univers sans l'homme. Et celui-là, l'imaginatif, dit: "Je veux illuminer les choses avec mon esprit et en projecter le reflet sur les autres esprits" (p. 329).

The imagination is called the queen of the faculties on pp. 320–24. Baudelaire's hostility to realism is also expressed in a fragmentary text of around 1855, notes for an article that was never written, "Puisque réalisme il y a" (ibid., pp. 823–25).

9. Ibid., p. 317. (A partir de ce moment, la société immonde se rua, comme un seul Narcisse, pour contempler sa triviale image sur le métal.)

10. Charles Baudelaire, *Oeuvres complètes,* ed. Y. G. Le Dantec and Claude Pichois (Paris: Gallimard, Bibliothèque de la Pléiade, 1961), p. 365. The paragraph reads:

Il arrive quelquefois que la personnalité disparaît et que l'objectivité, qui est le propre des poëtes panthéistes, se développe en vous si anormalement que la contemplation des objets extérieurs vous fait oublier votre propre existence, et que vous vous confondez bientôt avec eux. Votre oeil se fixe sur un arbre harmonieux courbé par le vent; dans quelques secondes, ce qui ne serait dans le cerveau d'un poëte qu'une comparaison fort naturelle deviendra dans le vôtre une réalité. Vous prêtez d'abord à l'arbre vos passions, votre désir ou votre mélancolie; ses gémissements et ses oscillations deviennent les vôtres, et bientôt vous êtes l'arbre. De même, l'oiseau qui plane au fond de l'azur *représente* d'abord l'immortelle envie de planer au-dessus des choses humaines; mais déjà vous êtes l'oiseau lui-même. Je vous suppose assis et fumant. Votre attention se reposera un peu trop longtemps sur les nuages bleuâtres qui s'exhalent de votre pipe. L'idée d'une évaporation, lente, successive, éternelle, s'emparera de votre esprit, et vous appliquerez bientôt cette idée à vos propres pensées, à votre matière pensante. Par une équivoque singulière, par une espèce de transposition ou de quiproquo intellectuel, vous vous sentirez vous évaporant, et vous attribuerez à votre pipe (dans laquelle vous vous sentez accroupi et ramassé comme le tabac) l'étrange faculté de *vous fumer.*

11. Baudelaire, *Curiosités esthétiques,* pp. 241–63, especially pp. 253–54.

12. Michael Fried, *Absorption and Theatricality: Painting and Beholder in the Age of Diderot* (Berkeley: University of California Press, 1980; new ed., Chicago: University of Chicago Press, 1988). The discussion of Diderot, Chardin, and Greuze that follows is based on fuller analyses in that book.

13. Denis Diderot, *Oeuvres esthétiques,* ed. Paul Vernière (Paris: Garnier Frères, 1959), p. 792. (La toile renferme tout l'espace, et il n'y a personne au delà.)

14. Three of these paintings in particular, *Las Meninas,* the *Syndics,* and the *Déjeuner sur l'herbe,* have been the focus of analyses concerned with the status of the implied viewer. On *Las Meninas* see, e.g., Michel Foucault, *The Order of Things,* English translation (New York: Pantheon, 1973), pp. 3–16; John R. Searle, "*Las Meninas* and the Paradoxes of Pictorial Representation," *Critical Inquiry* 6 (Spring 1980):477–88; Joel Snyder and Ted Cohen, "Reflections on *Las Meninas:* Paradox Lost," *Critical Inquiry* 7 (Winter 1980):429–47; Leo Steinberg, "Velásquez's *Las Meninas,*" *October,* no. 19 (Winter 1981):45–54; Svetlana Alpers, "Interpretation without Representation, or, The Viewing of *Las Meninas,*" *Representations,* no. 1 (Feb. 1983):30–42; and Joel Snyder, "*Las Meninas* and the Mirror of the Prince," *Critical Inquiry* 11 (June 1985):539–72. On the *Syndics* (and more broadly the question of the status of the beholder in seventeenth-century Dutch painting) see Alois Riegl, *Das holländische Gruppenporträt,* 2 vols. (Vienna: Osterreichischen Staatsdruckerei, 1931). On the *Déjeuner sur l'herbe* (and the issue of beholding in Manet) see Michael Fried, "Manet's Sources: Aspects of His Art, 1859–65," *Artforum* 7 (Mar. 1969):28–82, especially p. 69, n. 27; p. 70, n. 46. Manet's paintings are also central to Richard Wollheim's (to my mind unpersuasive) reflections on what he calls "the spectator in the picture" in *Painting As an Art,* The A. W. Mellon

Lectures in the Fine Arts, 1984, Bollingen Series 35 (Princeton: Princeton University Press, 1987), pp. 141–76. Wollheim also discusses Riegl's study of the Dutch group portrait (pp. 176–85).

15. See Fried, *Absorption and Theatricality,* pp. 28–32.

16. I make this claim in *Absorption and Theatricality* (pp. 136–38, 193), where I also suggest that, despite the gulf between their ages, Diderot and David would have known each other through their common friendship with the playwright Michel-Jean Sedaine, in whose household David lived between 1769 and 1775 (pp. 137, 232–33). The latter point is also made by Anita Brookner, *Jacques-Louis David* (New York: Harper & Row, 1980), p. 35. The significance of David's history paintings of the 1780s remains a burning topic; recent discussions of them include Brookner, ibid., pp. 68–94; Norman Bryson, *Word and Image: French Painting of the Ancien Régime* (Cambridge: Cambridge University Press, 1981), pp. 204–38; idem, *Tradition and Desire: From David to Delacroix* (Cambridge: Cambridge University Press, 1984), pp. 62–84; Thomas E. Crow, *Painters and Public Life in Eighteenth-Century Paris* (New Haven and London: Yale University Press, 1985), pp. 208–54; and Antoine Schnapper, *David, témoin de son temps* (Paris: Bibliothèque des Arts, 1980), pp. 59–93. See also my discussion of David's *Homer* drawings of 1794 (*Absorption and Theatricality,* pp. 175–78).

17. See Fried, *Absorption and Theatricality,* pp. 154–60.

18. E[tienne]-J[ean] Delécluze, *Louis David, son école et son temps, souvenirs,* new edition with preface and notes by Jean-Pierre Mouilleseaux (1855; Paris: Macula, 1983), p. 120. A striking feature of Delécluze's book is that it nowhere mentions Diderot, an exclusion I take to be deliberate. Owing to his training in David's atelier in the 1790s, a time when the master was drawing back from the starkly dramatic mode of his paintings of the second half of the 1780s (see below), Delécluze came to deplore what he considered Diderot's overemphasis on dramatic values and effects; later, in his practice as a critic, he saw himself as struggling against the pernicious influence of Diderot's views. Thus he wrote in his *Souvenirs de soixante années* (Paris: Michel Lévy Frères, 1862):

A major error in which most of those who have written on the arts since Diderot have fallen is to have considered sculpture and painting almost exclusively with regard to expression and dramatic effect. This tendency, which rapidly leads theatrical works [i.e., works for the stage] to melodrama, equally lowers the productions of the [visual] arts to the common and vulgar. Etienne [Delécluze himself] never ceased, from 1819 to the present (1858), to make both artists and public realize how much this false doctrine, unfortunately presented with such brilliance and vividness by Diderot, is contrary to the true principles of the art (p. 144).

Une erreur capitale dans laquelle sont tombés la plupart de ceux qui ont écrit sur les arts depuis Diderot, est d'avoir considéré la statuaire et la peinture presque exclusivement sous le rapport de l'expression et de l'effet dramatique. Cette tendance, qui conduit rapidement des oeuvres théâtrales au mélodrame, fait tomber également le productions des arts dans le commun et le vulgaire. Etienne n'a pas cessé depuis 1819 jusqu'à présent (1858) de faire sentir aux artistes et au public combien cette doctrine fausse, présentée malheureusement avec tant d'esprit et d'éclat par Diderot, est contraire aux vrais principes de l'art.

19. For the text of David's *livret,* including Hersilia's speech, see Daniel Wildenstein and Guy Wildenstein, eds., *Documents complémentaires au catalogue complet de l'oeuvre de Louis David* (Paris: La Bibliothèque des Arts, 1973), pp. 148–50. The suspension of action in the *Sabines* is noted by Louis Hautecoeur, *Louis David* (Paris: La Table Ronde, 1954), p. 180; see also Robert Rosenblum, *Transformations in Late Eighteenth Century Art* (Princeton: Princeton University Press, 1967), pp. 90–91. In important respects David's choice of subject reverts to his initial idea for the *Horatii.* Originally he had

planned to represent Horatius *père* defending his eldest son before the Roman people, but when he described his project to a group of friends, one of them, Sedaine, remarked, "The action you have chosen is almost nil, it is all in the words" (Hautecoeur, p. 71). Much of what I say here about David, Gros, Géricault, and Daumier is adumbrated in Michael Fried, "Thomas Couture and the Theatricalization of Action in 19th Century French Painting," *Artforum* 8 (June 1970):40–46. A recent article by Stefan Germer and Hubertus Kohle, "From the Theatrical to the Aesthetic Hero: On the Idea of Virtue in David's *Brutus* and *Sabines*," *Art History* 9 (June 1986):168–86, goes over some of the same ground, apparently unaware of previous writing on the subject. Their most valuable observation is perhaps that the *Sabines* depicts subsidiary figures engaged in actions that could only have followed Hersilia's intervention (p. 184), but the general conclusion they draw from their analysis, that "in the *Sabine Women* David . . . completely replaces action by aesthetic presence" (p. 184), seems to me misleading.

20. Delécluze, *Louis David,* p. 112. ([J]e lui donnais ce·que les modernes appellent de *l'expression,* et ce qu'aujourd'hui . . . j'appelle de la *grimace*.)

21. Ibid., pp. 225–27.

Vous avez choisi . . . un autre instant que celui que je me propose de rendre. Votre Léonidas donne le signal pour prendre les armes et marcher au combat, et tous vos Spartiates répondent à son appel. Moi, je veux donner à cette scène quelque chose de plus grave, de plus réfléchi, de plus religieux. Je veux peindre un général et ses soldats se préparant au combat comme de véritables Lacédémoniens, sachant bien qu'ils n'en échapperont pas; les uns absolument calmes, les autres tressant des fleurs pour assister *au banquet qu'ils vont faire chez Pluton.* Je ne veux ni mouvement ni expression passionnés, excepté sur les figures qui accompagneront le personnage inscrivant sur le rocher: *Passant, va dire à Sparte que ses enfants sont morts pour elle.* . . . Vous devez comprendre à présent, mon ami, le sens dans lequel sera dirigée l'exécution de mon tableau. Je veux essayer de mettre de côté ces mouvements, ces expression de théâtre, auxquels les modernes ont donné le titre de *peinture d'expression.* A l'imitation des artistes de l'antiquité, qui ne manquaient jamais de choisir l'instant avant ou après la grande crise d'un sujet, je ferai Léonidas et ses soldats calmes et se promettant l'immortalité avant le combat. . . . Mais j'aurai bien de la peine, ajouta David, à faire adopter de semblables idées dans notre temps. On aime les coups de théâtre, et quand on ne peint pas les passions violentes, quand on ne pousse pas *l'expression* en peinture jusqu'à la *grimace,* on risque de n'être ni compris ni goûté.

22. For Diderot's contrast in the *Entretiens* and the *Poésie dramatique* between *tableaux* and *coups de théâtre* see Fried, *Absorption and Theatricality,* pp. 78, 79, 93, 95–96, 207.

23. According to David, a certain failure of synchronization between the two was part of his intentions. Late in his life, he described Leonidas's action to Alexandre Lenoir in the following terms:

Leonidas is, in fact, in the attitude of a man who is meditating. On seeing the entire Orient descend on his native land, he judged that it was necessary to astonish the Persians and to rally the Greeks; he calculated that his death and that of his companions would produce this double effect. He was absorbed in these great thoughts when the trumpet sounded. At this signal, the hand holding the sword quivered with an almost mechanical movement; the right leg moved back as if involuntarily; this movement transpired only in his body; his soul is still totally engrossed in the great conception with which it is preoccupied, but one feels that it is about to emerge from its meditation and that the hero will accomplish his destiny ("David. Souvenirs historiques," *Journal de l'Institut Historique* 3, no. 1 [1835]:12–13).

Léonidas est, en effet, dans l'attitude d'un homme qui réfléchit. . . . En voyant tout l'Orient fondre sur sa patrie, il a jugé qu'il était nécessaire d'étonner les Perses et de ranimer les Grecs; il a calculé que sa mort et celle de ses compagnons produiraient ces deux effets. Il était absorbé dans ces grandes pensées lorsque la trompette a sonné. A ce signal, la main qui tient l'épée a frémi d'un mouvement presque machinal; la jambe droite s'est comme involontairement portée en arrière; ce mouvement

ne s'est passé que dans le corps; l'âme est encore toute entiere au grand dessein qui l'occupe, mais on sent qu'elle va sortir de sa méditation et que le héros va remplir sa destinée.

24. For reasons of space I have omitted discussing three major classes of David's paintings: works made in connection with the French Revolution, such as the *Tennis Court Oath* (begun 1790 but never finished) and *Marat* (1793); works commissioned by Napoleon in the service of the Empire, most importantly the *Coronation of Napoleon* (1808); and the "Anacreonic" paintings of David's years in exile in Brussels (1816–25). A passage from Delécluze's *Journal* for 11 April 1826 bears directly on the issues we have been tracing: on a visit to Lafayette he saw on the latter's wall an engraving of David's *Tennis Court Oath* alongside one of John Trumbull's *Signing of the Declaration of Independence.* "It's very curious to compare the two engravings," Delécluze writes.

[I]n the act passed by the Americans, all is calm, and one would say that these were wise and upright merchants arranging a contract. In the Tennis Court Oath, everyone is in a state of convulsion, and some even have the attitude of actors (*comédiens*). Is it the fault of the participants, is it the fault of the painter, is it the fault of everyone? It's a curious question and worth pondering (*Journal de Delécluze, 1824–1828,* ed. Robert Baschet [Paris: Grasset, 1948], p. 341).

C'est un rapprochement fort curieux à faire que celui des deux gravures dont je viens de parler: dans l'acte passé par les Américains, tout est calme, et l'on dirait des marchands sages et probes qui contractent un marché. Dans le Jeu de Paume de Versailles, tout le monde est en convulsion, et quelques-uns même ont l'attitude de comédiens. Est-ce la faute des acteurs, est-ce la faute du peintre, est-ce la faute de tous? C'est une question curieuse et bonne à approfondir.

Also, in *Absorption and Theatricality* I observe that in almost all of David's late "Anacreonic" paintings the presence of the beholder is positively implied and the mise-en-scène assumes a blatantly theatrical character (p. 231). This suggests that starting around 1809, the date of his *Sappho, Phaon, and Love,* David began to cast about for a subject matter and a mode of presentation that would allow him to embrace the theatricality he could no longer overcome but would also avoid encroaching upon the realm of heroic action, which was now closed to him. An important work in this development, in part because its subject explicitly involves a thematics of seeing and being seen, is his *Cupid Leaving Psyche* (1817). (According to myth, Psyche is never allowed to see Cupid with whom she makes love.)

25. On Gros (1771–1835) the major study remains J. Tripier-le-Franc, *Histoire de la vie et de la mort du Baron Gros . . .* (Paris: J. Martin, 1880). See also Robert Herbert, "Baron Gros's Napoleon and Voltaire's Henri IV," in *The Artist and the Writer in France: Essays in Honour of Jean Seznec,* ed. Francis Haskell, Anthony Levi, and Robert Shackleton (Oxford: Clarendon, 1974), pp. 52–75.

26. Thus the young art critic (and future politician and historian) Guizot remarks of Gros, whom he has just praised for his natural and original talent and for avoiding the theatrical in his compositions, that

his faults are those of his school, and his school will not have his genius; accustomed to seek only the truth, without joining beauty to it as a necessary condition, it will fall easily into a hideous exaggeration ([François-Pierre-Guillaume] Guizot, "De l'Etat des beaux-arts en France et du Salon de 1810," in *Etudes sur les beaux-arts en général* [Paris: Didier et Cie., 1858], pp. 22–23).

ses défauts sont ceux de son école, et son école n'aura pas son génie; accoutumée à ne chercher que la vérité, sans y joindre la beauté comme condition nécessaire, elle tombera facilement dans une exagération hideuse.

Guizot goes on to note that "among the three Arabs or Negroes in the foreground [of Gros's *Emperor Haranguing the Army before the Battle of the Pyramids* (1810)] two of them

are of a repugnant truthfulness" (p. 23; parmi les trois Arabes ou Nègres qui sont sur le devant, il y en a deux d'une vérité rebutante).

27. The most comprehensive and authoritative study of the artist is Lorenz E. A. Eitner, *Géricault: His Life and Work* (London: Orbis, 1983), but Géricault, like Gros, still awaits his modern interpreter.

28. Stanley Cavell, *The World Viewed: Reflections on the Ontology of Film,* enlarged ed. (Cambridge and London: Harvard University Press, 1979), pp. 89–91.

29. The *Satyr and Nymph* (ca. 1815–16) in Rouen, Musée des Beaux-Arts. See Eitner, *Géricault,* pp. 82–83.

30. As a result of the ensuing scandal, Géricault's aunt, Alexandrine-Modeste Caruel, retired permanently to her country estate, while the boy, Georges-Hyppolite, was looked after by Géricault's father. For a discussion of the affair and its aftermath see Eitner, *Géricault,* pp. 75–77, 99, 138, 175, 285.

31. According to Géricault's nineteenth-century biographer, the usually reliable Charles Clément, the artist painted ten such portraits for his friend, the alienist Etienne-Jean Georget. (Only five have come to light.) Their dating is uncertain: Eitner, for example, places them ca. 1822 following the artist's return from England (*Géricault,* pp. 241–49); but it has plausibly been suggested that they were painted in late 1819 and early 1820, when Géricault himself seems to have been under treatment by Georget (see Denise Aimé-Azam, *Mazeppa: Géricault et son temps* [Paris: Plon, 1956], pp. 216–33). In Georget's book, *De la folie. Considérations sur cette maladie* . . . (Paris: Crevot, 1820), depressive or melancholic monomania—a likely diagnosis for Géricault's sitters—is described as a state in which

the somber mad persons, disliking all tumult, absorbed and profoundly attentive to the idea that dominates them, flee their fellows, sometimes to remove themselves from their sight if they believe they displease them, or if they are afraid of becoming their victims, at other times to seek a repose they are unable to find, or to entrench themselves all the more securely in their own manner of looking (p. 112).

Dans la lypemanie [a term for depressive monomania invented by Georget's teacher, Esquirol] ou mélancolie, les aliénés sombres, ennemis du tumulte, absorbés et profondément attentifs à l'idée qui les domine, fuient leurs semblables, tantôt pour se soustraire à leur vue s'ils croyent leur déplaire, ou s'ils craignent d'en devenir victimes, d'autres fois pour chercher un repos qu'ils ne peuvent trouver, ou pour se fortifier à leur aise dans leur manière de voir.

32. In addition to his discussion of the *Raft* project in *Géricault* (pp. 158–206), see Eitner, *Géricault's "Raft of the Medusa"* (London and New York: Phaidon, 1972).

33. Stendhal, "Salon de 1824," in *Mélanges d'art* (1932; Nendeln/Liechtenstein: Kraus Reprint, 1968), pp. 45–47. See also his remarks on the fatal consequences of basing gestures in paintings on gestures that were effective on the stage in "Des beaux-arts et du caractère français" (1828), ibid., p. 160. By focusing here on Stendhal I don't mean to imply that his views were wholly original; in fact they were anticipated as early as 1810 by Guizot, who criticized the *Sabines* on identical grounds and warned against the theatricalizing effect of gestures taken from Talma ("De l'Etat des beaux-arts en France, et du Salon de 1810," pp. 12–14). At the same time Guizot criticized the increasingly widespread notion that energy of expression was the chief pictorial value (p. 24). See also his "Essai sur les limites qui séparent et les liens qui unissent les beaux-arts" (1816), in *Etudes sur les beaux-arts en général,* pp. 101–46.

34. Among the paintings in the Salon of 1824 Stendhal most admired was François-Pascal Gérard's smaller version of a work he had exhibited with great success in the Salon

of 1822, *Corinne Improvising at Cap de Misène in the Presence of Her Lover, Lord Oswald* (the subject was taken from Mme. de Stael's *Corinne*). Interestingly, Adolphe Thiers—another art critic who was later to become a leading politician—described the original version in terms that show he saw in it a *tour de force* of antitheatrical dramaturgy. Thus Thiers remarks of the figure of Corinne preparing to sing that

she is hardly on stage [or on view], I surprise her there, she doesn't know that I am looking at her. . . . Corinne isn't transported but moved; she isn't singing, she is about to sing; she could have shown her beautiful body, she hides it; she turns her back to the spectator; but from her beautiful shoulders, from her graceful yet strong figure, one divines a magnificent body, one follows its lines in its voluptuous and abandoned movement. I wouldn't even see her face, but she turns back on herself, turns back toward the heavens, and, by that very movement, presents her head to the spectator and to the light (*Salon de Mil Huit Cent Vingt-Deux* [Paris: Maradan, 1822], pp. 88–89).

Corinne, s'attendrissant à la vue du ciel et de la nature, Corinne se préparant à chanter, me fait tout apercevoir; elle n'est point en scène, je l'y surprends, elle ne sait pas que je la regarde. . . . Corinne n'est pas transportée, mais attendrie; elle ne chante pas, elle va chanter; elle pouvait montrer son beau corps, elle le cache; elle tourne le dos au spectateur; mais à ses belles épaules, à sa taille gracieuse et pourtant forte, on devine un corps magnifique, on en suit les lignes dans son mouvement si voluptueux et si abandonné. Je ne verrais pas même son visage, mais elle revient sur elle-même, se retourne vers le ciel, et, par le même mouvement, présente sa tête au spectateur et à la lumière.

It's typical of that historical moment that the issue of theatricality was seen as resolved by a painting with an explicitly theatrical subject.

35. On Delaroche see Norman D. Ziff, *Paul Delaroche: A Study in Nineteenth-Century French History Painting* (New York and London: Garland, Outstanding Dissertations in the Fine Arts, 1977).

36. Ibid., p. 105.

37. Stephen Bann, *The Clothing of Clio: A Study of the Representation of History in Nineteenth-Century Britain and France* (Cambridge: Cambridge University Press, 1984), p. 75. This is said in a chapter entitled "Image and Letter in the Rediscovery of the Past: Daguerre, Charles Alfred Stothard, Landseer, Delaroche"; the section on Delaroche is of great interest (pp. 70–76).

38. Thus Planche in his "Salon de 1831":

There are two routes, profoundly diverse and distant, by which to conceive and execute a . . . work of art . . . The first, by far the most difficult to follow, goes right from the mind to the canvas. In following it, the artist has only his idea in view. He doesn't think of anyone else. He works for himself, to please himself, to liberate himself from something weighing on him. . . . That route, so rarely followed, so difficult to follow, was that of Rubens, of Géricault; it is also that of Eugène Delacroix. In producing for oneself, one doesn't achieve a rapid and unanimous reputation; but one is assured of a lasting glory. . . . [In contrast, Delaroche] has found the task too difficult. Instead of raising the public up to him, he has descended to the public (Gustave Planche, *Etudes sur l'école française (1831–1852). Peinture et sculpture*, 2 vols. [Paris: Michel Lévy Frères, 1855], 1:21–22).

Il y a deux routes, profondément diverses et distantes, pour concevoir et pour exécuter . . . une oeuvre d'art . . . L'une, et c'est la plus difficile à suivre, va droit du cerveau à la toile. En la suivant, l'artiste n'a en vue que son idée. Il ne songe à rien autre. Il fait pour lui, pour se contenter, pour se débarrasser de quelque chose qui lui pèse. . . . Cette route-là, si rarement suivie, si difficile à suivre, ça été celle de Rubens, de Géricault; c'est aussi celle de M. Eugène Delacroix. En produisant pour soi, on arrive difficilement à une rapide et unanime réputation; mais on est assuré d'une gloire durable. . . . [Delaroche] a trouvé la tâche trop difficile. Au lieu d'élever le public jusqu'à lui, il est descendu jusqu'au public.

Planche went on to criticize both the puerility of thought and the banality of execution in the *Children of Edward*, commenting in particular that the young king and his

brother "have the air of being dressed up for a ball" (p. 24; Le roi et son frère ont l'air de s'être parés pour un bal), and that the furniture and costumes would serve admirably on the stage of the Opera or other theater, "but it can be seen that they have never been and never will be used or worn" (ibid.; mais il est visible qu'ils n'ont jamais été et ne seront jamais usés ni portés). Planche's disgust with Delaroche's theatricality as well as with the public response to the latter's work is even more evident in his scathing remarks on Delaroche's *Cromwell* further on in the same "Salon" (pp. 71–75). And he was strongly critical three years later of the *Jane Grey* ("Salon de 1834," pp. 237–42), of which he remarked that it was "more theatrical than dramatic" (p. 241; plutôt théâtrale que dramatique), the very distinction that I am suggesting was becoming increasingly difficult to sustain, or at least to find new positive examples to justify.

In fact the problem this involved was central to his criticism. For Planche in the early 1830s the future of ambitious painting in France required following Géricault's lead in the direction of pictorial drama. "From all this, what do we conclude?" he wrote in 1831. "It is that drama has entered violently into the kind of painting one calls *historical*. From now on, energy, dramatic expression, will be the first condition of all painting" ("Salon de 1831," p. 170). (De tout cela, que conclurons-nous? C'est que le drame vient d'envahir la peinture qu'on appelle *historique*. Désormais, l'énergie, l'expression dramatique, sera la première condition de toute peinture.) But the evidence of his subsequent "Salons" suggests that he had a hard time finding dramatic paintings to admire.

In this connection a passage in his "Salon de 1833" is especially telling. On the one hand, he argues, we are no longer content with the linear combinations and the emphasis on the beauty of individual figures that in his view characterize the art of Raphael. Instead we demand more artful and motivated compositions; we insist that all the figures in a painting be integrated with respect to their attitudes and gestures as well as to the planes in which they stand and the colors and tones in which they have been painted. (So far so good, it would seem.) However, Planche continues, one result of this new insistence on dramatic unity is that the basic modality of our responsiveness to art has become admiration rather than love. Even worse, if in order to satisfy the requirements of our intelligence the painter is led to represent a complex drama, he risks straying beyond the limits of his art into a realm that properly belongs to the spoken word. It is necessary, therefore, that the painter restrain his artistic will within a narrower compass, though what exactly Planche understands by such restraint—what it means for the representation of action and drama—is never specified (pp. 188–89). In his words:

[L]a vie romaine, simple, naïve, spontanée jusque dans ses déréglements, permettait, au peintre des Loges, des combinaisons purement linéaires que la vie française accueillerait par le dédain. Il nous faut et nous voulons des compositions plus savantes et plus motivées. Nous ne consentons pas à la valeur, individuelle et indépendante, de chaque figure, dans un tableau de vingt pieds. Nous demandons compte à tous les acteurs de leur attitude et de leur geste, aussi bien que du plan où ils sont placés, et de la gamme du ton qui les caractérise. Nous admirons, et nous n'aimons pas. Nos plus vives sympathies ne sont guère que des approbations sérieuses. Si pour satisfaire ce besoin de raison qui domine et gouverne nos impressions, si pour fermer la bouche aux récriminations du cerveau, qui gourmande les yeux et le coeur, le peintre essaie sur la toile un drame complexe, il peut lui arriver de dépasser les limites de son art, et d'exiger de sa palette une obéissance et une souplesse qui n'appartiennent qu'à la parole. La main la plus habile ne peut rivaliser avec les lèvres. Il faut qu'elle restreigne sa volonté dans un cercle beaucoup plus étroit, sous peine de voir sa pensée, malgré les efforts les plus patients, n'arriver sur la toile que boiteuse et mutilée.

In short Planche seems already to be qualifying his forthright advocacy of pictorial drama of two years before.

I should add that Delaroche's success was more than just popular: he had his critical supporters and succeeded in being elected to the Institut at an unusually early age (Ziff, *Paul Delaroche,* pp. 116–17).

39. Thus for example Théophile Thoré in 1845 refers to Delaroche as "the idol of the bourgeoisie" ("Salon de 1845," in *Salons de T. Thoré,* avec une Préface par W. Bürger [a pseudonym for Thoré] [Paris: Librairie Internationale, 1868], p. 116; l'idole de la bourgeoisie).

40. Exactly how they did this is an intriguing question. Broadly, two strategies might be noted. First, both Ingres and Delacroix emphasize what might be called "stylistic" factors at the expense of traditional forms of dramatic effect. In the case of Ingres (1780–1867), whose vision of painting was decisively shaped by his training in David's atelier during the years that saw the planning and execution of the *Sabines,* the emphasis on "style" involves a high degree of linear abstraction, ultimately sanctioned by the art of Raphael. In the case of Delacroix (1798–1863) exactly opposite "stylistic" values of painterliness and colorism are brought to the fore, ostensibly in the service of an often dramatic subject matter but in fact displacing attention away from the dramatic effect of the whole toward another kind of unity that contemporary critics found far from easy to describe. This order of priorities is already evident in the earliest of his ambitious canvases, the *Bark of Dante* (1822), but the work that more than any other exemplifies Delacroix's revolution is the wholly undramatic *Algerian Women* (1834), about which Planche wrote:

> This canvas is, in my opinion, the most brilliant triumph that M. Delacroix has ever attained. To hold one's interest by means of the art of painting reduced to its own resources, without the assistance of a subject that can be interpreted in a thousand ways and that sometimes distracts the eye of superficial spectators who then esteem the work only according to their dreams and conjectures, is a difficult task, and M. Delacroix has accomplished it" ("Salon de 1834," p. 248, with slight modifications).

> Cette toile est, à mon avis, le plus éclatant triomphe que M. Delacroix ait jamais obtenu. Intéresser par la peinture réduite à ses seules ressources, sans le secours d'un sujet qui s'interprète de mille façons, et trop souvent distrait l'oeil des spectateurs superficiels, pour n'occuper que leur pensée qui estime le tableau selon ses rêves ou ses conjectures, c'est une tâche difficile, et M. Delacroix l'a remplie.

See also the admiring commentary on that painting by Alexandre D[ecamps], *Le Musée, revue du Salon de 1834* (no publisher or date), pp. 57–60, which expressly contrasts it with works that resemble a *coup de théâtre* (p. 60). Significantly, however, the *Algerian Women* didn't provide a new paradigm of ambitious painting for Delacroix himself, much less for painting generally.

Second, the paintings of both Ingres and Delacroix often bear a more or less obvious relation to the art of the museums, and this too may be held to shift attention away from considerations of drama toward a play of references or say *differences* that radically undermines what Norman Bryson calls the image's effect of "presence" (see the discussion of Ingres in Bryson, *Tradition and Desire,* pp. 124–75). The same effect is achieved by Ingres's compulsive repetition of his own designs and compositions (ibid., p. 144), a repetition, moreover, that increasingly seals his paintings within a private, in that sense hermetic, realm. As for Delacroix, the relation of his art to that of his great predecessors is *the* crucial issue in Baudelaire's several extravagantly praising yet somehow baffled assessments of his achievement; see Michael Fried, "Painting Memories: On the Containment of the Past in Baudelaire and Manet," *Critical Inquiry* 10 (Mar. 1984):510–42, where I suggest that the special memory-activity that Baudelaire associates with Delacroix's paint-

ing tends "to collapse the classical [i.e., dramatic] scene of representation . . . into a giddy, disorienting, mainly 'spiritual' space in which nothing like a *confrontation* between painting and beholder could ever quite take place" (p. 532). A further implication of my essay is that Baudelaire's attempt in his "Salon of 1846" to make a certain instant memorability the decisive criterion of art involves a circumventing (more accurately, a forestalling) of beholding and therewith the whole problematic of theatricality.

41. Daumier is another artist on whom the modern literature is disappointing. See however James Cuno, "Charles Philipon and La Maison Aubert: The Business, Politics, and Public of Caricature in Paris, 1820–1840" (Ph.D. diss., Harvard University, 1985); and idem, "Charles Philipon, La Maison Aubert, and the Business of Caricature in Paris, 1829–41," *Art Journal* 43 (Winter 1983):347–54.

42. On the portrait busts see the exhibition catalog by Jeanne L. Wasserman et al., *Daumier Sculpture: A Critical and Comparative Study* (Cambridge, Mass.: Fogg Art Museum, Harvard University, 1 May–23 June 1969).

43. The lithograph was obviously based on a sculpture, but not the one sometimes identified as Soult. See the discussion in *Daumier Sculpture,* cat. no. 36, p. 158.

44. On the September Laws see for example Judith Wechsler, *A Human Comedy: Physiognomy and Caricature in 19th Century Paris* (Chicago: University of Chicago Press, 1982), pp. 80–81. Note though how Wechsler implicitly minimizes the political and artistic significance of the Laws for Daumier and others. She writes:

At the same time a deeper transformation was taking place: the caricaturists were beginning to shift their focus from public events, individual politicians and specific laws and policies, to their sources and consequences in social conditions. In this shift, Daumier, in collaboration with Philipon, played the major role. . . . This new strain of caricature was more resistant to censorship. The individual political *portrait-charge* and explicit political caricature were replaced by the representative or symbolic type, which stood for a recognizable category of protagonists, beneficiaries or victims of the regime. The classification of people by types became part of the caricaturists' armoury (p. 82).

Much the same view is developed by Richard Terdiman in his analysis of the "counterdiscursive" aspects of Daumier's post-1835 caricatures for Philipon's other major journal, *Le Charivari* (see Terdiman, *Discourse/Counter-Discourse: The Theory and Practice of Symbolic Resistance in Nineteenth-Century France* [Ithaca and London: Cornell University Press, 1985], pp. 149–97). In Terdiman's view, the paradoxical result of the "prohibition of explicit political caricature and satire was to hasten the emergence of the tendency toward more infrastructural critique of the social forces, practices, and discourses which sustained the self-proclaimed liberal regime. If the *government* of the nation could no longer legally be attacked, the dominant national *ideology* became open to the most corrosive ridicule" (p. 162). My own reading of the situation is closer to that of Walter Benjamin, who writes:

In 1841 there were seventy-six new physiologies [studies of types]. After that year the genre declined, and it disappeared together with the reign of the citizen-king Louis-Philippe. It was a basically petty-bourgeois genre. . . . Nowhere did these physiologies break through the most limited horizon. After the types had been covered, the physiology of the city had its turn. There appeared *Paris la nuit, Paris à table, Paris dans l'eau, Paris à cheval, Paris pittoresque, Paris marié.* When this vein, too, was exhausted, a "physiology" of the nations was attempted. Nor was the "physiology" of the animals neglected, for animals have always been an innocuous subject. Innocuousness was of the essence (Benjamin, "The Paris of the Second Empire in Baudelaire," in *Charles Baudelaire: A Lyric Poet in the Era of High Capitalism,* trans. Harry Zohn [London: New Left Books, 1973], pp. 35–36).

Terdiman cites Benjamin as noting the "inflection to a more infrastructural social satire" following the imposition of censorship (*Discourse/Counter-Discourse*, p. 163, n. 27), but curiously he doesn't acknowledge the latter's altogether different assessment of the political meaning of that shift.

45. Thus Millet to his biographer Alfred Sensier, *La Vie et l'oeuvre de J.-F. Millet* (Paris: A. Quantin, 1881), pp. 53–54:

The *Elizabeth* and the *Children of Edward* were exhibited [at the Luxembourg]. I was to attend Delaroche's atelier, but these paintings gave me no desire to enter it. I saw in them only enlarged vignettes and theatrical effects without true emotion, and everywhere I saw posing and [theatrical] arrangement.

L'*Elizabeth* et les *Enfants d'Edouard* de Delaroche y étaient exposés. On me destinait à l'atelier de Delaroche: tous ces tableaux ne me donnèrent pas le désir d'y entrer. Je n'y voyais que de grandes vignettes et des effets de théâtre sans véritable émotion, et partout je voyais la pose et la mise en scène.

Millet's hostility to the theatrical and the commensurately nontheatrical character of his own art are primary themes of Sensier's book. See also Etienne Moreau-Nélaton, *Millet raconté par lui-même*, 3 vols. (Paris: Henri Laurens, 1921). The most useful recent publication on Millet is the exhibition catalog by Robert Herbert, *Jean-François Millet* (Paris: Grand Palais, 17 Oct. 1975–5 Jan. 1976; London: Hayward Gallery, 22 Jan.–7 Mar. 1976); illustrations of works by Millet cited but not reproduced in my text can be found in Herbert's catalog.

46. Quoted in Herbert, *Millet*, p. 91. (Il évite tout effet dramatique parce qu'il serait faux. Et si ces femmes sont malheureuses, c'est nous qui devons tirer cette conclusion; elles l'ignorant [sic] elles-mêmes.) Cf. Millet's account of his attraction to the paintings of the so-called primitives (Sensier, *Millet*, p. 57), a passage I quote and discuss briefly in chapter seven (pp. 237–38).

47. Ernest Chesneau, "Jean-François Millet," *Gazette des Beaux-Arts*, ser. 2, 11 (1 May 1875):434–35.

Dans l'oeuvre de Millet rien ne pose: ni l'homme, ni l'animal, ni l'arbre, ni le brin d'herbe. Et cette remarque que chacun aura faite m'amène à parler du mode de procéder familier à l'artiste. Millet,— je le tiens de ceux qui l'ont suivi de plus près, et le caractère de son dessin confirme le fait d'une manière absolue,—Millet ne peignait ni ne dessinait d'après nature. Il observait patiemment, longuement, avec insistance et à maintes reprises, le phénomène immobile ou le phénomène d'action qu'il se proposait de reproduire. L'ensemble de la scène et la successivité des attitudes et des mouvements se gravaient ainsi dans sa mémoire, secourue au besoin par une note de crayon prise à la volée. Contrairement aux doctrines professées par les écoles de réalité, chaque geste posé est un geste faussé et figé. Les preuves abondent qui condamnent, dans toute oeuvre de maître, la théorie du travail d'après le modèle.

Just over ten years later the critic Félix Fénéon would give the same explanation for the truthfulness of Degas's images of women in "Les Impressionistes en 1886," in *Oeuvres plus que complètes*, ed. Joan U. Halperin, 2 vols. (Geneva: Droz, 1970), 1:30–31. The key passage reads:

Art of realism which nevertheless doesn't proceed from a direct vision: when someone knows he is observed, his functions lose their naïve spontaneity; therefore M. Degas never copies from nature: he accumulates a multitude of sketches on a single subject and from these his work draws an indisputable truthfulness: never have paintings less evoked the painful image of the "model" who "poses."

Art de réalisme et qui cependant ne procède pas d'une vision directe: des qu'un être se sait observé, il perd sa naïve spontanéité de fonctionnement; M. Degas ne copie donc pas d'après nature: il accumule sur un même sujet une multitude de croquis où son oeuvre puisera une véracité irréfragable; jamais tableaux n'ont moins évoqué la pénible image du "modèle" qui "pose."

48. Chesneau, "Millet," p. 435. (S'il se sait observé, croyez-vous que ce vigneron gardera cet affaissement de tout le corps, cette cambrure des malléoles internes si caractéristique, cette bouche béante, ce regard atone et vide? Point du tout. A défaut de ses vêtements que vous lui aurez fait conserver, il endimanchera ses membres, ses muscles et sa physionomie.)

Chesneau's antagonism to the theatrical found expression elsewhere in his criticism, as for example when he observed of Géricault:

The figures that animate his paintings aren't there to be seen suffering; they pay no attention to the public, they don't know that the public exists; they are there only because they suffer, and in order to suffer. Few masters, even among the greatest, knew so well how to avoid all staginess of mise-en-scène ("Géricault," *Les Chefs d'école* [Paris: Didier, 1864], p. 176).

Les figures qui animent ses tableaux ne sont pas là parce qu'on les regarde souffrir; elles n'ont aucun souci du public, elles ne savent pas qu'il existe; elles ne sont là que parce qu'elles souffrent, et pour souffrir. Peu de maîtres, je dis parmi les plus grands, ont su éviter l'apprêt de la mise en scène. . .

In the same book Chesneau criticized the paintings of Pierre-Narcisse Guérin (1774–1833) for their theatricality, adding:

It's that all the actors in Guérin's dramas compose their faces and act for the spectator; but at least they act, usually with a true elegance; in David's work, the preoccupation with the public is immobilizing (p. 92).

C'est que tous les acteurs des drames de Guérin composent leur visage et jouent pour le spectateur; cependant ils jouent, et le plus souvent avec une véritable élégance; chez David, la préoccupation du public les immobilise.

49. See for example Millet's letter of 18 February 1862 to the critic Théophile Thoré, a text discussed in chapter seven (pp. 237–38). Just how close Millet's pictorial aspirations were to those I have associated with the opening phase of the Diderotian tradition can further be gauged by his admiration for the earlier picture that was most talismanic for Diderot and his like-minded contemporaries, Poussin's *Testament of Eudamidas* (1650s). On one occasion, according to Wyatt Eaton, Millet began by criticizing a *Nativity* by Titian on the grounds of its unnaturalness. "Millet then turned to another engraving, after Poussin—a man upon his death-bed," Eaton writes.

"How simple and austere the interior [Millet said]; only that which is necessary, no more; the grief of the family, how abject; the calm movement of the physician as he lays the back of his hand upon the dying man's heart; and the dying man, the care and sorrow in his face, and his hands—perhaps your friend [who had criticized a painting by Eaton in terms that infuriated Millet] would not call them beautiful, but they show age, toil, and suffering: ah! these are infinitely more beautiful to me than the delicate hands of Titian's peasants" ("Recollections of Jean-François Millet, with Some Account of His Drawings for His Children and Grandchildren," *Century* 38 [May 1889]:99).

My thanks to Sheila McTighe for bringing this passage to my attention. On the importance of the *Testament of Eudamidas* for Diderot (and David) see Fried, *Absorption and Theatricality,* pp. 41, 43, 77–78, 108, 192–93, 205.

50. Quoted in Moreau-Nélaton, *Millet raconté par lui-même,* 2:42.

Ses trois *glaneuses* ont des prétentions gigantesques; elles posent comme les trois Parques du paupérisme. . . . Ces pauvresses ne me touchent point. Elles ont trop d'orgueil; elles trahissent trop visi-

blement la prétention de descendre des Sibylles de Michel-Ange et de porter plus superbement leurs guenilles que les moissonneurs du Poussin ne portent leurs draperies. . . . Il me déplaît de voir Ruth et Noémi arpenter, comme les planches d'un théâtre, le champ de Booz.

51. Baudelaire, "Salon de 1859," in *Curiosités esthétiques,* p. 372.

M. Millet cherche particulièrement le style; il ne s'en cache pas, il en fait montre et gloire. Mais une partie du ridicule que j'attribuais aux élèves de M. Ingres s'attache à lui. Le style lui porte malheur. Ses paysans sont des pédants qui ont d'eux-mêmes une trop haute opinion. Ils étalent une manière d'abrutissement sombre et fatal qui me donne l'envie de les haïr. Qu'ils moissonnent, qu'ils sèment, qu'ils fassent paître des vaches, qu'ils tondent des animaux, ils ont toujours l'air de dire: "Pauvres déshérités de ce monde, c'est pourtant nous qui le fécondons! Nous accomplissons une mission, nous exerçons un sacerdoce!" Au lieu d'extraire simplement la poésie naturelle de son sujet, M. Millet veut à tout prix y ajouter quelque chose. Dans leur monotone laideur, tous ces petits parias ont une prétention philosophique, mélancolique et raphaélesque. Ce malheur, dans la peinture de M. Millet gâte toutes les belles qualités qui attirent tout d'abord le regard vers lui.

52. Something of this dynamic can be glimpsed even in certain of Millet's own statements, as for example the passage from his letter to Thoré referred to in n. 49. Or consider the following remarks by Sensier:

[T]hat which cannot be learned, Millet possessed by virtue of his genius: [a mastery of] gesture, attitude, movement at its truest, expression at its *summa* of intensity. Admirable and dangerous research! A small step beyond his conception and the artist falls into an excess of character. . . . On occasion . . . [Millet] allowed himself to yield to that tendency which carried him toward too willed a mode of expression (*Millet,* pp. 176–78).

[C]e que nul ne peut apprendre, Millet le possédait par une faveur du génie: c'est le geste, l'attitude, le mouvement dans son extrême vérité; c'est l'expression à son *summum* d'intensité. Recherche admirable et dangereuse! Un pas au delà de sa pensée, l'artiste serait tombé dans l'excès du caractère. . . . Parfois . . . il se laissa aller à cette pente qui le portait vers une expression trop voulue.

Millet's art was indeed an art of will, and to the extent that the viewer was made aware that this was so, the antitheatricality toward which Millet aspired was undone.

53. On the invention of the daguerreotype and the early history of photography see for example Herbert Gernsheim and Alison Gernsheim, *L.-J.-M. Daguerre: The History of the Diorama and the Daguerreotype* (1956; reprint, New York: Dover, 1968); and Beaumont Newhall, *The History of Photography from 1839 to the Present Day* (4th ed. rev.; New York: The Museum of Modern Art, 1964).

54. André-Adolphe-Eugène Disdéri, *L'Art de la photographie* (Paris: Chez l'Auteur, 1862), pp. 299–300 (l'image photographique traduira toutes les nuances avec une exactitude absolue et laissera lire sur le personnage tout entier le conflit ou l'indécision de ses pensées). On Disdéri's life and career see Elizabeth Anne McCauley, *A. A. E. Disdéri and the Carte de Visite Portrait Photograph* (New Haven and London: Yale University Press, 1985). I am grateful to Dianne Pitman for bringing Disdéri's book to my attention. Her dissertation on Frédéric Bazille demonstrates with great subtlety the pertinence of the problem discussed by Disdéri and more broadly of the issue of theatricality to advanced painting and art criticism in France in the second half of the 1860s. See Dianne Williams Pitman, "The Art of Frédéric Bazille (1841–1870)" (Ph.D. diss., The Johns Hopkins University, 1989).

55. Disdéri, *L'Art de la photographie,* p. 300. (Le dessin photographique, dans son inexorable fidélité, ne manquerait pas d'indiquer très-clairement l'origine des personnages et représenterait bien plutôt les portraits en action de ces acteurs qu'un sujet de moeurs ou une scène de sentiment.)

56. Ibid., p. 305. (Nous savons avec quelle merveilleuse perfection les instruments photographiques expriment les plus délicates nuances de la réalité; nous savons qu'ils nous montreront l'acteur ou nous avons cru mettre l'homme, l'action théâtrale où nous avons tenté de placer l'action naturelle.)

57. It was therefore gratifying to discover Norman Bryson writing of my mode of argument in *Absorption and Theatricality* that it

enables [Fried] to describe change in presentation of the image—the difference, for example, between Boucher and Chardin—in *non*-formalist terms: the features he analyses are not those of design considered as configuration of shapes in two dimensions, design as it manifests to the formalist *ascesis,* but rather structures of narrative. These are of enormous importance in the description of discursive, that is representational, art; and Fried's approach marks, I believe, an important change in orientation in art history itself (*Tradition and Desire,* p. 46).

I quote Bryson not simply because he approves of what I do—he goes on to qualify his praise—but rather to show that I'm not alone in regarding my work as nonformalist in orientation. On the concept of form in art-historical writing see David Summers, "'Form,' Nineteenth-Century Metaphysics, and the Problem of Art Historical Description," *Critical Inquiry* 15 (Winter 1989):372–406.

58. Another major art critic of the period, Théophile Thoré, might also be cited in this connection. "Allegory is so inherent in true art," Thoré writes in 1845,

that the most spontaneous painters, devoted solely to the image, without concern for any underlying thought, sometimes make paintings in which reflection discovers symbolic poems and analogies that the author never suspected. I have often seen artists wholly surprised by critics' explanations of their work. They respond that they scoff at symbols and that art is an unreflective impulse that doesn't have to be conscious of its reason. Raphael and Poussin wouldn't have said this. But let's accept our painters as they are today. It isn't their fault if philosophy and thought have been proscribed by bourgeois society; and, after all, what does the procedure matter, if the result satisfies the conditions of art? ("A Béranger," preface to his "Salon de 1845," in *Salons de T. Thoré,* p. 105).

L'allégorie est tellement inhérente à l'art véritable, que les peintres les plus spontanés, dévoués seulement à l'image, sans préoccupation de la pensée qui est dessous, font quelquefois des tableaux où la réflexion découvre des poëmes symboliques et des analogies que l'auteur n'a pas soupçonnés. J'ai vu souvent des artistes bien surpris des explications que la critique donnait de leurs ouvrages. Ils disent à cela qu'ils se moquent du symbole, et que l'art est un entraînement irréfléchi, qui n'est pas forcé d'avoir conscience de sa raison. Raphaël et le Poussin n'en disaient pas autant. Main prenons les peintres comme ils sont aujourd'hui. Ce n'est pas leur faute si la philosophie et la pensée ont été proscrites de la société bourgeoise; et, après tout, qu'importe le procédé, si le résultat satisfait aux conditions de l'art?

59. For references to writings by Merleau-Ponty and others see chapter two, n. 7.

60. Maurice Merleau-Ponty, "Cézanne's Doubt," in *Sense and Non-Sense,* trans. Hubert L. Dreyfus and Patricia Allen Dreyfus (Evanston: Northwestern University Press, 1964), pp. 9–25.

61. The continual thematization in Whitman's poems of both the writer's and the reader's embodiedness has been noted by all his modern commentators, but we still lack a truly powerful reading of his work from that perspective. Evocations of embodiedness also figure prominently in Millet's paintings, in which the depiction of absorption in work-related bodily states, including physical exhaustion, largely displaces traditional absorptive themes and motifs. Some remarks by Millet to Sensier are suggestive here. On his first visit to the Louvre in his early twenties, Millet recalls, he was struck by a drawing by Michelangelo of a fainting man:

the expression of his slack muscles, the planes of his body, the modeling of that figure collapsed under physical suffering, gave me a whole series of impressions; I felt wracked with pain just as he did. I pitied him. I suffered in [or from: the preposition is ambiguous] that same body, in [or from] those same limbs (Sensier, *Millet,* p. 53).

l'expression des muscles détendus, les méplats, les modelés de cette figure affaissée sous la souffrance physique, me donnèrent toute une série d'impressions; je me sentais comme lui supplicié par le mal. J'avais pitié de lui. Je souffrais de ce même corps, de ces mêmes membres.

Clearly Millet would have welcomed—probably he sought to elicit—comparable responses of identification with his own paintings. An artist of an earlier generation whose work engages with issues of embodiedness is—as we have seen—Géricault. And before Géricault both Greuze and David in different ways mark crucial stages in the emergence of the body as *the* expressive vehicle par excellence.

See in this general connection Elaine Scarry's fascinating discussion of Marx's *Capital* in *The Body in Pain: The Making and Unmaking of the World* (New York and Oxford: Oxford University Press, 1985), pp. 243–77, to which I refer in chapter seven, and her "Work and the Body in Hardy and Other Nineteenth-Century Novelists," *Representations,* no. 3 (Summer 1983):90–123. On Gustave Flaubert, who will also turn up in chapter seven, see for example Jean Starobinski, "L'Échelle des températures: Lecture du corps dans *Madame Bovary,*" in *Travail de Flaubert,* ed. Gérard Genette and Tzvetan Todorov (Paris: Editions du Seuil, 1983), pp. 45–78. There are also suggestive remarks throughout Theodor Adorno, *In Search of Wagner,* trans. Rodney Livingstone (London: Verso, 1984), including the claim that "[Wagner's] music is conceived in terms of the gesture of striking a blow and that the whole idea of beating is fundamental to it" (p. 30) and the statement further on that "[t]here is indeed something in the idea that Wagner's orchestration is inseparable from the idea of the human body" (p. 79). (Adorno also says that "Wagner's talent was primarily theatrical rather than dramatic" [p. 59].)

62. See Michel Foucault, *Discipline and Punish: The Birth of the Prison,* trans. Alan Sheridan (New York: Pantheon, 1977); idem, *The History of Sexuality. Volume I: An Introduction,* trans. Robert Hurley (New York: Pantheon, 1978); and idem, *Power/Knowledge: Selected Interviews and Other Writings, 1972-1977,* ed. Colin Gordon (New York: Pantheon, 1980).

In the somewhat different language of Jean-Pierre Vernant, the body is "an entirely problematic notion, a historical category, steeped in imagination (to use Le Goff's expression), and one which must, in every case, be deciphered within a particular culture by defining the functions it assumes and the forms it takes on within that culture" ("Dim Body, Dazzling Body," trans. Anne M. Wilson, in *Fragments for a History of the Human Body,* 3 vols., ed. Michel Feher with Ramona Naddaf and Nadia Tazi (New York: Zone, 1989), 1:20.

63. See Fried, *Realism, Writing, Disfiguration,* especially pp. 21–22, 78–89.

64. Michael Fried, "Art and Objecthood" first appeared in *Artforum* 5 (June 1967):12–23; reprint in *Minimal Art: A Critical Anthology,* ed. Gregory Battcock (New York: Dutton, 1968), pp. 116–47. See also Michael Fried, "Shape as Form: Frank Stella's New Paintings," *Artforum* 5 (Nov. 1966):18–27; reprint in *New York Painting and Sculpture: 1940-1970,* ed. Henry Geldzahler (New York: Dutton, 1969), pp. 403–25.

Chapter Two

1. Four exhibition catalogs contain information pertaining to the self-portraits: *Gustave Courbet (1819-1877),* introductory essay by Palma Bucarelli, biographical and other

notes by Hélène Toussaint (Rome: Villa Medici, Oct. 1969–Jan. 1970); *Autoportraits;* Toussaint; and *Courbet Reconsidered.* See also the article by Marie-Thérèse de Forges, "A Propos l'exposition 'Autoportraits de Courbet,'" *La Revue du Louvre et des Musées de France* 22 (1972):451–62.

2. The *Sculptor* is, however, treated as exemplary of Courbet's early work—specifically, it is cited to show "what a bad, and what an *ordinary,* painter Courbet was when he began"—by Clark, pp. 39–40.

3. Recent studies suggest that Courbet began work on the canvas that eventually became the *Wounded Man* around 1844; that the definitive composition was arrived at only in the late 1840s or early 1850s; and that the painting may have been touched up as late as 1854 (see all four exhibition catalogs cited in n. 1).

4. Nochlin, pp. 14–15.

5. It doesn't trouble me that this view is in implicit conflict with the well-known passage from Courbet's letter of 3 May 1854 to his patron Alfred Bruyas, in which several of the early self-portraits are characterized in highly charged moral and psychological terms. For one thing, Courbet tended to say to Bruyas the sorts of things he believed the latter wanted to hear. For another, even if Courbet's statement could be taken at face value (my claim is that it can't), we wouldn't be justified in allowing it to govern our reading of the self-portraits individually or as a group. And yet the passage in question has been used by historians in just that way. For the text of the letter see *Courbet à Montpellier,* pp. 124–25.

6. René Huyghe, "Courbet," in the exhibition catalog, *Gustave Courbet (1819–1877)* (Philadelphia: Museum of Art; Boston: Museum of Fine Arts, 1959–60). Huyghe makes this assertion by way of accounting for the fact, as he sees it, that "Courbet's essential, obsessive theme is sleep." He writes: "It seems as though Courbet, adoring the visible and the concrete, wished to place all nature on an equal footing, and to quench the spark of the spirit whenever it showed itself in a human being, so that nothing should disturb the worship of matter."

7. My reading of Courbet's self-portraits as evoking a sense of the painter's own embodiedness is indebted to the writings of philosophers and researchers associated with existential phenomenology. A principal aim of those thinkers has been to give an account of what it means that human beings are incarnate, that they inhabit bodies that are from the first orientated to and implicated in the physical world. And a major theme in the writings to which I allude is the essential unity or "interwovenness" of body and world as the latter is given to us in perception, a theme that, as I shall show, is relevant to Courbet's treatment of subjects other than himself. For this study, arguably the most important general work is Maurice Merleau-Ponty, *Phenomenology of Perception,* trans. Colin Smith (London: Routledge & Kegan Paul, 1962). Three shorter pieces by Merleau-Ponty that bear specifically on painting are "Indirect Language and the Voices of Silence," in *Signs,* trans. Richard C. McCleary (Evanston: Northwestern University Press, 1964), pp. 39–83; "Cézanne's Doubt"; and "Eye and Mind," trans. Carleton Dallery, in *The Primacy of Perception and Other Essays,* ed. James M. Edie (Evanston: Northwestern University Press, 1964), pp. 159–90. A helpful exposition of Merleau-Ponty's thought at different stages of its development is Gary Brent Madison, *The Phenomenology of Merleau-Ponty: A Search for the Limits of Consciousness* (Athens, Ohio: Ohio University Press, 1981). In their study of Michel Foucault, Dreyfus and Rabinow remark that "Foucault probably finds Merleau-Ponty's structural invariants too general to be useful in understanding the historical specificity of body-molding techniques. [I shall briefly discuss Foucault's later work in chapter seven.] Reading Merleau-Ponty one would never know that the body

has a front and a back and can only cope with what is in front of it, that bodies can move forward more easily than backwards, that there is normally a right/left asymmetry, and so on" (Hubert L. Dreyfus and Paul Rabinow, *Michel Foucault: Beyond Structuralism and Hermeneutics* [Chicago: University of Chicago Press, 1982], pp. 111–12). The importance to an understanding of Courbet's art of most if not all of the considerations just cited will become clear as we proceed.

Three useful collections of essays by various writers are *Essays in Phenomenology,* ed. Maurice Natanson (The Hague: Martinus Nijhoff, 1966); *Readings in Existential Phenomenology,* ed. Nathaniel Lawrence and Daniel O'Connor (Englewood Cliffs, N.J.: Prentice-Hall, 1967); and *The Philosophy of the Body: Rejections of Cartesian Dualism,* ed. Stuart F. Spicker (New York: Quadrangle/The New York Times Book Co., 1970). See also the pioneering book by Paul Schilder, *The Image and Appearance of the Human Body: Studies in the Constructive Energies of the Psyche* (1950; reprint, New York: International Universities Press, 1978).

8. On the impossibility of perceiving one's body as an object see Merleau-Ponty, *Phenomenology of Perception,* pp. 90–92 (quoted in part in n. 12 below).

9. *Autoportraits,* pp. 10–16. In the catalog for the retrospective exhibition of 1977–78, Toussaint questions the view that the *Country Siesta* immediately precedes or is contemporary with the "première composition" of the painting that eventually became the *Wounded Man,* suggesting instead that it should be seen as a record of that composition executed at the moment when the painting was decisively altered to its present form (Toussaint, cat. no. 136, p. 224).

10. In Huyghe's introductory essay in the exhibition catalog cited in n. 6 above. See also Aaron Sheon, "Courbet, French Realism, and the Discovery of the Unconscious," *Arts* 55 (Feb. 1981): 114–28.

11. The phrase "primordial presence," used in a somewhat different context, occurs in Merleau-Ponty, *Phenomenology of Perception,* p. 92. Merleau-Ponty also refers to "that quasi-stupor to which we are reduced when we really try to live at the level of sensation" (p. 215), and he distingushes bodily from external space in the following terms: "Bodily space can be distinguished from external space and envelop its parts instead of spreading them out, because it is the darkness needed in the theatre to show up the performance, *the background of somnolence* [my emphasis] against which the gesture and its aim stand out, the zone of not being *in front of which* precise beings, figures, and points can come to light" (pp. 100–101). On the significance of the upright posture see Erwin Straus, "The Upright Posture," in *Essays in Phenomenology,* pp. 164–92, and idem, "Born to See, Born to Behold," in *The Philosophy of the Body,* pp. 334–59. On sleep as a surrendering of control and certain analogies in sense experience, see Merleau-Ponty, *Phenomenology of Perception,* pp. 211–12.

12. See Merleau-Ponty, *Phenomenology of Perception,* pp. 90–92. These pages, crucial for his argument, read in part as follows:

[The permanence of my body] is not a permanence in the world, but a permanence from my point of view. To say that it is always near me, always there for me, is to say it is never really in front of me, that I cannot array it before my eyes, that it remains marginal to all my perceptions, that it is *with* me. It is true that external objects too never turn one of their sides to me without hiding the rest, but I can at least freely choose the side which they are to present to me. . . . [My body's] permanence near to me, its unvarying perspective are not a *de facto* necessity, since such necessity presupposes them: in order that my window may impose upon me a point of view of the church, it is necessary in the first place that my body should impose upon me one of the world; and the first necessity can be merely physical only in virtue of the fact that the second is metaphysical . . . In

other words, I observe external objects with my body, I handle them, examine them, walk round them, but my body itself is a thing which I do not observe: in order to be able to do so, I should need the use of a second body which itself would be unobservable. . . . My visual body is certainly an object as far as its parts far removed from my head are concerned, but as we come nearer to the eyes, it becomes divorced from objects, and reserves among them a quasi-space to which they have no access, and when I try to fill this void by recourse to the image in the mirror, it refers me back to an original of the body which is not out there among things, but in my own province, on this side of all things seen. . . . The presence and absence of external objects are only variations within a field of primordial presence, a perceptual domain over which my body exercises power. Not only is the permanence of my body not a particular case of that of objects, but furthermore the presentation of objects in perspective cannot be understood except through the resistance of my body to all variation of perspective. . . . Thus the permanence of one's own body, if only classical psychology had analysed it, might have led it to the body no longer conceived as an object of the world, but as our means of communication with it, to the world no longer conceived as a collection of determinate objects, but as the horizon latent in all our experience and itself ever-present and anterior to every determining thought.

13. Paris, Louvre, Cabinet des dessins, RF 29234, fol. 23. Cited and briefly discussed in *Autoportraits,* cat. no. 9, pp. 12–13.

14. It's as though the hand were striving to feel what Sartre has described as "that famous 'sensation of effort' of Maine de Biran," by which would be revealed to the sitter not merely "the resistance of objects, their hardness or softness, but . . . the hand *itself*" (Jean-Paul Sartre, *Being and Nothingness,* trans. Hazel E. Barnes [New York: Philosophical Library, 1956], p. 304). Sartre argues that the "sensation of effort" does not exist, i.e., that one can see one's hand touching objects but not know it in its act of touching them, or, as he goes on to assert, "The body is lived and not *known*" (p. 324), but neither the distinction nor the arguments by which he tries to prove its validity need concern us here. More interesting is the allusion to Maine de Biran, especially in light of the connection I shall propose in chapter five between Courbet's paintings and the writings of a philosopher who stands in the tradition of Biran, Félix Ravaisson.

15. See for example the photograph by Etienne Carjat of Courbet painting the *Death of the Stag* (fig. 70); Francis Wey's account of visiting Courbet while the latter was working on the *After Dinner at Ornans* (Courthion 2:184–85); the self-portrait at the center of the *Painter's Studio,* to be discussed at length in chapter five (pl. 7); and the Fogg Art Museum drawing of the *Painter at His Easel,* to be discussed in connection with the *After Dinner* in chapter three (fig. 45).

16. Théophile Silvestre, "Courbet d'après nature," in Courthion 1:44. (Il rêve de lui-même en fumant la pipe.)

17. For example, a drawing in the Fogg Art Museum, which I cite in chapter three (fig. 50); an early painting, the *Draughts Players,* also discussed in that chapter (fig. 46); and the superb drawing in the Wadsworth Atheneum (*Autoportraits,* cat. no. 45).

18. According to Champfleury, shortly before the end of a visit to Germany Courbet was asked by a group of artists for a token of his having been there and complied by painting a portrait of his pipe with the signature: "COURBET, sans idéal et sans religion" (*Souvenirs et portraits de jeunesse* [Paris: E. Dentu, 1872], p. 179). Champfleury gives no date for this anecdote, but Riat, writing much later, places it in 1869 (p. 274). Fernier, however, observes that the lone extant painting of a pipe is dated 1858 and concludes that it was actually made on an earlier visit to Germany than the one to which Riat refers (Fernier, vol. 1, cat. no. 234).

19. Cf. Nochlin, p. 51:

One is particularly aware of the difficulties in the left hand (actually Courbet's right or "painting" hand in this self-portrait), which, seen in reverse, is the one that holds the bow. Courbet seems to have been unable to make the transformation of the actual reflected image of his hand manipulating the brush on the canvas into the imaginary one of the cellist's hand manipulating the bow on the strings of the instrument which his painting required.

20. A scalpel (in Eakins's *Gross Clinic*) is read as a figure for the painter's brush and blood as a figure for paint in Fried, *Realism, Writing, Disfiguration*, pp. 88–89.

21. Quite apart from the matter of orientation relative to the picture space, both sitting and lying down involve a yielding to the demands of gravity as well as an experience of physical pressure—of the seat and back of the chair, of the ground or bed—against sizable portions of the body. In general it is as though the upright posture as such were in conflict with Courbet's aims, in part because, as Straus has argued in the essays cited in n. 11, there exists a functional connection between that posture and beholding. In his words: "Sight the animal has in common with man, but in the upright posture seeing is transformed into beholding" ("Born to See, Born to Behold," p. 339).

## Chapter Three

1. The claim that the bearded figure depicts Cuenot and not Courbet was first made by Marie-Thérèse de Forges in *Autoportraits*, p. 43, and has been supported by Toussaint, cat. no. 18, pp. 94–95, and Mainzer, pp. 24–25. Courbet's description of the scene is quoted and briefly discussed below, p. 00.

2. Quoted by Francis Wey, "Notre maître peintre Gustave Courbet," in Courthion 2:186–87. ("Avez-vous jamais vu rien de pareil ni d'aussi fort sans relever de personne? Voilà un novateur, un révolutionnaire, aussi, il éclot tout à coup, sans précédent: c'est un inconnu.")

3. Clark, p. 72. See also Nochlin, pp. 64–65; and Linda Nochlin, "Innovation and Tradition in Courbet's *Burial at Ornans*" (1965), in *Courbet in Perspective*, ed. Petra ten-Doesschate Chu (Englewood Cliffs, N.J.: Prentice-Hall, 1977), pp. 74–87. Admiration of Courbet for composing in a resolutely antiacademic manner goes back at least to Champfleury (see Nochlin, "Innovation and Tradition," pp. 82, 84). The traditional association of Courbet's Realism with additive composition fits nicely with Jakobson's observations on the predominance of metonymic over metaphoric structures in realist art and literature (see Roman Jakobson, "Two Aspects of Language and Two Types of Aphasic Disturbances," in Roman Jakobson and Morris Halle, *Fundamentals of Language* [The Hague and Paris: Mouton, 1975], p. 92). As I suggested in chapter one, I seek in this book to reverse that emphasis as far as Courbet is concerned, or at any rate to show the extent to which metaphoric structures undergird ostensibly metonymic ones in his art.

4. Nochlin specifically compares the figures of Marlet and Cuenot in the *After Dinner* with those of the apostle at the left and Christ in the *Supper at Emmaus* (pp. 61–62). See also Clark, p. 72. On the La Caze collection see Sylvie Béguin, "Hommage à Louis La Caze (1798–1869)," *Revue du Louvre et des Musées de France* 19, no. 2 (1969):115–32.

5. See Nochlin, pp. 62–63, as well as Clark, who writes: "From the Le Nain [Courbet] took a certain gravity of tone and ruthless simplicity of arrangement, with the figures placed casually across the picture surface, each one 'added' to the next without any transitions of gesture or linking of pose" (p. 72). The classic article on the Le Nain-Champfleury-Courbet connection is Stanley Meltzoff, "The Revival of the Le Nains," *Art Bulletin* 24 (1942):259–86. On the *Peasants' Meal* see the entry in *Les Frères Le Nain*,

exhibition catalog (Paris: Grand Palais, 3 Oct. 1978–8 Jan. 1979), cat. no. 28, pp. 180–83.

6. Toussaint, pp. 95–96.

7. I find the Caravaggio connection unpersuasive in part because it assumes that Courbet adapted to his own altogether different purposes a dramatic composition that he could have known only at secondhand and of which (as we shall see) he had no need. By the same token, I shall be proposing other sources than the *Supper at Emmaus* for the figure of Marlet and indeed for the entire composition of the *After Dinner*. As for the *Peasants' Meal*, precisely when it entered La Caze's collection remains unclear; but the fact that it isn't cited in Champfleury's *Essai sur la vie et l'oeuvre des Lenain, peintres Laonnais* (1850) suggests a date in the 1850s (see the bibliography on that painting in *Les Frères Le Nain*, p. 182). In any case, Courbet would surely have known and admired other works by the Le Nains, and there is ample evidence of his admiration for Rembrandt throughout the mid- and late 1840s.

8. The illustration, a lithograph by Forest after a drawing by Lorentz, accompanies a short prose satire by Lorentz, "La Jérusalem des livrées"; satire and illustration take up the first page of the 19 February 1848 issue. *Le Journal pour rire* was edited by Charles Philipon, who previously had launched *La Caricature* and *Le Charivari;* 14,000 copies of each issue were printed, and there were 8,000 subscribers (see Jean Prinet and Antoinette Dilasser, *Nadar* [Paris: Armand Colin, 1966], p. 58). Its politics were anti-Bonapartist, but the Left was ridiculed as well; see for example the drawing by Bertall, "La Foire aux idées," in the 14 October 1848 issue.

9. For an interesting analysis of a different but not unrelated family of structures, see David Summers, "*Figure come Fratelli:* A Transformation of Symmetry in Renaissance Painting," *Art Quarterly*, n.s. 1 (Autumn 1977):59–88.

10. Traditionally, of course, scholars have emphasized Courbet's interest in *images d'Epinal* and other popular images of a provincial, folkloristic sort; see for example the pioneering essay by Meyer Schapiro, "Courbet and Popular Imagery: An Essay on Realism and Naïveté" (1941), in *Modern Art: Nineteenth and Twentieth Centuries, Selected Papers* (New York: Braziller, 1978), pp. 47–85. In contrast, the *Journal pour rire*-type of popular image was the product of Parisian illustrated journalism at its most sophisticated.

11. Cf. Jules Troubat, who knew Courbet in Montpellier in 1857, on the painter's notorious penchant for singing unrhymed Franc-Comtois songs:

[T]he good nature, full of refinement, *above all the rhythm with which he sang them and which was his invention,* the liveliness with which he repeated the refrains, gave them something completely original and untranslatable. It was the despair of musicians who tried to notate them. Nothing was less naive than these musical compositions, . . . so simple in appearance: *they were on the contrary the most composite,* which is not to say that Courbet would have been a great musician, any more than a great sculptor, as he one day had the pretension of being (*Plume et pinceau. Etude de littérature et d'art* [Paris, 1878], quoted by Philippe Bordes, "Montpellier, Bruyas et Courbet," in *Courbet à Montpellier,* p. 33; emphasis added).

Mais la bonhomie, pleine de finesse, le rythme surtout sur lequel il les chantait et qui était de son invention, l'entrain qu'il y mettait en répétant les refrains, en faisaient quelque chose de tout à fait original et d'intraduisible. C'était le désespoir des musiciens qui ont essayé de les noter. Rien n'était moins naïf que ces compositions musicales, sortes de tyroliennes franc-comtoises, d'apparence si simples: elles étaient au contraire des plus composites, ce qui ne veut pas dire que Courbet eût pu être un grand musicien, pas plus qu'un grand statuaire, comme il en a eu un jour la prétention.

12. Lemud was born in 1816 and died in 1887. On Lemud's career see Henri Beraldi, *Les Graveurs du XIXe siècle,* 12 vols. (Noyent-le-Roi: LAME, 1881), 9:118–22.

13. According to Beraldi: "Nul adjectif n'est de trop pour qualifier le succès de son *Maître Wolframb* (1839) [sic], succès qui restera fameux dans les annales de l'estampe; il fut instantané, énorme, prodigieux" (ibid., p. 119). In his *Histoire de Murger* Nadar recalls that "tout jeune France était tenu d'accrocher au mur de sa chambre, comme le prévot d'espadon son brevet, une lithographie sentimentale et surtout prétentieuse— *Maître Wolfram*—dont le principal mérite consistait en un travail de pointe alors nouveau en lithographie" (quoted by Prinet and Dilasser, *Nadar,* pp. 17–18).

14. Paris, Louvre, Cabinet des dessins, RF 29234, fol. 7 (verso). The connection is made by Nochlin, p. 59, n. 1.

15. As suggested by Forges, *Autoportraits,* p. 24.

16. The Brasserie Andler drawing is associated with the *After Dinner* by Margaret Stuffmann, "Courbet Zeichnungen," in *Courbet und Deutschland,* cat. no. 311, pp. 340–42. Stuffmann finds in the drawing and the painting contrasting representations of Courbet's Parisian and Franc-Comtois milieux respectively. For a good account of the atmosphere and clientele at the Brasserie Andler see Lindsay, pp. 40–44. Clark suggests that the Brasserie Andler drawing belongs to "a Bohemian series, with its own coherence within Courbet's work" (p. 44).

17. As was remarked in chapter two, the *Painter at His Easel* is one of two self-portraits, the other being the *Cellist* of the same year, in which Courbet's reliance on a mirror resulted in a reversal of right and left that remains a source of discomfort. Note especially how in the Fogg drawing the painter's right hand ("actually" his left) is surrounded by a dark, rounded shape that seems too large to be a cuff of his sleeve and suggests instead the silhouette of a palette.

18. In a recent essay, "Courbet's *Joueurs de dames* and 'La Vie de Bohème,'" *Gazette des Beaux-Arts,* ser. 6, 112 (Dec. 1988):276–80, Elisabeth L. Roark cites the resemblance between the figure on the left in the *Draughts Players* and an undated portrait of Alexandre Schanne by Léon Dehaisne, and persuasively suggests that the figure in question actually represents Schanne, with whom Courbet was acquainted. Schanne was the prototype for the character Schaunard in Henry Murger's *Scènes de la vie de Bohème;* his own memoirs, *Les Souvenirs de Schaunard* (Paris: Charpentier, 1887), include brief reminiscences of the Realist circle at the Brasserie Andler. See also William Hauptman, "Grosclaude and Courbet's *L'Après-dînée à Ornans* of 1849," *Gazette des Beaux-Arts,* ser. 6, 105 (Mar. 1985):117–21, where it is argued that the left-hand (or "Schanne") figure in the *Draughts Players* was based on the leftmost of four figures in Louis-Aimé Grosclaude's *Toasting the Grape Harvest of 1834,* which Courbet could have seen in the Musée du Luxembourg from 1842 on. This seems possible, though what Hauptman describes as "the unusual perspective of the head from below and tilting into the composition" of Grosclaude's figure would have had ample precedents and parallels in Courbet's own early work (p. 118). In any case, his further proposal that the right-hand figure in the *Draughts Players* may be seen as a variation on a laughing figure who looks out at the beholder in Grosclaude's painting is unconvincing. Nor does it seem likely, as he also suggests, that *Toasting the Grape Harvest of 1834* could have played more than the most tenuous role in the conception of the *After Dinner* itself.

19. The *Draughts Players* might even be said to contain a precedent for the figure of Cuenot in the *After Dinner*—the plaster cast of a Michelangelesque *écorché* on the shelf between the two men (I am thinking of the rough analogy between the tilt of the head and the action of the lower hand in both). The same cast was soon to reappear in the *Man with the Leather Belt,* where it functions—so I have argued—as a surrogate for the artist-sitter. Cf. in this connection another early self-portrait, the *Desperate Man.*

20. Wey describes Courbet seating himself again before his painting after wordlessly greeting Champfleury and Wey on their arrival at his studio ("Notre maître peintre Gustave Courbet," in Courthion 2:184). (Il se remit à son escabeau devant une toile que je démasquai en passant derrière l'artiste.)

21. Quoted in Toussaint, p. 94. (C'était au mois de novembre, nous étions chez notre ami Cuenot, Marlait revenait de la chasse et nous avions engagé Promayet à jouer du violon devant mon père.)

22. Quoted in English in Lindsay, p. 59; I have adapted Lindsay's translation.

J'avais pris notre voiture, j'allais au Château de Saint-Denis faire un paysage; proche de Maisières, je m'arrête pour considérer deux hommes cassant des pierres sur la route. Il est rare de rencontrer l'expression la plus complète de la misère, aussi sur-le-champ m'advint-il un tableau. Je leur donne rendez-vous pour le lendemain dans mon atelier, et depuis ce temps j'ai fait mon tableau. Il est de la même grandeur que la *Soirée à Ornans*. Voulez-vous que je vous en fasse la description? . . . Là est un vieillard de soixante et dix ans, courbé sur son travail, la masse en l'air, les chairs hâlées par le soleil, sa tête à l'ombre d'un chapeau de paille; son pantalon de rude étoffe est tout rapiécé; puis dans ses sabots fêlés, des bas qui furent bleus laissent voir les talons. Ici, c'est un jeune homme à la tête poussiéreuse, au teint bis; la chemise dégoûtante et en lambeaux lui laisse voir les flancs et les bras; une bretelle en cuir retient les restes d'un pantalon, et les souliers de cuir boueux rient tristement de bien des côtés. Le vieillard est à genoux, le jeune homme est derrière lui, debout, portant avec énergie un panier de pierres cassées. Hélas! dans cet état, c'est ainsi qu'on commence, c'est ainsi qu'on finit! Par-ci par-là est dispersé leur attirail: une hotte, un brancard, un fossoir, une marmite de campagne, etc. Tout cela se passe au grand soleil, en pleine campagne, au bord du fossé d'une route; le paysage remplit la toile (Courthion 2:75–76).

23. For a discussion of the *Stonebreakers* and related paintings and drawings see Michael Nungesser, "Die Steinklopfer," in *Courbet und Deutschland*, pp. 560–73.

24. The exception is Robert L. Herbert, "City vs. Country: The Rural Image in French Painting from Millet to Gauguin," *Artforum* 8 (Feb. 1970):44–55. Herbert proposes that the figures of the young and the old stonebreakers are modeled, respectively, on Millet's *Winnower* (1848) and the kneeling shepherd in Poussin's *Arcadian Shepherds* in the Louvre (p. 46). Herbert may be on to something, though once again I shall argue that the deepest sources of Courbet's figures lie closer to home.

25. See for example Nochlin, pp. 146–50, and Linda Nochlin, *Realism* (Harmondsworth and Baltimore: Penguin Books, 1971), pp. 117–21.

26. Schapiro, "Courbet and Popular Imagery," p. 49. See also Nochlin, pp. 150–54, and Clark, p. 80.

27. "The two stonebreakers are utterly unrelated to each other in terms of pose or gesture; there is no possibility of reading a narrative meaning into their conjunction" (Nochlin, p. 150). See also Nungesser, "Die Steinklopfer," p. 563.

28. Clark, p. 178. See also Nochlin, pp. 146–47. According to Mainzer, however, the "original" of the old stonebreaker, Claude-François Gagey, was not in fact a destitute laborer, as had previously been assumed, but rather a local farmer who took advantage of a law that allowed individuals to substitute road work for certain local taxes (pp. 27–29). This in itself by no means invalidates Courbet's statement to Wey that the scene he encountered on the road near Maisières represented "the most complete expression of poverty," but if in fact Gagey wasn't impoverished it does at least call into question the proposition that Courbet would have felt himself literally distanced from the two stonebreakers for reasons of class. Jean-Luc Mayaud, on the other hand, sees in Gagey "an old man of 68, forced to sell his labor power to avoid indigence, [who incarnates] the poverty of the rural world that knew neither retirement nor pension" ("Courbet, peintre

de notables à l'enterrement . . . de la République," in *Ornans à l'Enterrement. Tableau historique de figures humaines,* exhibition catalog [Ornans: Musée Départemental Maison Natale Gustave Courbet, 13 June–1 Nov. 1981], p. 65).

29. See Nochlin, pp. 149–50, and Nungesser, "Die Steinklopfer," p. 563. Note the strong shadows cast by the two figures, which, in the old photographs that are all we have to go on, appear almost to lie on the surface of the painting.

30. For some acute remarks on the apparent self-sufficiency of individual figures in Courbet, not centered on the *Stonebreakers* but germane to it, see Kermit S. Champa, "Gustave Courbet: The 1977–78 Retrospective Exhibition," *Arts* 52 (Apr. 1978): 101–2.

31. See Clark, p. 80.

32. Buchon said this in an *annonce* for Courbet's June 1850 exhibition in Dijon; it is quoted in its entirety in Clark, pp. 162–63 (soulevant un marteau casseur avec toute la précision automatique que donne une longue habitude).

33. The same angle recurs in other works as well (e.g., the distaff in the *Sleeping Spinner,* the kneeling sifter in the *Wheat Sifters,* the standing bather in the *Bathers*). For more on angles and obliqueness in Courbet's paintings see my discussion of what I call "lateralization" in chapter four.

34. Courthion 2:75 (see n. 22 above).

35. On the determining force of names (the title of a short article by Karl Abraham), see for example Jacques Derrida, *Glas* (Paris: Editions Galilee, 1974); idem, *Signeponge/ Signsponge,* trans. Richard Rand (New York: Columbia University Press, 1984); Ronald Paulson, "Turner's Graffiti: The Sun and Its Glosses," in *Images of Romanticism: Verbal and Visual Affinities,* ed. Karl Kroeber and William Walling (New Haven: Yale University Press, 1978), pp. 167–88; Jean Starobinski, *Words upon Words: The Anagrams of Ferdinand de Saussure,* trans. Olivia Emmet (New Haven: Yale University Press, 1979); Geoffrey H. Hartman, *Saving the Text: Literature/Derrida/Philosophy* (Baltimore: Johns Hopkins University Press, 1981), pp. 96–117, where Abraham's article is cited; Joel Fineman, "The Significance of Literature: *The Importance of Being Earnest,*" *October,* no. 15 (Winter 1980): 79–90; and idem, *Shakespeare's Perjured Eye: The Invention of Poetic Subjectivity in the Sonnets* (Berkeley: University of California Press, 1986). In Derrida's formulation: "The grand stakes of discourse (I mean *discourse*) that is literary: the patient, tricky, quasi animalistic or vegetative transformation, unwearying, monumental, derisive also, but turning derision rather against itself—the transformation of the proper name, *rebus,* into things, into the name of things" (*Glas,* p. 11, quoted in translation by Hartman, *Saving the Text,* p. 102). More recently, Sidney Geist has argued that Cézanne's paintings are full of rebus-like references to his given and family names in *Interpreting Cézanne* (Cambridge and London: Harvard University Press, 1988).

For more on signatures in painting see the articles by Andre Chastel, Jean-Claude Lebensztejn, and others gathered under the general rubric of "L'Art de la signature," *Revue de l'Art* 26 (1974); and Claude Gandelman, "The Semiotics of Signatures in Painting: A Peircian Analysis," *American Journal of Semiotics* 3, no. 3 (1985):73–108.

36. Quoted in translation by Lindsay, p. 192. (Cher et grand Poète, Vous l'avez dit, j'ai l'indépendance féroce du montagnard; on pourra je crois mettre hardiment sur ma tombe, comme dit l'ami Buchon: *Courbet sans courbettes* [Courthion 1:99].) Lindsay acutely adds in a footnote: "C. may well have been affected by the sound [sic] his own name (suggesting to bend or bow) and have resolved not to bend" (p. 358).

37. Cited without references by Georges Grimmer, "L'Exposition Courbet de 1855," *Les Amis de Gustave Courbet, Bulletin,* no. 15 (1955):10.

38. For an analysis of the dissemination of the writer Stephen Crane's initials as well as aspects of his material signature throughout his texts, see Fried, *Realism, Writing, Disfiguration,* pp. 124–26, 128, 136, 140, 142, 147–50, 155, and 161. See also Derrida, *Signeponge/Signsponge.*

39. In Bertall's contemporary caricature of the *Burial,* the signature takes up most of the lower left-hand quadrant of the image (reproduced in Toussaint, p. 103).

40. I'm therefore in basic disagreement with Nochlin's claim that "[an] insistence on catching the present moment in art . . . is an essential aspect of the Realist conception of the nature of time. Realist motion is always motion captured as it is 'now,' as it is perceived in a flash of vision" (*Realism,* pp. 28–29).

41. Thus the sculptor Max Claudet quotes Courbet in 1864 as saying apropos a picture of the *Source of the Lison* on which he was working: "You are astonished that my canvas [i.e., the underpainting] is black. However, nature, without the sun, is black and dark; I do what the light does; I illuminate the prominent points, and the painting is done" (cited by Riat, pp. 218–19). (Vous vous étonnez que ma toile soit noire. Cependant, la nature, sans le soleil, est noire et obscure; je fais comme la lumière; j'éclaire les points saillants, et le tableau est fait.)

42. The evocation of sound in painting is briefly discussed by Wollheim, *Painting As an Art,* p. 315. See also Cavell, *The World Viewed,* chap. 19, "The Acknowledgment of Silence," pp. 146–60.

## Chapter Four

1. I give the subtitle in French because any translation would distort it fundamentally. In particular, the word *tableau* as it is used here almost certainly is meant to carry connotations of an achieved unity that the English words "painting" or "picture" simply lack (see chapter seven, pp. 234–38); similarly, the adjective *historique* evokes the traditional concept of history painting, even as the curious opening phrase, *Tableau de figures humaines,* seems to acknowledge a certain distance from the standard phrases *tableau d'histoire* or *tableau historique.* As will emerge in chapter seven, contemporary critics specifically denied that Courbet's paintings deserved to be called *tableaux.*

2. Toussaint, p. 99. For a detailed account of the establishment of the new cemetery see Mainzer, pp. 49–74; and idem, "Une histoire de cimetière," in *Ornans à l'Enterrement,* pp. 11–23. The most reliable and knowledgable identifications of the various participants in the *Burial* we now have are those by Mainzer, pp. 75–116, and Mayaud, "Courbet, peintre de notables," pp. 40–76.

3. See for example Mack, *Courbet,* p. 77; and James C. McCarthy, "Courbet's Ideological Contradictions and the *Burial at Ornans,*" *Art Journal* 35 (Fall 1975):13–14.

4. Mainzer, pp. 117–25. Mainzer recalls that, according to Champfleury, Courbet was in Ornans in September 1848 and regards it as likely that he attended Teste's funeral (p. 119). From her analysis of the family relations among the persons represented in the *Burial* she concludes that rather than depicting a cross section of Ornans society, the painting "portrays something more akin to a clan" (pp. 120–21).

5. Lindsay, p. 61.

6. Charles Rosen and Henri Zerner, *Romanticism and Realism: The Mythology of Nineteenth-Century Art* (New York: Viking, 1984), p. 165. For the authors, the historical significance of Courbet's painting resides chiefly in what they take to be its devaluation of subject matter and its concomitant emphasis on the materiality of painting. "There is nothing anecdotal about Courbet's *Burial at Ornans,*" they assure their readers.

"[W]e do not know who is being buried and we would not be one hairsbreadth closer to understanding the picture if that question could be answered" (ibid.). More broadly, for Rosen and Zerner "the Realist movement in painting appears as an initial move toward abstract art" (p. 150), a statement that, in the spirit in which they mean it, is misleading with respect both to Realism and to abstraction. I have more to say about their views in chapter seven.

7. Nochlin, p. 149. The remarks in question refer specifically to the *Stonebreakers* but are consistent with her account of Courbet's breakthrough pictures generally.

8. Clark, p. 82.

9. Schapiro, "Courbet and Popular Imagery," pp. 49–52. In the same essay Schapiro observes: "The seemingly regressive tendencies of the looser and more static compositions of Courbet are bound up with unprimitive conceptions of a new coloristic, tonal and material unity of the painting that prepare the way for impressionism" (p. 67).

10. Nochlin, *Realism,* p. 48. The key passage reads:

A reflection of the social ideals of 1848 could be seen in the very pictorial structure of such a work as the *Burial at Ornans.* By its seemingly casual and fortuitous arrangement—without beginning, middle or end—by its lack of selectivity and hence its implied rejection of any accepted hierarchy of values, by its uniform richness of detail which tends to give an equal emphasis to every element and thus produces, as it were, a pictorial democracy, a compositional *égalitarisme,* by its simplicity, awkwardness and lack of all Establishment rhetoric, it could be seen as a paradigm for the *quarante-huitard* ideal itself. As exemplified in such works, both Realism and Democracy were expressions of the same naïve and stalwart confrontation of—and challenge to—the status quo.

See also Nochlin, "Innovation and Tradition," p. 80.

11. Nochlin, "Innovation and Tradition," p. 82. Nochlin cites Jakobson's distinction in *Realism,* p. 182, as does Clark, p. 183, n. 105.

12. Robert Fernier, "En marge de *l'Enterement d'Ornans*," *Les Amis de Gustave Courbet: Bulletin* 10 (1951):8–10; Nochlin, "Innovation and Tradition," pp. 84–85; and Clark, p. 81. Van der Helst's painting was first cited in connection with the *Burial* by Champfleury in an article of 1851, "L'Enterrement d'Ornans," reprinted in his *Grandes figures d'hier et d'aujourd'hui* (Paris: Poulet-Malassis et de Broise, 1861), p. 238.

13. Toussaint, p. 104; the full title of the painting often called *Meagre Company* is the *Corporalship of Captain Reynier Reael and Lieutenant Michielsz. Blaeuw.* No doubt Courbet was struck by Dutch group portraits during his visit to Amsterdam, and it's possible that the paintings by Van der Helst, de Keyser, and Hals made a strong impression on him. But I'm not persuaded by Nochlin's suggestion that the kneeling gravedigger in the *Burial* has been adapted from a figure in Van der Helst's canvas ("Innovation and Tradition," p. 85) and would argue that Courbet's canvas bears a general rather than a specific relation to its Dutch antecedents. All three pictures are illustrated in Riegl, *Das Holländische Gruppenporträt,* vol. 2, pls. 63, 51, 76 respectively.

14. See for example Nochlin, "Innovation and Tradition," p. 84; Clark, p. 81; and Toussaint, p. 104. It has also been suggested that there is a parallel between Courbet's mourning women in the *Burial* and the sculptured *pleurants* on fifteenth-century Burgundain tombs (Toussaint, p. 104; and Jean-Louis Ferrier, *Courbet, "Un Enterrement à Ornans"* [Paris: Denoel/Gonthier, 1980], pp. 37, 47–48).

15. In addition to Schapiro, "Courbet and Popular Imagery," see for example Nochlin, "Innovation and Tradition," p. 83, and Clark, p. 81. For Clark's most developed interpretation of Courbet's use of popular imagery see pp. 139–40, 156–61.

16. Champfleury, "L'Enterrement d'Ornans," p. 244. (L'effet est le même, parce que l'exécution est aussi simple. L'art savant trouve le même *accent* que l'art naïf.)

17. Charles Baudelaire, "Salon de 1846," in *Curiosités esthétiques,* p. 196.

Et cependant, n'a-t-il pas sa beauté et son charme indigène, cet habit tant victimé? N'est-il pas l'habit nécessaire de notre époque, souffrante et portant jusque sur ses épaules noires et maigres le symbole d'un deuil perpétuel? Remarquez bien que l'habit noir et la redingote ont non seulement leur beauté politique, qui est l'expression de l'égalité universelle, mais encore leur beauté poétique, qui est l'expression de l'âme publique;—une immense défilade de croque-morts, croque-morts politiques, croque-morts amoureux, croque-morts bourgeois. Nous célébrons tous quelque enterrement.

I have taken the English translation of this passage from Charles Baudelaire, *Art in Paris 1845–1862: Salons and Other Exhibitions,* ed. and trans. Jonathan Mayne (Ithaca: Cornell University Press, 1981), p. 118. Champfleury's article appeared in *L'Ordre,* 21 September 1850, and is cited in Abe, "*Un Enterrement à Ornans.*"

18. Cited in Abe, "*Un Enterrement à Ornans,*" p. 35.

19. In addition to Abe's article see the references in chapter one, n. 6.

20. Clark, p. 115.

21. Ibid.

22. Buchon quoted in ibid., p. 164 (. . . l'antithèse psychologique, le contre-poids; je dirais presque le vengeur). For the complete text of the *annonce* see pp. 162–64.

23. Ibid., p. 116. Buchon's *annonce* is viewed as more nearly indicative of the painter's intentions in an earlier two-part article by T. J. Clark, "A Bourgeois Dance of Death: Max Buchon on Courbet," *Burlington Magazine* 111 (Apr.-May 1969):208–12, 286–90. Cf. Lindsay, pp. 62–66.

24. Clark, p. 95.

25. Ibid., p. 83.

26. Clark follows tradition in identifying as Régis Courbet the figure in the rearmost row of mourners wearing a top hat and placed almost directly above the standing man weeping into a handkerchief and goes on to contrast that figure with the portrait of the elder Courbet wearing a worn blue smock, leggings, and stovepipe hat in the *Peasants of Flagey* (p. 114). The difference between the two portrayals, Clark implies, evokes an ambiguous class identity wavering between bourgeois and peasant. However, Toussaint notes that the mourner in question in no way resembles other representations of the elder Courbet and proposes instead that the latter is represented in the *Burial* by the bareheaded figure immediately to the left of the mourner with the handkerchief (p. 99). If Toussaint is right, and both Mayaud and Mainzer confirm that she is, this would mean that the contrast with respect to apparent social status between the respective portrayals of Régis Courbet in the *Burial* and the *Peasants of Flagey* would be much less striking than Clark finds it to be. See Mayaud, "Courbet, peintre de notables," p. 42; and Mainzer, p. 90.

27. As quoted in Clark, p. 163 (l'air de recueillement qui plane sur tout).

28. Elsewhere in his book, Clark calls attention to the diverse receptions given the *Stonebreakers* and *Burial* in Besançon, Dijon, and Paris in 1850–51. He argues that the *Burial* provoked intense hostility at the Salon chiefly because it gave the lie to a basic myth of contemporary bourgeois identity, a myth that drew a sharp distinction between Paris and the countryside and in particular denied that the latter too had a bourgeoisie (pp. 121–54). I find this line of reasoning unpersuasive, but what I want to emphasize is that here too Clark inserts the *Burial* whole, as an image of the rural bourgeoisie, in a

"second context . . . the implications it gained in the city." Of those implications Clark writes: "They were not *its* meaning, exactly; but they were not meanings it could wholly escape" (p. 128).

29. In this connection I will simply note the frequency with which we encounter paired or doubled personages, animals, and other entities (e.g., rocks, boats, divided caves, reflections in water, etc.) in Courbet's paintings, a feature of his art that works to diffuse rather than concentrate the viewer's attention. Cf. the *Peasants of Flagey* and the *Firemen Rushing to a Fire,* to be discussed later in this chapter.

30. The picture in question is in the Wilstach Collection of the Philadelphia Museum of Art under the title *View of Ornans.* Fernier includes it in his *Catalogue raisonné* under the title I have used but dates it far too late at 1868 (Fernier, vol. 2, cat. no. 638). Toussaint compares the picture to the Strasbourg and Minneapolis canvases and suggests a dating in the late 1840s, with which I concur; her remarks are made in a personal communication in the museum's files.

31. Fernier identifies this painting with one exhibited in the Salon of 1849 under the title *Vallée de la Loue, prise de la Roche-du-Mont* and bearing in the *livret* the further information that the village in the distance is Montgesoye (Fernier, vol. 1, cat. no. 104). Toussaint, however, questions this identification (cat. no. 23, p. 106), and in any case the village in the distance appears to be Ornans (cf. the *Castle of Ornans*).

32. See Steven Z. Levine, "Gustave Courbet in His Landscape," *Arts* 54 (Feb. 1980):67–69.

33. The *Castle of Ornans* is signed and dated 1855, which is when Fernier places it (Fernier, vol. 2, cat. no. 173). Once again Toussaint disagrees, arguing on the basis of style that the painting was made around 1849 and that the later date was added when Courbet exhibited the work at the Exposition Universelle of 1855 (cat. no. 22, pp. 105–6). I find Toussaint's reasoning persuasive and would add that Courbet may have retouched or perhaps even finished the *Castle of Ornans* in 1855, the foreground in particular giving the appearance of having been reworked. For an interesting discussion of the painting see Charles F. Stuckey, "Gustave Courbet's *Château d'Ornans,*" *Minneapolis Institute of Arts Bulletin* 60 (1971–73):27–37.

34. On Nadar's *Panthéon* lithographs see Prinet and Dilasser, *Nadar,* pp. 75–101. Courbet's *Painter's Studio* is associated with Nadar's *Panthéon* project, though not on visual grounds, by Benedict Nicolson, *Courbet: The Studio of the Painter* (London: Allen Lane, 1973), pp. 65–66.

35. In a discussion of Courbet's adaptation in *The Meeting* (1854) of a popular print of the Wandering Jew, Clark attaches great significance to the notion that the artist has exploited "another age's imagery of the bourgeoisie—an age which lived on in the art and attitudes of the people" (p. 159). He continues: "It is as if, to get the bourgeoisie in focus and place himself against it, Courbet needed to take the class back through time, to an age when it was part, not master, of the social body" (ibid.). I find this improbable on the face of it, but Clark's case is further weakened by the recognition that Courbet adapted an altogether different and emphatically contemporary sort of image to help depict the village bourgeoisie of the *Burial.*

36. Prinet and Dilasser cite as an example of an early composition *en cortège* Grandville's "Course au clocher académique" of 1844 (*Nadar,* p. 59).

37. It should be noted, however, that among several almost wholly vanished figures toward the rear of the *Burial* and immediately to the right of the crucifix is "[a] man with long hair who turns his back to the viewer and almost completely hides the face of [another]" (Mainzer, p. 84).

38. Rudolf Wittkower, *Art and Architecture in Italy, 1600–1750,* 2d ed. rev., Pelican History of Art (Harmondsworth and Baltimore: Penguin Books, 1965), p. 24.

39. Ibid. Writing of the same picture under the subhead "The Integration of Real and Fictive Space," John Rupert Martin says: "Caravaggio, in his *Supper at Emmaus,* relies on emphatic gestures which appear to thrust through the picture plane in order to persuade us that we are actually present at this unexpected intervention of divinity into the every-day world; even the basket of fruit is so placed at the very edge of the table that it seems in danger of falling at our feet" (*Baroque* [New York: Harper & Row, 1977], p. 157). Or in Howard Hibbard's more detailed account of the painting:

The left arm of the gesticulating disciple [earlier described as seeming "to cut through the picture plane"] unites the painted actors with us, the living viewers, in a manner that signals a new age of participatory art. The spectator is almost forced to take part in the painted religious drama. Manner-ist artists had long been toying with the illusion of continuity between spectator and painted scene, but in general these were tours de force that called attention to themselves as illusions rather than to the subjects and their meanings—indeed, the manner tends to become the meaning, the subject merely a motif. Caravaggio adapts Mannerist tradition only to the extent that he again seems to penetrate the picture plane, not as an exhibitionist but as a dramatist who seizes our attention in order to illuminate the meaning of the story within the frame (*Caravaggio* [New York: Harper & Row, 1983], pp. 77–78).

40. Of course, seventeenth-century illusionistic practice was extremely diverse and in no way limited to the particular mode I am here considering. Moreover, the *Supper At Emmaus* itself is perhaps somewhat more complex in its relation to the viewer than the remarks I have just quoted suggest (consider for example the overlarge size of the gestur-ing disciple's *right* hand, which calls into question the painting's internal illusionistic consistency). But overall the comparison I am about to make between the *Supper at Em-maus* (not however Caravaggio generally) and the *Burial* seems to me justified. For a subtle analysis of a remarkable seventeenth-century representation of burial see Leo Steinberg, "Guercino's *Saint Petronilla,*" *Studies in Italian Art History* (American Acad-emy in Rome), no. 1 (1980):207–34.

41. There is no contradiction between my emphasis on this point and the conspicu-ously large hand in the lower left corner of the sketchbook page discussed in chapter two (fig. 38) precisely because that hand is understood as belonging to the maker of the drawing. Similarly, the slightly overlarge right hand of the sitter in the *Man with the Leather Belt* doesn't belong to the immediate foreground, where in fact, as I have noted, illusionism is suppressed. Other paintings by Courbet in which foreground elements, often hands or feet, appear smaller than might be expected include the *Small Portrait of Courbet* (fig. 30), *Nude with White Stockings* (ca. 1861; fig. 77), and *Portrait of Jo* (1866; pl. 11). The same tendency is visible in some of his early drawings; see, for example, the study of a reclining man in the Louvre sketchbook to which I have already alluded (RF 29234, fol. 22 [verso]).

42. The letter is quoted in French by Clark, pp. 165–67. (Il faut être enragé pour travailler dans les conditions où je me trouve. Je travaille à l'aveuglette; je n'ai aucune reculée.)

43. Nochlin, "Innovation and Tradition," p. 85.

44. Just how resistant all this has been to being perceived, and for that matter just how reticent Courbet himself appears to have been about his art, is suggested by Champfleu-ry's comment in his article of 1851 that the gravedigger "is neither sad nor gay; the burial itself hardly concerns him; he didn't know the dead man. *His gaze strays to the horizon of the cemetery and is preoccupied with nature;* this gravedigger forever laboring on behalf of

death has never thought about death" ("L'Enterrement d'Ornans," p. 240; emphasis added). (Il n'est pas triste ni gai; l'enterrement ne l'occupe guère; il ne connaît pas le mort. Son regard court à l'horizon du cimetière et s'inquiète de la nature; ce fossoyer toujours travaillant pour le compte de la mort, jamais n'a pensé à la mort.) Inasmuch as Champfleury let the description stand when he reprinted the essay in 1861, it must be imagined that Courbet never took the trouble to explain himself on this simplest of levels.

45. The notion of a point of view isn't at all a neutral one with respect to Courbet. In chapter seven I emphasize the extent to which Courbet's Realism is inherently opposed to an esthetics (indeed to a metaphysics) of point of view. The *Burial* is thus exceptional in his oeuvre in its exploration of a structure based, as I am about to show, on the juxtaposition of two apparently separate points of view; but I shall also characterize one of the latter as a point of *no* view, and by the end of my account of the *Burial* I shall suggest that in crucial respects the two points of view are anything but stable and distinct.

46. Clark, p. 81.

47. Max Buchon was born in 1818 and died in 1869. Courbet and he were schoolmates at Ornans and Besançon, where they became fast friends; Buchon's first book of verse, published in 1839, included four lithographed illustrations by the aspiring painter. In the years that followed Buchon translated the German poet Hebel, wrote regional poetry of his own, and collected folktales and songs. His politics, which from the first inclined to the Left, became "radicalized" (Clark's word) by the Revolution of 1848, and within a few years he was in exile. On the relationship between Courbet and Buchon see Jules Troubat, *Une Amitié à la D'Arthez. Champfleury, Courbet, Max Buchon, suivi d'une conférence sur Sainte-Beuve* (Paris: L. Duc, 1900); Schapiro, "Courbet and Popular Imagery," pp. 54–55; Mack, *Courbet*, pp. 20–22, 51–52; and Clark, pp. 111–14. On Buchon in relation to Realism in art and literature see Bouvier, *La Bataille Réaliste*, pp. 183–99. Other references to works on Buchon are given by Mayaud, "Courbet, peintre de notables," p. 62.

48. See Emile Littré, ed., *Dictionnaire de la langue française*, 4 vols. (Paris: Hachette et Cie., 1885), 2:1889; and Paul Robert, ed., *Dictionnaire alphabétique et analogique de la langue française*, 9 vols., 2d ed. rev. and enlarged by Alain Rey (Montreal: Dictionnaires Le Robert, 1985), 4:972. My thanks to Herbert L. Kessler for helping me identify the implement in question. A passage in Emile Zola's short article of 5 May 1868, "'Le Camp des bourgeois' illustré par Gustave Courbet," may be pertinent here. The article is a review of Courbet's illustrations for his friend Etienne Baudry's book of that title and includes the following remarks, which I leave in the original French:

J'ouvre une parenthèse, pour y glisser un mot du maître [i.e., Courbet]. Un de mes amis l'entendait dernièrement donner une définition du talent d'un peintre accablé d'honneurs et de commandes, dont la peinture rose et blanche est un régal pour les personnes qui aiment les confitures. . . . "Vous voulez faire une Vénus pareille à celle de X . . . , n'est-ce pas?" disait Courbet. "Eh bien! vous peignez avec du miel une poupée sur votre toile; puis, vous emplissez *un goupillon de farine*, et, légèrement, vous *aspergez* la poupée. C'est fait" (Zola, *Mon Salon. Manet. Ecrits sur l'art* [Paris: Garnier-Flammarion, 1970], p. 176; emphasis added).

Cf. also the account of Emma's burial in *Madame Bovary*, which includes the following (here too I quote only the French):

On arriva.
Les hommes continuèrent jusqu'en bas, à une place dans le gazon où la fosse était creusée.
On se rangea tout autour; et, tandis que le prêtre parlait, la terre rouge, rejetée sur les bords, coulait par les coins, sans bruit, continuellement.

Puis, quand les quatre cordes furent disposées, on poussa la bière dessus. Il la regarda descendre. Elle descendait toujours.

Enfin, on entendit un choc; les cordes in grinçant remontèrent. *Alors Bournisien prit la bêche que lui tendait Lestiboudois; de sa main gauche, tout en aspergeant de la droite, il poussa vigoureusement une large pelletée;* et le bois du cercueil, heurté par les cailloux, fit ce bruit formidable qui nous semble être le retentissement de l'éternité.

*L'ecclésiastique passa le goupillon à son voisin. C'était M. Homais. Il le secoua gravement, puis le tendit à Charles,* qui s'affaissa jusqu'aux genoux dans la terre, et il en jetait à pleines mains tout en criant: "Adieu!" Il lui envoyait des baisers; il se traînait vers la fosse pour s'y engloutir avec elle (Gustave Flaubert, *Madame Bovary* [Paris: Gallimard, Collection Folio, 1972], p. 428; emphasis added).

The entire scene alludes broadly to Courbet's *Burial;* what I want to emphasize is Flaubert's representation of the *goupillon* in action and in particular the moment in his account when it is wielded together with a spade or shovel (*la bêche*). It may also be relevant to my final reading of the *Burial* that, if the passage in *Madame Bovary* is a reliable guide to the ceremony depicted in Courbet's painting, the *goupillon* will be shaken by more than one figure in the group around the grave.

49. By virtue of its shape and placement in the composition, the basin in the *Castle of Ornans* might be analogized to the grave in the *Burial,* which is to say that in these works reflection and excavation emerge as functionally equivalent. Velázquez's *Las Meninas* is probably the most famous instance of the use of mirror imagery in connection with a thematics of representation, but Svetlana Alpers has observed that "the image-making property of light" was a common concern of Northern painting from the Van Eycks on (*The Art of Describing: Dutch Art in the Seventeenth Century* [Chicago: University of Chicago Press, 1983], p. 71).

50. An alternative (or supplementary) account of the genesis of the structure of the *Burial* might suggest that as the painter-beholder strove to merge with the enormous painting on which he was working he simultaneously contested that aim by constructing a second, "personal" point of view to the left of the grave and this side of the picture surface: as though the sheer magnitude of the effort to become one with the *Burial,* to undo both distance and difference between himself and it, gave rise to a counterimpulse that up to a point (but only up to a point) successfully resisted that effort. Understood in these terms, the second point of view might be likened to a reaction formation to the fear of disappearing into the picture, a fear that could have been exacerbated by the claustrophobic conditions in which the *Burial* was painted, but that can be called paranoid only in that it ignores the impossibility of the painter-beholder actually achieving his object. I have also tried to show that the internal structure of the second point of view is such as to have enabled the painter-beholder to become reabsorbed into the painting in and through the figure of Buchon, a personage whose intimate connection with the individual Courbet and for that matter whose implied corporeal integrity as representation (although we are only shown his head, we don't doubt that the rest of him is "there") might have had the additional function of allaying any fear of too radical a dispersal of "self" across the pictorial field. And of course there is *another* hidden or implied body in the neighborhood, the corpse resting within the coffin carried by the pallbearers, which even apart from its relation to a thematics of the act of painting (the pallbearers-plus-coffin group as a figure for the painter-beholder's left hand gripping his palette) might have had a like import.

51. Bertall's caricature, which appeared in *Le Journal amusant* for 7 March 1851, is reproduced by Toussaint, p. 102. It may seem as if the problematic implications of the signature in the *Burial* would also have been present in the signature effects I have

claimed to detect in the *Stonebreakers* via the association of the two figures with Courbet's own initials, or rather in the difference of semantic register between those effects and the association of the old and the young stonebreakers with the painter-beholder's right and left hands. But the sheer inconspicuousness (the fantasmatic character) of the effects in question would have militated against the surfacing of any such implications.

52. For evidence that the painting now in Besançon is a second version painted in 1855, see Toussaint, cat. no. 42, pp. 130–33. The claim that none of the changes introduced between the two versions altered the painting's fundamental character is based in part on Bertall's caricature of the work exhibited in the Salon of 1850–51 (reproduced in Toussaint, p. 130). It might be noted that still another caricature published in the *Journal pour rire,* Nadar's "Emménagement de l'Assemblée législative" of 30 June 1849, which depicts at close range a procession of legislators marching six or seven abreast diagonally toward the lower left-hand corner of the image, may have played a role in the conception of the *Peasants of Flagey* and perhaps also, at a further remove, in that of the *Firemen Rushing to a Fire.*

53. Cf. Clark: "The old man in the *Stonebreakers* was stiff and awkward, built of parts that fitted clumsily together; but the man with the pig is a manikin, a robot, built of odds and ends that were never meant to match. In terms of pigment pure and simple, no picture could be more consistent" (p. 84). Clark's whole discussion of the *Peasants of Flagey* is highly interesting (pp. 83–85).

54. The *Firemen* has been the object of at least three competing political interpretations. See Toussaint, cat. no. 27, pp. 110–14; idem, "Le Réalisme de Courbet au service de la satire politique et de la propagande gouvernementale," *Bulletin de la Société de l'Histoire de l'Art Français, 1979* (1981):233–44; Jean Adhémar, "Deux Notes sur des tableaux de Courbet," *Gazette des Beaux-Arts,* ser. 6, 90 (Dec. 1977):200–204; and Jean Ziegler, "Victor Frond et les Pompiers de Courbet," *Gazette des Beaux-Arts,* ser. 6, 93 (Apr. 1979):172. It is also possible that no political meaning was intended but that Courbet was forced to abandon work on the painting when one of the firemen who posed for him, Second Lieutenant Victor Frond, was arrested for planning to set Paris on fire in the wake of Louis Bonaparte's *coup d'état* of 2 December 1851 (see Ziegler). The *Firemen* has most often been associated with Rembrandt's *Night Watch* (see, e.g., Toussaint, pp. 111–12), while Nochlin has suggested possible sources in contemporary journalism and popular imagery ("Gustave Courbet's *Meeting:* A Portrait of the Artist as Wandering Jew," *Art Bulletin* 49 (Sept. 1967):211–12.

## Chapter Five

1. Recent discussions of the *Wheat Sifters* include Lindsay, pp. 111–13; Toussaint, cat. no. 43, pp. 134–35; and Linda Nochlin, "The 'Cribleuses de blé': Courbet, Millet, Breton, Kollwitz and the Image of the Working Woman," in *Malerei und Theorie: Das Courbet-Colloquium 1979,* ed. Klaus Gallwitz and Klaus Herding (Frankfurt am Main: Städtische Galerie im Städelschen Kunstinstitut, 1980), pp. 49–73.

2. The identification of the wooden cabinet as a *tarare* was made by Nochlin, "The 'Cribleuses de blé,'" p. 60.

3. Toussaint, p. 134. It's now generally accepted that Courbet had an illegitimate son, Désiré-Alfred-Emile Binet, by Virginie Binet, with whom he lived intermittently until late 1851 when she left him. Désiré was born 17 September 1847 and died in Dieppe on 5 July 1872. The fullest discussion of these matters is in Lindsay, pp. 86–91.

4. Toussaint, p. 134; Nochlin too doubts the influence of Japanese art ("The 'Cribleuses de blé,'" p. 58).

5. Toussaint, p. 134.

6. Nochlin, "The 'Cribleuses de blé,'" pp. 59, 60. Even as she puzzles over the painting's subject, however, Nochlin finds its mode of composition thoroughly familiar. "Pictorial coherence is achieved here in what one might call true realist fashion by a sort of additive unity," she writes, "a piecemeal but effective coherence which tends to play down what would otherwise be the total domination of the central figure" (p. 58).

7. Ibid.

8. Ibid., p. 61. The larger passage reads:

If the subject of the *Cribleuses* remains richly indeterminate, the sense of dominating energy of the central figure grasping the *crible* is unequivocal in its forcefulness. A similarly posed, back-view figure of a working woman from Velázquez's *Hilanderas,* a figure which may in fact have inspired Courbet, looks positively lackadaisical in comparison . . . Indeed, the only figures which suggest the kind of confident muscular expansiveness characteristic of Courbet's grain sifter are male ones, like Tintoretto's marvelously energetic back-to iron-worker from his *Forge of Vulcan.* This is not, of course, to suggest a specific influence, but merely to point out that the kind of pose chosen by Courbet here is rare in the ranks of representations of 19th-century women workers.

Why this is the case will become clear as we proceed.

9. Ibid., p. 59.

10. Ibid., p. 55.

11. Toussaint, p. 134.

12. On the circumstances surrounding Courbet's one-man exhibition see Lindsay, pp. 135–44; and Patricia Mainardi, *Art and Politics of the Second Empire: The Universal Expositions of 1855 and 1867* (New Haven and London: Yale University Press, 1987), pp. 57–61, 92–96.

13. For the full text of the letter see Toussaint, pp. 246–47. (A droite, tous les actionnaires, c'est-à-dire les amis, les travailleurs, les amateurs du monde de l'art. A gauche, l'autre monde de la vie triviale, le peuple, la misère, la pauvreté, la richesse, les exploités, les exploiteurs, les gens qui vivent de la mort.)

14. Linda Nochlin, "The Invention of the Avant-Garde: France 1830–80," in *Avant-Garde Art,* ed. Thomas B. Hess and John Ashbery (New York: Macmillan, 1967, 1968), pp. 3–24; Alan Bowness, *Courbet's "Atelier du peintre,"* Fiftieth Charlton Lecture on Art (Newcastle upon Tyne: University of Newcastle Upon Tyne, 1972), p. 30; Werner Hofmann, *The Earthly Paradise: Art in the Nineteenth Century,* trans. Brian Battershaw (New York: George Braziller, 1961), pp. 11–22 and *passim;* James Henry Rubin, *Realism and Social Thought in Courbet and Proudhon* (Princeton: Princeton University Press, 1980); Toussaint, pp. 241–72; and Klaus Herding, "Das *Atelier des Malers*—Treffpunkt der Welt und Ort der Versöhnung," in *Realismus als Widerspruch: Die Wirklichkeit in Courbets Malerei,* ed. Klaus Herding (Frankfurt am Main: Suhrkamp, 1978), pp. 223–47. See also for example René Huyghe, Germain Bazin, and Hélène Adhémar, *Courbet, L'Atelier du peintre, allégorie réelle, 1855,* Monographies des peintures du Musée du Louvre 3 (Paris: Plon, 1944); Lindsay, pp. 129–35; Benedict Nicolson, *Courbet: The Studio of the Painter;* and Nochlin, pp. 210–23. Courbet's letter to Champfleury thus epitomizes the nondecisiveness of exactly the sort of "objective" evidence that a positivist art history likes to think would settle all questions of interpretation. Indeed Toussaint argues that the letter is nothing more than a red herring, fabricated by Courbet to mislead the authorities should they happen to suspect the true meaning of his allegory (p. 247)!

15. Toussaint, pp. 257–58. Among the other identifications Toussaint suggests are

the Jew as the financier Achille Fould, one of the Emperor's ministers; the curé as Louis Veuillot, a right-wing Catholic journalist; the veteran of 1793 in a long-brimmed cap (Courbet's "diehard republican" in his letter to Champfleury) as Lazare Carnot, the scientist and organizer of the revolutionary armies; and the hunter to his right as Garibaldi, the champion of Italian unity (pp. 252–55).

16. Herding, "Das *Atelier des Malers*," p. 244.

17. Linda Nochlin, "Courbet's Real Allegory: Rereading *The Painter's Studio*," in *Courbet Reconsidered*, pp. 20–21. Almost immediately, however, Nochlin questions the finality of Herding's solution, but the grounds on which she does so—a farrago of quotations about allegory drawn from Walter Benjamin, Terry Eagleton, Northrop Frye, and Frederic Jameson—are beside the point, and the re-allegorization she then produces, based on what she calls "reading as a woman," amounts to very little (pp. 21–41). See in this connection chapter six, n. 10.

18. Théophile Silvestre, "Courbet d'après nature," in Courthion 1:47.

19. Among the reasons the accords and parallels between the naked model and both the painter and the painting have never been remarked is the likelihood that the figure of the model was based in part on a photograph of a standing nude, perhaps by Vallou de Villeneuve (see, e.g., Lindsay, p. 126, and Toussaint, pp. 267–68)—as if Courbet's use of such a source has served to confirm the general presumption that nothing structurally interesting or complex takes place in his paintings.

20. This isn't to deny the possible influence on Courbet's treatment of the relationships between the figures and the (painted) natural scene in the central group of a work such as Titian's *Concert champêtre*, then as now in the Louvre (and then attributed to Giorgione). In fact I see not only in the *Studio* but also in the *Bathers* and the *Wheat Sifters* evidence of his interest in the *Concert champêtre*, which of course would later provide an important precedent for Manet's *Déjeuner sur l'herbe*. I might add that a further extension of the apparent effects of harmony with nature I have just described is the anthropomorphism that Toussaint claims to detect in a number of works by Courbet including the *Studio*, but I want to reserve discussion of that topic until chapter seven.

21. Eugène Delacroix, *Journal, 1822–1863* (1931–32; reprint, Paris: Plon, 1981), p. 529. (La seule faute est que le tableau qu'il peint fait amphibologie: il a l'air d'un *vrai ciel* au milieu du tableau.)

22. An impressive precedent for the insertion of a brightly illuminated landscape scene into an otherwise somewhat dark interior space is Fra Bartolommeo's *Ferry Carondelet Altar* (1511–12; fig. 110) in the Cathedral of St. John in Besançon. Various writers have likened the *Studio*, with its three-part structure, to Renaissance altarpieces, and while I see no strict correspondence between individual figures in the two works, I do find enough looser parallels to suggest that the Besançon panel be added to the possible sources of Courbet's painting. Recent discussions of such sources include: Jeannine Baticle and Pierre Georgel, *Techniques de la peinture: l'atelier*, Les dossiers du département des peintures 12 (Paris: Musée du Louvre, 1976); Bowness, *Courbet's "L'Atelier du peintre*," pp. 15–22; Nicolson, *Courbet: The Studio of the Painter*, pp. 65–71; Toussaint, pp. 266–69; and Matthias Winner, "Gemalte Kunsttheorie: Zu Gustave Courbets 'Allégorie réelle' und der Tradition," *Jahrbuch des Berliner Museen, 1962*, n.s. 4 (1963):151–85. On Fra Bartolommeo's painting see Ludovico Borgo, "The Problem of the Ferry Carondelet Altar-Piece," *Burlington Magazine* 113 (July 1971):362–71.

23. On the X-rays of the *Studio* see Lola Faillant-Dumas, "Etude au laboratoire de recherches des Musées de France," in Toussaint, p. 276.

24. Delacroix, *Journal*, pp. 327–28: "There takes place between these two figures an

exchange of thoughts that one cannot understand" (p. 328). (Il y a entre ces deux figures un échange de pensées qu'on ne peut comprendre.) In "Courbet's 'Baigneuses' and the Rhetorical Feminine Image," Beatrice Farwell notes that the pose of the seated companion "suggests ecstatic admiration . . . of a luminous wonder that we cannot see" (in *Woman as Sex Object: Studies in Erotic Art, 1730–1970,* ed. Thomas B. Hess and Linda Nochlin [London: Allen Lane, 1973], p. 67). In a different but related vein, Werner Hofmann suggests that the underlying structure of the *Bathers* is that of traditional representations of the Annunciation and the "Noli me tangere" ("Courbets Wirklichkeiten," in *Courbet und Deutschland,* pp. 607–8).

25. See Nochlin, p. 190. In a letter of 13 May 1853 to his family Courbet wrote: "As for the *Bathers,* it is a little shocking, even though, since you saw it, I've added some

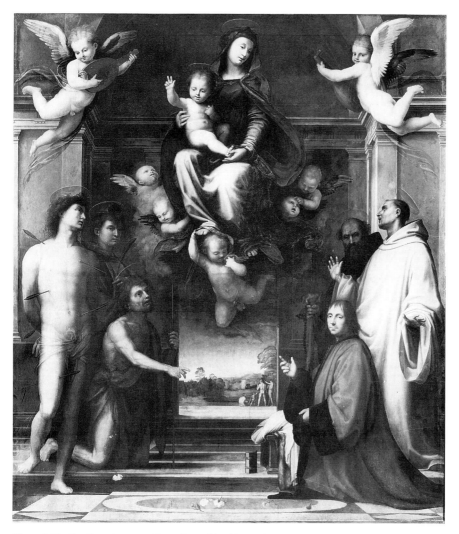

Figure 110. Fra Bartolommeo, *Ferry Carondelet Altar,* 1511–12.

drapery across the posterior" (quoted by Riat, p. 102). (Pour les *Baigneuses,* ça épouvante un peu, quoique, depuis vous, j'y aie ajouté un linge sur les fesses.)

26. An even more uncharacteristic picture of the same year, the *Wrestlers* (1853; fig. 89), often considered a pendant to the *Bathers,* evokes an experience of total bodily effort, of physical strain amounting to deadlock and canceling vision: as though by virtue of a comprehensive series of contrasts—of gender, subject matter, bodily orientation, handling of space, color, finish, etc.—the two paintings respectively come close to epitomizing, one might say to personifying, an almost literally blind effort of painting and the condition of being beheld. But just as the posture of the standing bather hints at a no longer functional connection with the painter-beholder, so the wrestlers have been depicted as performing before a grandstand of spectators too remote and ill-positioned to be able to see what is going on. For more on the *Wrestlers* see chapter seven, pp. 000–00.

27. We owe to Margaret Stuffmann the brilliant suggestion that the *Seated Model* dates from the first half of the 1850s, perhaps around 1853 ("Courbet Zeichnungen," in *Courbet und Deutschland,* cat. no. 317, p. 347). My impulse is to move it just slightly later, but in any case Stuffmann's dating is far more persuasive than Fernier's dating of 1849 (Fernier, vol. 2, "Dessins," cat. no. 32), or the recent dating (without discussion of Stuffmann) of ca. 1845–47 in *Courbet Reconsidered,* cat. no. 92, pp. 208–10.

28. The exact date of the *Portrait of Baudelaire* remains an open question but ca. 1849 seems likely. See, e.g., Nochlin, pp. 65–69; Clark, pp. 74–76; Toussaint, cat. no. 15, pp. 91–92; Fernier, vol. 1, cat. no. 115; and *Courbet Reconsidered,* cat. no. 7, pp. 95–97. Rembrandt's *Bathsheba* was then in the La Caze collection, where Courbet would have known it.

29. In fact a predilection for books tilted at that improbable angle with respect to their readers is one of the hallmarks of Courbet's art. Early instances include the impressive drawing, *Woman Asleep while Reading* (1849) and the *Portrait of Trapadoux* (1849), in both of which the disposition of the book makes it equally acccessible as a surface to the figure in the painting and the painter-beholder seated before it.

Two elements in the *Seated Model* not yet mentioned, the partial casts of sculptures behind the figure of the model, seem almost deliberate references to the *Wrestlers* (the foot) and the *Bathers* (the back), which perhaps indicates that the drawing took upon itself the task of overcoming the difference between the effort of painting and the condition of being beheld I have suggested the *Wrestlers* and the *Bathers* respectively epitomize.

30. Recent discussions of the *Quarry* and related works include Bruce MacDonald, "*The Quarry* by Gustave Courbet," *Bulletin: Museum of Fine Arts, Boston* 67, no. 348 (1969):52–71; Toussaint, cat. no. 53, pp. 144–46; and Peter-Klaus Schuster, "Courbet Gemälde," in *Courbet und Deutschland,* cat. nos. 247–48, pp. 243–46.

31. *Autoportraits,* cat. no. 53, p. 43.

32. MacDonald, "*The Quarry,*" p. 69. See this article for a careful discussion of the pictorial and physical disparities between individual segments.

33. Originally, though, it was round (see Faillant-Dumas, "Etude au laboratoire de recherches des Musées de France," in Toussaint, p. 276). Courbet's decision to change the shape of the palette in the course of working on the *Studio* may be seen as bringing it into association both with the painting on the easel and with Baudelaire's book.

34. See Littré, ed., *Dictionnaire,* 1:935. Littré also notes that *sonner la curée* is to blow a hunting horn to summon the dogs to a feeding (ibid.).

35. Obvious pentimenti reveal that originally the tail of the black-and-white dog, farther to the right, was roughly parallel to its partner's; the curving tail appears in its

present position in Célestin Nanteuil's lithograph after the *Quarry*, published in *L'Artiste*, 18 July 1858 (reproduced by MacDonald, "*The Quarry*," p. 60).

36. My suggestion that the *Quarry* calls attention to the roe deer's undepicted genitals and to their exposure to the hunter or at least to his position invites discussion in terms of the Freudian problematic of castration. Now what chiefly characterizes the painting's treatment of these motifs (if I may so describe them) is the absence of any signs of strong affect and in particular of anxiety, which may seem to indicate that for the painter-beholder the implied threat to the roe deer's genitals was simply that, an objective menace, not the expression of a primal insecurity. On the other hand, the absence of affect ought perhaps to be seen as a further expression of the splitting of the painter-beholder into passive hunter and active *piqueur:* that is, it would be a further index of the hunter-painter's passivity, which itself might be described as a sort of castration. In any case, the threat to the roe deer's genitals that is only suggested in the *Quarry* is brought to the fore in a later hunting picture to be discussed toward the end of this chapter, the *Death of the Stag.*

37. Other animal pictures by Courbet that imply a similar movement toward the picture surface include the *Dead Roe Deer* (1855) in the Hague, a work that was the basis for the roe deer in the *Quarry;* the *Fox in the Snow* (1860) in Dallas; and the *Dead Fox Hanging from a Tree in the Snow* (1860–65?) in Stockholm.

38. MacDonald suggests that the roe deer may have preceded the figure of the hunter, indeed that the latter may not have been part of Courbet's initial conception of the core image ("*The Quarry*," p. 64). If this is true—we are unlikely ever to be certain one way or the other—we might imagine either that the painter-beholder came to project himself into the core image in response to the outward movement of the dead roe deer, or that an initial relationship of something like mirroring obtained between the painter-beholder and the core segment as such, say the blank canvas, on which both roe deer and hunter were then realized.

39. See the remarks on Chardin in Fried, *Absorption and Theatricality,* pp. 49–51, and on Eakins in Fried, *Realism, Writing, Disfiguration,* pp. 42–45.

40. The *piqueur's* obliviousness to his surroundings and indeed his uncanny resemblance to the hunter in this regard were noted by one Armand Bartlet in his comments on the *Quarry* on the occasion of its exhibition in Besançon in 1862:

[The *Quarry's*] personages trouble me: one, leaning against a fir tree and smoking his pipe while turning his back on the scene that ought to interest him, sleeps gently in an indifference that I hardly understand at the hour of an ardent *curée;* the other, his cheek puffed up by the pretensions of an impossible fanfare, sleeps, like his master, to whom he turns his back in his turn (quoted in *Les Amis de Gustave Courbet, Bulletin,* no. 30 [1962]: 15).

Ses personnages me gênent: l'un, arcbouté contre un sapin, et fumant sa pipe en tournant le dos à la scène qui doit l'intéresser, s'endort doucement dans un indifférence que je ne comprends guére à l'heure d'une curée chaude; l'autre, la joue enflée par des prétentions à une fanfare impossible, s'endort, comme son maître, auquel il tourne le dos à son tour.

41. Félix Ravaisson, *De l'Habitude* (1838; reprint, Paris: Libraire Philosophique J. Vrin, 1984), with a short "Présentation" by Jean-François Courtine. Although a student of Victor Cousin, Ravaisson (1813–1900) was unsympathetic to his views and perhaps for that reason never tried to have a university-based career. His closest intellectual affinities were with Maine de Biran in the French tradition and Friedrich Schelling in the

German (though the most profound influence on his thought was undoubtedly Aristotle). He studied painting with David's student Broc, served on a government commission establishing reforms in the teaching of drawing, and in 1870 was appointed Conservator of Antiquities and of Modern Sculpture at the Louvre. In addition to *De l'Habitude,* his doctoral dissertation, Ravaisson's publications include the important *Essai sur la métaphysique d'Aristote,* 2 vols. (1837, 1846), and the highly influential *La Philosophie en France au XIXème siècle* (1868), as well as various essays on the visual arts. In a brief biography, George Boas emphasizes Ravaisson's importance to Bergson and more broadly his place in a spiritualist tradition in French philosophy stemming from Biran (in *The Encyclopedia of Philosophy,* ed. Paul Edwards, 8 vols. [New York: Macmillan, 1967], 7:75–76). See also Henri Bergson, "The Life and Work of Ravaisson," in *The Creative Mind: An Introduction to Metaphysics,* trans. Mabelle L. Andison (New York: Philosophical Library, 1946), pp. 220–52.

    42. Ravaisson, *De l'Habitude,* p. 27.

    43. Ibid., pp. 22–23.

. . . l'habitude est la commune limite, ou le terme moyen entre la volonté et la nature; et c'est un *moyen terme* mobile, une limite qui se déplace sans cesse, et qui avance par un progrès insensible d'une extrémité à l'autre.

    L'Habitude est donc pour ainsi dire la *différentielle* infinitésimale, ou, encore, la *fluxion* dynamique de la Volonté à la Nature. La Nature est la *limite* du mouvement de décroissance de l'habitude.

    Par conséquent, l'habitude peut être considérée comme une méthode, comme la seule méthode réelle, par une *suite convergente* infinie, pour l'approximation du rapport, réel en soi, mais incommensurable dans l'entendement, de la Nature et de la Volonté.

Ravaisson continues, all but untranslatably:

En descendant par degrés des plus claires régions de la conscience, l'habitude en porte avec elle la lumière dans les profondeurs et dans la sombre nuit de la nature. C'est une nature acquise, une *seconde nature,* qui a sa raison dernière dans la nature primitive, mais qui seule l'explique à l'entendement. C'est enfin une nature *naturée,* oeuvre et révélation successive de la nature *naturante* (p. 23).

    44. Ibid., pp. 23–24. The crucial paragraphs read:

L'effort veut donc nécessairement une tendance antécédente sans effort, qui dans son développement rencontre la résistance; et c'est alors que la volonté se trouve, dans la réflexion de l'activité sur elle-même, et qu'elle s'éveille dans l'effort. La volonté, en général, suppose un penchant antérieur, involontaire, où le sujet qu'il entraîne ne se distingue pas encore de son objet.

    Le mouvement volontaire n'a donc pas seulement sa matière, sa substance, mais son origine et sa source dans le désir. Le désir est un instinct primordial, dans lequel le but de l'acte est confondu avec l'acte, l'idée avec la réalisation, la pensée avec l'élan de la spontanéité; c'est l'état de nature, c'est la *nature* même (p. 24).

Slightly further on Ravaisson adds: "Le dernier degré de l'habitude répond à la nature même."

    Thus Dominique Janicaud refers to "la découverte authentiquement ravaissonienne du fond de la nature comme autocausation immédiate" (*Une Généalogie du spiritualisme français. Aux sources du bergsonisme: Ravaisson et la métaphysique* [The Hague: Martinus Nijhoff, 1969], p. 48). I have found Janicaud's book helpful in understanding Ravaisson's arguments and in particular in distinguishing Ravaisson's views from those of Bergson, who admired Ravaisson and was influenced by his thought but whose summary of *De l'Habitude* in *An Introduction to Metaphysics* is misleading (see Janicaud, ibid., pp. 39–50 and *passim*).

    45. Ravaisson, *De l'Habitude,* p. 28. (La forme la plus élémentaire de l'existence, avec

l'organisation la plus parfaite, c'est comme le dernier moment de l'habitude, réalisé et substantifié dans l'espace sous une figure sensible. L'analogie de l'habitude en pénètre le secret et nous en livre le sens.)

46. Ibid., p. 26. In Janicaud's words: "La spontanéité ne cesse pas d'un coup; ses limites sont celles de la nature, ou plutôt celles de notre imagination et de notre entendement essayant de se représenter et de comprendre la nature" (*Une Généalogie,* p. 47).

47. Ravaisson, *De l'Habitude,* pp. 28–29.

Toute la suite des êtres n'est donc que la progression continue des puissances successives d'un seul et même principe, qui s'enveloppent les unes les autres dans la hiérarchie des formes de la vie, qui se développent en sens inverse dans le progrès de l'habitude. La limite inférieure est la nécessité, le Destin si l'on veut, mais dans la spontanéité de la Nature; la limite supérieure, la Liberté de l'entendement. L'habitude descend de l'une à l'autre; elle rapproche ces contraires, et en les rapprochant elle en dévoile l'essence intime et la nécessaire connexion.

48. Ibid., p. 27. The full passage reads:

Ainsi, dans son progrès au sein de la vie intérieure de la conscience, l'habitude figure sous une forme successive l'universalité des termes qui marquent dans le monde extérieur, sous la forme objective et immobile de l'espace, le développement progressif des puissances de la nature. Or, dans l'espace, la distinction des formes implique la limitation; il n'y a que des différences déterminées, finies; rien, donc, ne peut démontrer entre les limites une absolue continuité, et, par conséquent, d'une extrémité à l'autre de la progression, l'unité d'un même principe. La continuité de la nature n'est qu'une possibilité, une idéalité indémontrable par la nature même. Mais cette idéalité a son type dans la réalité du progrès de l'habitude; elle en tire sa preuve, par la plus puissante des analogies.

49. Wey, "Notre maître peintre, Gustave Courbet," in Courthion 2:188. (S'il faut un éclairage plus vif, j'y penserai et quand je le verrai, la chose sera faite sans que je le veuille.) Cf. Flaubert's statement in a letter to Louise Colet of 25 June 1853 that he would like to produce books that would entail only the writing of sentences, "just as in order to live it is enough to breathe air" (Gustave Flaubert, *Correspondance,* ed. Jean Bruneau, 2 vols. [Paris: Gallimard, Bibliothèque de la Pléiade, 1973, 1980], 2:362). (Je voudrais faire des livres où il n'y eût qu'à *écrire* des phrases [si l'on peut dire cela], comme pour vivre il n'y a qu'à respirer de l'air.) What's striking about Flaubert's remark is not so much his emphasis on the activity of writing as the unexpected analogy he draws between an ostensibly *willed* activity, the writing of sentences, and an *involuntary* one, breathing. I shall have more to say about analogies between Courbet's and Flaubert's realisms in chapter seven.

50. Quoted in Léger, p. 66. (A voir Courbet un instant à l'ouvrage, on dirait qu'il produit ses oeuvres . . . tout aussi simplement qu'un pommier produit des pommes. Pour mon compte, je n'ai jamais compris qu'il fût possible de déployer plus de puissance et de rapidité dans le travail. Sous ce rapport au moins, Courbet doit être le premier peintre du monde . . . Aussi rapidement Courbet travaille, aussi plantureusement il dort.)

51. Ravaisson, *La Philosophie en France au XIXème siècle,* Collection Recueil de Rapports sur les Progrès des Lettres et des Sciences en France (Paris: Imprimerie Impériale, 1868), p. 258. "A bien des signes," Ravaisson writes, "il est donc permis de prévoir comme peu éloignée une époque philosophique dont le caractère général serait la prédominance de ce qu'on pourrait appeler un réalisme ou positivisme spiritualiste, ayant pour principe générateur la conscience que l'esprit prend en lui-même d'une existence dont il reconnaît que toute autre existence dérive et dépend, et qui n'est autre que son action."

52. Silvestre, "Courbet d'après nature," in Courthion 1:31. ([J]e reconnais à tout être sa fonction naturelle; je lui donne une signification juste dans mes tableaux; je fais même penser les pierres.) And here is Ravaisson on stones: "Si les pierres de la fable obéissent à une mélodie qui les appelle, c'est qu'en ces pierres il y a quelque chose qui est mélodie

aussi, quoique sourde et secrète, et que, prononcée, exprimée, elle fait passer de la puissance à l'acte" (*La Philosophie en France*, p. 244; cited by Janicaud, *Une Généalogie*, p. 106). Or to cite a fragmentary remark: "Tout est mécanisme à la surface, au fond *Musique, ou Persuasion*" (Joseph Dopp, *Félix Ravaisson, la Formation de sa pensée d'après des documents inédits* [Louvain: Editions de l'Institut Supérieur de Philosophie, 1933], p. 374; cited by Janicaud, *Une Généalogie*, p. 85).

53. On Ravaisson's method of analogy, which I regard as providing a contemporary parallel to my approach to Courbet's paintings, see Janicaud, *Une Généalogie*, pp. 90–102.

54. The full title in French is *Hallali du cerf, épisode de chasse à courre sur un terrain de neige*. The *Hallali* is the name given to the sounding of the horn that signals the kill is near (Littré, ed., *Dictionnaire*, 2:1975).

55. Sigmund Freud, "Instincts and Their Vicissitudes" (1915) in *The Standard Edition of the Complete Psychological Works of Sigmund Freud*, ed. James Strachey, 24 vols. (London: Hogarth, 1953–66), 14:109–40; Jean Laplanche, *Life and Death in Psychoanalysis*, trans. Jeffrey Mehlman (Baltimore: Johns Hopkins University Press, 1976), pp. 85–102; and Leo Bersani, *The Freudian Body: Psychoanalysis and Art* (New York: Columbia University Press, 1986), pp. 29–50 and *passim*. In the last of these, Bersani sums up Laplanche's and his own reflections on the Freudian scenario as follows:

> In order to account for the mystery of sadistic sexuality—that is, how we can be sexually aroused by the suffering of others, as distinct from the easier question of why we wish to exercise power over others—Freud is led to suggest that the spectacle of pain in others stimulates a mimetic representation which shatters the subject into sexual excitement. Sadism is defined in "Instincts and Their Vicissitudes" as a masochistic identification with the suffering object. Sexual pleasure enters the Freudian scheme, Laplanche has noted, "within the suffering position" and he suggests that fantasmatic representation is in itself *ébranlement* and is therefore "intimately related, in its origin, to the emergence of the masochistic sexual drive" . . . Thus sadomasochistic sexuality would be a kind of melodramatic version of the constitution of sexuality itself, and the marginality of sadomasochism would consist of nothing less than its isolating, even its making visible, the ontological grounds of the sexual (p. 41).

Or as Laplanche remarks in his discussion of a related essay by Freud, "A Child Is Being Beaten" (1919):

> The process of turning round [on the subject] is not to be thought of only at the level of the content of the fantasy, but *in the very movement of fantasmatization*. To shift to the reflexive [i.e., to move from the initial formulation "A child is being beaten" to the construction "I am being beaten by my father"] is not only or even necessarily to give a reflexive content to the "sentence" of the fantasy; it is also and above all to reflect that action, internalize it, make it enter into oneself as fantasy. To fantasize aggression is to turn it round upon oneself, to aggress oneself: such is the moment of autoeroticism, in which the indissoluble bond between fantasy as such, sexuality, and the unconsciousness is confirmed (p. 102).

See also Leo Bersani, "Representation and Its Discontents," in *Allegory and Representation: Selected Papers from the English Institute, 1979–80*, ed. Stephen J. Greenblatt (Baltimore: Johns Hopkins University Press, 1981), pp. 145–62, as well as the chapter called "Desire and Death" in Leo Bersani, *Baudelaire and Freud* (Berkeley: University of California Press, 1977), pp. 67–89.

56. It should be noted that dogs with erect penises are often found in seventeenth-century hunting scenes, as for example in Paul de Vos's *Stag Hunt* (Brussels, Musées Royaux des Beaux-Arts) and Jan Fyt's *Boar Hunt* (Munich, Alte Pinakothek). No doubt Courbet was familiar with such precedents. But the sexual thematics of the *Death of the*

*Stag,* in particular the analogy between the exposed genitals of the dog at the lower left and of the dying stag, can't be explained merely in these terms. My thanks to Seanna Wray for alerting me to the de Vos and Fyt paintings.

57. In an important sense, however, the entire scenario must be understood as constituting a single psychic "moment." As Bersani remarks of a similar scenario, "[t]he chronology is false because of the intersubjective nature of the entire fantasy process. . . . The different steps of a process must already be accomplished at the moment the process 'begins'; the various representations along a line of fantasy are merely the spelling out of an intentionality sufficently dense to inspire the articulations of a fantasy-drama" (*Baudelaire and Freud,* p. 87, n. 17). And yet—having insisted on this point—I also want to stress (again) the extent to which Courbet's paintings invite us to read them in terms of scenarios that unfold or continue or repeat themselves over time.

## Chapter Six

1. A jeer directed against feminists meeting at Vincennes in 1970 (Elaine Marks and Isabelle de Courtivron, "Introduction III: Contexts of the New French Feminisms," in *New French Feminisms: An Anthology,* ed. Elaine Marks and Isabelle de Courtivron [New York: Schocken Books, 1981], p. 31).

2. My understanding of these and related issues is informed by the (often mutually conflicting) work of a number of writers, including Parveen Adams, Beverley Brown, Stanley Cavell, Hélène Cixous, Jacques Derrida, Mary Ann Doane, Stephen Heath, Neil Hertz, Jane Gallop, Sarah Kofman, Luce Irigaray, Teresa de Lauretis, Juliet Mitchell, Michèle Montrelay, Laura Mulvey, Jacqueline Rose, and Kaja Silverman. For useful overviews of Freud and Lacan on sexual difference, see the introductory essays by Juliet Mitchell and Jacqueline Rose in *Feminine Sexuality: Jacques Lacan and the école freudienne,* trans. Jacqueline Rose, ed. Juliet Mitchell and Jacqueline Rose (New York and London: Norton, 1982).

The crucial text for the Lacanian distinction between having and being the phallus is the essay, "The Signification of the Phallus" (1958), in Jacques Lacan, *Ecrits: A Selection,* trans. Alan Sheridan (New York: Norton, 1977), pp. 281–91. Lacan writes:

[O]ne may, simply by reference to the function of the phallus, indicate the structures that will govern the relations between the sexes.

Let us say that these relations will turn around a "to be" and a "to have," which, by referring to a signifier, the phallus, have the opposed effect, on the one hand, of giving reality to the subject in this signifier, and, on the other, of derealizing the relations to be signified.

This is brought about by the intervention of a "to seem" that replaces the "to have," in order to protect it on the one side, and to mask its lack in the other, and which has the effect of projecting in their entirety the ideal or typical manifestations of the behaviour of each sex, including the act of copulation itself, into the comedy. . . .

Paradoxical as this formulation may seem, I am saying that it is in order to be the phallus, that is to say, the signifier of the desire of the Other, that a woman will reject an essential part of femininity, namely, all her attributes in the masquerade. It is for that which she is not that she wishes to be desired as well as loved. But she finds the signifier of her own desire in the body of him to whom she addresses her demand for love. Perhaps it should not be forgotten that the organ that assumes signifying function takes on the value of a fetish. But the result for the woman remains that an experience of love, which, as such, deprives her ideally of that which the object gives, and a desire which finds its signifier in this object, converge on the same object (pp. 289–90).

In Stephen Heath's gloss: "[T]he man invests the woman as being the phallus, giving what she does not have, denies the function of castration; the woman invests the man as

having the phallus, wishing to be the phallus for him, desiring his castration. In short, the phallus as privileged signifier, the constant and final meaning of symbolic exchange, for men and women" ("Difference," *Screen* 19 [Autumn 1978]:67). Or in Parveen Adams's paraphrase of Lacan's developmental account: "The child of both sexes identifies with the mother's lack and thus with the imaginary object of the mother's desire—the phallus. The boy, by constructing the phallic signifier with a part of his own body, *has* it and ceases to *be* it. The girl can only continue to *be* the phallus. It is this that makes her a woman" ("Representation and Sexuality," *m/f*, no. 1 [1978]:76). See also n. 11 below.

3. On Courbet's attitudes toward women and views on marriage, free love, and related questions, see Lindsay, pp. 86–91. Two quotations from contemporaries are particularly revealing. "He boasted that he had freed himself from women," Courbet's early biographer Jules-Antoine Castagnary writes. "'If I suffered from my passions when young,' he used to say, 'I suffer from them no longer today.' Illusion. He had a tender heart and was jealous. He rolled his eyes. Woman in his life never went beyond the second order. She was a companion; she was a model" (quoted in English by Lindsay, p. 90). And Théophile Silvestre reports Courbet as saying:

Impossible . . . to stick to one woman if you want to know woman, and as nothing 'belongs' to a man but his ideas . . . it's only a fool who can say that the least thing, his woman for instance, is exclusively his. She belongs to all men, and all men to her. She plays in the world a mysterious role that one can call an apostolate. If you can seduce her by money, sentiment, or glory, she belongs to you more naturally, more legitimately, than to her husband. She's a bird in passage which stops for a certain time in your place. Love is born to run through the world and not to install itself in households, like an old domestic; and the artist who gets married isn't an artist; he's a sort of jealous proprietor, always ready to be irritated when you visit his home, and who says, "My wife," as he'd say "My stick" or "My umbrella" (ibid., quoted in English).

For the original French, see Silvestre, "Courbet d'après nature," in Courthion 1:32–33.

4. A paragraph from a recent essay by the feminist critic and theorist Jacqueline Rose may be relevant here. "At the extreme edge of this investigation," Rose writes,

we might argue that the fantasy of absolute sexual difference, in its present guise, could be upheld only from the point when painting restricted the human body to the eye [i.e., the invention of Albertian perspective]. That would be to give the history of image in Western culture a particularly heavy weight to bear. For, even if the visual image has indeed been one of the chief vehicles through which such a restriction has been enforced, it could only operate like a law which always produces its own violation. It is often forgotten that psychoanalysis describes the psychic law to which we are subject, but only in terms of its *failing*. This is important for a feminist (or any radical) practice which has often felt it necessary to claim for itself a wholly other psychic and representational domain. Therefore, if the visual image in its aesthetically acclaimed form serves to maintain a particular and oppressive mode of sexual recognition, it does so only partially and at a cost. Our previous history is not the petrified block of a singular visual space since, looked at obliquely, it can always be seen to contain its moments of unease [Rose refers here to Lacan's reading of the anamorphic skull in Holbein's *The Ambassadors* in *The Four Fundamental Concepts of Psychoanalysis*]. We can surely relinquish the monolithic view of that history, if doing so allows us a form of resistance which can be articulated *on this side of* (rather than beyond) the world against which it protests (*Sexuality in the Field of Vision* [London: Verso, 1986], pp. 232–33).

5. See for example Mary Ann Doane, "Film and the Masquerade: Theorising the Female Spectator," *Screen* 23 (Sept.–Oct. 1982):74–87, in which it is argued that "it is precisely [the] opposition between proximity and distance, control of the image and its loss, which locates the possibilities of spectatorship within the problematic of sexual difference. For the female spectator there is a certain over-presence of the image—she *is* the

image" (p. 78). Doane goes on to note "the constant recurrence of the motif of proximity in feminist theories (especially those labelled 'new French feminisms') which purport to describe a feminine specificity" (ibid.), citing relevant passages from Irigaray, Cixous, Kofman, and Montrelay. Against the essentialism implicit in much recent French work, however, Doane insists that "the entire elaboration of femininity as a closeness, a nearness, as present-to-itself is not the definition of an essence but the delineation of a *place* culturally assigned to the woman" (p. 87). This is surely correct. In a similar spirit, I am struck by the coincidence between certain aspects of my reading of Courbet and Irigaray's (essentialist) speculation that what she calls a feminine syntax "would involve nearness, proximity, but in such an extreme form that it would preclude any distinction of identities, any establishment of ownership, thus any form of appropriation" (Luce Irigaray, *This Sex Which Is Not One,* trans. Catherine Porter with Caroline Burke [Ithaca: Cornell University Press, 1985], p. 134). As Irigaray also puts it, "We would thus escape from a dominant *scopic* economy, we would be to a greater extent in an economy of *flow*" (p. 148), a remark that might be applied not only to Courbet's paintings of river landscapes but to an entire metaphorics of flow in his art.

6. See Laura Mulvey's highly influential "Visual Pleasure and Narrative Cinema," *Screen* 16 (Autumn 1975): 6–18. "In a world ordered by sexual imbalance," Mulvey writes, "pleasure in looking has been split between active/male and passive/female. The determining male gaze projects its phantasy on to the female figure which is styled accordingly. In their traditional exhibitionist role women are simultaneously looked at and displayed, with their appearance coded for strong visual and erotic impact so that they can be said to connote *to-be-looked-at-ness.* Woman displayed as sexual object is the leitmotif of erotic spectacle . . . she holds the look, plays to and signifies male desire" (p. 11). In a later essay, "Afterthoughts on 'Visual Pleasure and Narrative Cinema' Inspired by *Duel in the Sun* (King Vidor, 1946)," Mulvey takes up the question of the experience of the female spectator of a film (a Western) in which a female character is at the center of the narrative and so bears a more complex relation to the active/passive dyad (*Framework,* no. 15/16/17 [1981]:76–79). A similar desire "to displace the active-passive, gaze-image dichotomy in the theory of spectatorship and to rethink the possibilities of *narrative* identification as a subject-effect in women spectators" is expressed by Alice de Lauretis, *Alice Doesn't: Feminism, Semiotics, Cinema* (Bloomington: University of Indiana Press, 1984), p. 207, n. 52.

The relation of the opposition active/passive to the opposition masculine/feminine is a vexed question in Freud, who emphasizes that the two cannot simply be superimposed but finds it difficult to separate them definitively. See in this connection Irigaray, *Speculum of the Other Woman,* trans. Gillian C. Gill (Ithaca: Cornell University Press, 1985), pp. 15–24, 90–94, and *passim;* Jane Gallop, *The Daughter's Seduction: Feminism and Psychoanalysis* (Ithaca: Cornell University Press, 1982), pp. 56–79 (a commentary on Irigaray); and Sarah Kofman, *The Enigma of Woman: Woman in Freud's Writings,* trans. Catherine Porter (Ithaca and London: Cornell University Press, 1985), pp. 114–21, 148–58, and *passim* (a reading of Freud taking issue with Irigaray).

7. "Philosophy has never spoken—I do not say of *passivity:* we are not effects—but I would say of the passivity of our activity" (Maurice Merleau-Ponty, *The Visible and the Invisible,* trans. Alphonso Lingis, ed. Claude Lefort [Evanston: Northwestern University Press, 1968], p. 221). In fact Merleau-Ponty is forgetting Ravaisson, whose work he had earlier discussed mainly in relation to Bergson (see Janicaud, *Une Généalogie,* pp. 11–12, and *passim*).

8. Cf. Jane Gallop, "Annie Leclerc Writing a Letter, with Vermeer," *October,* no. 33

(Summer 1985):103–18. Gallop's article is largely a discussion of Leclerc's "La Lettre d'amour"; what interests Gallop is Leclerc's notion that the woman writer is split between masculinity and femininity by the act of writing and that the split is embodied in the difference between the writer's two arms: "The right arm, the writing arm, is for Leclerc 'virile.' [Thus] she says: 'If you only look at my . . . right hand, you'll see it at a distance from my body, you'll see it independent, abstract, male'" (p. 114). But the writer herself isn't thereby simply masculinized: "Leclerc wants her right hand to copy down what the left hand knows" (p. 116). The mythic association of maleness with the (superior) right side of the body and of femaleness with the (inferior) left side goes back as far as the Greeks (see for example James Hillman, "First Adam, Then Eve: Fantasies of Female Inferiority in Changing Consciousness," *Art International* 14 [Sept. 1970]:33).

9. Questions concerning the interrelationship between activity and passivity—the latter sometimes thematized as receptiveness, i.e., an active passivity—have come to play an increasingly important role in the writings of Stanley Cavell, where they are often crossed with questions of gender. See for example his essay "Psychoanalysis and Cinema: The Melodrama of the Unknown Woman," in *Images in Our Souls: Cavell, Psychoanalysis, and Cinema*, ed. Joseph H. Smith and William Kerrigan, vol. 10 of *Psychoanalysis and the Humanities* (Baltimore and London: John Hopkins University Press, 1987), pp. 11–43; Timothy Gould, "Stanley Cavell and the Plight of the Ordinary," in *Images in Our Souls*, pp. 109–36; and Karen Hanson, "Being Doubted, Being Assured," in *Images in Our Souls*, pp. 187–201.

10. In an essay on the *Studio* in *Courbet Reconsidered*, Nochlin disputes my reading of the central group on the grounds that the positioning of the figures of the painter and the model is "overtly and blatantly" oppositional and in general that "there is nothing ambiguous" about the Oedipal "lesson" or "message" constituted by that group ("Courbet's Real Allegory: Rereading 'The Painter's Studio,'" p. 31). See my response to her remarks in a postscript to an earlier and shorter version of this chapter in the same catalog ("Courbet's 'Femininity,'" pp. 52–53).

11. The exact status of the concepts of the phallus and of castration in Freud's and Lacan's accounts of sexual difference has been a matter of dispute among feminist theorists (and others). Stephen Heath, for example, criticizes both Lacan and Freud for the emphasis on vision inherent in their respective appeals to the concept of castration, or rather for what he takes to be the essentialist implications of that emphasis, their failure to recognize that the production of sexuality must be considered in relation to the larger question of the historical constitution of the subject ("Difference," p. 54 and *passim*). (Similar critiques are developed by de Lauretis in *Alice Doesn't* and Doane in various essays, and of course a large French feminist literature contests Lacan's privileging of the phallus.) Jacqueline Rose, however, argues that Lacan at any rate is often misrepresented by his critics. "When Lacan is reproached with phallocentrism at the level of his theory," she writes, "what is most often missed is that the subject's entry into the symbolic order is equally an exposure of the value of the phallus itself. The subject has to recognise that there is desire, or lack in the place of the Other, that there is no ultimate certainty or truth, and that the status of the phallus is a fraud (this is, for Lacan, the meaning of castration). The phallus can only take up its place by indicating the precariousness of any identity assumed by the subject on the basis of its token" ("Introduction II," in *Feminine Sexuality*, p. 40). Rose doesn't deny "that Lacan was implicated in the phallocentrism he described" (he could not not have been, she seems to suggest), and she acknowledges that it is far from clear *why* the phallus should play so crucial a role "in the structuring and securing (never secure) of human subjectivity" (p. 56). But she is critical of recent at-

tempts by feminist theorists to counter the primacy of the phallus by appealing either "to a concept of the feminine as pre-given" [e.g., as a function of more comprehensive differences between men's and women's bodies] or "to an androcentrism in the symbolic which the phallus would simply reflect. The former relegates women outside language and history, the latter simply subordinates them to both" (p. 57). See also Gallop, *The Daughter's Seduction*, pp. 43–55 (on Heath on Lacan), 92–112, and *passim*.

12. On the phallic significance of distaffs in European painting, see for example Donald Posner, "An Aspect of Watteau 'peintre de la réalité,'" in *Etudes d'art français offertes à Charles Sterling*, ed. Albert Châtelet and Nicole Reynaud (Paris: Presses Universitaires de France, 1975), pp. 279–86. See also Werner Hofmann, "Uber die 'Schlafende Spinnerin,'" in *Realismus als Widerspruch*, pp. 212–22.

13. Littré, ed., *Dictionnaire*, 4:1416.

14. Cf. Naomi Schor's claim that in Flaubert's *Madame Bovary* a feminine ideal of writing coexists with a masculine (i.e., a phallic) ideal of literary style ("For a Restricted Thematics: Writing, Speech, and Difference in *Madame Bovary*," in *Breaking the Chain: Women, Theory, and French Realist Fiction* [New York: Columbia University Press, 1985], pp. 3–28). "In the last analysis," she writes, "the 'bizarre androgyn' [Baudelaire's characterization of Emma Bovary] is neither Flaubert (Sartre) nor Emma (Baudelaire), but the book, locus of the confrontation, as well as the interpenetration of *animus* and *anima*, of the masculine and the feminine" (p. 28). Elsewhere in *Breaking the Chain* Schor remarks of Zola that "he is the heir to an entire century of questioning of social roles. Indeed the nineteenth-century novel—whether it be that of Balzac, Stendhal, Gautier, or Flaubert—rehearses an interminable 'crisis of distinctions' [René Girard's phrase], which is made manifest by the proliferation of effeminate male characters and viriloid female characters, not to mention the multiplication of borderline cases: androgyns and castrati" (p. 30). See also idem, *Zola's Crowds* (Baltimore and London: Johns Hopkins University Press, 1978), pp. 87–103.

In a similar vein, Leo Bersani remarks of Baudelaire:

In the *Journaux intimes*, the shattering of the artist's integrity is also seen as a momentous sexual event. In order to be possessed by alien images, the artist must open himself in a way which Baudelaire immediately associates with feminine sexuality. Psychic penetrability is fantasized as sexual penetrability, and in glorifying "the cult of images" as "my great, my unique, my primary passion," Baudelaire is also confessing a passion which may change him into a woman (*Baudelaire and Freud*, pp. 11–12).

A few pages further on Bersani adds in a note:

Baudelaire's attitude toward the artist's dual sexuality is not always negative. In *Les Paradis Artificiels*, he speaks of "a delicate skin, a distinguished accent, a kind of androgynous quality" acquired by men raised principally by women . . . . Without these qualities, ". . . the roughest and most virile genius remains, as far as artistic perfection is concerned, an incomplete being." [Michel] Butor sees the *mundus muliebris* as the "necessary theater" in which the artist, by an act of will, conquers his virility—and his artistic powers. The devirilized male artist who desires women is, Butor concludes, a lesbian, and lesbians for Baudelaire are "the very symbol of the apprentice poet, of the poet who has not yet published" (p. 14).

The reference to Butor is to his fascinating *Histoire extraordinaire: Essai sur un rêve de Baudelaire* (1961; reprint, Paris: Gallimard, Collection Folio/Essais, 1988); see especially pp. 69–89. On Baudelaire's "androgyny" see also Christine Buci-Glucksmann, *La Raison baroque: De Baudelaire à Benjamin* (Paris: Editions Galilée, 1984). For Baudelaire's article on *Madame Bovary*, in which he argues that Flaubert in effect "divested himself of his sex and made himself a woman [i.e., the character Emma Bovary]," see Baudelaire,

*Oeuvres complètes,* pp. 647–57. (Il ne restait plus à l'auteur, pour accomplir le tour de force dans son entier, que de se dépouiller [autant que possible] de son sexe et de se faire femme [p. 652].)

Schor, Bersani, Butor, and Buci-Glucksmann are by no means the only critics to draw attention to a thematics of femininity, bisexuality, or what I have been calling bigendered-ness in the works of major nineteenth-century French writers. (The most influential recent critical work on the topic is undoubtedly Roland Barthes's *S/Z,* trans. Richard Miller [New York: Hill and Wang, 1974].) That Courbet too should be readable in these terms is therefore not surprising, though in my account the meaning of such a thematics in his art is importantly a function of his distinctively pictorial aims.

15. Quoted in Léger, p. 66 (on dirait qu'il produit ses oeuvres . . . tout aussi simplement qu'un pommier produit des pommes). See also chapter five, n. 50.

16. Thomas Laqueur, "Orgasm, Generation, and the Politics of Reproductive Biology," *Representations,* no. 14 (Spring 1986):27. Laqueur goes on to cite "Pouchet's eighth law, the view . . . that 'the menstrual flow in women corresponds to the phenomena of excitement which manifests itself during the rut [*l'époque des amours*] in a variety of creatures and especially in mammals.'" The reference to [F.-A.] Pouchet is to his epochal book, *Théorie positive de l'ovulation spontanée et de la fécondation des Mammifères et de l'espèce humaine* (Paris: J.-B. Baillière, 1847).

The mid-nineteenth-century writer most obsessed with the meaning of menstruation and related questions was of course Jules Michelet, who hailed Pouchet's *Théorie positive* as a work of genius and corresponded with Pouchet and other scientists on the topic (see Thérèse Moreau, *Le Sang de l'histoire: Michelet, l'histoire et l'idée de la femme au XIXe siècle* [Paris: Flammarion, 1982]). Of Pouchet's "laws" of reproductive biology Moreau writes:

Ces lois font entrer la femme dans le cycle de la *production* et lient les menstrues à un phénomène positif. La menstruation change alors de sens: de néfaste elle devient bénéfique, productrice de changement et de positif. Elle qui n'était qu'une expulsion de surplus, devient la préparation et l'annonciatrice de la production possible d'un nouvel être. Elle reste néanmoins une crise, crise nécessaire au fonctionnement du corps. Dès lors elle devient aussi modèle de circulation, prototype d'une nouvelle *conception* (p. 86).

On Michelet and Pouchet see also Jean Borie, "Une Gynécologie passionée," in *Misérable et glorieuse: La Femme au XIXe siècle,* ed. Jean-Paul Aron (Paris: Fayard, 1980), pp. 153–89.

17. See Littré, *Dictionnaire,* 4:2322. The use of *labeurs* to signify the effort of giving birth is extremely rare (ibid., 3:226).

18. Littré, *Dictionnaire,* 1:897.

19. There is thus a continual oscillation between fantasies of pictorial production by the body alone and the fantasmatically invested reality of pictorial production with the help of the painter's tools, an oscillation that reflects the ontologically uncertain status of the phallus as a signifier at once of bodily wholeness and of castration. On the one hand, Bersani notes,

[t]he self's integrity is threatened by the infant's separation from its mother; the body's wholeness is destroyed by the actual or fantasized loss of feces or of the penis. The body no longer makes sense when something drops away from it. On the other hand, the phallus becomes meaningful only by detaching itself from the body. It is not the phallic objects themselves which symbolize meaning. As long as the penis remains on the body, it has no general symbolic value; it is only in castration that, by threatening a constituted whole, it becomes the "figure" for a mysterious "ex-centricity" of the self—for the scattering of psychic coherence (*Baudelaire and Freud,* pp. 59–60).

20. Recent studies showing the multiplicity and fluidity of distinctions within the world of prostitution in nineteenth-century France are Alain Corbin, *Les Filles de noce: Misère sexuelle et prostitution au XIXe et XXe siècles* (Paris: Aubier Montaigne, 1978); and Jill Harsin, *Policing Prostitution in Nineteenth-Century Paris* (Princeton: Princeton University Press, 1985).

21. Cf. Jack Lindsay, who writes that the motif of a return to nature, "expressed in other works by a girl, clothed or naked, asleep among trees, has here the effect of showing up remorselessly all that is artificial, soiled, dehumanised, in the [*Young Women*]. Their rich clothes resist the flowers and foliage, and obliterate the humanity of their bodies. And yet the penetration into their being, ruthless as it is, is made with entire sympathy" (p. 148). Obviously I think this is wrong, or at best much too simple. I should add, however, that to emphasize the pervasiveness and consistency of the floral imagery in the *Young Women* is not to concur in a mythological reading of the women themselves: they are no symbols of fertility, even if some of their accoutrements—the blonde's bouquet, the brunette's garland—ultimately derive from traditional images of that type (see Peter-Klaus Schuster on the *Young Women* and related works in *Courbet und Deutschland*, pp. 230–32). Nor, I think, were they intended to be seen as a modern version of the traditional figure of Flora-as-prostitute (see Julius Held, "Flora, Goddess and Courtesan," in *De Artibus Obuscula XL: Essays in Honor of Erwin Panofsky*, ed. Millard Meiss [New York: New York University Press, 1961], pp. 201–18).

Werner Hofmann too interprets a number of Courbet's paintings of women, including the *Sleeping Spinner, Wheat Sifters, Young Women on the Banks of the Seine,* and *Sleep,* as modern reworkings of traditional mythological themes ("Courbets Wirklichkeiten," in *Courbet und Deutschland,* pp. 590–613). The most intriguing of his comparisons is between the falling grain in the *Wheat Sifters* and the shower of gold in traditional representations of Danaë (p. 600).

22. It's tempting to compare the feminization of the phallus/paintbrush in the *Young Women on the Banks of the Seine* with the implied castration of the dead roe deer and indeed of the passive hunter in the *Quarry,* an almost exactly contemporary work. Cf. Jacques Derrida's speculations on the interplay between phallic and floral imagery in the writings of Jean Genet in *Glas, passim.*

23. Also linking the two works is the analogy between the single rose petal lying just above the sleeping woman's face in the *Hammock* and the single leaf breaking the contour of the nearer of the two women's right arm in the *Young Women.*

24. Moreover, the flowers with their long stalks can be read as figures for the brushes and palette knife that the painter holds in his left hand in the central group from the *Studio.* Note too the multiple affinities between the *Women in a Wheatfield* and the *Wounded Man,* the two works taken together offering feminine and masculine versions of the same essential subject.

25. The *Portrait of Jo* exists in four variants, all of which have traditionally been dated 1866. A suggestion that the version considered to be the first of these (in the Nationalmuseum in Stockholm) may have been painted in 1865 is made in *Courbet Reconsidered,* cat. no. 53, p. 162, on the basis of a letter from Courbet to Bruyas. Also in that catalog it's proposed that Courbet may somehow have been influenced by Dante Gabriel Rossetti's *Lady Lilith* (1868), which Rossetti began in 1864. This seems unlikely. My counter-proposal is that the *Portrait of Jo* recalls Greuze's *Le Petit Mathématicien* (1780s) in the Musée Fabre, Montpellier.

26. This relation between Jo's little finger and her tresses holds only in the Metropolitan Museum of Art version of the painting, which in this respect as in others represents a

more developed conception of the subject than the others (see *Courbet Reconsidered,* cat. nos. 53–56, pp. 162–65). In the Stockholm, Zurich, and Kansas City versions, however, a single tress emerges from beneath (within?) Jo's left hand, very much as if it were affixed to the handle of the mirror as to the shaft of a brush.

27. The following much too brief account of Manet's enterprise is based on Fried, "Manet's Sources" (cited in chapter one, n. 14). See also Theodore Reff, "'Manet's Sources': A Critical Evaluation," *Artforum* 8 (Sept. 1969):40–48; and Fried, "Painting Memories" (cited in chapter one, n. 40). On the relationship between Manet's *Déjeuner sur l'herbe* and Courbet's *Young Women on the Banks of the Seine,* see Fried, "Manet's Sources," p. 46. Other connections between works by the two painters are discussed by Reff, "Courbet and Manet," *Arts* 54 (Mar. 1980):98–103.

28. In Manet's last ambitious work, *A Bar at the Folies-Bergère* (1882), the preemption of beholding is made explicit by the reflection in the bar mirror of a male customer standing directly in front of the barmaid, or rather by the unresolvable conflict between the tendency of the composition to position the actual beholder precisely there and the laws of optics ostensibly governing the reflection in the mirror that would have the beholder stand well over to the right. (Cf. the structure of beholding in Courbet's *Burial,* in which an initial separation between two points of view is progressively undone, at least with respect to the painter-beholder.) For an alternative reading of the *Bar* based on the hypothesis "that inconsistencies so carefully contrived must have been felt to be somehow appropriate to the social forms the painter had chosen to show," see T. J. Clark, *The Painting of Modern Life: Paris in the Art of Manet and His Followers* (New York: Knopf, 1985), pp. 239–55.

29. On sexuality in Manet see Clark's chapter on *Olympia* in *The Painting of Modern Life,* pp. 79–146; Eunice Lipton, "Manet and a Radicalized Female Imagery," *Artforum* 13 (Mar. 1975):48–53; Peter Wollen, "Manet, Modernism and Avant-Garde," *Screen* 21 (Summer 1980):15–25; Griselda Pollock, *Vision and Difference: Femininity, Feminism and the Histories of Art* (London and New York: Routledge, 1988), pp. 53–54; and, most recently, Edward Snow, "Theorizing the Male Gaze: Some Problems," *Representations,* no. 25 (Winter 1989):34.

30. Clark's chapter on *Olympia* includes a subtle and persuasive analysis of the crisis of the genre of the traditional erotic nude in the 1860s (*The Painting of Modern Life,* pp. 119–31). On the vexed question of the relation of the traditional nude to contemporaneous pornographic photography, a topic not dealt with by Clark, see Gerald Needham, "Manet, 'Olympia' and Pornographic Photography" in *Woman as Sex Object,* pp. 80–89; and Abigail Solomon-Godeau, "The Legs of the Countess," *October,* no. 39 (Winter 1986):65–108, especially 98–99.

31. Two paintings of 1863 in which a naked woman is depicted lying on her back, Paul Baudry's *The Pearl and the Wave* and Alexandre Cabanel's *Birth of Venus,* make interesting comparisons with the *Woman with a Parrot;* both are illustrated in Clark, *The Painting of Modern Life,* figs. 43, 45.

32. Potentially disquieting because the combination of the woman's open mouth and snakelike hair invites being read as a displaced representation of her concealed genitals, and this in turn might be assumed to produce the petrifying effects that Freud associates with castration imagery in his short essay, "Medusa's Head" (*Standard Edition,* 18:273–74). Such effects would, of course, run counter to my account of Courbet's antitheatrical project, and it may be that the tensions and imbalances I have detected in the *Woman with a Parrot* owe something to the Freudian dynamic. In general, however, Courbet's imagery of women's hair even at its most snakelike does not give rise to effects of this sort;

on the contrary, as I suggested earlier (chapter five, n. 36), his art characteristically avoids the petrifying consequences of castration anxiety. Thus to the extent that in a painting like *Portrait of Jo* Courbet may be said to have "invested the woman as being the phallus, giving what she does not have, thereby denying the function of castration" (an adaptation of Heath, "Difference," p. 67), the association of the woman's hair with the painter-beholder's brush (and of her mirror with both palette and painting) made possible a quasi-identification with the image that forestalled any disruptive consequences of the sort alluded to by Freud in "Medusa's Head." See in this connection Neil Hertz's discussion of Courbet's *The Origin of the World* and related pictures in *The End of the Line: Essays on Psychoanalysis and the Sublime* (New York: Columbia University Press, 1985), pp. 209–14.

33. In a picture from the end of the previous decade, the *German Huntsman* (fig. 109), a wounded or dying stag fallen partly on its back with its antlered head twisted around so as to allow it to lick water from a stream is gazed at from above by the hunter who presumably shot it. The result is a curious (though by no means untypical) anticipation of the implied relation between woman and painter-beholder in the *Woman with a Parrot*. A much earlier painting that looks forward compositionally to the *Woman with a Parrot* is *Lot and His Daughters* (1840).

34. Another work roughly contemporary with the *Hammock*—one already discussed in some detail—is pertinent here. In the *Sculptor* (fig. 28) the partial figure of a woman carved in the rock to the sitter's left is oriented with her head nearer us than is the rest of her (mostly absent) body, and of course just below her head water spills from an orifice in the rock and flows toward the picture surface and by implication beyond it. Note too the suggestive resemblance between the sculptor's elevated right arm and hand (the latter holding a small mallet) and the woman with a parrot's upraised left arm and hand in the later painting.

I might add that the dying stag in the *German Huntsman* is also oriented with its head toward us and that the stream from which he strains to drink clearly flows in the direction of the picture surface. The *Woman with a Parrot* is thus inscribed in a network of relations within Courbet's oeuvre that goes beyond the subject of the female figure, whether nude or (as in the *Hammock*) more or less clothed. But the converse is also true, by which I mean that the reading of his paintings of women I have been developing in this chapter has implications for our understanding of paintings with an altogether different subject matter (the *German Huntsman*, for example).

35. Littré, *Dictionnaire*, 4:1416.

36. Toussaint, for example, cites an early pencil sketch of two clothed women embracing in a bed, the *Women in a Wheatfield* (fig. 72), and two versions of *Venus and Psyche* (1864, 1866) (p. 186). To this list Alan Bowness would add the *Bathers* (ibid., p. 16). The possibility that *Sleep* reflects an awareness of Ingres's *Le Bain Turc*, acquired by Khalil Bey in 1865, is raised by Francis Haskell in an article on Bey, "A Turk and His Pictures in Nineteenth-Century Paris," *Oxford Art Review* 5, no. 1 (1982):40–47. Haskell notes the lesbian undertones of certain figures in Ingres's tondo and remarks that, although the two works are compositionally unlike, "[*Sleep*] explores one of [*Le Bain Turc*'s] underlying themes with a blatancy, a vulgarity even, that would have horrified Ingres, but which could nevertheless have been suggested by his picture" (p. 45). In addition Beatrice Farwell has associated *Sleep* with lesbian imagery in popular lithographs of the 1830s and after ("Courbet's 'Baigneuses' and the Rhetorical Feminine Image," in *Woman as Sex Object*, p. 71). More recently, *Sleep* has been cited as an influence on later nineteenth-century paintings of lesbian themes by Bram Dijkstra, *Idols of Perversity: Fantasies of Feminine Evil*

*in Fin-de-Siècle Culture* (New York and Oxford: Oxford University Press, 1986), p. 155.

37. See Toussaint on Courbet's *Venus and Psyche,* cat. no. 94, pp. 182–84.

38. Castagnary's remarks are taken from his unfinished manuscript on Courbet (see Courthion 1:188–89). The full passage reads: "Courbet, lui, avait eu une intention. Il poussait à sa façon un cri d'alarme. Il disait à la bourgeoisie de son temps: 'Vous tolérez l'Empire, prenez garde: voilà les femmes qu'il est en train de vous faire.'" For Proudhon's comments on the *Venus and Psyche* of 1864 see his *Du Principe de l'art et de sa destination sociale* (Paris: Garnier Frères, 1865), pp. 261–63. My thanks to Steven Z. Levine for drawing both to my attention.

39. Cf. Leo Steinberg's discussion of Picasso's attempts to represent "the form of a woman who possesses both front and back, as though the fullness of her were on display" ("The Algerian Woman and Picasso at Large," in *Other Criteria: Confrontations with Twentieth-Century Art* [New York: Oxford University Press, 1972], p. 154). A very different sort of merging of a pair of male figures takes place in Courbet's *Wrestlers* (fig. 89), a work mentioned in connection with the *Bathers* and discussed further in chapter seven.

40. Toussaint sees in this a modern version of a religious allegory: "[Courbet] offers us the expressive symbol of remorse or absolution in this broken string of pearls that trails from the crystal goblet in the same way that evil, incarnated by a snake, emerges from the 'poisoned chalice' in old pictures of the legend of St. John the Evangelist" (p. 186). It seems unlikely that Courbet intended anything of the sort, but Toussaint's remarks usefully focus attention on the relationship between the pearls and goblet. (My reading of that relationship is indebted to conversations with Neil Hertz.)

One further point: Jo Heffernan was the painter James McNeill Whistler's mistress. The recent work of Eve Kosofky Sedgwick on the exploitation of women in the interests of what she calls male homosocial desire raises the possibility that, in addition to its other significances (and not entirely congruent with them), lesbianism in *Sleep* might be a figure for a homosocial relationship, at once of friendship and of rivalry, between the two male painters. See Sedgwick, *Between Men: English Literature and Male Homosocial Desire* (New York: Columbia University Press, 1985).

41. *The Origin of the World,* also commissioned by Khalil Bey, belonged in recent decades to Jacques Lacan. See *Courbet Reconsidered,* cat. no. 66, pp. 176–78.

42. Lindsay, pp. 217–18.

43. Hofmann, "Courbets Wirklichkeiten," in *Courbet und Deutschland,* p. 610.

44. Lindsay, pp. 131–32.

45. Neil Hertz too compares *The Origin of the World* with Courbet's paintings of caves and grottos, finding similar ontological and psychological structures in both. Thus he discovers at the heart of the Buffalo *Source of the Loue* (fig. 80) a "literally indiscernible" difference between "the dark waters and the dark rock walls above them," claiming that "what we *see* are identical strokes of black paint, though some of them render what we 'know' to be water, others what we 'know' to be rock" (*The End of the Line,* pp. 210–11). The question as to the difference between "what the eye sees and what it 'knows' to be there" is called by Hertz "the fetishist's question *par excellence,*" and what distinguishes Courbet's fetishism, Hertz suggests, "is not just the desire to get to the heart of the matter . . . but the will to patiently explore the matter along the way." He continues:

The signs of that patience are in [Courbet's] linking of the fetishist's questions (what does the eye see? what does it "know" to be there?) with questions of technique (how can strokes of paint represent the surfaces of things?), and these signs, though they are focused with emblematic intensity at the heart of the cave, in the "difference" between black and black, are in fact spread all over the surface of the canvas. The rock walls that frame the cave, which may seem like an austerely con-

tracted version of "the world," nevertheless allow for astonishingly varied effects of coloring. . . . This variety of texture, and the particular way in which Courbet's application of paint draws attention to itself (not as brushstrokes, but as paint) engages the eye, slowing down and complicating its movement along the lines of the stratified rock toward the "source" itself, and allowing for contrary movements, in which interest is diffused and dispersed across the whole visual field (p. 211).

By the same token, in *The Origin of the World,* although the viewer's gaze is drawn toward the dark central triangle of pubic hair,

this centripetal movement is impeded, if not entirely checked, by the substantiality of the figure's thighs and torso, by details like the almost uncovered breast at the top of the picture, and by what I take to be (judging from black-and-white reproductions of the painting) Courbet's characteristic care in representing the surfaces of the model's body—the care, at once painterly and mimetic, that can be observed in his rendering of the rocks surrounding the cave of the Loue. The desire to zero in on that central point . . . is countered and dispersed in these ways, while the wish to believe that what one is drawn to is *a* center, one thing, *la chose même,* is problematized by a detail that is both realistic and abstract: the curved line that marks the vaginal cleft and that is visible disappearing under the triangle of hair, producing not a single dark focal patch but the erotic version of the equivocations "visible" in the center of *La Source de la Loue* (p. 213).

Hertz's account of the diffusion and dispersal of interest across the entire canvas captures an important aspect of the Buffalo picture, though I think he overstates the extent to which Courbet's rendering of the cave interior and river surface would originally have involved "a difference without a distinction" (p. 211), the darker portions of the painting having become even darker with the passage of time, and probably having lost delicate final touches through cleaning or abrasion. (Such losses are evident in the version of the subject in Washington, D.C., which Hertz also discusses [pp. 217–18].) I'm therefore dubious about the starkness of his antithesis between seeing and knowing or indeed between paint and what it represents, oppositions that perhaps risk simplifying and stabilizing what I have tried to show is the multivalent, metaphoric, even metamorphic nature of representation in Courbet's art.

In addition I would question Hertz's emphasis on the structure of reflection in the *Source of the Loue* series to the exclusion of some more "active" relationship between painter-beholder and painting did he not go on to amplify his account by suggesting that the (invisible) difference between the black rock walls and black water "can serve as an emblem of tensions that join and separate the viewer (and painter) outside the frame from their surrogates within the frame [Hertz is referring to the Washington picture with its figure of a fisherman] as well as from the 'scene itself,' in this case the cave" (p. 218). Hertz's elaboration, through readings of passages from Flaubert, George Eliot, and Wordsworth, of the idea "[t]hat a differential play of subject and object can find its echo and emblem 'within' the nominal object" is extremely acute, and of course the idea itself has much in common with the approach to Courbet's art this book has taken from the first. (That Hertz and I came independently to our respective understandings of the *Source of the Loue* series and related landscapes suggests that something more than an act of critical fiat may be at work in both cases.) Where I perhaps still differ from him, or at least wish to assert a different emphasis, is in the weight I give to the notion of a double movement into and out from the painting, and more broadly in my insistence on the importance of corporeal as distinct from specular and/or psychoanalytic considerations in my readings of Courbet's pictures.

46. Quoted in Pierre Schneider, *Louvre Dialogues,* trans. Patricia Southgate (New York: Atheneum, 1971), p. 38. See also Miró's remarks on the *Burial* and the *Studio* (pp. 39–40).

47. It may or may not be significant that the grotto in the *Source of the Loue* pictures is divided into two somewhat unequal smaller caves, but in any case there exists a number of works by Courbet in which the implied movements into and out from the painting are each associated with a distinct half of the pictorial field. For example, in one of the grandest of all Courbet's landscapes, *The Stream of the Black Well, Valley of the Loue (Doubs)* in the National Gallery in Washington, D.C. (1855; fig. 111), the right half of the composition is largely given over to the stream itself, which as it approaches the picture surface descends past slight shifts of level in its stony bed, while the left half includes what is perceived to be a lushly overgrown path leading back into the picture space between the central stand of trees and the grayish vertical rock walls further to the left. Indeed it may be the appeal to Courbet of the possibility of evoking that double movement that explains his choice of so difficult a motif, the stand of trees seen end-on, which being perpendicular to the picture plane could scarcely be developed spatially and which moreover bisects the composition into two nearly equal halves.

Or consider a different sort of picture, one not irrelevant to the topic of this chapter—*The Trellis* or *Young Woman Arranging Flowers* (1862; fig. 112). In this attractive but also disorienting work the young woman's insertion into the picture space (note how her body has been depicted partly from behind) is juxtaposed with a point-blank outpouring

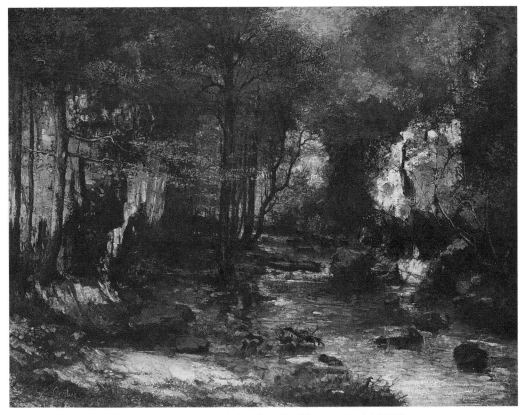

Figure 111. Gustave Courbet, *The Stream of the Black Well, Valley of the Loue (Doubs)*, 1855.

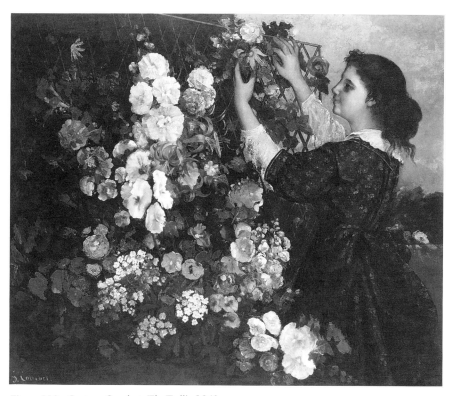

Figure 112. Gustave Courbet, *The Trellis,* 1862.

of flowers that not only is conspicuously nearer to us than she is but seems on the verge of erupting this side of the picture surface. Here too a comparison with the central group in the *Studio* is pertinent, the young gardener combining aspects of the seated painter and standing model, the advancing flowers being comparable to the outward-flowing water-like representations, and the overall rectilinearity and indeed the open weave of the trellis recalling the shape and, metaphorically, the permeability of the picture on the easel in the central group.

Finally, there are works in which the signs of a double movement into and out from the painting play a subordinate if not marginal role. For example, the large and awkward *Hunt Picnic* (1858–59; fig. 113) depicts at the lower left a bright blue stream that reads as if it is flowing toward the picture surface, while in the middle distance toward the right a curving path winds back into the landscape, culminating in a black cavelike entrance in the rocky hillside just above and to the right of the standing huntsman's head. (The notion of a double movement is also suggested by the mouth of the huntsman's horn, which faces directly toward us as if we were the target of its sound but which in its blackness and "holeness" repeats the motif of the cave.) Yet the composition as a whole is static and the viewer's relation to it is in no way unusual.

Similarly, in the even larger *Fighting Stags, Rutting in Spring* (1861; fig. 90), the shallow stream that fills the lower right portion of the composition is plainly meant to be perceived as flowing toward the picture surface (note the shifts of level on its route),

while a counterdirection if not quite a countermovement is indicated by the bodily orientation of the leftmost of the two fighting stags and perhaps also by the hint of a sunlit clearing further back in the woods. Or again, in the final version of *The Young Women of the Village Giving Alms to a Cow-Girl in a Valley near Ornans* (1851; fig. 114) traces of a path leading into the scene are juxtaposed with a thin stream that wanders toward the picture surface from a source in the hillside rising beyond the figure group. None of the three works just mentioned can be ranked among Courbet's masterpieces, and it is unclear whether their marginal or otherwise less than determining notations of movement into and out from the painting should be seen as mere repetitions of characteristic motifs or whether, on the contrary, the notations in question express a desire for merger which, taken in their entirety, these particular works are more than usually powerless to actuate. In this connection we might note that in the small, exquisite *Study for the Young Women of the Village* in Leeds (1851; fig. 115) both path and stream are far more evident than in the final canvas, and that one consequence of Courbet's decision to focus much more closely on the young women in the latter seems to have been the suppression of interplay between reciprocal directionalities. But there is in the final version perhaps a vestige of that interplay in the confusing scale of the cows, which appear either too small for their distance from the picture surface or too near for their physical size.

48. A similar platform appears in the Washington, D.C., picture mentioned in n. 45 above, and indeed a figure standing on it and wielding a long staff has been viewed by Hertz as a surrogate for the painter (*The End of the Line,* p. 217).

49. Louvre, RF 29234, fol. 24.

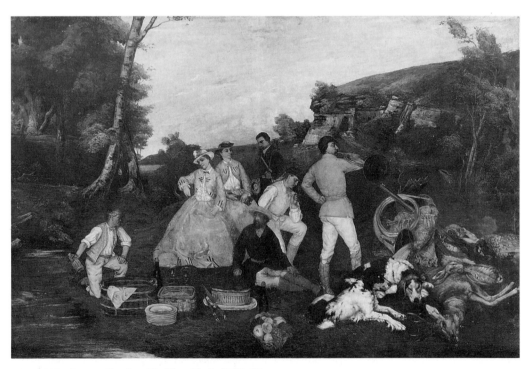

Figure 113. Gustave Courbet, *The Hunt Picnic,* 1858–59.

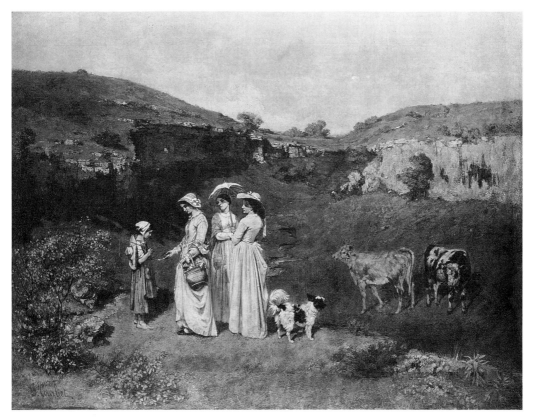

Figure 114. Gustave Courbet, *The Young Women of the Village Giving Alms to a Cow-Girl in a Valley near Ornans,* 1851.

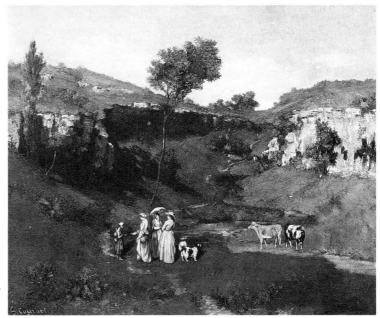

Figure 115. Gustave Courbet, *Study for the Young Women of the Village,* 1851.

50. See Robert Rosenblum, "The Origin of Painting: A Problem in the Iconography of Romantic Classicism," *Art Bulletin* 39 (Dec. 1957):279–90.

51. To go a step further in making these images read one another, if we now ask what in the drawing of the bridge similarly preconditions representation (i.e., its reflection in the river), the answer would have to be the bridge's—nature's—absorption *in itself*. I think of such a state as one that can be neither seen nor represented directly but that, like Ravaisson's continuity of nature, Courbet's art continually finds means to evoke.

52. Other depictions of figures absorbed in reading (or looking at images in a book) include the *Portrait of Trapadoux* (1849), the *Portrait of Adolphe Marlet* (1851), and the portrait drawing of *François Sabatier* (1854 or 1857), not to mention the image of Baudelaire bent over his book at the extreme right of the *Studio*.

53. Steinberg, "The Algerian Women and Picasso at Large," pp. 174–75.

## Chapter Seven

1. The two points are related: the life-size or just-over-life-size human figure functioned for Courbet as for David as a module of naturalness (*vide* the conspicuously displayed and meticulously described right hand of Horatius *père* in the *Oath of the Horatii*), and that module in turn enabled both painters to produce much larger canvases than nonfigure-based genres (e.g., landscape) found it credible to authorize, or for that matter than twentieth-century abstract painting has been able comfortably to sustain (the largest successful *Unfurleds* by Morris Louis run to around fourteen feet in width; both the *Sabines* and the *Leonidas* surpass that easily, while the *Burial at Ornans* is roughly half again as wide).

2. This isn't to overlook that in several works (mainly known to us from engravings) Chardin depicted small groups of children collectively engrossed in an activity or pastime, but compositionally these tend to depend on centripetal structures that are altogether different in feeling from the continuous or "processional" ones that have been noted in paintings like the *After Dinner, Stonebreakers,* and *Burial*.

3. In the earlier, Stockholm version of the *Draughtsman* (ca. 1738) the tear reveals a bright red shirt or lining underneath.

4. See for example Brookner, *Jacques-Louis David*, p. 43.

5. The *Wrestlers* was exhibited in the Salon of 1853 along with the *Bathers* and the *Sleeping Spinner*. For a political reading of the *Wrestlers* see Klaus Herding, "*Les Lutteurs* 'détestables': Critique de style, critique sociale," *Histoire et Critique des Arts,* nos. 4–5 (May 1978):95–122. I have touched on the relationship between the *Wrestlers* and the *Bathers* in chapter 5, n. 26.

6. In the *Man with the Leather Belt,* of course, the hand on the (viewer's) right is the sitter's left hand, which compositionally is subordinate to the sitter's right hand. But in the *Stonebreakers* and the *Wheat Sifters,* as in the *Wrestlers,* the dominant figure is on the right.

7. See Courthion 2:90. (Chez ces animaux, il n'y a aucun muscle apparent; le combat est froid, la rage profonde, les coups sont terribles et ils n'ont pas l'air d'y toucher.)

8. Ibid., p. 89. (Le *Combat de Cerfs* doit avoir, dans un sens différent, l'importance de l'*Enterrement*.)

9. Nochlin has persuasively associated the image of the stag with an engraving after a picture by the British artist Sir Edwin Landseer ("Gustave Courbet's *Meeting*," p. 213), but the dramatic force of Courbet's painting—arguably his greatest success in this vein—feels positively Davidian.

10. This isn't to question Nochlin's discovery that the basic composition was derived from traditional images of the Wandering Jew (see Nochlin, "Gustave Courbet's *Meeting*").

11. In fact the first word of the painting's French title, *Combat des cerfs, rut de printemps,* contains in order the consonants that also appear in Courbet's name. I was led to think about the *Fighting Stags* in this connection by the painter Bram van Velde's remark in front of it: "Courbet is one of those men who have made a name become a thing" (quoted in Schneider, *Louvre Dialogues,* p. 78).

12. Claude Vignon, quoted in "Pour ou contre l'*Enterrement à Ornans*," *Les Amis de Gustave Courbet, Bulletin,* no. 9 (1951):10. (Imaginez-vous une toile de huit ou dix mètres qui semble avoir été coupé dans une de cinquante, parce que tous les personnages, rangés en ligne sur le devant de tableau, sont au même plan et paraîssent ne former qu'un épisode d'un immense décor; il n'y a point de perspective, point d'agencement, point de composition.)

13. Edmond About, *Nos Artistes au salon de 1857* (Paris: Hachette, 1858), p. 26. (La sottise consiste à prendre la partie pour le tout et l'accessoire pour le principal; à tâter la nature au lieu de la regarder; à nier ce qu'on ne voit pas, à mépriser ce qu'on ne comprend pas, et à croire que le monde a six pieds de long parce qu'on est myope.)

14. On the importance of the notion of the *tableau* for French painting and criticism starting around the middle of the eighteenth century see Fried, *Absorption and Theatricality,* pp. 89, 91, 93, 104, 211, 212. The significance of the distinction between *tableaux* and *morceaux* for our understanding of Courbet and Manet is adumbrated in Fried, "Manet's Sources," nn. 11, 27, 46, 99, 114, 228. On the use of the concepts of *morceau, tableau,* and related terms in criticism of the art of Claude Monet see Steven Z. Levine, *Monet and His Critics* (New York and London: Garland, Outstanding Dissertations in the Fine Arts, 1976).

15. E[tienne]-J[ean] Delécluze, *Exposition des artistes vivants, 1850* (Paris: Comon, 1851), pp. 30–32. Delécluze's point is that what he sees as Courbet's abnegation of the resources of art on the level of composition couldn't have been based on ignorance, both because of the widespread dissemination of artistic ideas and because of the evidence of Courbet's paintings themselves. The crucial passage reads: "Comment croire que M. Courbet aurait pu, lui seul, échapper à ce chaos scientifique au milieu duquel nous vivons, surtout si, après avoir accoûtumé son oeil à l'aspect repoussant de son tableau d'*enterrement,* on découvre dans certains détails de cette toile des parties très-bien peintes et jusqu'à des figures entières qui décèlent une habileté peu commune?" (p. 36).

16. Gustave Planche, "Salon de 1852," in *Etudes sur l'école française (1831–1852),* 2:292–93 (il a gardé . . . toute son inaptitude pour la composition, et cette inaptitude est tellement évidente, que ses toiles sont tout bonnement des morceaux copiés et ne ressemblent pas à des tableaux).

17. As noted by Planche, ibid., p. 294. See also chapter six, n. 47.

18. Quoted in Sensier, *Millet,* pp. 202–3 (J'aime voir la peinture robuste, saine, jeune; Courbet en fait souvent de bien étonnante; mais l'homme manque de sens commun. Il ne saura jamais faire un tableau).

19. Zacharie Astruc, *Le Salon intime. Exposition au Boulevard des Italiens avec une préface extraordinaire* (Paris: Poulet-Malassis et De Broise, 1860) p. 65. (M. Courbet n'apporte pas, dans l'ordonnance de ses oeuvres, tout le soin désirable. . . . A l'inverse de Delacroix, qui ne voit plus qu'un ensemble où résonne l'idée, lui se plaît au morceau spécial qui l'éloigne. Du morceau on monte à l'ensemble, au tableau: de là des erreurs et des contradictions d'accord.)

20. See Moreau-Nélaton, *Millet*, 2:106–107; I have taken certain slight liberties with the translation. ([J]e désire, dans ce que je fais, que les choses n'aient point l'air d'être amalgamées au hasard et par l'occasion, mais qu'elles aient entre elles une liaison indispensable et forcée; que les êtres que je représente aient l'air voués à leur position, et qu'il soit impossible d'imaginer qu'ils pourraient être autre chose; somme toute, que gens ou choses sont toujours là pour une fin. Je désire mettre pleinement et fortement ce qui est nécessaire . . .)

21. Diderot, *Oeuvres esthétiques*, p. 780. (Une composition doit être ordonnée de manière à me persuader qu'elle n'a pu s'ordonner autrement; une figure doit agir ou se reposer, de manière à me persuader qu'elle n'a pu agir autrement.) On Diderot's ideal of internal causal necessity in painting see Fried, *Absorption and Theatricality*, pp. 85–87, 210, 214.

22. Sensier, *Millet*, p. 57. (Après Michel-Ange et Poussin, j'en suis resté à ma première inclination pour les maîtres primitifs, à ces sujets simples comme l'enfance, à ces expressions inconscientes, à ces êtres qui ne disent rien, mais se sentent surchargés de la vie, ou qui souffrent patiemment sans cris, sans plaintes, qui subissent la loi humaine et n'ont pas même l'idée d'en demander raison à qui que ce soit. Ceux-là ne faisaient pas de l'art révolté comme de nos jours.) As Albert Boime points out, however, Sensier worked for the Ministry of the Interior during Louis Napoleon's reign, which suggests that he may not be a reliable guide to Millet's politics then or later ("The Second Empire's Official Realism," in *The European Realist Tradition*, ed. Gabriel P. Weisberg [Bloomington: Indiana University Press, 1982], p. 105).

23. On Millet's politics see Clark, *The Absolute Bourgeois*, pp. 72–98, who concludes:

So whether Millet's art was a compensatory myth—whether he tried to redefine a peasant status he had lost, or never had; whether it was a way to forget the actual context of his poverty, the long years of painting nudes for the market and feeding bastards in a Paris slum—that is an open question. . . . He was more literary than he pretended, but he was also more specific in his references. He painted in the shadow of Virgil or La Bruyère; but also in the shadow of the forest guard and the "certificate of indigence." His peasant was the farmer of the *Georgics*, but also "the proletarian of 1860," or the peasant in the *banlieu* in the spring of 1849 (p. 98).

A page earlier Clark refers to a letter from Millet to Théodore Pelloquet dated 2 June 1863 that speaks of the impossibility of imagining that the figures in his compositions "'should ever have the idea of being anything except what they are'" (p. 97; qu'il soit impossible d'imaginer qu'il leur puisse venir à l'idée d'être autre chose que ce qu'ils sont). Clark continues: "That formula corrects an earlier remark that Millet made to Thoré [in the letter cited above], that it should be impossible for *us* to think of them otherwise. But we can see oppression, even if they cannot. Perhaps we are shown it, and expected to react" (p. 98). (For the text of the letter to Pelloquet see Moreau-Nélaton, *Millet*, 2:130–32). But the difference—the equivocation—between the two formulas is one that Millet's art, precisely because of its compositional ideal, is itself powerless to resolve.

See also Herbert, "Peasant Naturalism and Millet's Reputation," in the exhibition catalog *Jean-François Millet*, who argues that Millet "was essentially a pessimist who believed that fate and history were apolitical forces that kept the peasant in his weary place. However, the liberal reformers who commented upon his art believed that fate and history were the weapons of established authority, and therefore subject to challenge: the artist's dialogue between man and fate became the reformer's dialectic between man and oppressive social forces" (p. 11). Herbert goes on to insist that Millet "was not a reactionary

opposed to change" and that "[h]e recognized and sanctioned, within reason, the use to which his art was put, although he was sufficiently detached to doubt its efficacy" (ibid.).

Finally, Boime has some interesting comments on the Imperial regime's attempted and, in his view, partly successful cooptation of both Millet and Courbet in "The Second Empire's Official Realism," pp. 104–10.

24. It's perhaps worth emphasizing that my claim that Courbet's repudiation of drama involved, with certain rare exceptions, a rejection of conflict and opposition as thematic and structural principles is *not* a claim that his art, with those exceptions, is devoid of all traces of conflict. Thus I have called attention to a recurrent psychomachy concerning the homonyms Courbet/*courbé;* to the possibility that conflictual forces may have been at work in the genesis of the *Burial* (see chapter four, n. 50); and to the tension between Courbet's desire for merger and the demands of genre in both the self-portraits and the nudes. More broadly, I argue further on in this chapter that the impossibility of actually, corporeally, merging with the paintings before him was constitutive of his project of quasi-corporeal merger (see below, pp. 269–70).

Also, before leaving the general topic of Courbet and drama I want to suggest that Courbet's antidramatic vision may help explain the conspicuous weakness of his few sculptures. The pertinent contrast in this regard would be with the two great painter-sculptors who preceded him, Géricault and Daumier, for both of whom plasticity as such was a vehicle of drama. The failure of the *Wrestlers,* Courbet's most "sculptural" painting, is also to the point.

25. Toussaint, p. 152.

26. Ibid., p. 150. See also Toussaint, "Mystères et symboles chez Courbet," *Connaissance des Arts,* no. 308 (Oct. 1977):66. Surprisingly, the catalog for the recent exhibition, *Courbet Reconsidered,* in which the *Gour de Conches* was shown, doesn't mention Toussaint's observations and in fact says nothing about the question of anthropomorphism in her sense of the term.

27. Toussaint, p. 269.

28. Ibid., p. 152.

29. The drawings and watercolors, which formerly belonged to Courbet's sister Zoë and her painter husband Jean-Eugène Reverdy, are attributed to Courbet by Klaus Herding, "Die Lust, aus Gegensätzen eine Welt zu bauen. Courbet als Zeichner," in the exhibition catalog by Klaus Herding and Katharina Schmidt, *Les Voyages secrets de Monsieur Courbet: Unbekannte Reiseskizzen aus Baden, Spa und Biarritz,* (Baden-Baden: Staatliche Kunsthalle, 15 Jan.–11 Mar. 1984; Zurich: Kunsthaus, 13 Apr.–10 June 1984). If accepted as authentic they would entail a comprehensive reappraisal not just of previous notions of Courbet's activity as a draughtsman but also of other, more central aspects of his art. But they are plainly not by Courbet, as Petra ten Doesschate-Chu was the first to demonstrate in her review of the above exhibition in *Master Drawings* 22 (Winter 1984):455–61. See also the negative assessment by Matthias Bleyl, *Pantheon* 42 (Apr.–June 1984):161–62.

30. Doesschate-Chu, ibid., p. 46, n. 13. She writes: "The authors [Herding and Schmidt] place a good deal of emphasis on the use of 'hidden pictures' in the drawings . . . But, so far the only example of this practice in Courbet's art is the *Fantastic Landscape with Anthropomorphic Rocks* (private collection), which was first seen at the Courbet exhibition in the Louvre in 1977 (cat. no. 81). There is no unanimous agreement as to the attribution of this painting."

31. See Nochlin, "Gustave Courbet's *Meeting,*" p. 213, as well as the catalog entry by Nochlin in *Courbet Reconsidered,* cat. no. 44, p. 150. As Nochlin explains in her entry,

the complete subtitle of [Courbet's picture], ". . . known as the oak of Vercingétorix, Caesar's Camp near Alesia, Franche-Comté," suggests that the oak played a role in a heated archaeological dispute of the mid-nineteenth century over the precise location of the historic plateau that had served as the battleground for Caesar's defeat of the Gallic chieftain, Vercingétorix, in the Battle of Alesia in B.C. 52. The choice was between Alaise, near Flagey, where Courbet's family owned property, or the Mont Auxois, near Alise-Ste.-Reine in the Côte d'Or. The latter location finally won out.

She also notes that a dominating oak tree had appeared at least four times in Courbet's oeuvre before the *Oak at Flagey,* and concludes: "There is a sense in which this tree is a kind of self-portrait, a portrait of the artist as an old oak tree, rooted firmly in the ground: energetic, powerful, if twisted in his body, outreaching and expansive in his creation. Nature and artist, landscape and art, seem to have assumed a single identity here."

32. In fact I'm not persuaded by her reading, no doubt partly because of my own interpretation of the model's dress as swirling water. In any case, nothing about the dress can be said to frighten the cat (as Toussaint claims), who seems rather to be absorbed in playing with a ball.

33. In *Courbet und Deutschland* the drawing is given the title "The Source of the Loue," which is plainly inappropriate (cat. no. 321, pp. 351–52).

34. Cf. Neil Hertz's fine discussion of a passage from the opening of book two of William Wordsworth's *The Prelude* in which a split consciousness on the part of the poet-narrator is associated *both* with "a grey stone of native rock" and with "that old dame from whom the stone was named" (*The End of the Line,* pp. 233–39).

35. See Peter-Klaus Schuster, *Courbet und Deutschland,* cat. no. 294, p. 313; cited in *Courbet Reconsidered,* cat. no. 79, p. 195. The classic essay on the topic is Meyer Schapiro, "The Apples of Cézanne: An Essay on the Meaning of Still-life," in *Modern Art,* pp. 1–38. More recently, Cézanne's still lifes have been read in terms of a hidden unconscious sexual and familial imagery by Geist, *Interpreting Cézanne,* pp. 75–98 and *passim.* Geist's study, with its purported discovery of innumerable "cryptomorphs" and rebus-like structures in Cézanne's paintings, is pertinent to the larger issue of anthropomorphism in Courbet as well as to other issues treated in this book (e.g., the signature effects discussed in relation to the *Stonebreakers* and *Fighting Stags*), with the important difference that Geist situates his discoveries in an exclusively psychological rather than a primarily pictorial context.

36. This brings to mind the passage in Diderot's *Salon de 1767,* cited in *Absorption and Theatricality* as another instance of his pastoral conception (p. 122), in which the viewer is said to stop in front of a still life by Chardin "as if by instinct, as a traveller tired of his journey sits down almost without being aware of it in a spot that offers him a bit of greenery, silence, water, shade, and coolness" (Denis Diderot, *Salons,* III, ed. Jean Seznec and Jean Adhémar [Oxford: Clarendon Press, 1963], pp. 128–29). (On s'arrête devant un Chardin comme d'instinct, comme un voyageur fatigué de sa toute va s'asseoir, sans presque s'en appercevoir, dans l'endroit qui lui offre un siège de verdure, du silence, des eaux, de l'ombre et du frais.) Once again the crucial difference between Chardin (as seen by Diderot) and Courbet (as described by me) turns out to involve, on Courbet's part, a more intensely corporeal relation between painting and beholder, a relation emblematized by the fantasmatic nudes and the possibility of merger they evoke.

37. See Nochlin, *Realism,* pp. 72–73, where it is said that

we are hard pressed to decide whether or not this is simply a still life in the making or some sort of disguised and highly ambivalent self-image of the artist in prison or caught on the hook of circumstances of post-Commune retribution. In the end we accept it for what it is: a fish, captured in

paint, at the moment between watery life and earthy death, something Courbet, who was an enthusiastic hunter and fisherman, would have been extremely familiar with and which he felt he wanted to record (p. 73).

See also *Courbet Reconsidered,* cat. no. 86, p. 200.

38. This sort of echoing or miming of elements within a single picture occurs elsewhere in Courbet's oeuvre. For example, in the *Young Women of the Village* a rock in the lower right-hand portion of the canvas is a close match for the head of the black-and-white dog who perhaps is barking at the cows, while slightly to the left of the young cowherdess another rock suggests the image of a bearded male head facing downward at roughly the same angle as the head of the leftmost of the three women.

39. Courbet's final illness grotesquely bloated his body with liquid. We also know, though naturally we can't be confident we know what it means, that as the dying painter lay in his bed in La Tour-de-Peilz gazing at Lake Leman he repeatedly cried out, "If I could swim in it for even five minutes I would be cured" (Courthion 1:320). (Si je pouvais y nager, seulement cinq minutes, je serais guéri!) In a letter of 31 December 1877, Dr. Paul Collin, who attended Courbet at the end, reports him as saying "Je suis comme un poisson dans l'eau" and "[S]i je pouvais m'étendre dans les eaux du lac, je serais sauve [sic]" ("Gustave Courbet à La Tour de Peilz. Lettre du Docteur Paul Collin," *Les Amis de Gustave Courbet, Bulletin,* no. 57 [1977]:3). See also Collin's moving account of the dying Courbet's love of baths in the same letter.

40. The flower pieces of 1862–63 were painted in Saintonge where Courbet was staying with Etienne Baudry, a young collector and man of letters. See Roger Bonniot, *Gustave Courbet en Saintonge* (Paris: Librairie C. Klincksieck, 1973).

41. In addition we might think of the odor of the flowers as figuring the odor of turpentine and oil paint. On the history of the concern with odor in eighteenth- and nineteenth-century France see Alain Corbin, *The Foul and the Fragrant: Odor and the French Social Imagination,* trans. Miriam L. Kochan with Dr. Roy Porter and Christopher Prendergast (Cambridge: Harvard University Press, 1986).

42. Baudelaire, "De l'Essence du rire, et généralement du comique dans les arts," in *Curiosités esthétiques,* pp. 241–63.

43. Ibid., p. 254.

Le comique est, au point de vue artistique, une imitation; le grotesque, une création. Le comique est une imitation mêlée d'une certaine faculté créatrice, c'est-à-dire d'une idéalité artistique. Or, l'orgueil humain, qui prend toujours le dessus, et qui est la cause naturelle du rire dans le cas du comique, devient aussi cause naturelle du rire dans le cas du grotesque, qui est une création mêlée d'une certaine faculté imitatrice d'éléments préexistants dans la nature. Je veux dire que dans ce cas-là le rire est l'expression de l'idée de supériorité, non plus de l'homme sur l'homme, mais de l'homme sur la nature. Il ne faut pas trouver cette idée trop subtile; ce ne serait pas une raison suffisante pour la repousser. Il s'agit de trouver une autre explication plausible. Si celle-ci paraît tirée de loin et quelque peu difficile à admettre, c'est que le rire causé par la grotesque a en soi quelque chose de profond, d'axiomatique et de primitif qui se rapproche beaucoup plus de la vie innocente et de la joie absolue que le rire causé par le comique de moeurs. Il y a entre ces deux rires, abstraction faite de la question d'utilité, la même différence qu'entre l'école littéraire intéressée et l'école de l'art pour l'art. Ainsi le grotesque domine le comique d'une hauteur proportionnelle.

On the comparison between "l'école littéraire intéressée" and "l'école de l'art pour l'art," see Baudelaire's first article on Pierre Dupont (1851), which includes the remark: "The puerile utopia of the school of *l'art pour l'art* excluded morality and often even passion, and this necessarily made it sterile" (*Oeuvres complètes,* p. 605). (La puérile utopie de l'école de *l'art pour l'art,* en excluant la morale, et souvent même la passion, était néces-

sairement stérile.) See also Benjamin's commentary on that remark in "The Paris of the Second Empire in Baudelaire," pp. 26–27.

44. Baudelaire, "De l'Essence du rire," p. 262 (l'essence de ce comique est de paraître s'ignorer lui-même et de développer chez le spectateur, ou plutôt chez le lecteur, la joie de sa propre supériorité et la joie de la supériorité de l'homme sur la nature).

45. On Courbet, the Commune, and the Vendôme Column see for example Rodolphe Walter, "Un Dossier délicat: Courbet et la Colonne Vendôme," *Gazette des Beaux-Arts,* ser. 6, 81 (Mar. 1973):173–84; Linda Nochlin, "Courbet, die Commune und die bildenden Kunste," in *Realismus als Widerspruch,* pp. 248–62; and the useful summary of events by Sarah Faunce, "Reconsidering Courbet," in *Courbet Reconsidered,* pp. 14–15.

46. See Pierre-Joseph Proudhon, *Du Principe de l'art et de sa destination sociale.*

47. See Champfleury, "L'Enterrement d'Ornans"; and Emile Zola, "Proudhon et Courbet," in *Mes Haines: Causeries littéraires et artistiques* (Paris: Bibliothèque-Charpentier, 1923), pp. 21–40.

48. The full story of Courbet's relations with the Imperial regime remains to be written. On Bruyas's political views see Philippe Bordes, "Montpellier, Bruyas et Courbet," in *Courbet à Montpellier,* pp. 23–38. According to Bordes, "[Bruyas] voit dans la prise du pouvoir par Louis Napoléon, Prince-Président puis Empereur, le triomphe du bien et l'espoir d'une réconciliation sociale après une période d'épreuves pour la France" (p. 27). See also Herding, "Das *Atelier des Malers,*" pp. 235–36. On Courbet's relations with the comte de Nieuwerkerke, Superintendant of Fine Arts under the Second Empire, see Herding, ibid., pp. 235–37; Boime, "The Second Empire's Official Realism," pp. 107–10; and Marie-Thérèse de Forges, "Biographie," in Toussaint, pp. 30, 35–36, 42. Toussaint indeed has gone so far as to suggest that Courbet's unfinished *Firemen Rushing to a Fire* was commissioned by Louis Bonaparte as an allegory in support of his presidency and that the painter's acceptance of the commission was somehow linked with "l'incontestable protection dont va bénéficier Courbet tout au cours du Second Empire, en dépit de ses perpétuelles rodomontades d'opposant au régime" ("Le Réalisme de Courbet au service de la satire politique et de la propagande gouvernementale," p. 243).

49. Linda Nochlin, "The De-Politicization of Gustave Courbet: Transformation and Rehabilitation under the Third Republic," *October,* no. 22 (1986):76–86.

50. See for example Nochlin's comparison of Courbet's *Portrait of Baudelaire* with Chardin's *Boy with the Top,* the point of which is to show that whereas the latter "is arranged according to an established hierarchy of values, one might indeed say that Courbet's is a democratic portrait in every sense of the word" (pp. 68–69). See also the passage from her *Realism* quoted in chapter four, n. 10. Analogous notions are applied to Courbet's landscapes by Klaus Herding in "Egalität und Autorität in Courbets Landschaftsmalerei," *Stadel-Jahrbuch* 5 (1975):159–87.

51. Clark, p. 13. A few pages earlier Clark writes: ". . . I do not want the social history of art to depend on intuitive analogies between form and ideological content—on saying, for example, that the lack of firm compositional focus in Courbet's *Burial at Ornans* is an expression of the painter's egalitarianism, or that Manet's fragmented composition in the extraordinary *View of the Paris World Fair* (1867) is a visual equivalent of human alienation in industrial society" (pp. 10–11). In this connection see also Anne M. Wagner's criticisms of Herding's reading of Courbet's landscape style in "Courbet's Landscapes and Their Market," *Art History* 4 (Dec. 1981):428.

52. Clark, p. 12.

53. Ibid., pp. 121–54.

54. Clark's interpretation of the Parisian response to the *Burial* and related works is

disputed, to my mind convincingly, by Françoise Gaillard, who insists on the importance of considerations of picture-size, composition, technique, etc., in the writings of the *Burial*'s critics ("Gustave Courbet et le réalisme: Anatomie de la réception critique d'une oeuvre: 'Un Enterrement à Ornans,'" *Revue d'Histoire Littéraire de la France* 6 [1980]:978–96). See also my brief discussion of Clark's claim that the ambiguous social status of Courbet's family is represented in his paintings in chapter four, n. 26.

Another point of disagreement with Clark concerns his assessment of the place and meaning of landscape in Courbet's oeuvre. "Courbet's landscape style was in fact an integral part of his Realism," Clark writes:

> Its failure, for it seems to me the weakest part of Courbet's art, is almost necessary to the figure paintings' success. It is as if he split his art in two, and made landscape the absolute antithesis of his paintings of the human world. He made it a world from which human beings, and even for the most part the traces of human industry and transaction, were essentially absent. He adopted the new myths of solitude, the Romantic view of landscape. And in the process he rejected the most fertile tradition in landscape painting—its essential theme, in the hands of the French and Dutch masters of the seventeenth century—the record of a human presence, the painting of landscapes thick with the remains of a human past, landscape created by man, in fact as well as on canvas, dragged from the sea, drained, enclosed, cultivated; a landscape on which wilderness and solitude merely encroach, as reminders of the efforts men make to end them both (p. 132).

Clark is right to distinguish Courbet's landscapes from the work of the seventeenth-century masters to whom he alludes, but naturally I don't agree that Courbet "split his art in two" or that his landscapes are the "absolute antithesis" of his figure paintings—on the contrary, I have tried to show that the figure paintings and the landscapes represent the same fundamental project, one that belongs precisely to the realm of "human industry and transaction." (A sharp distinction between the landscapes and figure paintings is also made by Wagner, "Courbet's Landscapes and Their Market.") See also the discussion of Clark's reading of the *Stonebreakers* later in this chapter.

55. See Herding, "Das *Atelier des Malers*," pp. 223–47, as well as my brief summary of his argument in chapter five (pp. 157–58).

56. See the bibliography in *Courbet Reconsidered* for references to articles by Diane Lesko, James McCarthy, Patricia Mainardi, and Neil McWilliam, among others.

57. Foucault first develops the account of what he calls disciplinary society in *Discipline and Punish*, and elaborates on it in *The History of Sexuality* as well as in *Power/Knowledge* (see chapter one, n. 62). See also the helpful discussion of his later views in Dreyfus and Rabinow, *Michel Foucault*, pp. 101–207.

58. At any rate, Foucault places the "completion of the carceral system" around 1840 (*Discipline and Punish*, p. 293). See also his comments on the 1840s in *Power/Knowledge*, pp. 45–47. Incidentally, Foucault's remarks on the way in which power interacts with the body are pertinent to my insistence that Courbet was less than fully conscious of his antitheatrical project. "What I want to show is how power relations can materially penetrate the body in depth," Foucault says, "without depending even on the mediation of the subject's own representations. If power takes hold on the body, this isn't through its having first to be interiorised in people's consciousnesses. There is a network or circuit of bio-power, or somato-power, which acts as the formative matrix of sexuality itself as the historical and cultural phenomenon within which we seem at once to recognise and lose ourselves" (*Power/Knowledge*, p. 186). Foucault's main concern in these remarks is sexuality, but the general principle holds for other historical and cultural phenomena as well.

59. On Foucault's notion of resistance see *Power/Knowledge*, p. 142, where he hypothesizes that

there are no relations of power without resistances; the latter are all the more real and effective be-
cause they are formed right at the point where relations of power are exercised; resistance to power
does not have to come from elsewhere to be real, nor is it inexorably frustrated through being the
compatriot of power. It exists all the more by being in the same place as power; hence, like power,
resistance is multiple and can be integrated in global strategies.

Elsewhere in *Power/Knowledge* Foucault remarks:

As always with relations of power, one is faced with complex phenomena which don't obey the
Hegelian form of the dialectic. Mastery and awareness of one's own body can be acquired only
through the effect of an investment of power in the body: gymnastics, exercises, muscle-building,
nudism, glorification of the body beautiful. All of this belongs to the pathway leading to the desire
of one's own body, by way of the insistent, persistent, meticulous work of power on the bodies of
children or soldiers, the healthy bodies. But once power produces this effect, there inevitably
emerge the responding claims and affirmations, those of one's own body against power, of health
against the economic system, of pleasure against the moral norms of sexuality, marriage, decency.
Suddenly, what had made power strong becomes used to attack it, Power, after investing itself in the
body, finds itself exposed to a counterattack in that same body (p. 56).

See also Foucault's essay, "The Subject of Power," in which he suggests that

at the heart of power relations and as a permanent condition of their existence there is an insubordi-
nation and a certain essential obstinacy on the part of the principles of freedom [and that therefore]
there is no relationship of power without the means of escape or possible flight. Every power rela-
tionship implies, at least *in potentia,* a strategy of struggle, in which the two forces are not superim-
posed, do not lose their specific nature, or do not finally become confused. Each constitutes for the
other a kind of permanent limit, a point of possible reversal (in Dreyfus and Rabinow, *Michel Fou-
cault,* p. 225).

60. See especially Foucault's association of "the global functioning of what I would
call a *society of normalisation*" with the rise of an "arbitrating discourse . . . a type of power
and of knowledge that the sanctity of science would render neutral" (*Power/Knowledge,* p.
107). On "the power of the Norm" see for example *Discipline and Punish,* p. 184 and
*passim.*

61. Karl Marx, *Grundrisse: Foundations of the Critique of Political Economy,* trans. Mar-
tin Nicolaus (New York: Vintage Books, 1973), p. 93; I have slightly modified the trans-
lation in response to suggestions by Werner Hamacher, to whom I am also indebted for
sharing with me his understanding of Marx's thought. The original reads:

Die Produktion ist nicht nur unmittelbar Konsumtion und die Konsumtion unmittelbar Produk-
tion; noch ist die Produktion nur Mittel für die Konsumtion und die Konsumtion Zweck für die
Produktion, d. h. dass jede der andren ihren Gegenstand liefert, die Produktion äusserlichen der
Konsumtion, die Konsumtion vorgestellten der Produktion; sondern jede derselben ist nicht nur
unmittelbar die andre, noch die andere nur vermittelnd, sondern jede der beiden schafft, indem sie
sich vollzieht, die andre; sich als die andre. Die Konsumption vollzieht erst den Akt der Produktion,
indem sie das Produkt als Produkt vollendet, indem sie es auflöst, die sebständig sachliche Form an
ihm verzehrt; indem sie die in dem ersten Akt der Produktion entwickelte Anlage durch das Bedürf-
nis der Wiederholung zur Fertigket steigert; sie ist also nicht nur der abschliessende Akt, wodurch
dans Produkt Produkt, sondern auch, wodurch der Produzent Produzent wird. Andrerseits produ-
ziert die Produktion die Konsumtion, idem sie die bestimmte Weise der Konsumtion schafft, und
dann, indem sie den Reiz der Konsumtion, die Konsumtionsfähigkeit selbst schafft als Bedurfnis
(*Grundrisse der Kritik der Politischen Ökonomie* [Berlin: Dietz Verlag, 1974], pp. 14–15).

62. On at least one occasion Courbet is reported to have spoken of his desire to de-
vour nature (see p. 278), while Edmond About was moved by his paintings to describe
Courbet in the following terms: "He throws himself on nature like a glutton, he seizes

huge fragments, and swallows them without chewing with the appetite of an ostrich" (*Nos Artistes au salon de 1857,* p. 144). (Il se jette sur la nature comme un glouton; il happe les gros morceaux, et les avale sans mâcher avec un appetit d'autriche.)

63. Marx himself writes: "The object of art—like every other product—creates a public which is sensitive to art and enjoys beauty. Production thus not only creates an object for the subject, but also a subject for the object" (*Grundrisse,* p. 92).

64. Thus Marx: "The individual produces a certain article and turns it again into himself by consuming it; but he returns as a productive and a self-reproducing individual. Consumption thus appears as a factor of production" (ibid., p. 27).

65. Ibid., pp. 90–91.

66. See Elaine Scarry's insistence on the centrality of the theme of embodiment to Marx's *Capital* in *The Body in Pain,* pp. 243–77. For example, Scarry writes that Marx

throughout his writings assumes that the made world is the human being's body and that, having projected that body into the made world, men and women are themselves disembodied, spiritualized. A made thing remade not to have a body, the person is himself an artifact. For Marx, material culture incorporates into itself the frailties of sentience, is the substitute recipient of the blows that would otherwise fall on that sentience, and thus continues in its colossal and collective form the "passover" activity of scriptural artifacts. Through this generous design the imagination performs her ongoing work of rescue, and because of that design Marx never disavows or discredits the western impulse toward material self-expression but is, instead, in deep sympathy with it (p. 244).

The whole of Scarry's section on Marx (and Engels) has a bearing on my account of Courbet, as for example when she remarks, apropos Engels's claim that the human hand "is not only the organ of labour, *it is also the product of labour*": "[W]hatever the specific subject matter of a particular canvas (the sea breaking on the shore, flowers opening in a vase), part of its subject matter, part of what it makes available to the viewer, is the shape of the interior complexities and precisions of the sentient tissue that held the brush" (p. 253; the quotation from Engels is from his essay, "The Part Played by Labour in the Transition from Ape to Man"). Engels's and Scarry's point would hold for all paintings; part of my aim in this book has been to show how richly Courbet's paintings reward being understood in those terms. See also Scarry's brief discussion of several works by Millet as exemplifying "the sentient continuity between subject and object" (pp. 248–49).

67. The phrase "the severing of projection and reciprocation" is part of the title of a subsection of Scarry's section on Marx (*The Body in Pain,* p. 256); the phrase "in some particular aspect" comes from the quotation from Marx cited above (see n. 65).

68. For example, in *Discipline and Punish* Foucault writes: "Surveillance thus becomes a decisive economic operator both as an internal part of the production machinery and as a specific mechanism in the disciplinary power. 'The work of directing, superintending and adjusting becomes one of the functions of capital, from the moment that the labour under the control of capital, becomes cooperative. Once a function of capital, it requires special characteristics' (Marx, *Capital,* vol. 1)" (p. 175). In an interview in *Power/Knowledge* Foucault goes so far as to say: "It is impossible at the present time [1975] to write history without using a whole range of concepts directly or indirectly linked to Marx's thought and situating oneself within a horizon of thought which has been defined and described by Marx. One might even wonder what difference there could ultimately be between being a historian and being a Marxist" (p. 53).

69. Short of what Scarry calls the "vast artifact" of material culture itself, which she characterizes as "a recreation of the body or instead, with slightly more precision, [as] a recreation of the way in which the single artifact recreates the body. If it is accurately

identified as a metaphor for the body, it is with more accuracy identified as a metaphor of the single object—it performs metaphorically the activity of absorption [of sentience] that the single object [e.g., a chair] much more literally performs" (p. 246). Whereas Courbet's paintings are single objects that bear a remarkably full, multisensory, if also largely imaginary relation to his live bodily being.

70. The crucial passage reads: "Only by dissolving the product does consumption give the product the finishing stroke [in English in the original]; for the product is production not as objectified activity, but rather only as object for the active subject . . ." (*Grundrisse*, p. 91, with slight changes). (Die Konsumtion gibt, indem sie das Produkt auflöst, ihm erst den finishing stroke; denn Produkt ist die Produktion nicht als versachlichte Tätigkeit, sondern nur als Gegenstand für das tätige Subjekt [*Grundrisse*, p. 13].) On the young Marx's interest in the visual arts see Margaret A. Rose, *Marx's Lost Aesthetic: Karl Marx and the Visual Arts* (Cambridge: Cambridge University Press, 1984), especially chap. 5, "Toward an Outline of Artistic Production, or the 'Charm' of a Materialist Aesthetic" (pp. 79–96).

71. Clark, p. 79.

72. Ibid., pp. 79–80.

73. Ibid., p. 178, n. 6. This is said by way of contrasting the "personal" nature of the *After Dinner at Ornans* with the "anonymity" of the *Stonebreakers*, or rather of making clear that Clark considers it

an achievement to see and represent one's personal involvement in an institution or a class situation, when that involvement is a reality, even if a hidden one. . . . Equally it is an achievement—and in this case a rare one—to *avoid* such a reading of a class-situation or a work-situation, when avoidance of personal reference corresponds to the facts: the "facts" of a bourgeois's radical incomprehension of the psychology of the working man, for instance. Hence the anonymity of [the *Stonebreakers*], as opposed to the conventional bourgeois reading of such scenes in terms of a personal tragedy or a generalized, but "individual," dignity of labour.

74. Baudelaire, "Puisque réalisme il y a," *Oeuvres complètes*, p. 637. (*Courbet sauvant le monde.*)

75. See Herding, "Das *Atelier des Malers*," p. 241. Thus Nochlin, summarizing Herding's reading of the *Studio*, alludes to "the redemptive and productive centering of the artist who is himself in harmony with the source and origin of all social and personal reconciliation: unspoiled nature, represented by a landscape of Courbet's native Franche-Comté on the easel before him" ("Courbet's Real Allegory: Rereading 'The Painter's Studio,'" in *Courbet Reconsidered*, pp. 20–21). I have already explained why such an interpretation of the relationship between the landscape on the easel and the seated painter at the center of the *Studio* fails to satisfy me.

76. Rosen and Zerner, *Romanticism and Realism*, p. 165.

77. Ibid., p. 153.

78. Ibid., pp. 151–52.

79. Am I reading Rosen and Zerner too strictly and do they really mean to say that whatever the respective intentions of all three artists may have been, the results are as they describe them? If so, it never occurs to them that "our" experience may be historically conditioned, and in fact the passage just quoted shifts back and forth between a rhetoric of original intention and a rhetoric of present effect in a manner that suggests it would be pointless to distinguish between the one and the other. As for their assurance that Courbet's paintings never allow us to believe that we have before us "a vivid but unreal world" along the lines of Delacroix's *Death of Sardanapalus*, who ever thought otherwise? Their

question ought to have been whether his paintings primarily evoke the existence of a vivid *and real* world or whether they compel us to focus on them as material entities of a special sort. And here the authors seem perhaps not to know their own mind: at any rate, it isn't obvious that being forced to remember that we are in front of "a painted object" is exactly equivalent to an insistence "on representation, on painting as a transcription of the experience of things." What Rosen and Zerner are certain about, however, besides the somewhat obscure proposition that in Courbet's paintings imagination is only the power of visualizing the real world, is that his subject matter is everywhere subordinated to his handling of paint, an order of priorities that makes Courbet an exemplar of the "autonomy of art" (p. 151) and that leads directly, so they maintain, to the rise of abstract painting in the twentieth century (pp. 46, 150). But for one thing, the idea that artistic modernity involved a progressive recognition of "the aesthetic indifference of subject matter" (p. 150, said apropos Flaubert) is a dubious and, one had hoped, outworn principle by which to survey the evolution of nineteenth- and twentieth-century painting (which isn't to deny that many nineteenth- and twentieth-century writers, artists, and critics professed such a doctrine); and for another, the underlying formalist assumption that paintings such as Courbet's can satisfactorily be understood in terms of a simple distinction between subject matter and execution or illusion and materiality is one that the present book explicitly opposes.

Just how complex issues of facture actually were in the middle of the nineteenth century is suggested by the fact that Ernest Meissonier, who Rosen and Zerner contrast with Courbet, was admired by contemporary critics precisely for the largeness of his touch *on a minute scale*. Here for example is Théophile Thoré:

Our *small* French painters work in a better direction than their Belgian contemporaries. Meissonier, there is a painter of small proportions, but of the grand manner. If you magnify with a strong enough loupe one of his figures, you will find an execution like that of Van der Helst, and sometimes like that of Salvator Rosa ("Salon de 1847," in *Salons,* p. 509).

Nos *petits* peintres français sont dans une meilleur direction que les Belges contemporains. Meissonier, voilà un peintre de petite proportion, mais de grande manière. Si vous grossissez avec une loupe suffisante un de ses bonshommes, vous trouverez une exécution comme celle de van der Helst, et quelque fois comme celle de Salvator Rosa.

Indeed Rosen and Zerner's comparison of Meissonier's paintings to a window is explicitly contravened by Edmond About, for whom Meissonier's "principal merit . . . is to paint more grandly [with a superior largeness of touch] and above all more solidly than our so-called history painters. Each of his little paintings is constructed like a wall" (*Salon de 1864* [Paris: Hachette, 1864], p. 74). (Son principale mérite . . . est de faire plus grand et surtout plus solide que nos soi-disant peintres d'histoire. Chacun de ses petits tableaux est construit comme un mur.) My thanks to Marc Gotlieb for drawing About's remarks to my attention.

Another significant aspect of Meissonier's art from the perspective of my argument is his predilection for absorptive themes and effects, which links his work, despite enormous differences, with Millet's and Courbet's. Indeed Meissonier's frequent choice of mid-eighteenth-century subjects (e.g., *La Lecture chez Diderot* [1859]), makes all but explicit the sense in which he too can be seen as reverting dramaturgically to the moment of or immediately preceding the inception of the Diderotian tradition.

80. Kermit Champa, "The Rise of Landscape Painting in France," draft of an essay to be published as part of the catalog for an exhibition of French landscape paintings to open at the Currier Gallery of Art in Manchester, New Hampshire, in the fall of 1990.

The main argument of the essay concerns the prevalence of a musical model for landscape practice in nineteenth-century France; Champa grants that Courbet would seem to be an exception to this, but goes on to suggest that the *Studio* may be seen as based in part on the notion of an orchestral performance, with the seated painter an instance of the "tradition of the 'composer conducting.'" "If *The Studio* is a real allegory, of what it is allegorical?" Champa asks. "Is it perhaps too glib to suggest that it is about defining painting (rather than architecture) as silent music? However, it *does* seem to be at least partly about that. What it seems more about, though, is the complexity of the strategy of pictorial making—Realist or otherwise. A theatricalized *tour de force* of painting's enterprise, where memory and technique and genius combine into an expression-laden paint construction, this seems more completely to account for *The Studio*'s appearance." I'm grateful to Kermit Champa for allowing me to see his essay in advance of publication.

81. Rosen and Zerner, *Romanticism and Realism,* p. 150. The key text in this regard is Flaubert's letter of 16 January 1852 to Louise Colet in which he describes his desire to write "a book about nothing, a book without any exterior tie, which would hold together on its own by the inner force of its style, just as the earth stays up without support, a book which would have almost no subject, or at least where the subject would be almost invisible, if that is possible" (ibid., pp. 160–61). (Ce qui me semble beau, ce que je voudrais faire, c'est un livre sur rien, un livre sans attache extérieure, qui se tiendrait de lui-même par la force interne de son style, comme la terre sans être soutenue se tient en l'air, un livre qui n'aurait presque pas de sujet ou du moins où le sujet serait presque invisible, si cela se peut.) All references but one to the French originals of Flaubert's letters are to Gustave Flaubert, *Correspondance,* 2 vols., ed. Jean Bruneau (Paris: Gallimard, Bibliothèque de la Pléiade, 1980). For the above passage see ibid., 2:31.

82. Rosen and Zerner, pp. 221–22, with slight revisions.

83. Dominick LaCapra, *"Madame Bovary" on Trial* (Ithaca and London: Cornell University Press, 1982), p. 127.

84. Quoted by LaCapra, ibid., p. 77; Flaubert, *Correspondance,* 2:204. Letter dated 9 December 1852. (L'auteur, dans son oeuvre, doit être comme Dieu dans l'univers, présent partout, et visible nulle part. L'art étant une seconde nature, le créateur de cette nature-là doit agir par des procédés analogues: que l'on sente dans tous les atomes, à tous les aspects, une impassibilité cachée et infinie. L'effet, pour le spectateur, doit être une espèce d'ébahissement.) This is said after a long critical discussion of the obviousness of the author's views in *Uncle Tom's Cabin* and immediately following a reference to the *Merchant of Venice* which concludes, "Mais la forme dramatique a cela de bon, elle annule l'auteur" (ibid.).

85. The passage is cited by LaCapra as part of a longer quotation from a study by Dorrit Cohn, but Flaubert's thought is somehow mangled in transmission (*"Madame Bovary" on Trial,* p. 133; letter dated 15–16 December 1866). I have based my translation on the original French: "Je me suis mal exprimé en vous disant 'qu'il ne fallait pas écrire avec son coeur.' J'ai voulu dire: ne pas mettre sa personnalité en scène. Je crois que le grand art est scientifique et impersonnel. Il faut, par un effort d'esprit, se transporter dans les Personnages et non les attirer à soi. Voilà du moins la méthode . . ." (Alphonse Jacobs, ed., *Gustave Flaubert–George Sand Correspondance* [Paris: Flammarion, 1981], p. 110).

86. LaCapra, *"Madame Bovary" on Trial,* p. 135.

87. Ibid.

88. Ibid., p. 127; Flaubert, *Correspondance,* 2:61. Letter to Louise Colet of 27 March 1852. (Toi disséminée en tous, tes personnages vivront, et au lieu d'une éternelle personnalité déclamatoire, qui ne peut même se constituer netttement, faute des détails précis

qui lui manquent toujours à cause des travestissements qui la déguisent, on verra dans tes oeuvres des foules humaines.)

89. The preceding remarks barely suggest the scope of the connections that can be drawn between Flaubert and Courbet; in this connection see Neil Hertz, "Afterword: The End of the Line," in *The End of the Line*, pp. 217–39.

90. There is in this regard a striking contrast between Courbet's paintings' structural inability to break out of a primary reference to the painter-beholder to achieve what might be called a "transparent" relation to the beholder in general (including us) and Walt Whitman's poems' relation to their imagined readers. As Philip Fisher remarks in an impressive essay, "[i]n [Whitman's democratic] aesthetics of identity each person becomes transparent to every other within society. . . . The most remarkable implication of his aesthetics Whitman works out in the poem 'Crossing Brooklyn Ferry,' where the transparency and cellular identity that he assumes between himself and all of his countrymen that he sees around him is extended into the future to become the form of continuity for national identity through time. The poem depends on Whitman's dazzling arrogance in looking forward generations and even centuries to those who will see the same things, have the same feelings, and look back to him, knowing that he also saw and felt just these things" ("Democratic Social Space: Whitman, Melville, and the Promise of American Transparency," *Representations*, no. 24 [Fall 1988]:67–68). The contrast with Whitman is significant because of his closeness to Courbet in other respects. See also Allen Grossman, "The Poetics of Union in Whitman and Lincoln: An Inquiry toward the Relationship of Art and Policy," in *The American Renaissance Reconsidered*, ed. Walter Benn Michaels and Donald E. Pease, Selected Papers from the English Institute, 1982–83, n.s., no. 9 (Baltimore and London: Johns Hopkins University Press, 1985), pp. 183–208.

91. The *German Huntsman* was earlier compared with the *Woman with a Parrot*, the setting of which combines aspects of an interior space and a forest clearing (see chapter six, n. 33).

92. My thanks to Sheila McTighe for first suggesting to me these implications of Courbet's late "workshop" productions. Thus Courbet wrote to Bruyas: "L'action que j'ai prise dans cette révolution a fait tripler le prix de ma peinture" (quoted by Wagner, "Courbet's Landscapes and Their Market," p. 415). On the larger question of the relation of Courbet's landscapes to the beholder, cf. Wagner's claim that the bulk of his landscape production in the 1860s and after (i.e., not just his late "workshop" pictures) was specifically directed at a bourgeois market. "Paradoxically," she writes, "it is as a 'vision of nature' that most of Courbet's landscapes . . . seem most aware of their beholders" (p. 429). Wagner's article is extremely interesting: I agree with her that Courbet's finest landscapes involve a process or reading, and she is surely correct to emphasize the role of the market in his extensive landscape production of the second half of the 1860s; but she risks drawing too stark an opposition within that production, and I don't at all agree that Courbet's seascapes (for example) aim at an instantaneous effect based on a "facile" technique (pp. 426–27). See, however, Wagner's admirable insistence that in his best landscapes (among which I would include many of the seascapes) "materiality is neither first nor last the fiction of paint" (p. 429).

93. Silvestre, "Courbet d'après nature," in Courthion 1:27. (Il n'a de violent que l'amour-propre: l'âme de Narcisse s'est arrêté en lui dans sa dernière migration. Il se peint toujours dans ses tableaux avec volupté; et pâme d'admiration pour son oeuvre.)

94. The proliferation of literary texts involving the Narcissus myth in France during the 1880s and after is a major theme in Steven Z. Levine, *Reflections and Repetitions: Meanings in the Water Paintings of Claude Monet* (work in progress).

95. Lynne Layton and Barbara Schapiro, "Introduction," in *Narcissism and the Text: Studies in Literature and the Psychology of Self,* ed. Lynne Layton and Barbara Ann Schapiro (New York and London: New York University Press, 1986), p. 2. The authors provide a useful overview of pertinent developments in American and British psychoanalysis since Freud. In his study cited in n. 94, Levine argues that Monet is a narcissistic personality and in general situates his reading of Monet's art in the context of the psychoanalytic theory in question (see also *idem,* "Monet, Fantasy, and Freud," in *Psychoanalytic Perspectives on Art,* ed. Mary Mathews Gedo [Hillsdale, N.J.: The Analytic Press, 1985], pp. 29–55).

96. From the perspective of the developments within psychoanalysis just alluded to, it would no doubt be further suggested that such a tendency to see (and love) himself in his surroundings expressed a desire to return fantasmatically to the Mother (or the maternal environment). In a sense, nothing that I am about to say will militate against such an interpretation of Courbet's antitheatrical project. But I would emphasize, first, that the readings of specific paintings put forward in *Courbet's Realism* in no way derive from a theory of narcissism; and second, that any attempt to characterize Courbet's project in psychological terms would still have to explain why that project took the particular forms it did, which would mean having to come to terms with the state of painting in France in the late 1830s and early 1840s. In other words, I am suggesting that narcissism as a theory of the self has little or nothing to add to the present study (as opposed to what I am persuaded by Levine is its relevance to Monet). See, however, Neil Hertz's ingenious use of Julia Kristeva's notion of the *vide* in *The End of the Line,* pp. 231–39.

97. G. W. F. Hegel, *Aesthetics: Lectures on Fine Art,* trans. T. M. Knox, 2 vols. (Oxford: Clarendon, 1975), 1:31. The *Aesthetics,* based on lectures delivered in Berlin in the 1820s, was first published posthumously in 1835. The original reads:

Das allgemeine und absolute Bedürfnis, aus dem die Kunst . . . quillt, findet seinen Ursprung darin, dass der Mensch *denkendes* Bewusstsein ist, d. h. dass er, was er ist und was überhaupt ist, aus sich selbst *für sich* macht. . . . Dies Bewusstsein von sich erlangt der Mensch in zwiefacher Weise; *erstens theoretisch,* insofern er im Innern sich selbst sich zum Bewusstsein bringen muss, was in der Menschenbrust sich bewegt, was in ihr wühlt und treibt, und überhaupt sich anzuschauen, vorzustellen, was der Gedanke als das Wesen findet, sich zu fixieren und in dem aus sich selbst Hervorgerufenen wie in dem von aussen her Empfangenen nur sich selber zu erkennen hat.—*Zweitens* wird der Mensch durch *praktische* Tätigkeit für sich, indem er den Trieb hat, in demjenigen, was ihm unmittelbar gegeben, was für ihn äusserlich vorhanden ist, sich selbst hervorzubringen und darin gleichfalls sich selbst zu erkennen. Diesen Zweck vollführt er durch Veränderung der Aussendinge, welchen er das Siegel seines Innern aufdrückt und in ihnen nun seine eigenen Bestimmungen wiederfindet. Der Mensch tut dies, um als freies Subjekt auch der Aussenwelt ihre spröde Fremdheit zu nehmen und in der Gestalt der Dinge nur eine äussere Realität seiner selbst zu geniessen. Schon der erste Trieb des Kindes trägt diese praktische Veränderung der Aussendinge in sich; der Knabe wirft Steine in den Strom und bewundert nun die Kreise, die im Wasser sich ziehen, als ein Werk, worin er die Anschauung des Seinigen gewinnt. Dieses Bedürfnis geht durch die vielgestaltigsten Erscheinungen durch bis zu der Weise der Produktion seiner selbst in den Aussendingen, wie sie im Kunstwerk vorhanden ist (Eva Moldenhauer und Karl Markus Michel, eds., *Vorlesungen über die Ästhetik,* 3 vols. [Frankfurt am Main: Suhrkamp, 1970], 1:50–51).

98. Ovid, *Metamorphoses,* trans. Rolfe Humphries (Bloomington and London: Indiana University Press, 1955), p. 70.

99. Quoted in Riat, p. 332 (est de marcher, de courir, de respirer à pleine poitrine, de se vautrer dans l'herbe . . . Il voudrait prendre la terre des champs à poignée, la baiser, la flairer, la mordre, donner des tapes sur le ventre des arbres, jeter des pierres dans les trous d'eau, barboter à même le ruisseau, manger, dévorer la nature).

100. My attention was drawn to the quotation from Puissant's article by an eloquent and perceptive passage in Pierre Courthion's introductory essay to the second volume of *Courbet raconté par lui-même et par ses amis,* "Comme un pommier produit des pommes." Courthion writes:

Dans l'univers matériel, c'est sa propre réalité qu'il reconnaît. Il se saisit pour le manger des yeux de ce grand corps en grume, dont il sent monter en lui la sève envahissante. Il voudrait 'prendre la terre des champs à poignées [sic], la baiser, la flairer, la mordre, donner des tapes sur le ventre des arbres, jeter des pierres dans les trous d'eau, barboter à même le ruisseau, manger, dévorer la nature.' C'est par cette identification avec le chuchotement des eaux, le rut des grands cerfs, la craie humectée de la roche que s'est libéré son génie de reproducteur de vie. Car à force de se choisir pour thème et de s'incorporer à son admirable peinture, cet adversaire de l'art pour soi, de l'art pour l'art, l'homme qui s'est sans doute le moins connu (et dont les contemporains nous ont montré l'orgueilleuse puérilité), le peintre qui de tous eut le moins conscience de l'art qu'il avait reçu en partage est devenu une chose, une sorte d'homme-objet en quoi se métamorphose, sous son aspect physique, la réalité tout entière (Courthion 2:18–19).

Courthion also comments "Ce qu'il a laissé sur la toile, ce n'est pas la vision d'un monde intérieur, mais l'image physique de sa personne, diluée dans la reproduction du monde matériel" (p. 19). Courthion's is by far the most impressive formulation in the modern literature on Courbet of a narcissistic reading of his art (the introduction to the first volume of *Courbet raconté* is called "Narcisse paysan").

101. Stanley Cavell, *The World Viewed,* p. 23.

102. Ibid., p. 25.

103. Ibid., p. 119. Earlier in the book he writes:

One impulse of photography, as immediate as its impulse to extend the visible, is to theatricalize its subjects. The photographer's command, "Watch the birdie!" is essentially a stage direction. One may object that the command is given not to achieve the unnaturalness of theater but precisely to give the impression of the natural, that is to say, the *candid;* and that the point of the direction is nothing more than to distract the subject's eyes from fronting on the camera lens. But this misses the point, for the question is exactly why the impression of naturalness is conveyed by an essentially theatrical technique. And why, or when, the candid is missed if the subject turns his eye into the eye of the camera (p. 90).

Cf. the discussion of A.-A.-E. Disdéri's attempt to theorize the group photograph in chapter one (pp. 45–46), as well as the fine analysis of the problem of the photographic pose in Dianne Williams Pitman, "The Art of Frédéric Bazille," pp. 44–53.

104. Ibid., p. 118. The key passage reads: "Setting pictures to motion mechanically overcame what I earlier called the inherent theatricality of the (still) photograph. The development of fast film allowed the subjects of photographs to be caught unawares, beyond our or their control. But they are nevertheless *caught;* the camera holds the last lanyard of control we would forgo" (pp. 118–19). See also Fried, "Art and Objecthood," pp. 140–41: "There is . . . one art that, by its very nature, *escapes* theater entirely—the movies. . . . Because cinema escapes theater—automatically, as it were—it provides a welcome and absorbing refuge to sensibilities at war with theater and theatricality."

105. Cavell, *The World Viewed,* pp. 101–03. The first sentence occurs roughly a page earlier than the rest of the quotation.

106. Ibid., p. 127.

107. Ibid., p. 130.

108. Ibid., p. 203. A few pages later Cavell speaks of Carl Dreyer's *Gertrud* as trading on and refining "the fact of the limitedness, or arbitrariness, of the single view" (pp. 204–5).

109. That the construction of the photographic apparatus involves the embedding of something like an array of intentions concerning the images to be produced is insisted upon by Neil Walsh Allen and Joel Snyder, "Photography, Vision, and Representation," *Critical Inquiry* 2 (Autumn 1975):143–69, especially 149–51. For Allen and Snyder, however, this is part of a larger argument against the proposition that "there [is] anything peculiarly 'photographic' about photography" (p. 143), including a particular relation to automatism. See also Joel Snyder, "Picturing Vision," *Critical Inquiry* 6 (Spring 1980): 499–526.

The separation *as if temporally* of the intentionality of photographic automatisms from the activation of those automatisms is perhaps reflected (or displaced) in the fact that, as Cavell puts it, "[Y]ou cannot know what you have made the camera do, what is revealed to it, until its results have appeared. . . . [T]he mysteriousness of the photograph lies not in the machinery that produces it, but in the unfathomable abyss between what [the photograph] captures (its subject) and what is captured for us (*this* fixing of the subject), the metaphysical wait between exposure and exhibition, the absolute authority or finality of the fixed image" ("More of The World Viewed," in *The World Viewed*, p. 185). The same metaphysical wait—"[an] internal opacity . . . the fact that you cannot know exactly what you are doing until it is done"—is held by Walter Benn Michaels to be characteristic both of the taking of photographs and of the representation of agency in various late nineteenth- and early twentieth-century American texts (in *The Gold Standard and the Logic of Naturalism: American Literature at the Turn of the Century* [Berkeley: University of California Press, 1987], pp. 217–44; the quotation is from p. 225).

110. Baudelaire's hostility to photography is well known, but rather than rehearse that topic here I want to cite his discussion of Ingres in his commentary on the Exposition Universelle of 1855. There Baudelaire observes that Ingres's art is inhabited by "an automatistic population that would trouble our senses by its too visible and palpable foreignness," and a few pages further on identifies "the faculty that has made M. Ingres what he is [as] the will, or rather an immense abuse of the will" ("Exposition Universelle de 1855," *Curiosités esthétiques,* p. 224, pp. 229–30) (une population automatique et qui troublerait nos sens par sa trop visible et palpable extranéité . . . la faculté qui a fait de M. Ingres ce qu'il est, le puissant, l'indiscutable, l'incontrôlable dominateur, c'est la volonté, ou plutôt un immense abus de la volonté). For Baudelaire the abuse consisted in leaving no place for the imagination, but what I find suggestive in his remarks is that Ingres's hypostatization of the will would have had for its complement a denial of automatism that would have made his art in this respect if in no other the antithesis of photography. His paintings' population of automata would then be tantamount to a return of the repressed (both Ingres's and Baudelaire's). It is suggestive too that Baudelaire in the same pages characterizes Courbet as "a savage [or wild] *and patient* will" (p. 225; emphasis added), the notion of patience implying a capacity for passivity that leaves room for automatism.

111. Léger, p. 191. (Vous me rappelez ce pauvre Baudelaire, qui, un soir, en Normandie, au coucher du soleil m'amène sur un rocher dominant la mer. Il me conduit devant une ouverture béante encadrée par les découpures des rocs: "Voilà ce que je voulais vous montrer, me dit Baudelaire, voilà le point de vue." Etait-il assez bourgeois, hein! Qu'est-ce que c'est que des points de vue? Est-ce qu'il existe des points de vue?)

112. Riat, p. 72. (Corot eut du mal à trouver sa place; il cherchait son motif, clignait des yeux, penchait la tête tantôt à gauche, tantôt à droite. . . . Quant à Courbet, il s'était installé n'importe où. "Où je me mette, déclara-t-il, ça m'est égal; c'est toujours bon, pourvu qu'on ait la nature sous les yeux.")

113. See Alvin Plantinga, ed., *The Ontological Argument. From St. Anselm to Contemporary Philosophers* (Garden City, N.Y.: Anchor Books, 1965), pp. 3–27, especially p. 15.

114. Henry David Thoreau, *The Variorum Walden,* ed. Walter Harding (New York: Washington Square Press, 1962), p. 11. In this connection see Cavell's discussion of "the general relation the writer [of *Walden*] perceives as 'being next to,'" which leads to the conclusion that, "The externality of the world [specified as the world "as a whole"] is articulated by Thoreau as its nextness to me" (*The Senses of Walden* [New York: Viking Press, 1972], pp. 103–5). In a related passage Cavell links Thoreau's "obsession with necessity" with Kant's "*a priori* conditions of our knowing anything *überhaupt*" and goes on to say: "[Thoreau's] difference from Kant on this point is that these *a priori* conditions are not themselves knowable *a priori,* but are to be discovered experimentally; historically, Hegel had said" (p. 93).

115. Jonathan Crary, "Techniques of the Observer," *October,* no. 45 (Summer 1988):3–35; the quotation is on p. 35. In this important essay Crary draws attention to the abandonment in the early nineteenth century of the camera obscura as a model for vision and its replacement by a largely physiological account that emphasized the production of the phenomena of vision within the body of the observer. He also describes the workings of a variety of early optical devices, including the diorama and the stereoscope, all of which were addressed to a frankly corporeal (e.g., spatially situated, binocular) spectator. His ultimate point, however, is that the invention or rather the development of the photograph served to repress the awareness of the body that had been coming to the fore:

Photography . . . defeated the stereoscope as a mode of visual consumption because it recreated and perpetuated the fiction that the "free" subject of the camera obscura was still viable. Photographs seemed to be a continuation of older "naturalistic" pictorial codes but only because their dominant conventions were restricted to a narrow range of technical possibilities (that is, shutter speeds and lens openings that rendered elapsed time invisible). But photography had already abolished the inseparability of observer and camera obscura, bound together by a single point of view, and made the new camera an apparatus fundamentally independent of the spectator, yet which masqueraded as a transparent and incorporeal intermediary between observer and world. The prehistory of the spectacle *and* the "pure perception" of modernism are lodged in the newly discovered territory of a fully embodied viewer, but the eventual triumph of both depends on the denial of the body, its pulsings and phantasms, as the ground of vision (p. 35).

Elsewhere Crary expresses the desire not to give art works "a kind of ontological priority" but rather to define the nineteenth-century observer "as an *effect* of a heterogeneous network of discursive, social, technological, and institutional relations" (in *Vision and Visuality: Discussions in Contemporary Culture,* ed. Hal Foster, no. 2 [Seattle: Bay Press, 1988, p. 48]). Crary's Foucauldian approach is, however, entirely compatible with the recognition that there could be no fuller instance of the embodied, time-bound spectator his essay evokes than the painter-beholder of Courbet's paintings.

116. Clement Greenberg, "Modernist Painting," in *The New Art: A Critical Anthology,* ed. Gregory Battcock (rev. ed., New York: Dutton, 1973), p. 68, with slight revisions.

117. Ibid., pp. 68–69.

118. In fact Rosen and Zerner don't use the term modernism or speak of the evolution of modern art as involving immanent self-criticism. But their account of that evolution as involving a progressive minimizing of considerations of subject matter and a concomitant foregrounding of the material properties of the medium (culminating in the emergence of abstract art) is a classic if belated expression of a formalist-modernist position.

119. This is to say nothing of the inherent deficiencies of Greenberg's theory of mod-

ernism, about which I have written elsewhere. In this connection see Michael Fried, "How Modernism Works: A Response to T. J. Clark," *Critical Inquiry* 9 (Sept. 1982):217–34; and Stephen W. Melville, *Philosophy Beside Itself: On Deconstruction and Modernism,* Theory and History of Literature, vol. 27 (Minneapolis: University of Minnesota Press, 1986), pp. 3–33.

120. Cavell, *The World Viewed,* pp. 128–30; see also pp. 109–12, 123–24, and *passim.*

121. See for example my essay in the catalog to the traveling exhibition, *Anthony Caro: Table Sculptures, 1966–77* (British Council, 1977–78), reprinted in *Arts* 51 (Mar. 1977):94–97; and "How Modernism Works," 230–34. I first thematized the concept of acknowledgment in "Shape as Form: Frank Stella's New Paintings," pp. 403–25. The latter essay includes the statement that "hypostatization is not acknowledgment. The continuing problem of *how* to acknowledge the literal character of the support—of *what counts* as that acknowledgment—has been at least as crucial to the development of Modernist painting as the fact of its literalness; and this problem has been eliminated, not solved, by [minimalist or, my term, literalist artists like Donald Judd and Larry Bell]. Their pieces cannot be said to acknowledge literalness; they simply *are literal.* And it is hard to see how literalness as such, divorced from the conventions which, from Manet to Noland, Olitski and Stella, have *given* literalness value and have *made* it a bearer of conviction, can be experienced as a *source* of both of these—and what is more, one powerful enough to generate new conventions, a new art" (p. 414).

122. Cavell, *The World Viewed,* p. 103.

123. Or see Fried, "Shape as Form," which begins: "Frank Stella's new paintings investigate the viability of shape as such. By *shape as such* I mean not merely the silhouette of the support (which I shall call literal shape), not merely that of the outlines of elements in a given picture (which I shall call depicted shape), but shape as a medium within which choices about both literal and depicted shape are made, and made mutually responsive. And by the viability of shape, I mean its power to hold, to stamp itself out, and *in*—as verisimilitude and narrative and symbolism used to impress themselves—compelling conviction. Stella's undertaking in these paintings is therapeutic: to restore shape to health, at least temporarily, though of course its implied 'sickness' is simply the other face of the unprecedented importance shape has assumed in the finest Modernist painting of the past several years . . ." (p. 403).

124. Thus I assume in my essays on Caro and Stella that the artists understood themselves to be engaged with issues of abstract scale and shape respectively. In this connection see the passage in Cavell, *The World Viewed,* beginning, "My harping on acknowledgment is meant to net what is valid in the notion of self-reference and in the facts of self-consciousness in modern art" (pp. 123–24). The link between self-awareness and acknowledgment as a concept of epistemology is developed further in Cavell's *The Claim of Reason: Wittgenstein, Skepticism, Morality, and Tragedy* (Oxford and New York: Oxford University Press, 1979), where for example it is argued that "acknowledgment 'goes beyond' knowledge, not in the order, or as a feat, of cognition, but in the call upon me to express the knowledge at its core, to recognize what I know, to do something in the light of it, apart from which this knowledge remains without expression, hence perhaps without possession" (p. 428).

125. I think of Manet as having attempted to make his paintings face the beholder *everywhere and as a whole.* And I think of that attempt in turn as involving, first, a pursuit of effects of instantaneousness (as of the painting's total revelation to the beholder, or say the beholder's perception of the painting in its entirety); and second, an emphasis on the value of unity I have associated with the concept of the *tableau* but taking unprecedented

forms (e.g., the combining of various genres into a single super-genre in the *Déjeuner sur l'herbe*). In these respects, too, the differences between Manet's and Courbet's art are fundamental. (See Fried, "Manet's Sources," and idem, "Painting Memories.") I might add that the frequent characterization of Manet as exclusively preoccupied with vision is at bottom a response to (and a misdescription of) his concern with "facingness."

126. For an intelligent discussion of the *Hunter on Horseback* see William M. Kane, "Courbet's 'Chausseur' of 1866–1867," *Yale University Art Gallery Bulletin* 25 (Mar. 1960):30–38. The painting is dated 1867? in *Courbet Reconsidered,* cat. no. 69, pp. 179–82, even though it is there acknowledged that Robert Fernier in his *Catalogue raisonné* cites a photograph of Courbet's studio in Ornans taken in June 1864 by Eugène Feyen that shows the *Hunter on Horseback* (Fernier, vol. 1, cat. no. 375). Feyen's photograph is reproduced in *Courbet und Deutschland,* cat. no. 453, pp. 532–33.

127. In his article on the painting, Kane quotes a postscript to a letter written by Courbet to his father from exile in Switzerland: "I certify having made the *Chasseur à cheval,* a hunt in the snow. This confirmation is better proof than a painted signature, which is not recognized by the law" ("Courbet's 'Chasseur' of 1866–67," pp. 31–32). The postscript is cited by Léger, p. 122. (Je déclare avoit fait le *chasseur à cheval, chasse à la neige.* Cette affirmation fait foi davantage qu'une signature peinte sur le tableau qui n'est pas reconnu par la loi.)

# Credits

*Color Plates*

1,2: © Réunion des Musées Nationaux; 3: phot. Ph. Bernard; 4–7: © Réunion des Musées Nationaux; 8: Henry Lillie Pierce Fund, courtesy, Museum of Fine Arts, Boston; 9: © Réunion des Musées Nationaux; 11: Bequest of Mrs. H. O. Havemeyer, 1929. The H. O. Havemeyer Collection; 13: The Baltimore Museum of Art, The Cone Collection, formed by Dr. Claribel Cone and Miss Etta Cone of Baltimore Maryland, BMA 1950.202; 14: The Norton Simon Foundation; 15: Kunsthaus Zurich; 16: Gift of J. Watson Webb, B.A. 1907, and Electra Havemeyer.

*Figures*

1: Andrew W. Mellon Collection 1937. Photo courtesy of The National Gallery of Art, Washington, D.C.; 4–10: © Réunion des Musées Nationaux; 13: Photo, Statens Konstmuseer; 14: Giraudon/Art Resource; 15–17: © Réunion des Musées Nationaux; 18: Reproduced by courtesy of the Trustees, The National Gallery, London; 19–23: Phot. Bibl. Nat. Paris; 25: © Réunion des Musées Nationaux; 26: The Chrysler Museum, Norfolk, VA, gift of Walter P. Chrysler, Jr.; 32: © Nasjonalgalleriet, Oslo; 33, 35: © Réunion des Musées Nationaux; 36: Giraudon/Art Resource; 38: Louvre, RF 29234, fol. 23, © Réunion des Musées Nationaux; 39: © Réunion des Musées Nationaux; 40: Photo, Statens Konstmuseer; 42: Phot. Bibl. Nat. Paris; 43: Louvre, RF 29234, fol. 7 (verso), © Réunion des Musées Nationaux; 44: Photo courtesy of André Jammes; 45: Bequest of Grenville L. Winthrop; 46: Giraudon/Art Resource; 48, 49: Oskar Reinhart Collection "Am Römerholz", Haldenstr. 95, 8400 Winterthur; 50: Bequest of Grenville L. Winthrop; 51: Phot. Nat. Bibl. Paris; 53: Giraudon/Art Resource; 54: W. P. Wilstach Collection; 55: Giraudon/Art Resource; 56: Courtesy of The Minneapolis Institute of Arts; 57: Phot. Bibl. Nat. Paris; 59: Reproduced by courtesy of the Trustees, The National Gallery, London; 60,62: © Réunion des Musées Nationaux; 61,63: Photo Bulloz; 64: Simeon B. Williams Fund, 1968.163. © 1989 The Art Institute of Chicago. All rights reserved. Courtesy of The Art Institute of Chicago; 65: Photo Bulloz; 66,67: © Réunion des Musées Nationaux; 68: Henry Lillie Pierce Fund, courtesy, Museum of Fine Arts, Boston; 69: © Réunion des Musées Nationaux; 70: Photo courtesy of André Jammes; 71: Oskar Reinhart Collection "Am Römerholz," Haldenstrasse 95, 8400 Winterthur; 73,74; © Réunion des Musées Nationaux; 75: Bequest of Mrs. H. O. Havemeyer, 1929. The H. O. Havemeyer Collection (29.100.57); 77: Phot. © 1990 by The Barnes Foundation; 79: Louvre, RF 29234, fol. 10, © Réunion des Musées Nationaux; 80: Kunsthaus Zurich; 81: George B. and Jenny R. Mathews Fund, 1959; 82, 83:

© Réunion dés Musées Nationaux; 84: Nationalgalerie, Staatliche Museen, Preussischer Kulturbesitz, Berlin (West); 85: Louvre, RF 29234, fol. 24, © Réunion des Musées Nationaux; 86: © Réunion de Musées Nationaux; 87: By courtesy of The Lefevre Gallery, London; 88: Photo Studio Madec; 89: Reproduced by courtesy of the Budapest Museum of Fine Arts; 90–92: © Réunion des Musées Nationaux; 94: The Baltimore Museum of Art, The Cone Collection, formed by Dr. Claribel and Miss Etta Cone of Baltimore, Maryland, BMA 1950.202; 95: © Réunion des Musées Nationaux; 96: Photo Bulloz; 97: The Phillips Collection, Washington, D.C.; 98: Emily Crane Chadbourne Fund, 1967.140. © 1989 The Art Institute of Chicago. All rights reserved. Courtesy of The Art Institute of Chicago; 99: Reproduced by courtesy of The Budapest Museum of Fine Arts; 101,102: By courtesy of The Lefevre Gallery, London; 104: © Réunion des Musées Nationaux; 105: Kunstmuseum Bern; 107: The Louis E. Stern Collection; 108–9: © Réunion des Musées Nationaux; 110: Giraudon/Art Resource; 111: Gift of Mr. and Mrs. P. H. B. Frelinghuysen in memory of her father and mother, Mr. and Mrs. H. O. Havemeyer. Photo courtesy of The National Gallery of Art, Washington, D.C.; 112: Gift of Edward Drummond Libbey; 114: Gift of Harry Payne Bingham, 1940 (40.175).

# Index

Page numbers in bold type refer to illustrations. Paintings are listed under the names of artists.